SCULPTURE AND PSYCHOANALYSIS

SUBJECT/OBJECT: NEW STUDIES IN SCULPTURE
Series Editor: Penelope Curtis
The Henry Moore Institute, Leeds

We have become familiar with the notion that sculpture has moved into the 'expanded field', but this field has remained remarkably faithful to defining sculpture on its own terms. Sculpture can be distinct, but it is rarely autonomous. For too long studied apart, within a monographic or survey format, sculpture demands to be reintegrated with the other histories of which it is a part. In the interests of representing recent moves in this direction, this series will provide a forum for the publication and stimulation of new research examining sculpture's relationship with the world around it, with other disciplines and other material contexts.

Other titles in the series include

Henry Moore: Critical Essays
Edited by Jane Beckett and Fiona Russell

Pantheons
Transformations of a Monumental Idea
Edited by Richard Wrigley and Matthew Craske

Figuration/Abstraction
Public Sculpture in Europe, 1945–1968
Edited by Charlotte Benson

Rodin
The Zola of Sculpture
Edited by Claudine Mitchell

Sculpture and Psychoanalysis

Edited by Brandon Taylor

ASHGATE

Published by
Ashgate Publishing Limited
Gower House
Croft Road
Aldershot
Hants GU11 3HR

Ashgate Publishing Company
Suite 420
101 Cherry Street
Burlington, VT 05401-4405
USA

Ashgate website: http://www.ashgate.com

British Library Cataloguing in Publication Data
Sculpture and psychoanalysis. - (Subject/object : new
 studies in sculpture)
 1. Sculpture, Modern 2. Psychoanalysis and art
 I. Taylor, Brandon
 730.1'9

Library of Congress Cataloguing-in-Publication Data
Sculpture and psychoanalysis / edited by Brandon Taylor.
 p. cm -- (Subject/object--new studies in sculpture)
 Includes index.
 ISBN 0-7546-0984-7 (hardback : alk paper)
 1. Sculpture--Psychological aspects. 2. Sculpture, Modern--20th century.
 3. Psychoanalysis and art. I. Taylor, Brandon. II. Series.

 NB1153.P74S38 2005
 735'.23--dc2

 2005049268

ISBN-10: 0754609847

Typeset by Bournemouth Colour Press, Parkstone, Poole.

Printed and bound in Great Britain by Biddles Ltd, King's Lynn.

Contents

Installation and Performance

Matter and Process

List of illustrations

R. Guggenheim Foundation, New York (photograph: David Heald)

3.4 Donald Judd, *Untitled*, 10 units, each 23 x 101.6 x 78.7 cm, stainless steel, yellow plexiglas, 1968, DSS/123, Froehlich Collection, Stuttgart, art © Judd Foundation, licensed by VAGA, New York / DACS, London 2004 (photograph: Uwe H. Seyl, Stuttgart)

3.5 Donald Judd, *Untitled*, 122 x 84 x 54.6 cm, light cadmium red oil on wood with iron pipe, 1962, DSS/33, collection of the Judd Foundation, art © Judd Foundation, licensed by VAGA, New York / DACS, London 2004 (photograph: Nic Tenwiggenhorn)

4

4.1 Barbara Hepworth, *Infant*, 438 x 273 x 254, wood, 1929, © Trustees of the Barbara Hepworth Estate / Tate, London 2004

4.2 Barbara Hepworth, *Figure (Mother and Child)*, 66.0 cm, grey alabaster, 1933, © Trustees of the Barbara Hepworth Estate / Tate, London 2004

4.3 Barbara Hepworth, *Reclining Figure*, 17.8 cm, alabaster, 1933, © Trustees of the Barbara Hepworth Estate / Hirshhorn Museum and Sculpture Gardens, Smithsonian Institution, Washington

4.4 Barbara Hepworth, *Two Forms*, 26.0 x 29.6 x 17.6 cm, alabaster on limestone base, 1933, private collection, © Trustees of the Barbara Hepworth Estate / Tate, London 2004

4.5 Barbara Hepworth, *Mother and Child*, alabaster, 1934, © Trustees of the Barbara Hepworth Estate

4.6 Barbara Hepworth, *Mother and Child*, 22.8 cm, Cumberland alabaster 1934, © Trustees of the Barbara Hepworth Estate/ Tate, London 2004

4.7 Henry Moore, *Suckling Child*, 43.2 cm, cast concrete, 1927, courtesy of the Henry Moore Foundation

4.8 Henry Moore, *Ideas for Sculpture: Page from No 1 Drawing Book*, 1930–1, courtesy of the Henry Moore Foundation

4.9 Barbara Hepworth, *Madonna and Child*, 78.8 cm, bianco del mare, 1954, St Ives Parish Church, © Trustees of the Barbara Hepworth Estate

5

5.1 'New Aspects of British Sculpture', Venice Biennale, 1952, showing Bernard Meadows' sculpture and drawings (centre: *Crab*, 1951–52, bronze, 68 cm), courtesy of the British Council

5.2 Henry Moore, *Standing Figure* (Shawhead, Dumfries), 214 cm, bronze, 1950, courtesy of the Henry Moore Foundation (photograph: © W. J. Keswick)

5.3 Lynn Chadwick, *Fisheater*, 230 cm, iron and copper, 1951, courtesy of Tate Britain and the Lynn Chadwick Estate (photograph: David Hulks)

5.4 Geoffrey Clarke, *Complexities of Man*, 26 cm, iron, 1951, courtesy of the British Council

5.5 Reg Butler, *Oracle*, 173 cm, shell, bronze, 1953, courtesy of Rosemary Butler

5.6 Alison and Peter Smithson, Eduardo Paolozzi, Nigel Henderson, *Patio and Pavilion*, installed at the exhibition 'This is Tomorrow', 1956, Whitechapel Art Gallery, London, © Photo Tate Archive / Estate of Nigel Henderson (photograph: Nigel Henderson)

6

6.1 Jean-Jacques Lebel, *Portrait of Nietzsche*, 140 x 145 x 32 cm, sound,

wood, metal, antler, glass, paper, leather, feathers, electricity and green cactus, 1962, with kind permission of the artist

6.2 Jean-Jacques Lebel, *Monument to Félix Guattari*, 800 x 600 x 600 cm, electric sculpture, multi-media machine, 1994, with kind permission of the artist

6.3 Jean-Jacques Lebel, *Monument for Antonin Artaud*, 200 x 170 x 55 cm, wood, metal, hair, electric light bulb and painted skull, 1959, with kind permission of the artist

6.4 Jean-Jacques Lebel, *Enterrement de la chose*, happening, Venice 1960, with kind permission of the artist

6.5 Jean-Jacques Lebel, *Enterrement de la chose*, happening, Venice 1960, with kind permission of the artist

6.6 Jean-Jacques Lebel, Lawrence Ferlinghetti, and Félix Guattari, 2nd International POLYPHONIX Festival, Paris 1980, with kind permission of the artist (photograph: F. Garghetti)

7

7.1 Gilbert & George, *The Singing Sculpture*, 1971, Sonnabend Gallery, courtesy of Gilbert & George (photograph: © John Garrett / Corbis)

7.2 Gilbert & George, the artists at home in Fournier Street, © Gilbert & George

7.3 Gilbert & George, *Ill World*, (from 'The Naked Shit Pictures', 1995), 253 x 426 cm, 1994, © Gilbert & George

7.4 Gilbert & George, *Twelve*, (from 'The New Horny Pictures', 2001), 213 x 338 cm, 2001, © Gilbert & George

7.5 Gilbert & George, *Eight Shits*, (from 'The Naked Shit Pictures', 1995), 253 x 355 cm, 1994, © Gilbert & George

7.6 Gilbert & George, *Bum Holes*, (from 'The Naked Shit Pictures', 1995), 253 x 355 cm, 1994, © Gilbert & George

8

8.1 Eva Hesse's Studio, 1966, © The Estate of Eva Hesse, Hauser and Wirth, Zürich and London

8.2 Eva Hesse, *Hang Up*, 182.9 x 213.4 x 198.1 cm, acrylic painted on cloth over wood; acrylic paint on cord over steel tube, 1966, The Art Institute of Chicago, Gift of Arthur Keating and Mr and Mrs Edward Morris by exchange, © The Estate of Eva Hesse, Hauser and Wirth, Zürich and London

8.3 Eva Hesse, 'Chain Polymers', Fischbach Gallery, New York, 1968, installation view: on walls, *Sans I* (left), *Stratum* (right); on floor, *Schema* (foreground), *Sequel* (background), © The Estate of Eva Hesse, Hauser and Wirth, Zürich and London

8.4 Eva Hesse, *Untitled* (Rope Piece), dimensions variable, latex and filler over rope and string with metal hoods, completed March 1970, Whitney Museum of American Art, New York, purchased with funds from Eli and Edyth L. Broad, the Mrs Percy Uris Fund, and the Painting and Sculpture Committee, © The Estate of Eva Hesse, Hauser and Wirth, Zürich and London (photograph: Geoffrey Clements)

8.5 Eva Hesse, *Untitled*, 19 x 19 x 10.2 cm, acrylic paint and cord over papier-mâché on wood, 1966, LeWitt Collection, Hartford, Connecticut, courtesy of the Wadsworth Atheneum Museum of Art, Hartford, Connecticut

9

9.1 Rebecca Horn, *Homage to Barceloneta*, 2.5 m, iron, glass and mixed materials, 1992 (photograph: Camilla Taylor)

9.2 Rebecca Horn, *Homage to Barceloneta* (detail), 2.5 m, iron, glass and mixed materials, 1992 (photograph: Camilla Taylor)

11

11.1 Robert Morris, *Steam*, 1967
(photograph: courtesy of the artist)

11.2 Robert Morris, *Dirt*, 1968
(photograph: courtesy of the artist)

11.3 Robert Morris, *Untitled
(Threadwaste)*, 1968, courtesy of Leo
Castelli Gallery

11.4 Robert Morris, *Continuous Project
Altered Daily*, 1969, courtesy of Leo
Castelli Gallery

11.5 Anthony Caro, *Woman Waking Up*,
bronze, 26.7 x 67.9 x 34.9 cm, Collection
Tate Gallery London, 1955

11.6 Ilya Kabakov, *The Rope of Life*,
dimensions variable, 1995, courtesy of
Museum für Moderne Kunst, Frankfurt
am Main (photograph: Axel Schneider,
Frankfurt)

Notes on contributors

SIMON BAKER is Lecturer in Art History at the University of Nottingham and a member of the editorial group of the *Oxford Art Journal*. His current research concerns the photography of devastation in France after the Great War. He has published several essays on Surrealism and is currently working on an exhibition about George Bataille and the journal *Documents* for the Hayward Gallery. Recent publications include 'Tales from the crypt/a Surrealist pantheon', in R. Wrigley and M. Craske (eds), *Pantheons: Transformations of a Monumental Ideal* (London: Ashgate, 2004) and 'Narrative as shell in the work of Julião Sarmento', in L. Neri (ed.), *Julião Sarmento* (Ediçiones Poligrafa, 2003).

GEORGES DIDI-HUBERMAN teaches at the École des Hautes Études en Sciences Sociales, Paris. Among his publications are *Devant le temps: Histoire de l'art et l'anachronisme des images* (Paris: Éditions de Minuit, 2000), *L'image suivante* (Paris: Éditions de Minuit, 2002), *The Invention of Hysteria: Charcot and the Photographic Iconography of the Salpêtrière* (Cambridge, Mass./October Books, 2003), and *Confronting Images: Questioning the Ends of a Certain History of Art* (Pennsylvania State University Press, 2005).

MARTIN GOLDING has been a Fellow of Peterhouse, Cambridge, where he teaches undergraduates and directs studies in English, since 1970. He is also an Associate Member of the British Association of Psychotherapists, and is in private practice in Cambridge. He has published numerous essays, principally on art – sometimes in relation to psychoanalytic themes – in a variety of periodicals and exhibition catalogues.

BRIAN GROSSKURTH is Professor of Art History at York University, Toronto. His research is in nineteenth and twentieth century art history, in particular the

work of Delacroix, Géricault, Miró, Surrealism and the Rue Blomet group, as well as contemporary art and philosophy in France and issues surrounding public sculpture. His recent publications have included 'Bataille, the Body and Contemporary Art', in *Elective Affinities* (Tate Gallery, London, 1993), and 'Drawing on Lacan' (1994) and 'Blinding Theory' (1995), both in the *Oxford Art Journal*.

DAVID HULKS was recently Henry Moore Foundation Fellow in the Study of Sculpture, and now teaches at the School of World Art Studies and Museology, the University of East Anglia. He completed his PhD on 'Adrian Stokes and the Changing Order of Art' at Reading University. He is joint editor of a forthcoming reader in sculpture theory from 1845 to the present, to be published by the Henry Moore Institute (2006).

ALYCE MAHON is Lecturer in History of Art and Fellow of Trinity College, Cambridge University. She has published widely on Surrealism and post-World War II European art, including essays on Hans Bellmer, André Masson and Klossowski. She contributed the essay 'Staging Desire' to the catalogue *Surrealism, Desire Unbound* (London: Tate Publishing, 2001). She is the author of *Eroticism and Art* (Oxford: Oxford University Press, 2005) and *Surrealism and the Politics of Eros in France 1938–1968* (London: Thames and Hudson, 2005).

TIM MARTIN is an art and architecture theorist and scholar, and Senior Lecturer at the Leicester School of Architecture. He has published extensively on twentieth-century art, including articles on Robert Smithson, *The Essential Surrealists* (London, 1999) and contributions to the television series *Landmarks in Western Art* (1999).

MIGNON NIXON is Senior Lecturer in the History of American Art at the Courtauld Institute of Art, University of London, and an editor of *October*. She is the co-editor of *The Duchamp Effect* (MIT Press/October Books, 1996) and the editor of *Eva Hesse* (MIT Press/October Files, 2002). Her book *Fantastic Reality: Louise Bourgeois and a Story of Modern Art* was published by MIT Press/October Books in 2005.

GRANT POOKE lectures in contemporary art at the University of Kent where he is Programme Director of the open-entry BA Honours degree in the History and Theory of Art. A graduate of St Andrews University, he is co-author of *Teach Yourself Art History* (London: Hodder & Stoughton, 2003) and is presently writing a book on British post-conceptual art practice in addition to undertaking research on Marxist art historiography. He has also recently

worked as an authoring consultant and art history curriculum adviser for the BBC and Open University *Teach & Learn* initiative.

BRANDON TAYLOR is Professor of History of Art, University of Southampton. Among his publications are *Art and Literature under the Bolsheviks* (2 vols, London: Pluto Press, 1990 and 1991), *The Nazification of Art: Art, Design, Music, Architecture and Film* (Winchester: Winchester Press, 1990), *The Art of Today* (London: Weidenfeld, 1995), *Art for the Nation: Exhibition and the London Public 1747–2001* (Manchester: Manchester University Press, 1999), *Collage: The Making of Modern Art* (London: Thames and Hudson, 2004) and *Contemporary Art* (New York: Prentice-Hall, 2005). He recently curated 'Elements of Abstraction: Space, Line and Interval in Modern British Art' (Southampton City Art Gallery, 2005).

ANNE M. WAGNER is an art historian whose interests are focused on the forms and meanings of nineteenth- and twentieth-century art, particularly sculpture, as well as its more recent manifestations in earthworks, performance, and beyond. Since 1988 she has been a professor in the Department of History of Art at the University of California, Berkeley, where she is a member of the editorial board of *Representations*. Recent essays include studies of Kara Walker's black-and-white imagery, Willem de Kooning's drawings, Gordon Matta-Clark's photographs and Rosemarie Trockel's *Painting Machine. Jean-Baptiste Carpeaux: Sculptor of the Second Empire*, appeared in 1986 and *Three Artists (Three Women)* was published in 1996. Her third book, *Mother Stone: The Vitality of Modern British Sculpture*, was published by Yale University Press in 2005.

Acknowledgements

The present collection of papers originated in a session of the annual conference of the Association of Art Historians in Exeter, England, in 1997, convened by Fiona Russell for the Henry Moore Institute, Leeds, and chaired by her and myself. Penelope Curtis suggested it might make a suitable volume for the Institute's new 'Subject/Object: New Studies in Sculpture' series, and Fiona Russell and I began the task of editing the texts and discussing the scope and shape of the final volume. It soon became clear that the book would benefit from the addition of new, or additional, material, and, after several delays brought on by the pressure of other commitments, I took over the editing in 2004. My thanks are due first to Fiona Russell for her early work; to Penelope Curtis for gently pushing the project forward, and to Martina Droth, who as current Research Coordinator at the Henry Moore Institute has done so much to give the volume final form. A number of artists and their agents deserve our gratitude, both for giving permission for illustrations and expediting their availability, and for their creative contribution to a field of sculpture which can be as daunting and mysterious as in any period in the past. These include Gilbert & George, with Sophie Grieg of the White Cube Gallery, London, Robert Morris, New York, and Jean-Jacques Lebel, Paris. I must also record my gratitude to Tania Robertson of the University of Southampton, whose skills as an editorial assistant proved indispensable, and to Elizabeth Teague for her sensitive copy-editing.

Above all, the publishers warmly thank our contributors, who have patiently awaited the final realization of this book. We are particularly grateful to Anne Wagner for permission to reprint her essay on Barbara Hepworth, which first appeared in D. Thistlewood (ed.), *Barbara Hepworth Reconsidered* (Liverpool: Tate Gallery, 1996), pp. 53–74, and to Georges Didi-Huberman for permission to include his essay on wax sculpture, first

published as 'Die Ordnung des Materials. Plastizität, Unbehagen, Nachleben', in *Vorträge aus dem Warburg-Haus, III* (Berlin: Akademie Verlag, 1999) pp. 1–29, which appears here for the first time in English.

Introduction

Brandon Taylor

The theories and institutions of psychoanalysis have had numerous points of contact with the visual arts, but relatively few with modern sculpture as that term is normally understood. Very few indeed of the pioneer figures of psychoanalysis, even those that took a close interest in the arts, devoted significant amounts of time to the problems and qualities of the sculptural object in general, and almost none addressed him- or herself to the particular effects and strategies of the *modern* work of art. Too many of those in the first rank of psychoanalysis were openly conservative when it came to modern art. Some were openly hostile, bemoaning the loss of concrete representation in much twentieth-century art as itself symptomatic of a crisis of subjectivity and/or varying degrees of fragmentation in the modern ego. The task, then, for cultural conservatives such as C.G. Jung or the Scottish psychoanalyst Ronald Fairbairn – to take two very different cases – was to read the generic condition of modern art as a symptom of wider cultural disarray. Surrealism, especially, as well as Cubism in so far as it showed 'split' or 'fractured' subjects, threw up multiple evidence that modern art in its typical public manifestations was a symptom of underlying societal neurosis. I think that Jung was in fact indifferent to the distinction between painting and sculpture when he launched his attack on Picasso as an artist 'alienated from feeling', as a seeker-out of 'the ugly, the sick, the grotesque, the incomprehensible, the banal'.[1] And I suspect that Fairbairn was insensible of the particular attractions and demands of three-dimensional art when he complained of the work of Miró, Dalí and others that it failed to disguise the turbulence of the instincts, failed to clothe the pressures of the sexual imagination in the 'secondary revisions' of conscious thinking.[2]

In English-language psychoanalysis (or that which has been translated into English) the more productive writings have been those of art critics,

historians, or cultural philosophers with a deep and sympathetic understanding of art, who have contributed significantly to psychoanalytical speculation on particular works of art, or to particular problems of representation. An example of the former is Adrian Stokes; of the latter, Richard Wollheim. And yet, significantly, neither writer spent more than a limited amount of energy on questions peculiar to modern sculpture. Stokes, himself a painter of more than passing interest as well as the author of *The Quattro Cento* and *The Stones of Rimini* – and as someone married for a time to Margaret Mellis, a painter and object-maker of great talent – wrote in his illuminating but often tortured style about Barbara Hepworth, Henry Moore and Ben Nicholson, but scarcely strayed beyond the modern sculptors of his milieu. Wollheim, for his part, though close to the London school of psychoanalysts including Stokes, Hanna Segal and the Imago group, was more concerned as a thinker with philosophical questions, and more concerned as an art critic with questions of painting and representation.

However the generally hesitant engagement of psychoanalysts themselves with modern visual art has not prevented psychoanalytic ideas from becoming available for use by those outside the clinical profession. And not until quite recently have the particular qualities of three-dimensional art come under the scrutiny of art historians with some knowledge of the literature and techniques of psychoanalysis. And yet, despite Freud's own misgivings about modern art, it is in the reuse or updating of the still controversial ideas of Freud and his immediate successors that we encounter so many provocative (and, it has to be admitted, speculative) applications. We are therefore less concerned with the implications of Freud's own efforts to write about artists – notably Michelangelo and Leonardo da Vinci – than with his wider theoretical legacy. Its salient parts are well known to familiars in the field: they include Freud's own writings on narcissism and the uncanny, as well as his more general theoretical picture of the ego and its processes of splitting, repression and projection, as well (of course) as sexuality. They include his speculations on fetishism and the dynamics of the gaze. Identification, symbolisation, transference – these too are all concepts that have issued from his pen. But the legacy also includes Melanie Klein's elaboration of the stages of early ego formation and particularly the interplay between destructive energies and the restorative motions of the psyche. It includes a whole school of so-called 'Object Relations' theorists, working in Great Britain in the shadow of Melanie Klein and concerned with the mental objects of the growing child and how they coalesce, move and change with the flow of anxiety, desire and ego-survival: especially the writings of Donald Winnicott, Michael Balint, Harry Guntrip and John Bowlby. It includes the important 'revisions' of Jacques Lacan and his speculations on the interplay of the Symbolic, the Imaginary, and the Real. And it includes two recent

generations of art historians and cultural theorists, some of whom have had first-hand experience of psychoanalytical techniques and processes (perhaps a necessary condition for any sympathetic application of its ideas), who have mobilised in the service of specific analyses, applied to specific art objects, ideas relating to the gaze, the schizoid mechanisms, feminist accounts of the psyche, questions of maternity, subjectivity, ideas of horror, beauty, the abject, and so on – a whole theoretical armoury of tremendous internal diversity and frequent difficulty. By now, the full catalogue of applications of psychoanalytic concepts to modern works of art is a large and impressive one.

But what is the place of sculpture in this catalogue? In a book devoted to modern and contemporary sculpture it needs to be pointed out that 'sculpture' no longer denotes unique, well-bounded objects made in durable materials, but, and in common with conventional usage nowadays, includes many kinds of artistic product that lie outside the confines of 'two-dimensional art'. Here, it includes performance, installation, process art, art placed on the floor in pieces, scattered as well as upright, soft and amorphous as well as hard. 'Sculpture' in that far wider designation is often called 'three-dimensional art' or simply 'art'. Under any definition, it is widely accepted today that virtually any material format can take the place of the singular, upright sculptural object well known to the European tradition up to the end of the nineteenth and well into the twentieth century. Now, a century later – the century of psychoanalysis and its theoretical cousins phenomenology, existentialism and critical theory – when we visit a sculptor's installation we are prepared to experience almost any variety of what the American sculptor Robert Morris has called 'three-dimensional work'.[3]

Against this background, it is striking and also significant how theories of psychoanalysis, from Freud's tentative early models of the 1890s through to the Lacanian revisions of the 1940s and 1950s and later, depend, at times it seems crucially, upon languages of articulation that are frequently those of the same world of matter, process, space and to a lesser extent time, with which the 'sculptor' in this extended sense has been dealing. In a trivial sense this may be necessarily true: in what other terms could the language of the psyche be framed? But in a stronger sense, too, metaphors and similes of the material world have dominated psychoanalysis from its beginnings and contain suggestive analogies for the artist working in materials. In Freud's early economic model a rich terminology of quantities, quotas, levels, pressures and discharges, all metaphors from the already metaphorical language of electricity, but also hydraulics, proved essential. In his early 1894 paper 'The Psychoneuroses of Defence', as well as in the long-abandoned 'Project for a Scientific Psychology', the all-important concept of *Besetzung*, which in English means something like 'occupation' or 'filling', is explicitly

characterised as 'a quota of affect or sum of excitation, which possesses all the characteristics of a quantity … capable of increase, diminution, displacement and discharge'.[4] Freud's later and better-known distinction of the ego, id and superego was from the start a 'topology' operating on the basis of repressions, excitations and discharges across labile boundaries. The creative process itself is described in corresponding ways. The fundamental process of sublimation, whereby sexualised energy becomes usable for 'higher' ends such as art, science or religion, was fashioned in the somewhat quaint image of the change of state of matter, as in an eighteenth-century alembic or retort. That metaphor is from chemistry: sublimation *either* as the conversion (under heat) of solid matter into vapour or gas; *or* the crystallisation of solid particles out of liquidity: in either case a change of state, a conversion from one form of matter to another, in the former case matter ascending, getting higher, subliming (sublimating); in the latter, matter liquefying and sometimes crystallising on cooling and descending. For Freud, the concept was occasionally and somewhat incompletely used to account for a deflection of instinctual and particularly sexual energy to aims other than the sexual ones: in a paper of 1908 he wrote that the sexual instinct

places extraordinarily large amounts of force at the disposal of civilised activity, and it does this in virtue of its especially marked characteristic of being able to displace its aim without materially diminishing its intensity. This capacity to exchange its originally sexual aim for another one, which is no longer sexual but which is psychically related to the first aim, is called the capacity for sublimation.[5]

The feeling derived from the satisfaction of wild instinctual impulses, suggested Freud, was 'incomparably more intense' than that derived from an instinct that has been tamed.

The task [then] … is that of shifting the instinctual aims in such a way that they cannot come up against frustration from the external world … [A] satisfaction of this kind, such as an artist's joy in creating, in giving his phantasies body … has a special quality which we shall certainty one day be able to characterise in metapsychological terms.[6]

Metapsychology for both Freud and his successors, then – not only the development of the ego and its creative capacities but the concepts of analysis itself such as transference, counter-transference, identification, projection and introjection – has been indebted to the physical sciences of optics, medicine and even geography in addition to hydraulics and electricity.

By the later 1920s when *Civilisation and its Discontents* was being written, a particular development of psychoanalysis was being formulated by the young Melanie Klein in the course of her researches on infants and the organisation of the neonate ego. In Klein's mental universe, the mergence, coherence and survival of the ego are processes driven to a large extent by

anxiety: anxiety at loss, at the threat of loss, or induced by shattering projections which cruelly mistreat 'objects' in a violent drama of defence and ultimately of repair. The images of breaking, destruction and then of tolerant acceptance of the fragile objects of the mind resonate in Klein's psychoanalytical vocabulary as directly comprehensible counterparts of the processes of depletion, construction and rebuilding in the world of solid matter.

Even more directly physical is the image of the object/mirror as deployed by Lacan. He is describing, like Freud before him, the very earliest and most basic steps by which the ego comes to exist at all. Lacan's conception of the mirror-stage (*stade du miroir*, meaning also 'stadium' or 'arena' of the mirror) is that of a moment in which the infant of approximately six to eight months proceeds beyond mere 'interest' in the pattern of a human form or a human face, and becomes aware of a Gestalt over against him, either in a literal mirror or in the presence of another person or thing, with which he identifies in a manner comparable to the imprinting of young animals discovered by Henri Wallon and by Tinbergen and Lorenz in 1930s zoology and biology. Lacan cites observations in biology such as the fact that for the maturation of the gonad of the female pigeon it is only necessary that it should see another member of its species, or the fact that migratory locusts only become gregarious when exposed to the Gestalt of another species member. And yet the form of mirror-imprinting in humans has certain features specific to the species. The moment of recognition occurs at a stage when the muscular coordination of the human body is still primitive: the child is unable as yet to walk or stand, and needs to be held in a human support or in a *trotte-bébé*. At this moment the child 'overcomes, in a flutter of jubilant activity, the obstructions of his support and, fixing his attitude in a slightly leaning-forward position, in order to hold it in his gaze, brings back an instantaneous aspect of the image'.[7] And though Lacan's literary style is such as to flow from literal language to figural and back again, there are passages in the mirror-stage essay when the literalness of the parable is plain. The Gestalt appears to the infant 'in a constrasting size that fixes it' and 'in a symmetry that inverts it, in contrast with the turbulent movements that the subject feels are animating him'.[8] Those 'turbulent movements' are the effects of an initial developing instrumental intelligence which is slower even than the chimpanzee – a retardation which the human infant manages to make up only by the age of eleven months. Lacan suggests that until then the neonate 'is invested with all the original distress resulting from the child's intra-organic and relational discordance during the first six months, when he bears the signs, neurological and humoral, of a physiological natal prematuration'.[9] In such a circumstance, what is characteristic of the mirror is that its Gestalts have a scale and an orientation that correspond to the *human* scale and

orientation, just as, we might say, in the adult apperception of three-dimensional art. The Gestalt is 'still pregnant with the correspondences that unite the I with the statue in which man projects himself, with the phantoms that dominate him, or with the automaton in which, in an ambiguous relation, the world of his own making tends to find completion'. Lacan's references here to sculpture, to the apparition, and to the robot bring him close to a field in which he seldom ventured, that of the aesthetic. The constitutive but at the same time alienating imprinting of the mirror-stage, says Lacan, makes up 'an order of homeomorphic identification that would itself fall within the larger question of the meaning of beauty as both formative and erogenic'.[10] The entire human orientation to space, distance and number might easily be added to this list. The mirror is horizontally removed from the infant in his *trotte-bébé*. The Gestalt is unitary, single, an image of figure and ground: its disposition *vis-à-vis* the infant – Lacan calls it 'spatial captation' – contains the coordinates of above and below, high and low, the interval of distance, the pull of gravity and the play of light.

And yet the particular correspondences between the languages of psychoanalysis and those of recent sculpture, highly suggestive though they are, make up only one dimension of a wider network of affinities. The present volume is not only an attempt to redress the balance in favour of sculpture as opposed to painting and the image in general; its component essays have the particular virtue of addressing three-dimensional art *as* three-dimensional art; that is, as matter, material, space-occupancy and visibility. In addition, most of the essays manifest a consciousness of the position of modern sculpture as a historical as well as an aesthetic act, a dimension that readers today often find missing in the psychoanalytical writings on art of (say) Jung and Freud. Now, we expect psychoanalytical speculation on art to be intermingled or perhaps fused with the historical, the economic and the social, at least aware of the broader conventions of making, displaying and apprehending that were in force at a given historical or social moment or in a particular critical milieu.

This then is the framework for the question posed by Martin Golding in his chapter on how and why modern sculpture came gradually to throw off its cloak of 'enchantment', as a thing removed from the ordinary world, to eventuate in the bare presence of *material* in the most vivid works of contemporary sculpture. In common with others, Golding locates the origin of the long historical exhaustion of the sculptural object as a 'thing apart' in Surrealism, the form of art that was highly suspect to Freud and to Fairbairn precisely because it dispensed with the secondary revisions of conscious thought and presented the art object as 'primitive', literal, and unclothed. These were the very attributes that rendered the art object discontinuous with the functional world of the bourgeois imagination, and rendered it

capable, at the same time, of being able to re-enchant an interior world deprived of the older landscapes of shared and meaningful symbolisation. It is the Surrealist object that also concerns Simon Baker, but within a closely defined moment of Surrealist history. In his essay he addresses the temporary alliance between Georges Bataille and André Breton in 1935–6, a time when, almost a decade after the first pronouncements of the movement in favour of dream and unconscious imagery, the mood inside the leading Surrealist conversations presaged both a concerted investigation into the Surrealist *object* as well as a politically motivated engagement with questions of revolutionary spectatorship from within Contre-Attaque, the formation Bataille and Breton believed could oppose the political compromise offered by the Popular Front. For both Bataille and Breton at this moment, Baker reminds us that it was not the object *per se* but the consciousness of the crowd that pressed most urgently for reformulation. For in the context of mass politics and charismatic leaders upon the European stage, it was indeed the crowd that had animated Freud's 1922 essay on 'Group psychology and the analysis of the ego' – and that would prove applicable to religious fervour as much as to Fascism or totalitarian versions of Marxism–Leninism. As Freud and others had by that time come to realise, all forms of collective activity depended on the same, or similar psychological mechanisms such as fascination, hypnotic identification and irrational belief. Baker's essay explains to us how this little-known episode in the history of later Surrealism served to widen the psychological scope of that movement and pointed towards the imaginatively heterodox writings and teachings of the Collège de Sociologie in 1938–9.

When we come to a later phase of sculpture premised upon the material qualities of the modern object, namely Minimalism, we encounter not only the drive to what Michael Fried called 'literalism' and a new kind of pact with the viewer, but also, as Tim Martin's essay shows, a strong lingering sense in which *mere* geometry and *mere* precision can be registered as psychological concealments of a particular kind. Donald Judd, the subject of Martin's essay, at a number of stages in his career let slip the possibility that more was at work in the production of his precision-made sculptural objects than could be seen at first glance; that questions of identity and desire in the maker, and questions of the mental construction in the viewer, cannot be avoided in any full phenomenological account of how these sculptures mean. Where, Martin asks, is Judd's ego in the work of Minimal sculpture? What roles are being played by anxiety and melancholy in both the fabrication and spectatorship of the work? The subtle and largely concealed relationship between Judd and his friend and junior the artist Robert Smithson reveals how the loss of enchantment staged by the modern sculptural object, while an indisputable trend, nevertheless overlaps and is overlain by cognitive as

well as unconscious identifications which certain psychoanalytical constructions can reveal uniquely well.

To the affective life of the modern art object can be added particular psychological and social speculations about abstract art. When Barbara Hepworth entered her most abstract phase as a sculptor in the early 1930s, she attracted the attention of two writers who had strong interests in psychological readings of art and specifically psychoanalysis. Herbert Read and Adrian Stokes addressed themselves to Hepworth's abstraction, but the latter did so, unusually and adventurously for the time, from a perspective derived from Melanie Klein. As Anne Wagner shows in her essay, Stokes was able to draw upon his own experience in analysis with Melanie Klein to bring to light qualities in the carved stone sculpture of that decade that have to do with gender, maternity, and above all the so-called 'depressive' position of Kleinian theory that accompanies the tolerance of paranoid–schizoid experience and acknowledges the loss of the fantasised wholly good mother. In Wagner's chapter we see how the momentary but powerful interplay between the attentions of a psychoanalytically resourced critic and a sculptor at the apogee of her daring as a carver – the mode of making so important to Stokes – resulted in a form of artistic autobiography more illuminating of important questions about the female form, and about the mother–child relationship, than artistic autobiography can ordinarily provide.

To jump to the other side of World War II is to find Herbert Read, for his part, confronting a wholly different kind of sculpture and using a set of wholly different terms for it. In David Hulks's essay, we see Read confronting the stick-like, often tortured sculpture of the early 1950s, and describing it as a 'geometry of fear'. Deploying the Kleinian language of 'splitting' but now transposed into a social pathology of the post-war Western nations, the new phraseology became inevitably the stock-in-trade of both art criticism and medical psychiatry at the time. The question for Hulks is whether splitting, fracturing and dividing – the idiom of so much international sculpture after 1945 – is to be seen, or was then seen, as a symptom of 'schizoid' or schizophrenic consciousness either in the artist or in the ravaged Cold War society to which the artist belonged. While conservative critics in the later 1940s and 1950s alleged the latter interpretation, Hulks's essay goes to work on the correspondences between the medical confinement of schizophrenic patients and the containment and display of materially fractured sculptural objects. Alternatively, the Kleinian emphasis on 'reparation' supplied the possibility of social recovery even while lending to the viewing relationship all the critical complexities of the analytical encounter. The art object, as Hulks then goes on to show, became capable of collecting and intensifying the most primitive anxieties and resolutions within the 'consulting room' of the viewing space.

With the widening of the definition of modern sculpture after about 1960 to embrace performance, process and installation, the terms of the encounter between psychoanalysis and art modulate once more. Taking as her subject the defiantly anarchic French sculptor Jean-Jacques Lebel, Alyce Mahon in her essay lays emphasis first on the pluralistic nature of his practice – he has been an adept of painting, collage, film, curating and performance – but also on the roots of Lebel's work in desire: both libidinal desire and the kind of politicised desire that so often drives his work and his imagery towards openness, polyvalency and multiplicity. Lebel in that sense represents the artist in some kind of revolt against form itself, as a metaphor for complete emancipation from bourgeois confinement, repression and etiquette. For, advocating the reclaiming of 'primitive' expression in the manner of Antonin Artaud's theatre and extolling the practices of Surrealist *dépaysement* through the use of hallucinogenic drugs, Lebel consistently manufactured forms of art which refused to embody well-tried formulae of aesthetic satisfaction: for him, both psychological and emotional disorientation were to be courted as counter-arguments to the over-sublimated, bureaucratic cultures of everyday life. A series of 'portraits' of key philosophical or psychoanalytical thinkers – Artaud, Nietzsche, and Félix Guattari – put into play a posture of anti-modernist, anti-formal and anti-individualist creativity whose roots were intended to be ultimately social. Lebel's closest point of contact with a version of psychoanalysis came not only from his veneration for the eroticised philosophical writings of de Sade, but from his long-lasting collaborative friendships with the 'anti-psychiatrists' Guattari and Gilles Deleuze. As Mahon shows here, their concept of the 'rhizome' or network system has much in common with the free-flowing indeterminacy of the performance happening, while their rich elaboration of the concept of 'anti-Oedipus' narrates a different order of priorities from those of classical psychoanalysis and launches a celebration of unconscious thought and action in graphic contrast to its analytical dissection on the consulting-room couch.

On the other hand, the style of performance initiated by the British artists known as Gilbert & George, as the chapter by Grant Pooke goes on to argue, though anti-sculptural in the older sense of that word, is dominated by highly regularised devices of repetition, physical endurance, disguise, and a kind of fictive artistic autobiography, which invite very particular psychoanalytical tools for their decoding. Here, we see devices of self-invention structured by extremes of deference and politeness on the one hand, combined with a lurid catalogue of coprophiliac, genital and anal imagery on the other: the invitation is to read these still controversial works in terms of a series of pregenital or 'anal-sadistic' characteristics which dominate the life of the infant before sexual individuation. The survival of pregenitality into adult behaviour is Pooke's theme here: his analysis

proceeds on the basis of clear signs not only of primary narcissism, the urge to ensure survival and extension of libido, but of features reminiscent of the Sadean world of endurance and spectacle, ritual and ceremony, to which self-representation in the aesthetic register is the key. Pregenital dramas of retention, defilement, power and self-becoming radiate from Gilbert & George's work with obvious and dramatic force.

When we turn, however, to the work of the German sculptor Eva Hesse, we are faced less with questions of symbolism or behaviour than with installation: the relation of the work to the traditional sites of 'painting' and 'sculpture' respectively. For Hesse's short but brilliant career found her not only in the 'milieu' of Minimal art, but complexly modifying that milieu through the use of unorthodox materials and extremely original yet unstable formats of positioning. From Mignon Nixon's essay we learn how to view these strategies through the lens of the concept of *transference*: the relation between analyst and analysand informed not only by their conversations and their intertwined projections, but by the shuttling to and fro of material between the analytic encounter and the wider culture. In this way of looking at and thinking about Hesse's art, the task devolves into a curatorial one, namely how to keep alive in successive exhibitions the work's ability to transform its milieu. The psychoanalytic conceptualisation of the work's functioning can assist, in such a case, to determine the understandings and activities of the critical curator.

Physical positioning turns out to be the salient quality too of certain notable public sculptures – as orthodox labelling calls them – namely sculptural objects located in an urban space whose memories and associations become immediately relevant to the work. In Brian Grosskurth's study of a singular sculptural work by Rebecca Horn, he deploys the Lacanian concept of *extremité* to span and indeed to complicate the spatial and psychic relations between inside and outside, absence and presence, public and private, that the sculpture seems to evoke. By no means all the sculptural objects of modernity possess a visible interior, but those that do pose particular questions: Grosskurth explicates the route by which Lacan takes Freud's term '*Das Ding*' and unravels a series of double processes by which an external provider of infantile needs first becomes incorporated within the psyche but then rests there as a foreign and excluded object: agent of both fulfilment and lack, substance and absence, fullness and empty space. In the case of Horn's rickety tower on the new beach-front in Barcelona, the sculpture not only has public presence as well as interior space; it summarizes the dramatic political past of the city as well as its recent conversion into a leisure area for a new tourist crowd. Intriguingly, the sculpture also has two names – and Grosskurth shows how the layers of paradox and destabilised identity come to stand for the historical narrative of

the city as well as a way in which, in Lacan's account of the psyche and its structuring in relation to language, 'objects' and the space of objects function as a counterpart to memory and to the real. What begins as an evocative sculpture on the beach comes, under the spotlight of Lacan's powerful notion of the unknowable *objet petit a*, to encompass the motions of the psychic drama no less than the traumas of the historical itself.

The final two essays in the book pay closer attention to matter in process – but matter of a certain kind. In itself, as Georges Didi-Huberman points out in his essay, matter has formed a secondary concern for art historians and critics throughout the tradition, relegated to a place somewhere below that assigned to form. And yet the particular case of wax proves to pose the age-old question of the relation of matter to form in a new and revealing light. Tracing the paradoxes of wax – at once melting, hard, ductile, imprintable – from Plato, Aristotle and Pliny through to Descartes and beyond, Didi-Huberman turns to the function of wax in the manufacture of ex-votos and figurines right up to the present day, as a way of fathoming the essence of the plasticity of this most humble yet ubiquitous material. In view of the extraordinary versatility of wax, does its plasticity consist in anything at all? A partial answer, Didi-Huberman proposes, to be found in Bataille, is to look again at the twin terms Freud used in characterising the concept of 'the drive', namely plasticity but also *viscosity*: it is in their combination, perhaps, that wax's 'fixed instability' is to be found, as evidence not of its formlessness and passivity, but of its active, intrinsic power – the power to shock and disturb, for example, when wax is moulded to become an excessive likeness of a person or fictional character – but active too in its ability to upset the canonical histories of art that proceed teleologically through fixed successions of objects. Wax, so Didi-Huberman urges, has been instrumental also in coming finally to validate the radically heterodox invention that we call modern art.

Indeed, matter in a liminal state finds particular affinities in the modern; and in the final chapter, my own, we look more closely at certain instances in contemporary sculpture where the artist has wrestled with what may be the ultimate disenchantment, the confrontation with liquid matter in all its disorderliness and viscosity: material that has had, in two or three significant and memorable cases, the power to repel and to disgust – both the artist himself and perhaps also the viewer. In a series of works from the 1960s by Robert Morris, himself deeply engaged at the time with a new range of fluidity metaphors from the psychoanalytical writings of Anton Ehrenzweig, we find the artist confronting the interplay of the body's encounter with formlessness in a structured yet aleatory way. Matter for Morris in that admittedly recondite context became disgusting, but a conduit for energy and process at the same time. Both in his work and that of Ilya Kabakov, the

encounter with brute matter then opened onto a rhythmic alternation between differentiation and dedifferentiation, Eros and Thanatos, that spoke not of revulsion against existence as such, but of a transition from what Sartre had already termed a 'psychoanalysis of things' to various moments and intimations of redemption.[11] The rootedness of this kind of sculptural engagement in the period of, or shortly following, totalitarianism and the mass destruction of World War II leads directly, and finally, to a consideration of a historical and indeed a social dimension which theoretical psychoanalysis on its own has seldom been able to supply.

If there is a single overarching conclusion, it is that the modern sculptural object, in this and the other readings, proves to be as permeable to the models and speculations of psychoanalysis as psychoanalysis in its many and varied constructions has proved permeable to the terminologies of matter. The various stages of the 'disenchantment' of the modern art object may be real enough – but the processes of societal and artistic secularisation have enabled other, no less rich enchantments to come slowly into view.

Notes

1. C.G. Jung, 'Picasso', *Neue Zürcher Zeitung*, 13 Nov. 1932; in Jung, *The Spirit in Man, Art and Literature*, London, 1957, p. 138.

2. B. Taylor, 'Beauty from Violence', *TwoNineTwo: Essays in Visual Culture*, Vol. 3, Edinburgh, 2002, pp. 29–43.

3. R. Morris, 'Notes on Sculpture, Part 3: Notes and Non Sequiturs', *Artforum*, June 1967.

4. S. Freud, 'The Psychoneuroses of Defense' (1894), in *Standard Edition of The Complete Psychoanalytical Works of Sigmund Freud*, London: Hogarth Press (trans. J. Strachey et al.), (hereafter referred to as *Standard Edition*), Vol. 3, p. 28.

5. S. Freud, '"Civilised" Sexual Morality and Modern Nervous Illness' (1908), *Standard Edition*, Vol. 9, p. 187.

6. S. Freud, *Civilisation and Its Discontents* (1930), *Standard Edition*, Vol. 21; London: The Hogarth Press, p. 16.

7. J. Lacan, 'The mirror stage as formative of the function of the I as revealed in psychoanalytic experience' (1949), reprinted in *Ecrits: A Selection*, Paris, 1966; London, 1989, pp. 1–2.

8. Ibid., p. 2.

9. J. Lacan, 'Aggressivity in psychoanalysis' (1948), *Ecrits*, p. 19.

10. Lacan, 'The mirror stage', pp. 2–3, 3.

11. J.-P. Sartre, *Being and Nothingness: An Essay in Phenomenological Ontology* (1943), London, 1972, p. 600.

MODERN OBJECTS

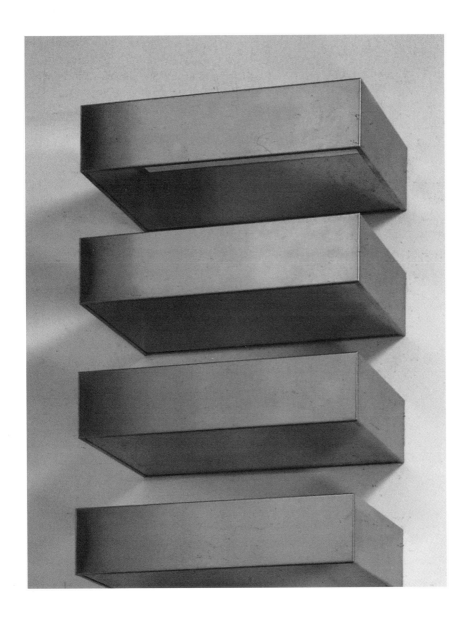

Sculpture and disenchantment

Martin Golding

And yet it [sculpture] had to distinguish itself somehow from other things, the ordinary things which everyone could touch. It had to become unimpeachable, sacrosanct, separated from chance and time, through which it rose isolated and miraculous, like the face of a seer.[1]

Rilke's statement in *Rodin* reminds us that art's mode of representing the world had always, until the early twentieth century, assumed a difference and separateness from the world as ordinarily experienced. This was the case even when the critic's praise centred on the 'lifelikeness' of the image – as with Pliny the Elder on Apelles, or Callistratus on Praxiteles. The skill that they held up for admiration was that of a different creation – remarkable in its illusion but neither magical nor belonging to Nature – as Callistratus implied when he contrasted the achievement of Praxiteles with the reputation among the Cretans of Daedalus for making statues 'endowed with motion'.[2] The separation from the work of Nature also meant that work's transformation by the powers of the artist. To paint grapes (as Pliny reports of Zeuxis) that deceive the birds is not to make an *equivalent* of their originals: the story points up above all the *human* capacity to see and to recreate which makes the status of what has been made human, not natural – the natural turned into a representation that, beyond 'chance and time', remains permanently and unchangeably itself.[3] Maurice Merleau-Ponty had this same transformation in mind when he wrote of Cézanne that the task he set himself in painting – because he could not be the *Pater Omnipotens* who had created the world – was 'to change it completely into a spectacle'.[4] The 'spectacle' evokes immediately the distance of the spectator from what the artist has made: it intimates an order modelled on the world but wholly separate from it.

Symbolisation and transformation, and separateness, are interdependent

concepts. They belong to a picture of human development which Hannah Segal later presupposed when describing the nature of the symbol: 'the symbol is not a copy of the object – it is something created anew. The world the artist creates is created anew.'[5] The capacity for symbolisation requires as its condition a fundamental *psychic* separation in the human agent from an original state of union with his environment; with his mother. For symbolisation, conceived through the idiom of psychoanalysis, is the outcome of a process in which the infant's loss of his exclusive possession of his mother and the reality of the parental couple are, with the resignation central to what Melanie Klein called the Depressive Position, accepted. The infant can then in consequence develop the capacity, through his experience and acceptance of separation and difference, to create symbolically a new thing of his own that recognizes and incorporates the creative intercourse which has made him but which also must exclude him. This capacity is the foundation, both in Kleinian thought and in that of D.W. Winnicott, of our ability to see the Other *as* other, and to make of our experience symbols that bring the world, in a changed form, within the purview of our imagination, making forms that receive our projections and render them back to us in a way that gives them, as Segal puts it, 'a life of their own'.[6] I want to explore a number of themes that arise from the disjunction between the confidence that Rilke could still intermittently feel in the power of European civilisation to sustain the possibility of symbolisation and a condition in which the idea of 'material' becomes a self-subsistent *experiential* warrant for the nature of the art object.

Technology, said Adorno,

is making gestures precise and brutal, and with them men. It expels from movements all hesitation, deliberation, civility. It subjects them to the implacable, as it were ahistorical demands of objects ... What does it mean for the subject that there are no more casement windows to open, but only sliding frames to shove, no gentle latches but turnable handles, no forecourt, no doorstep before the street, no wall around the garden?[7]

Adorno's 'reflections from damaged life' saw in the technological makeover of ordinary objects signs of an impoverishment of *meaning*: in the catalogue of losses is intimated also a sense of physical exposure and displacement which strips the human agent of the indirections and correlatives of 'civility' – of that symbolic space in which the need for an imaginative self-presentation is provided by the conventions of social intercourse. What Adorno might have described as a *literalisation* of objects that robs them of physical grace robs them equally of symbolic potentiality. They can be none other than what they are, and cannot be experienced in familiar ways as natural extensions of human volition. Rilke's evocation of the 'crowding over from America of empty and indifferent things, pseudo-things, dummy life'

that replaces 'the animated experienced things that share our lives'[8] equally suggests the prospect of a world of objects without meaning – corresponding to what he describes in his 9th *Elegy* as 'an imageless act' (*ein Tun ohne Bild*):[9] self-exhausting, unregisterable by the mind. We see parallel attitudes in Adrian Stokes's despairing vignettes, in *Inside Out* (1946) and *Smooth and Rough* (1951), of the landscape, and especially the traffic, of pre-war London.

Objects and actions, in such an understanding, seem suddenly sterile of symbolic potentiality: they are merely what they are, and cannot nourish a more excursive imagination that might see them as the sign of others, or that might be able to conceive the whole scene in terms of some transformative redescription. And the banality of the modern object, its resistance to imaginative appropriation and transformation, is a familiar theme which could lead into a straightforward lament for the decline of the traditional sculptural object. However, that conception has a more complex history. I think here of the Surrealist insistence on

disposing altogether of the flagrant contradictions that exist between dreams and waking life, the current and the real, the unconscious and the conscious, and thus to make of what has hitherto been regarded as the special domain of poets, the acknowledged common property of all.[10]

What is striking is the Surrealists' implication that 'symbolisation' is to be replaced by 'equation':[11] instead of undergoing a sublimatory transformation, the contents of the unconscious are held to be presented literally to the spectator. I see in this a correspondence with the physical experience of the literal, unsymbolisable object without penumbra: Adorno's 'turnable handles', say. But for its proponents, this supposed reduction of the complicating interventions of the creative intelligence is not seen as loss – rather as permitting a direct recourse to the fountainhead. Similar claims were made in the 1920s by Hans Prinzhorn on behalf of schizophrenic patients in his care who painted pictures.[12] A layer of 'secondary revision' is removed in order to confer a unique privilege on an imagined route to the source of creativity: the literal contents of the unconscious become the subject. And yet Stokes's evocation of the civilisation that produced Surrealism was that

We have in common a complete lack of the iconographic symbols that once enabled the arts to build symbolic structures of an evident cultural ramification. Indeed the wish to cut out all the 'nonsense', to symbolise by art the 'inner man' alone, may be said to have reinforced the ambition to possess by means of art an object rather than the symbol for it.[13]

He suggests how this obsession with the thing itself may feel, in a landscape bereft of symbolic textures, like a way of securing a sense of the concrete foundations to which one can trust one's feet – a basis of trust in a state of

*dis*enchantment. To hold fast to the object for itself might suggest nostalgia: it might also be a way of trying to re-enchant an interior denuded by modernity.

This play between objects and symbols may help us to focus on what the role of the object can tell us more generally of how a sculpture can mean. It may also illuminate how modern and post-modern sculpture may be seen as a series of prisms through which the environment of a civilisation can be characterised and understood. This is made possible both by the way certain sculptors have invoked that environment directly in their use of common objects, and by the way some have in effect declared a role for their work which makes their view of the public world central to how they expect their work to be viewed.

The potential nostalgia inherent in the use of 'found objects' is both present and confuted in the achievements of, for example, Anthony Caro. Thus a 'civilisation' defined primarily by the products of heavy industry finds what Stokes would have called its 'emblem' by the way the strangeness of the object is made use of but not sentimentalised: on the contrary, in Caro's steel works, what seem to be created are forms in which the original disparate energies of the 'things' are brought into a vivid relation with each other that creates an exhilarating sense of unity and openness at once – as in *Table Piece CCLXV* (1975) (Figure 1.1) or *Emma Scribble* (1977–9). Here a direct reference to calligraphy brings up without equivocation the presence of a *work*, not an assemblage of broken pieces. Yet the sense of half-recognisable pieces of an industrial environment is powerful in both pieces. At the same time, in their half-secured, half-floating state, they become the means of form: enigmatic pieces of scrap coalesce, create an independent sense of balance, tension and potential disintegration – a strongly energetic *gathering* of the whole to make something in which the oddity of its constituents ceases to register. Where this might tend seems to issue in Caro's versions after Rubens, Rembrandt and Monet of the late 1980s, in which an idea of figuration that infuses the inanimate both with passion and the means of identification is explicit. However, the way that, in these 'source sculptures', figurative drawing has been translated into a pattern of enigmatic shapes – strongly reminiscent of pipework or the machine-shop – that render abstract the human figure while vividly retaining the dynamic of its planes and curves in relation to each other, suggests a figurative underpinning for the way that calligraphy seems to direct its energies. Thus the assemblage of shapes that might resemble the detritus of the breaker's yard both refers to that contemporary condition and makes wholly independent use of it. Michael Fried, in 'Art and Objecthood' (1967), famously characterised the effects of Caro's work by suggesting that 'it is this continuous and entire *presentness*, amounting, as it were, to the perpetual creation of itself, that one experiences as a kind of *instantaneousness*'.[14]

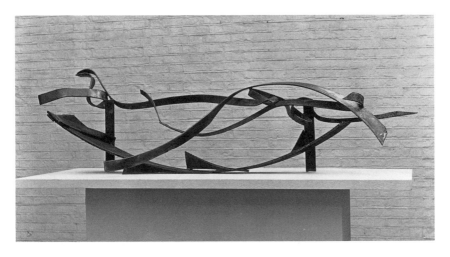

1.1 Anthony Caro, *Table Piece CCLXV*, rusted steel and varnish, 1975

And yet the 'unknowableness' of the motif itself, allied with its capacity to draw to itself elements of associating experiences, is reflected in a steel sculpture by Anthony Caro (or indeed in one by David Smith) in a quality that is enigmatic and unequivocal at once; that is involved deeply with a sense of the self-subsistence and independence that the spectator feels himself addressed by in front of these works. The realm of the 'object' is that of the known, the familiar, the banal: that of the city whose banality, when brought into preternaturally sharp focus, becomes strange for its own sake. The enigmatic quality of the original material remains just that; and yet it might allow the spectator, beside the joke of recognition, a *frisson* of the unusual.

The boxes of Joseph Cornell had previously exploited the classic notion of a cabinet of curiosity to create, as though in a space reserved for a relic, a presentation of the banal in a manner that made it surprise us. The range of contents of his boxes was extremely wide: some, for example *Soap Bubble Set* (*c.* 1936) (Figure 1.2) or *Cabinet of Natural History (Object)*, (1934), suggested an approximate gravity of material, texture and object that only on a second look gradually revealed its numerous puns, slippages, disjunctions and subversions. Others (say *Doll Habitat, c.* early 1950s–1965) were more obvious and direct. His association with Marcel Duchamp allied the work to a particular orientation towards the enterprise of undermining existing conventions through an oblique mimicry;[15] but at the same time Cornell exercised an idiosyncratic intention to make a simulacrum of a precious object which actually is so. Here, the world of ordinary objects was invested

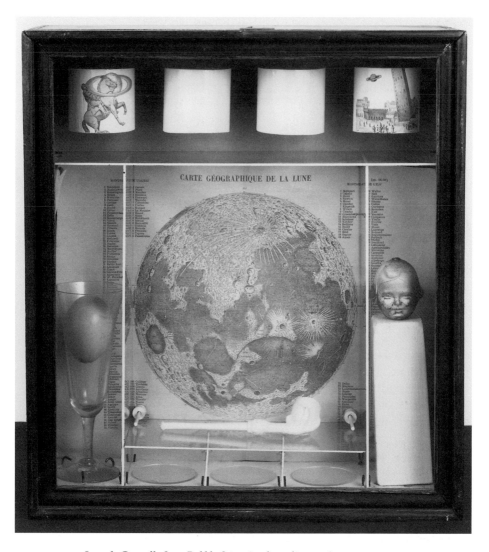

1.2 Joseph Cornell, *Soap Bubble Set*, mixed media, 1936

with the spirit of the metaphoric curiosity which had once characterised the urban ruminations of a Walter Benjamin or of an Ernst Bloch. The works could be seen 'instantaneously': indeed time, a parody of time passing and an exploitation of quaintness which made the contemporary seem strangely archaic, like a memory, was central to their effect. They seemed to construct memories out of objects, at once playing on their familiarity *and* defamiliarising them. The contents of Cornell's boxes insisted on their literal

existence, and the oddity of their extraction from the world to which they belonged exacted a tribute from the spectator which was not that of simple acknowledgement, but brought him back inescapably to that world and its confusions, as well as – in Cornell's quotation of Duchamp's words – 'exhaling romantic vapor'.[16] Cornell's boxes have spoken widely to a condition increasingly bereft of conventional symbols of psychic order. It is no surprise, for example, that among Robert Rauschenberg's earliest productions were boxes of his own (the *Scatole Personali* of 1952–3); and from this starting point one can see that same influence in the way the diverse found materials are distributed, in his 'combines', on the surface of the support. This sense of a continuum between what Adrian Stokes in *Smooth and Rough* calls the 'slight yet very frequent traumatic experiences [which] are peculiar to the modern world'[17] seems strongly present in Rauschenberg's robust insertions and building up of objects as though to 'amplify' the experience of urban trauma in kaleidoscopic fashion; while in later, free-standing works like *Dry Cell* (1963) and *Shades* (1964) the miscellaneousness and promiscuity of the technological environment become in turn constructions that at once enforce the machine's reality on the spectator, and also parody it. Yet it seems to me that Rauschenberg recuperates the same sense of a complete entity which, by not confining itself to the simple assemblage of that found in Cornell, succeeds in his most powerful works in presenting an image of process and experience that forms something immediate and coherent while remaining open, doing justice to the 'unknowable' quality of its enabling condition. As Stokes writes in his essay 'Collages',

> There are compensations in the strong impact and often in the purity of composition released from a variety of trammels, particularly subject matter; in the employment of actual, formed objects or of an unexpected weighty substance as implements of the urgent spirit however vague its voice … Some artists … seek to make capital out of the fugitive propensities of matter, to harness decay or destruction to the purposes of art, a pile of distorted mineral rubbish.[18]

The potential 'descent into formlessness' might be understood as an urban experience whose chaotic impingements are overwhelming – one which often sits on the edges of Rauschenberg's works, and the clamour of which inside them is carefully managed. Stokes's notion of the 'fugitive propensities of matter', allied with his sense of a forceful vagueness that operates through a medium of untransformed objects, suggests the appeal of a surrender: the confusions of urban experience find an objective correlative in mere matter – 'mineral rubbish' – which might stand as a metaphor for a disorderly populousness, a malignant vacancy of bureaucracy and mass-production.

In an interview with David A. Ross, the Russian artist Ilya Kabakov says of himself, 'this little person felt a unity with everyday life. There wasn't a

desire to disappear, to run away from the everyday, to do something romantically high; there was rather a desire to express this unity with banal everyday life'.[19] The experience that he describes was that of the Soviet Union before *perestroika*. The complex of nightmarish and pervasive irrationality, physical and moral squalor and confusion, a marginality entailed by the phantasms, the endless hall of mirrors through which the imagined centre sustained itself, led naturally to a conception of individual life which expressed itself through pure idiosyncrasy: an identification, for the purposes of sheer survival, with the most meaningless textures of everyday life. The 'banal' here became a source of imaginative freedom; an attachment to 'the ordinary things' an unassailably private source of identity; the 'known' rather than the 'unknowable' the means by which that identity could most securely express itself.

The 'special' circumstances that have given Kabakov's projects their urgency and satirical edge are those of a tragic world-historical dystopia; but they reflect the more general condition of modernity, one in which the appeal of the 'knowable' displaces confidence in less palpable potentialities of symbolisation. Kabakov, as sharply as Adorno, has asked 'what does it mean for the subject?', and as sharply, though from an altogether different direction, has evoked an impoverishment of materials which obstructs the ways in which an individual might represent the world to himself or gain a purchase on it: 'I feel that it is precisely the garbage, that very dirt where important papers and simple scraps are mixed and unsorted, that comprises the genuine and only real fabric of my life ...',[20] and on the other hand: 'The whole world, everything which surrounds me here, is to me a boundless dump with no ends or borders, an inexhaustible, diverse sea of garbage. In this refuse of an enormous city one can feel the powerful breathing of its entire past'.[21]

And the experience of his installations (for example *The Toilet*, 1992) (Figure 1.3) forces the spectator to experience the claustrophobic concreteness of this condition, its puzzlement, confinement and disgust. What is continually repeated is the mark or *trace* of the individual, rather than a more compact self-presentation. As *trace*, Kabakov's installations do not create symbolic shapes or emblems: the piling up, the laying out, does indeed relinquish the ambition to transform, as untrue to a condition in which social meaning is dispersed into multiple functionalities that exhaust themselves in their performance. One finds instead assemblages of inheritance, mental clutter, adventitious associations, a sense of danger, nostalgia, suspicion, imaginative and physical poverty and its retreats. The object becomes, in a wholly different context from that of Cornell, liminal: not what it once was – an object of use, a possession – nor what it might become. Both obdurately itself and open in an undirected and unformed

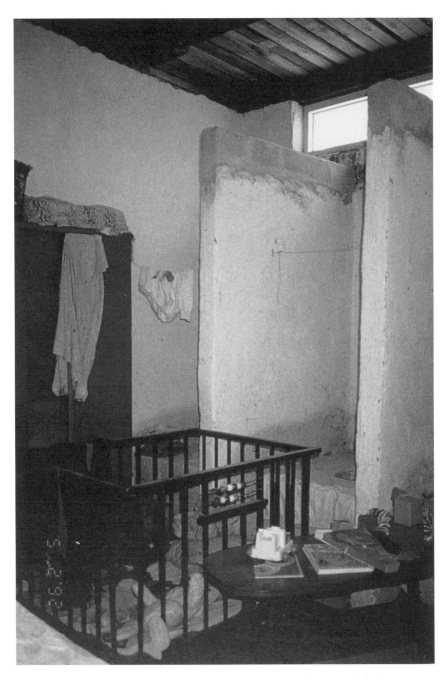

1.3 Ilya Kabakov, *The Toilet,* installation at Documenta, Kassel, 1992

way to the spectator's fantasy, it becomes a harbinger perhaps of a future state that it can neither intimate nor define.

The work of Christian Boltanski is apposite in this piecemeal development into disenchantment – partly, in the first place, because a sense of what he calls 'the great memory that is preserved in books', and in particular that of the memory of war and death in Europe, offers a parallel to the disaster of the Soviet experiment for Kabakov. Against that 'great memory', Boltanski posits 'small memory, an emotional memory, an everyday memory … This small memory, which for me forms our singularity, is extremely fragile, and it disappears with death'.[22]

In retreat from the grandiose claims of history, the core of Boltanski's installations is the concrete presence of individuals in their images, their names, their belongings, in a way that at once registers individuality and anonymity. The installations to which this description is most pertinent are those based on photographs: their blank literalness; the way they are capable of turning randomness and replication into iconicity; the blandishment of the object made strange as a repository of projection; the implicit promise of transformative knowledge, never delivered except by the fantasy of the spectator himself. Boltanski often endows his photographs with a quasi-sacred status, in their arrangement and often in a setting of monumental or religious character (for example, *Altar to the Chases High School* (1988) or *Monument: the Children of Dijon* (1986)): the image of the individual life is presented as the repository of a private truth that takes the place of the shared symbolic structure on which its setting was founded.

More ambitiously, in various installations called *Canada*, named after the depositories of victims' effects in Auschwitz and other camps, he has filled large spaces with discarded clothes. The most dramatic was *The Lost Workers Archive and the Work People of Halifax 1877–1982* at Dean Clough (1994), in which not only an archive (Figure 1.4) but a spectacular field of lost possessions, which accepts, parodies and insists on the chaotic denaturing of memory under totalitarian rule, is posed as detritus charged with imaginary sentiment, bringing up in sheer number and mass the idea of a lost population of individuals. To call these objects 'liminal' is not however to concede to them the capacity to symbolise. Just like the anonymous photographs, extracted from 'recovered' family photograph albums or from newspaper obituaries and thereby divested of all the recognition and sentimental attachment which would have once charged their images, the objects persistently retain their 'objecthood', their inanimate indifference and resistance to being seen as more than the things and images they are. Instead, they become the sign of a past whose unknowability is curiously packed up without residue in the manifestly known quality of the objects themselves, and which becomes the

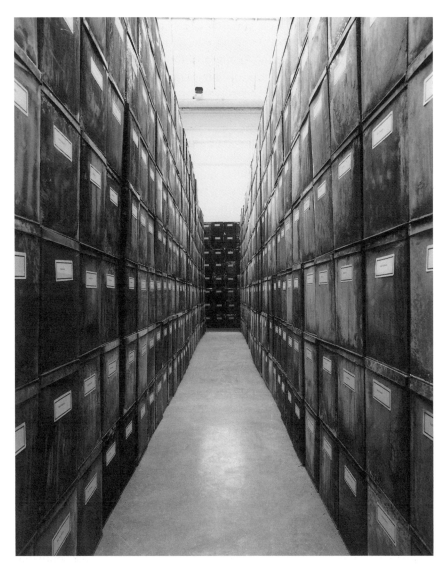

1.4 Christian Boltanski, *The Lost Workers Archive and the Work People of Halifax 1877–1982*, 1994

object of a generalised pathos which is repeated in each instance. Boltanski's installations may leave the spectator at a loss: the objects, images and settings allow him too little and too much to respond to at once. Though it may be accurate to call this state 'transitional', it is not clear that the objects that incite it have any of the symbolising implication of Winnicott's concept of the

'transitional object'. It is not a question of the *infant*'s first proto-symbolic possession. Rather the concept's vivid evocation of an intermediate entity, belonging neither wholly to the mother nor to the self but bringing into the external world an object that takes up memory, attachment and identity and transforms it into a new thing of which, as Segal says of the symbol, 'the subject has the freedom of its use', evokes equally the realm of art. The experience in Boltanski of a sorrow that cannot settle and cannot be resolved, since it appears more often than not to be a sorrow for the passing of time and for death itself, feels unintegrated, moving the spectator from object to object in an unanchored, inescapably restless and continually repeated state.[23]

The sense of an invisible and pervasive past, or of a present whose physical and ideological setting withholds commonly accessible emblems of experience, need not issue in such poignant but ultimately sterile repetitions. I want in conclusion to touch on the work of sculptors whose orientation and whose practice seem capable of creating genuinely transformative works, and which in doing so reveal how the slide into disenchantment of the modern sculptural object can issue in re-enchantment instead.

'I was trying … to bring an unregistered and forgotten space into the world', Rachel Whiteread has said of her first sculpture of a table in 1989.[24] The bringing into presence of the absent – the underneath or interior spaces of things that in the sculptor's hands become solid objects – offers an analogy for the way that an ancient and absent symbolic function is being given new life. To create this new life, the objects themselves must disappear, like a casting from lost wax, only for the core of what is then created to become the invisible inside of the experience of common objects that points to the unconscious continuity and comprehensiveness of bodily experience. That unconsciousness can be seen as the repository of memory and dream – inaccessible to anybody else, but *symbolised* in the cast of the space in which it was once experienced. It is important to insist on the *clarity* of the form to see the extent of Whiteread's achievement. She is strongly aware, of course, of the associations that come inevitably with using second-hand furniture, the flotsam of 'London's detritus … abandoned everywhere in the streets': 'it is inevitable', she acknowledges, 'that the history of the objects becomes part of the work', and she recognises the 'element of nostalgia'.[25] This might seem, from one point of view, to overwhelm the experience of the sculpture in, for example, *House* (1993) (Figure 1.5). My impression, however, is that for the most part what Fried said of Caro applies equally to Whiteread: 'In the grip of his best work one's view of the sculpture is, so to speak, eclipsed by the sculpture itself'.[26] Fried was thinking of the varieties of standpoint from which one might look at the three-dimensional object: here it is more a matter of varieties of imaginings with which one might wish to charge Whiteread's objects almost before one sees them. The shape itself, its mass and what is

1.5 Rachel Whiteread, *House*, cast concrete, 1993

incised upon it by what has disappeared, is however usually enough: an imaginative force seems to rest in its interstices, the breaks in its surface and outline, the way it is not simply the block, its texture, the sense of its construction, which make it up.

I am struck too by Ewa Lajer-Burcharth's characterisation of Cornelia Parker's installation *Thirty Pieces of Silver* (1988) (Figure 1.6), which 'wrested the objects from our potentially fetishizing grasp, for unlike fetishes or souvenirs, which acknowledge but also disavow the past, they re-present it as, literally, a thing-in-itself, beyond our use'.[27] If these works constitute a 'trace', it is one that creates an *imaginative* reorientation in the spectator towards the external world.

But it may be said that the destiny of the modern object has come full circle in the recent work of Tony Cragg, who has summarised the end-point of the process by the statement that 'only the present is truly material'.[28] To think about the meaning of this enigmatic statement is to bring us immediately to Cragg's position about materials as such:

Naturally occurring formations, materials, phenomena, and objects are part of the original inventory of the universe and as such provide us with a vocabulary of qualities which has also become the language for describing human activities and their results.[29]

This suggests that the materials and changes in them are implicitly vested by us with a vision of the possible world, and are in themselves highly charged emotionally. This allows him later to speak of how

artists have liberated a common vocabulary of materials, objects, environments, concepts and activities from the non-art world, for use as parts of a rich language capable of expressing the most complicated ideas and emotions. The nomination of banal objects and actions as carriers of important information ... has been of great significance.[30]

That inclusion of the 'banal' as part of a current potentiality for expression helps us to see that 'material', as a gauge of the authentic that is rooted in the structure of the world itself, is proposed, on the one hand, virtually as a metaphysical principle that underlies the possibility of creating works of art, of itself generating the vocabulary of expression that makes this possible. On the other, it is in effect the vital principle of the present that repeatedly must make its claim for itself against the accumulated history of artistic practice. Its emphasis is significantly different from Rilke's insistence on a profound separation of the work from the world as given: 'What does it mean to us', he asks 'at a conscious or, perhaps more important, unconscious level to live amongst ... completely new materials?'[31] For these new materials are irreversibly part of the means of expression of the present. One might see in a work like *Stack* (1985), for example, a use of 'materials nobody else wants'[32]

1.6 Cornelia Parker, *Thirty Pieces of Silver*, crushed silver plate suspended on wire, 1988

to create a sense of the precipitate of a population, an archaeological layering, a promiscuity of juxtaposition, together with the simple presence of this block-like form that intensely delivers these notions to the spectator at the same time as remaining enigmatically something put together. It is the reverse of 'garbage' – in effect turning garbage into an object that frees itself from what it manifestly is. *Eroded Landscape* (1992) (Figure 1.7) suggests a dense population, packed and delicate at once, taken from the past, roughly and tightly assembled in a present that is both respectful of the beauty of its elements and careless of it: a parable, perhaps, of the quandaries (in Patrick Wright's phrase) of 'living in an old country'. Yet the primary sensation must be of the grace and fragility of these forms so strangely filling the space. This seems very far from a *literal* reinstatement of things, still less a mere replication of the given – rather they seem like forms that are wholly accessible to what Stokes calls 'the imaginative point of view'.[33] They are by no means 'unconquerable natural or manufactured objects', but ones whose

1.7 Tony Cragg, *Eroded Landscape*, glass, 1992

enigmatic disclosure allows a full range of what one might properly call 'aesthetic' response.

In 1991, Cragg rebutted those of his critics who had turned him into 'an artist who works with junk', maintaining that 'waste must cease to be waste before it can be of any use to the artist'.[34] I am reminded of a passage in Henry Mayhew's *London Labour and the London Poor* (1851) where the author visits a marine-store. As he inventories the apparently chaotic, squalid and disorderly repository of objects that 'nobody else wants' – an image of a city pullulating with overwhelming numbers, threatening conventional distinctions and adumbrating a state of moral and civil revolution – the reader becomes aware that what Mayhew is reconnoitring is not in reality a garbage heap but a rationally conceived accumulation of innumerable objects of potential use, on their way, by different means and in different forms, to recovery and to restoration to an active role in the world which has, for the time being, used them up. The store is in fact the embodiment and emblem of an economy.[35] The example suggests how the promiscuities, the chance

and formless agglomerations, the disintegration of customary expectations in the modern city, might indeed provide what Cragg described as 'a common vocabulary of materials, objects, environments, concepts and activities' for the purpose of complex artistic expression. That is, the artist is not bound simply to *reproduce* the objects that surround us, but may *use* them: may see, even in their distance from the rich histories and associative potentialities of the materials that were native to previous generations, the medium for a new symbolic life. In a world of continuing disenchantment, such recoveries may still have the capacity to offer us transformational symbols of human hope and fear.

What Cragg defines as 'banal', though its presence may engender a particular dynamic in the work, is freed from being determinately identical with its source, which is not simply reproduced, but becomes part of an imaginative expression that takes it beyond itself. Correspondingly, a sculptural environment, however strongly reminiscent of the 'ordinary' it might be, resists assimilation to the familiar world of its original. Just as the psychic journey initiated by the first acceptance of the Other must be a journey into the unknown, so the contemporary sculptor's capacity to make symbols rests frequently on his ability to recognise that which *cannot* be known and which, in consequence, can give gravity to what can only be discovered in the event. It requires the renunciation of knowing in advance. The all-too-frequent deployment of 'irony' in contemporary art depends on something known so thoroughly in advance that it in effect merely repeats it. To accept the opposite is to recognise, as psychoanalysis teaches, that 'the world created anew' is made possible only by the acknowledgement of a primary loss which, internalised, becomes the basis of one's own creativity. That inescapable loss, however formulated, is at the core of the activity of the sculptor. Marcel Proust makes his painter, Elstir, exclaim, 'one can only create what one has renounced'.[36] Perhaps one might add to that assertion 'and what one has yet to know'. For it is in their penumbra of unknowableness that the most distinguished works of contemporary sculpture resonate for us.

Notes

1. R.M. Rilke, *Rodin*, trans. J. Lemont and H. Transil, London, 1946, p. 9.

2 . Callistratus (ed. A. Fairbanks), *Descriptions* (with Philostratus, *Imagines*), Cambridge, Mass., 1979, p. 403.

3. See Pliny (ed. H. Rackham), *Natural History*, Cambridge, Mass., 1952, IX, pp. 308–11.

4. Maurice Merleau-Ponty (trans. H. and P. Dreyfus), 'Cézanne's Doubt', in *Sense and Non-Sense*, Evanston, 1964, p. 19.

5. H. Segal, *Dream, Phantasy and Art*, London, 1991, p. 95.

6. Ibid.

7. T. Adorno (trans. E. Jephcott), *Minima Moralia – reflections from damaged life*, London, 1974, p. 40.

8. Quoted by J.B. Leishman, 'Introduction' to R.M. Rilke, *Sonnets to Orpheus*, London, 1967, p. 19.

9. R.M. Rilke (trans. J. Leishman and S. Spender), *Duino Elegies*, London, 1963, pp. 84–5.

10. D. Gascoyne, *A Short Survey of Surrealism*, London, 1935, p. x.

11. I am here adapting Hannah Segal's notion of a 'symbolic equation': see her 'Notes on symbol-formation ' (1957), reprinted in *The Work of Hannah Segal*, London, 1986.

12. H. Prinzhorn, *Artistry of the Mentally Ill, a contribution to the psychology and psychopathology of configuration*, Berlin, 1922.

13. A. Stokes, 'Is-ness and Avant-Garde', in *Three Essays on the Painting of our Time*, London, 1961, p. 54.

14. M. Fried, title essay in *Art and Objecthood*, Chicago, 1998, p. 167.

15. See *Joseph Cornell/Marcel Duchamp … in resonance*, exh. cat., Ostfildern-Ruit, 1999.

16. Quoted by Don Quaintance, 'Ephemeral Matter: Traces of Cornell and Duchamp', in *Joseph Cornell/Marcel Duchamp*, p. 246.

17. A. Stokes, *Smooth and Rough*, London, 1951, p. 16.

18. A. Stokes, *Reflections on the Nude*, London, 1967, p. 23.

19. I. Kabakov, 'Interview', in B. Groys, D.A. Ross and I. Blazwick, *Ilya Kabokov*, London, 1998, p. 14.

20. Ibid., p. 101.

21. Ibid., p. 102.

22. C. Boltanski, 'Le Voyage au Pérou', *Dernières Années*, Paris, 1998.

23. I have argued this more fully in 'Photography, Memory and Survival', *Literature and Theology*, 14.1, March 2000, pp. 52–68.

24. 'Rachel Whiteread interviewed by Andrea Rose', in *XLVII Venice Biennale*, exh. cat., 1997, p. 30.

25. Ibid., p. 29.

26. Fried, 'Art and Objecthood', p. 167.

27. E. Lajer-Burcharth, 'Metamorphoses', in *Cornelia Parker*, exh. cat., Turin, 2001, p. 92.

28. T. Cragg, 'Why Am I This Shape?' (1998) in H. Friedel (ed.), *Anthony Cragg*, Munich, 1998, p. 87.

29. T. Cragg, 'Preconditions' (1985), in Friedel (ed.), *Anthony Cragg*, p. 59.

30. T. Cragg 'Vantage Point' (1998), in Friedel (ed.), *Anthony Cragg*, p. 63.

31. Statement by Cragg, *Documenta VII*, exh. cat., 1982, p. 57.

32. *Tony Cragg*, exh. cat., 1981.

33. A. Stokes, 'Collages', from 'Reflections on the Nude' (1962), in *The Critical Writings of Adrian Stokes*, Vol. III, London, 1978, p. 30.

34. T. Cragg, 'Art from Waste' (1991), in Friedel (ed.) *Anthony Cragg*, pp. 69–70.

35. P. Quennell (ed.), *Mayhew's London*, London, n.d., pp. 278–81.

36. M. Proust, cited by Segal, *Dream, Phantasy and Art*, p. 89.

'Psychologie des foules': Surrealism and the impossible object

Simon Baker

> Whenever one has recourse to images, most often peremptory and provocative ones, borrowed from the most concrete of contradictions, it is reality on the material order, human physiology, that comes into play.[1]

It has become commonplace to imagine that Surrealism in some way attempted, or even achieved, a radical synthesis of Marxist historical materialism and Freudian psychoanalysis. Surrealism as a critical category has suffered from this diagnostic conflation, which accommodates a pointed, even deliberate failure to acknowledge the absence of any such synthesis in the field of visual culture. It is as though while assembling the Surrealist bandwagon, the wheels prove difficult to attach and are discarded because of their shape. The shortcomings of this synthetic account of Surrealism are most evident in the incompatibilities between textual and visual forms of representation, and in the differences between the production and consumption of Surrealist ideology. This essay identifies and analyses the point at which it became clear that the conditions might never exist for a revolutionary Surrealism that might be both aesthetically and politically *effective*. At stake is the potential for Surrealism to generate collective activity, and the political and ideological implications of its failure to do so, in the context of André Breton's formulation of the idea of the Surrealist object between 1934 and 1936. This interval of time, spanning and over-reaching the brief lifetime of Contre-Attaque, a group that drew André Breton and Georges Bataille together for the first time, also includes the moment that Surrealist objects infested Parisian galleries; the moment that Surrealism achieved international recognition; the moment that Surrealism ceased to be able to contain its internal contradictions; and the moment that it unravelled.

'It was André Breton who rightly recognised that a poet or a painter does not have the power to say what is in his heart but that an organisation or

collective body could'.[2] The centripetal force that Georges Bataille, among others, identified at the heart of Surrealism, although not necessarily *strong*, was never stronger than in the winter of 1935–6 when, for the first time, he and André Breton laid aside their personal and ideological differences to form a political organisation called Contre-Attaque.[3] The significance of Contre-Attaque, however, goes beyond the symbolism of its formation as a Surrealist collective.[4] As with the Surrealists' contemporaneous retrieval of Sade in the absence of a portrait likeness, critical accounts of Surrealism have found the absence of images with which to associate Contre-Attaque problematic.[5] It could be suggested, for example, that Contre-Attaque was not properly speaking a Surrealist formulation; that it operated alongside Surrealism while being in some way opposed to the aesthetic preoccupations of the movement proper. Michel Surya has described Contre-Attaque as 'one of the final and most significant displays of the French intellectual far left before the declaration of the Second World War', but as a Surrealist phenomenon its failure to produce images emphasises, rather than detracts from, its success as a collective.[6] However, for this essay, the significance of this low-profile aspect of the history of Surrealism, and its contemporaneity with an effusion of Surrealist objects, lies in the construction of revolutionary spectatorship espoused within Contre-Attaque that challenged the efficacy of representation in any conventional sense. Although not quite 'in opposition' to the production of objects, Contre-Attaque was more immediately concerned with the formulation of revolutionary *subjects*.

It was in September 1935 that Bataille and Breton formally agreed to work together to find an acceptable revolutionary position from which to speak, outside, and in opposition to, the all-encompassing political compromise offered by the Popular Front.[7] Contre-Attaque was formed out of necessity – not in an atmosphere of revolutionary exuberance, but in *reaction* to the ascendancy of a politics of left-wing conciliation.[8] The Popular Front was itself formed in response to fascist action 'in the street', as communists and socialists marched together in a groundbreaking display of unity after the fascist uprising in Paris on 6 February 1934.[9] From that point onwards, support for the Popular Front grew, despite the unpalatable political compromises made by the participating parties, and 14 July 1935 saw unparalleled popular demonstrations in Paris. Five hundred thousand people retraced the steps of 1789, through the faubourg Saint-Antoine to the place de la Bastille, triumphantly reviving the revolutionary site under the watchful gaze of huge portrait posters of Marat and Robespierre.[10] In the face of such consensus, the urgency of Contre-Attaque lay in the possibility of its existence, the fashioning of a space from which to speak against the threat of fascism but also against the threat of a populist left-wing alternative.

In the first speech that he gave to Contre-Attaque, Breton described this

'space' in the most oblique terms, offering new possibilities for expression to the man in the street:

There is a truly geometric space which must be found, but at Contre-Attaque we think that it is possible to find this geometric space. We think that there is, among a hundred men in the street, one who is disposed to make our current ideas his own, who among all others, is young and willing to triumph at all costs.[11]

This optimism, however, was not based on romantic or idealistic notions of revolutionary politics but on an informed knowledge of contemporary theories of crowd formation and interaction. It was André Breton, a most unlikely expert on united, undirected action, who introduced the study of crowd psychology to his lectures to Contre-Attaque in November and December 1935.

Breton's contributions to Contre-Attaque were of a more demonstratively intellectual nature than those offered by Bataille, but both were equally concerned with the immediate question of effective action. In his first lecture Breton asserted the regressive, counter-revolutionary nature of the Popular Front's emphasis on the family, confirming it as a prime target for Contre-Attaque, before moving on to discuss the relative theoretical positions of Hegel and Marx on the revolutionary potential of language.[12] Breton's self-conscious frame of reference also extended to the science of collective psychology, which he developed as a theme during his commitment to Contre-Attaque. In his first lecture he pointed out the distinction that Freud had made between 'natural' and 'artificial' crowds in 'Group Psychology and the Analysis of the Ego', in order to suggest a theory of popular 'exaltation' diametrically opposed to the quasi-religious behaviour of the crowd affected by the psychology of Hitlerism.[13]

Freud's text, which had been translated and published in French in 1927, offers a commentary on the history of crowd psychology, which turns out to have been a particularly French phenomenon.[14] Freud begins with the work of Gustave LeBon, whose 1895 book *Psychologie des foules* (The Psychology of Crowds) was still widely regarded as the principal text on the topic.[15] LeBon's analysis of the crowd was situated firmly in the tradition of revolutionary history. His later work, *The Psychology of Revolution*, reveals that he often conceived of the relationship of a crowd to its leader in terms of the Terror.[16] This conception of the Terror was heavily determined by a post-Commune fear of popular insurrection. LeBon therefore sought to make considerable claims for the power that leaders were believed to have exerted on crowds, and the consequent effect that this had on the individuals of which they were composed:[17]

By the mere fact that he forms part of an organised group, a man descends several rungs in the ladder of civilisation. Isolated, he may be a civilised individual; in a

crowd, he is a barbarian – that is, a creature acting by instinct. He possesses the spontaneity, the violence, and also the enthusiasm and heroism of primitive beings.[18]

In his critique of LeBon, Freud points out that while LeBon, perhaps mistakenly, identifies the leader as the source of the 'fascination' of the crowd, he fails adequately to explain the process of transformation from a group of free-thinking individuals to a crowd.[19] Freud notes with some surprise that LeBon actually believed crowd psychology to *be* hypnotic, rather than being *like* hypnotism.[20] Robert Nye, who has written extensively on the subject, draws attention to LeBon's idea of the hypnotic state as a 'collective hallucination':

The crowd thinks in images, but having lost its ability to distinguish a real (perceived) from an unreal (internal) image, owing to its dream-like torpor, its mental functioning is reduced to hallucination. These hallucinations are the unifying foci of any crowd, and spread from individual to individual by 'imitation' or 'mental contagion' until they universalise themselves.[21]

Freud recast this mental contagion as 'suggestibility', which he nevertheless believed was 'actually an irreducible, primitive phenomenon', rooted in the libido.[22] At the same time, Freud evidently had deep misgivings about LeBon, believing him to have been overly influenced by a negative conception of the crowd during the French Revolution.[23] To highlight this basic flaw in LeBon's approach, Freud posited the existence of the 'natural' and 'artificial' crowds to which Breton was then able to refer. Freud's exemplary artificial crowds were the church and the army; 'unhomogeneous' groups of people held together by a common relationship to one another structured by their common relationships to a leader or head.[24] Natural crowds, Freud believed, were motivated by a common identification or bond of love: 'a number of individuals who have put one and the same object in the place of their ego ideal and have consequently identified themselves with one another in their ego'.[25] Freud also distinguished between what he called the 'herd instinct' and his preferred notion of the 'primal horde'.[26] Describing this 'primal horde', Freud posited a causal relationship between a familial structure and suggestibility. The definition of 'suggestion', the unsatisfactory link from LeBon's theory, is offered as nothing less than 'a conviction which is not based upon perception and reasoning but upon an erotic tie'.[27]

Breton referred to this same assertion in his third lecture to Contre-Attaque in which he proposed a novel application of Freud's reading of LeBon in order to generate what he called 'exaltation' in the revolutionary crowd:

'A collective formation', says Freud, 'is primarily and essentially characterised by the establishment of new, affective bonds between its members'. These affective bonds, he states unequivocally, are a response to the need to fulfil 'erotic tendencies, which

without losing their drive, have deviated from their primitive goals'. In such circumstances, the erotic pull gives way to what Freud calls 'identification' (a phenomenon in which the ego seeks to become like a proposed 'model'.) In his eyes a motivated crowd is essentially a grouping together of individuals who have come to recognise a common identity, an identity founded upon 'affective' community.[28]

Breton's interest in the 'affective' nature of the identification that this crowd had to make led him right back to LeBon, whose evocation of mental contagion, collective hallucination and spontaneous, violent barbarism was exactly what he had in mind: 'Let others recoil in horror from this dark scene, they're free to do so'.[29]

Returning to LeBon's text with a full understanding of Freud's characterisation of the libidinous drive behind affective identification, Breton was now able to construct a revolutionary theory of the potential of the crowd. Not only is collective action, 'une foule en marche', effective in the street, but it represents the possibility for a new revolutionary subject founded upon this notion of identification: '"The coincidence of the ego and the ego ideal",' Breton quotes Freud, '"always manifests a sensation of triumph. Guilt (or inferiority) can be considered to be the expression of a state of tension between the ego and its ideal". We incontestably stand for triumph in the Freudian sense.'[30]

Freud's 'primal horde', however, was predicated upon a patriarchal masculine economy of fathers and sons; an Oedipal structure which ill suited Breton in facing the Popular Front. Breton preferred instead subtly to re-cast Freud's theory, positing a second kind of crowd. In place of what he referred to as Freud's 'paternal horde' there was to be a 'fraternal community':

It is actually this second kind of crowd which particularly interests us, it is the driving force of this crowd we wish to acknowledge. Where we revolutionaries want to go is into the very core of this crowd, a crowd which at the designated hour decapitates kings and gods.[31]

It was violent engagement rather than revolutionary psychology which lay at the heart of Bataille's agenda for Contre-Attaque, but his interest in the phenomenology of fascism and the politics of spectatorship determined his conception of collective action. His ideological appeal to the workers was that the 'defensive' Popular Front had to be transformed into an aggressive Popular Front of 'combat'. He agreed with Breton, however, that any violence had to come *directly* from the revolutionary crowd: 'The crowds of February 12th '34, July 14th '35, and February 18th 1936, must become aware of their almighty power and sweep aside those who still stand in the way of their domination'.[32]

'Just' violence could only originate within the crowd itself, through what Bataille described as 'organic' means. The principal characteristic of an

organic crowd was that it should have no leader, and eschew even symbolic associations with leadership.[33] Bataille had categorically defined his objections to what he called the 'Psychological Structure of Fascism', citing the destructive 'glory' imparted by strong leadership to a mass audience, in response to developments in Nazi Germany in 1933.[34]

This attitude to the relationship between the symbolism of the spectacle and leadership is evident from Bataille's introduction to 'Towards a Real Revolution' in which he is unequivocal on the role that the crowned head, the object of collective desire, plays even *after* its removal, suggesting that it may well return to haunt the Revolution:

With or without spilling blood each one amongst them knocked off a crowned head. It is necessary to draw attention to the primary and essential role played in these violent historical movements by the heads that they removed ... When a crowned head plays the role of unifying the insurgent crowds, and when the movement falls apart after the triumph of the insurrection, increasing the turbulence which results from the upheaval, the Revolution is in serious trouble.[35]

The importance of the symbolic relationship of head and body in revolutionary rhetoric is underlined by the only representative image of Contre-Attaque (Figure 2.1). Bataille's invitation to a Contre-Attaque meeting was deliberately designed to draw attention to the anniversary of the execution of Louis XVI, but not simply to revive the memory of past events.[36] Bataille took the obvious and over-exploited link between the French revolutionary past and current circumstances as the subtext for commemorating the death of the king.[37] This gesture was compounded by reference to the '200 Families', an obscure historical myth which both the Popular Front and their fascist opponents had attempted to use for purposes of propaganda. The invitation itself, superimposed over a sacrificial calf's head on a plate, consisted of the following:

CONTRE-ATTAQUE, 21st January 1793–21st January 1936, *The Anniversary of the Execution of King Louis XVI* Tuesday 21st January 1936, 9 p.m. at Grenier des Augustins, 7 rue des Grands-Augustins, St Michel metro. Object of the meeting: The 200 Families, a matter for the justice of the people.[38]

The symbolic significance of the '200 Families' in the winter of 1935–6 reveals the analogy at the heart of Bataille's invitation. With the help of a series of specious historical justifications, the 'families' were established by Popular Front politicians as capitalist opportunists who had profited from wars in Europe since the nineteenth century.[39] Right-wing propagandists simply trawled through the names offered as evidence that the 'families' were a cabal of Jews and free-masons.[40] The decapitation of the king, the removal of the symbolic 'head' of the French people, is thus drawn by Bataille into a hotly contested, if slightly paranoid, argument about whether a select

CONTRE-ATTAQUE

21 JANVIER 1793 – 21 JANVIER 1936

ANNIVERSAIRE DE L'EXÉCUTION CAPITALE DE LOUIS XVI

Le MARDI 21 JANVIER 1936, à 21 heures,
réunion ouverte au Grenier des Augustins,
7 rue des Grands-Augustins. Métro: St Michel

Objet de la réunion:

LES 200 FAMILLES

qui relèvent de la justice du peuple

Prendront la parole: Georges BATAILLE, André BRETON, Maurice HEINE.

2.1 Invitation to Contre-Attaque Meeting of 21 January 1936, from M. Nadeau,
Histoire du Surréalisme II, Documents Surréalistes, Paris 1948

group of families really ruled France. It also, by implication, functions as a critique of the way in which a historical narrative can be made to serve two conflicting agendas.[41]

The adoption of the families as a totemic target by both right and left between 1935 and 1936 reveals the sophistication in Bataille's invitation, which attacks the concept of leadership as a symbolic category rather than the results of specific policies or directives.[42] 'It is clear from now on', he wrote in 'Popular Front in the Street', 'that in order to have confidence in its own resources, the Popular Front must first lose the confidence it currently has in its principal leaders'.[43]

For the members of Contre-Attaque, moving forward 'in the street' meant a permanent reorientation of perspective towards this point of recognition; towards the threat of violence posed by the crowd; away from chimerical symbols of oppression and the spectacular representations of a 'heroic' population attacking hollow idols.

The single identifiable object that can be said to 'represent' Contre-Attaque can therefore be no more than a schematic drawing. Bataille offers the '200 families' to the people on a platter; the calf's head is for collective consumption rather than exhibition. There are no group photographs of Contre-Attaque members shoulder to shoulder with the workers, no images of the distribution of pamphlets, no one seen taking their place in the revolutionary crowd.[44] In a speech given at a Contre-Attaque meeting entitled 'Popular Front in the Street', Bataille rejected entirely the possibility of representing popular protest.[45] He reminded his audience of the birth of the Popular Front on the Cours de Vincennes, on 12 February 1934, at a march protesting the fascist insurgency of 6 February:

Most of us, comrades, were in the street that day. Many of you, no doubt, can remember the huge old bald worker with a reddish face and heavy white moustache, who walked slowly, one step at a time, in front of that moving human wall, holding high a red flag. It was no longer a procession, or anything purely political; it was the curse of the working people, and not only in its rage, IN ITS IMPOVERISHED MAJESTY, which advanced, made greater by a kind of rending solemnity – by the menace of slaughter still suspended at that moment over all of the crowd.[46]

What is at stake here is the danger implicit in representation itself. The curse of the working people lies in the reactionary complicity of accounts, descriptions and, above all, visual representations of their heroism. Revolutionary representations are impossible, Bataille suggests, precisely because, in the production of revolutionary objects, they court reactionary subjects. The only alternative to this visual regime is a fraying or defraying of focus, away from the centre, away from the point of interest, towards and back into the crowd itself, back to the collective point of recognition.

Breton expressed the belief, prior to his participation in Contre-Attaque, that the failure of intellectual commitment lay in a fundamental misunderstanding about the nature of an expanded political consciousness.[47] In a 1934 essay for *Minotaure* entitled 'La Grande Actualité Poétique', he had evoked Freud to reveal the problematic nature of the Marxists' call for 'plus de conscience', offering fourteen years of Surrealist activity as evidence that it was possible to reach beyond the conscious, to find an alternative means of resistance and revolt.[48] Through Contre-Attaque, Breton pursued the logic of this belief, taking on board complex arguments about perception, identification and the bases of collective action, which, nevertheless, failed to produce 'revolutionary' images. Breton's 'affective' psychology of the revolutionary crowd was a vital contribution to the agenda of Contre-Attaque, but the evolution of his concept of spectatorship, of which it forms a part, can also be traced through his formulation of a particular form of Surrealist image-production. Although the detail of Breton's engagement with revolutionary politics draws upon a precise

tactical deployment of psychoanalytical theory concerning the nature of the subject, it is within a longer time-frame encompassing his exposition of the Surrealist 'object' that this engagement can best be understood. The discussions and arguments precipitated by Bataille's challenge to the politics of the Popular Front illuminate, and inform by contrast, a long-running thread of Breton's thought on the Surrealist object and particularly the 'found object', to which he returned frequently in the political turbulence of the 1930s.

The staging of a group exhibition of Surrealist objects in the summer of 1936, following hot on the heels of the collapse of Contre-Attaque, throws the issue of Surrealism's collective efficacy into sharp relief,[49] as indeed do the accompanying issue of *Cahiers d'Art*, the politically timid 1935–6 issues of the beaux-arts journal *Minotaure*, and the subsequent publication of Breton's book *Mad Love*.[50] After 1936, Surrealism could either seek a consensus about the things that its revolutionary crowd wished to look at, or it could continue to challenge the presumptions about what a crowd was meant to be.

This reordering of priorities, perhaps most obvious in the differing paths that Breton and Bataille followed *after* Contre-Attaque, suggests that for both, the experience was less of a dead end than a one-way street. For Breton, it led to the consolidation of Surrealism's tactical gains, a virulent defence of the relevance and efficacy of the poetic logic of *Mad Love*.[51] For Bataille, however, the strategic competencies projected for Contre-Attaque were carried forward through the arcane and secretive *Acéphale* to the irrational politics of the College of Sociology.[52]

Breton's interest in the concept of the Surrealist object dates back to the late 1920s, giving rise to both textual and physical manifestations.[53] His key texts, however, date from the years 1934–6. 'Surrealist situation of the object – situation of the Surrealist object' was given as a lecture in Prague in March 1935, linking the politics of production to the psychology of perception.[54] 'The crisis of the object' was produced for *Cahiers d'Art* to accompany the 1936 exhibition of Surrealist objects and offers a vastly expanded taxonomy of object-types, including an explanation of the role Euclidean and non-Euclidean geometry in mathematical objects.[55]

The best-known text, however, is that forming the third section of *Mad Love*, which contains a photograph of what Breton describes as a 'statue' by Giacometti, *The Invisible Object (Hands Holding the Void)* (1934–5), photographed by Dora Maar (Figure 2.2), and two photographs of 'found objects' taken by Man Ray.[56] Although completed in 1936, it consists principally of a text originally entitled 'Equation of the Found Object', which had appeared with the same illustrations two years earlier in the Belgian journal *Documents 34* (Figure 2.3).[57] It is possible to identify similarities and differences in emphasis between the two versions of Breton's text, but the nuances effected by the contexts of their publication are of more immediate interest.[58]

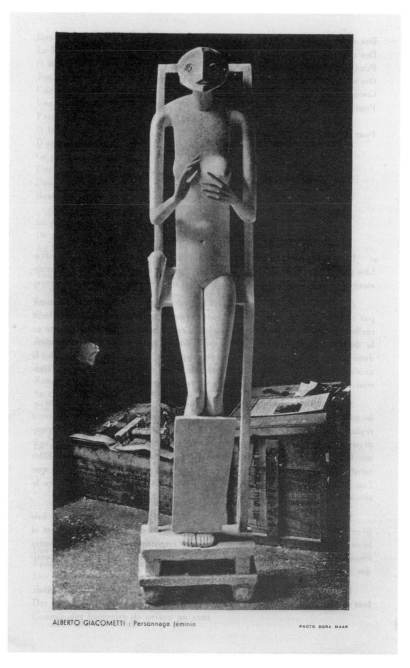

ALBERTO GIACOMETTI : Personnage féminin PHOTO DORA MAAR

2.2 Dora Maar, *Alberto Giacometti: Personnage féminin*, photograph from *Documents 34*, 1934

PHOTO MAN RAY

d'abord retenus. Bien que le caractère remarquablement définitif de cet objet semblât échapper au marchand qui nous pressait de l'acheter en suggérant de le peindre d'une couleur vive et de le faire monter en lanterne, Giacometti, pourtant très détaché en général de toute idée de possession à propos de telles choses, le reposa à regret, parut chemin faisant concevoir des craintes sur sa destination prochaine, finalement revint sur ses pas pour l'acquérir. A quelques boutiques de là, un choix presque aussi électif se porta pour moi sur une grande cuiller en bois, d'exécution paysanne, mais assez belle, me sembla-t-il, assez hardie de forme, dont le manché, lorsqu'elle ,reposait sur sa partie convexe, s'élevait de la hauteur d'un petit soulier faisant corps avec elle. Je l'emportai aussitôt.

19

PHOTO MAN RAY

2.3 Man Ray, photographs of André Breton's found objects, *Documents 34*, 1934

Documents 34 was a politically motivated publication, a reaction to the February 6th fascist uprising, and is introduced by a series of political demands and calls for collective action.[59] 'Equation of the Found Object', as it first appeared in 1934, assumes its place in a wider network of projected actions 'in the street', where the fascist uprising and left-wing responses had raised the stakes immeasurably. Breton's text, Dora Maar's photograph, and Breton's 'found objects' photographed by Man Ray, appear alongside Maurice Heine's homage to the *revolutionary* Sade of the 'Section des Piques', Crevel's evocation of Marat and Robespierre, and Louis Scutenaire's collage/homage to Gracchus Babeuf.[60] Breton further embellished his text with a visual coda elsewhere in the journal, a murky, unattributed photograph of a virtuoso display of serviette-folding with arcane instructions entitled 'Communication relative au hasard objectif'.[61]

Mad Love, published in 1937, saw Breton revisiting the concepts of 'convulsive beauty' and 'objective chance', now central to the movement as he saw it, in the awareness of (although not necessarily in response to) recent public accounts of Surrealism offered by the 1936 'Fantastic Art, Dada & Surrealism' exhibition in New York, and, to a lesser but potentially more aggravating extent, that offered by the 1935 Hollywood film *Mad Love*, directed by Carl Freund and starring Peter Lorre. The latter can be seen as both a clever synopsis and an artless travesty of Surrealism, replete with references to Freud's essay on the uncanny, re-animated body-parts, mannequins, and even *Documents*-style close-ups of carnivorous plants.

Breton thus returned to his text on the found object with a renewed sense of purpose, but also with some tangible results.[62] Between 1934 and 1936 the objects at the heart of Breton's text had been recognised from Man Ray's photographs in *Documents* 34. The mask that took its place on Alberto Giacometti's sculpture was returned to a gruesome historical moment via the reminiscences of Joe Bousquet, who recalled its wartime use. The object 'found', photographed and published subsequently 'found' another narrative, and, according to Breton, thus found its 'evil role'.[63] This afterlife of the object, far from making it in any way disagreeable, fulfils Breton's desire that the object multiply in significance, drawing its various viewers into a complicit web:

I recently learned that while Giacometti and I were examining this object, we had been seen without seeing them by two people who had just, a few seconds before, been handling the mask ... an encounter based upon such an object, led me to think that in this moment it becomes the precipitate of the 'death instinct' ... [64]

The found objects, the spoon and the mask, only *gradually* came to symbolise the sexual and death instincts as they circulate within the Surrealist crowd. In the process of accumulating significance, Breton confesses, the objects 'measure their strength on me, blow by blow'.[65]

It is evident from this sketch of Breton's theorising of the 'found object' that its purpose was to multiply the potential for representation within a carefully ordered viewing context. The central idea is that everyday objects might surprise and disturb *per se*, in advance of the requisite witty Surrealist juxtaposition (umbrella and sewing-machine style). There is, however, a clause in Breton's democratisation of the sculptural marvellous, namely that it is the perceptual regime into which the object is introduced that dignifies it with a 'found' status.[66] It is here, precisely, that photography comes into play. Just as Jacques-André Boiffard's photographs of monuments for Bataille's *Documents* effectively rob the objects of their monumental function, cancelling them out, drawing attention to their pedestals, Breton's found objects are imbued with a superlative aesthetic quality (a tongue-in-cheek version of 'significant form') in spite of their claims to banality.[67] This change in register is apparent in the installations for the Surrealist exhibitions, all glass cases and 'intelligent' arrangements; of tribal totems, scientific 'results' and Surrealist works.[68] It is however overwhelming in the photographs that not only record but in fact *produce* found objects for Breton's texts, preserving their found status intact in perpetuity.[69] Rosalind Krauss's suggestion that photography 'produces' a Surrealist vision has far-reaching implications in this context, locating photography at the heart of even the found object's effectiveness.[70] The logic is that of Brassai's 'involuntary sculptures', an object-lesson in the aestheticisation of detritus that perfectly illustrates the agenda of *Minotaure* as a Surrealist journal.[71] As Breton stated in 'Situation of the Surrealist Object' in 1935: 'Photography, by mechanising to an extreme the plastic mode of representation, was furthermore bound to deal it a decisive blow'.[72]

It is possible to establish two points of departure for Contre-Attaque, arranged around the concept of the collective experience of representation but focusing upon the utility of photography. Whereas for Bataille aestheticism was a danger implicit in the photograph, for Breton it was not only its redeeming feature, but a feature that could redeem. Although Contre-Attaque was to be almost completely 'object'-free, Breton extended his interest in object-choice as an efficacious form of representation into the political sphere. There is in fact a degree of continuity in Breton's emphasis on reaching beyond what he (following Freud) called the 'perception-consciousness' system for both the efficacy of the production of objects and the workings of an effective revolutionary crowd. The point is put forcefully in 'Situation of the Surrealist Object', written in 1935:

Now in the modern period painting, for example, has until very recently been almost entirely preoccupied with expressing the manifest relations between external perception and the *ego*. The expression of this relation has been demonstrated to be less and less adequate and increasingly deceptive, so in a process of turning full

circle, it has become virtually impossible to claim for man an expansion, or more accurately, a deepening of the 'perception-consciousness' system.[73]

This methodological 'call to arms' prioritises photography and film for the 'necessity of expressing internal perception' of the object, in order to combat the incipient realism and *'fidélisme'* for which these mechanical processes are prized.[74] In fact, realism and the reality principle constitute the sum of barriers that the object, but more importantly, those conditioned to perceive the object, can overcome.

In art, the increasingly systematic nature of research into these feelings works towards the abolition of the ego in the *self* and as a consequence strives to make the pleasure principle more distinctly predominant than the reality principle. This tends to weaken the barrier which looms up before civilised man; a barrier unknown to both primitive and child.[75]

The continuity between the description of the kind of sense attributed to cameras, children, and 'uncivilised' (or perhaps *de*-civilised) people, and the liberation of society, entails a critical shift from the object to the subject.[76] Breton seems to be suggesting that there is a necessary form of instinctual sense which the object might facilitate, at odds with the concept of external perception.[77] Within Contre-Attaque, Breton was to take what he had hitherto regarded as the 'poetic' potential of an enquiry into consciousness onto the street.

It is certain, from Breton's careful exposition of collective psychology, that Freud's 'conviction … based not upon perception and reasoning but upon an erotic tie', confirms and develops the strategic evocation of the found object. Prior to the political context offered by Contre-Attaque, Breton's 'Situation of the Surrealist Object' suggested something which could bypass or reach beyond the perception-consciousness system, capable of 'breaking down barriers' or 'de-civilising'. A clear path is visible from this phenomenology of identification to what we could call an 'erotics of conviction': the 'object' leads, theoretically at least, to the revolutionary subject, through methodology if not practical application. Ignoring the coincidence of the psychoanalytic term and Surrealist work denoted by 'object', it is worth repeating Freud's definition of a 'natural crowd' as 'a number of individuals who have put one and the same object in the place of their ego ideal and have consequently identified themselves with one another in their ego'.[78] In these terms it will always be the 'looking towards' which predetermines what is seen: the empty hands of Giacometti's figure offer not an invisible, but an impossible, solution.

In their contributions to Contre-Attaque, both Breton and Bataille sought to transpose the rhetoric of revolt into effective action by challenging modes of spectatorship and participation. Despite the short life of their collective

activity, the momentary agreement between them was remarkable in its implications. Together, they identified the need for a theoretically determined, leaderless fraternity, which neither would have been willing or able to direct, as it exercised its collective will. At this singular, brief and perhaps even *final* moment in the development of Surrealism as a collective venture, the politics of representation descended into the street, offering the potential for Surrealist engagement based upon issues of identity, recognition and libidinous affect. For a moment, the fascinated and receptive gaze of the fascist mass was opposed by the possibility of an active, contagious, omnivorous alternative. That this potential force should have exploded into the gallery rather than onto the streets suggests that a desire for objects was satisfied at the cost of Surrealism's promise of revolution.

Notes

1. G. Bataille, 'The "Old Mole" and the prefix *Sur* in the words *Surhomme* and *Surrealist'*, *Visions of Excess: Selected Writings, 1927–1939* ed. A. Stoekl, trans. A. Stoekl, C.R. Lovitt and D.M. Leslie Jr, Minnesota, 1985, pp. 35–6.

2. For this claim, see G. Bataille, 'Surrealism and how it differs from Existentialism', *The Absence of Myth: Writings on Surrealism*, trans. M. Richardson, London and New York, 1994, p. 60.

3. In what remains the key text on Contre-Attaque, Robert Short described the series of meetings which took place between Bataille and Breton in September 1935 to set out the parameters for their joint action: R.S. Short, 'Contre-Attaque', in F. Alquié (ed.), *Entretiens sur le Surréalisme*, Paris, 1968, pp. 144–65. The proclamation which appeared as a result, 'Contre-Attaque – Union de Lutte des intellectuels révolutionnaires', appeared in Breton's *Position Politique du Surréalisme*, which was published in 1935 (A. Breton, *Position Politique du Surréalisme*, Paris, 1971, pp. 121–6).

4. Both Short and Henri Dubief describe the remarkable fact of the coming together of the 'souverainiens', who had been associated with Boris Souvarine's *La Critique Sociale* (including Leiris, Jacques Baron and Raymond Queneau), and contributors to *Le Surréalisme au Service de la Révolution*. See Short, 'Contre-Attaque', pp. 147–8; also H. Dubief, 'Témoinage sur Contre-Attaque (1935–6)', *Textures*, no. 6, Bruxelles, 1970, pp. 52–3.

5. Contre-Attaque takes its place in the political histories of Short, Dubief and Helen Lewis (*Dada Turns Red: The Politics of Surrealism*, New York, 1983), but is rarely included in accounts of Surrealism that concern the production of images. A notable exception is Steven Harris's recent article concerning an object by Claude Cahun, a member of Contre-Attaque, made for the 1936 group exhibition at the galerie Charles Ratton; S. Harris, 'Coup d'Oeil', *Oxford Art Journal*, Vol. 24, No. 1, 2001.

6. M. Surya, *Georges Bataille, an Intellectual Biography*, trans. M. Richardson and K. Fijalkowski, London, 2001, p. 18.

7. For a complete list of contributions see A. Breton, *Oeuvres Complètes II*, Paris, 1992, pp. 585–611; G. Bataille, *Oeuvres Complètes I, Premiers Ecrits, 1922–40*, Paris, 1970, pp. 379–432.

8. For a brief but thorough account of the emergence of the Popular Front see J. Danos and M. Gibelin, 'The Masses take to the Streets', in *June '36 Class Struggle and the Popular Front in France*, trans. P. Fysh and C. Bourry, London and Chicago, 1986, pp. 29–44. For an account of reactions to these events, see Philippe Bernier's notes to 'Trois Interventions d'André Breton à Contre-Attaque', in Breton, *Oeuvres Complètes II*, pp. 1663–7.

9. For a detailed account of cultural responses to the Popular Front see P. Ory, *La Belle Illusion*, Paris, 1993.

10. See Danos and Gibelin, *June '36*; also C. Amalvi, 'Bastille Day', in P. Nora (ed.), *Realms of Memory III: Symbols*, trans. A. Goldhammer, New York, 1998, pp. 145–9.

11. 'C'est là un véritable lieu géométrique à trouver, mais, à Contre-Attaque, nous croyons que ce lieu géométrique est trouvable. Nous croyons qu'il existe entre cent un homme de la rue qui est disposé à faire siennes des thèses à l'heure actuelle qui sont les nôtres que cet homme entre tous est jeune et prêt à faire triompher coûte que coûte.' Breton, *Oeuvres complètes II*, p. 589.

12. Ibid., pp. 586–91.

13. This text appears in the form of a letter written by Breton to Jules Monnerot, which Breton read out to the group, ibid., pp. 591–2. It was Monnerot who later prompted Bataille's own ruminations on the collective nature of Surrealism in his critique of Monnerot's *La Poésie Moderne et le Sacré*, in 'Surrealism in 1947'.

14. S. Freud, 'Group Psychology and the Analysis of the Ego', *The Complete Psychological Works of Sigmund Freud*, Vol. 18, 1920–2, trans. J. Strachey, London, 1955. Breton's references are to 'Psychologie collective et analyse du moi', S. Freud, *Essais de Psychanalyse*, trans. S. Jankélévitch, Paris, 1927.

15. G. LeBon, *Psychologie des foules* (Paris, 1895). Serge Moscovici describes Freud as 'the best disciple of LeBon and Tarde' (Tarde was a contemporary of LeBon), underlining the huge impact that LeBon's work on crowd psychology had in the first years of the twentieth century. Moscovici describes the huge number of re-editions of LeBon's work as equivalent to that of a 'best-seller'. S. Moscovici, *The Age of the Crowd, A Historical Treatise on Mass Psychology*, trans. J. C. Whitehouse, Cambridge, 1985, pp. 49–55, 'Who was Gustave LeBon?', pp. 219–88, 'The Best Disciple of LeBon and Tarde: Sigmund Freud'. This chapter of Moscovici's book provides the most detailed available analysis of Freud's 'Group Psychology and the Analysis of the Ego' and its position in relation to LeBon.

16. G. LeBon, *The Psychology of Revolution*, trans. B. Miall, London, 1913.

17. Freud acknowledges basis of LeBon's conception of the crowd in his work on the French Revolution, 'Group Psychology', p. 83. Robert Nye attributes this influence to the same atmosphere in which Taine produced *De l'Intelligence and Les Origines de la France Contemporaine*; R.A. Nye, *The Origins of Crowd Psychology: Gustave LeBon and the Crisis of Mass Democracy in the Third Republic*, London & Beverly Hills, 1975, p. 29. Moscovici attributes LeBon's 'fear of crowds' to the same influence: *Age of the Crowd*, pp. 79–80.

18. G. LeBon, from *The Crowd*, cited by Freud, 'Group Psychology', p. 77.

19. Ibid., p. 81.

20. Ibid., p. 76. See also Moscovici, *Age of the Crowd*, pp. 81–91; 'Mass Hypnosis'.

21. Nye, *Origins*, p. 68.

22. Freud, 'Group Psychology', pp. 88–92, 'Suggestion and Libido'. Moscovici, *Age of the Crowd*, pp. 244–51, 'Crowds and Libido'.

23. The association with the French Revolution is simply and effectively broken by Freud by positing alternative types of crowd which are self-evidently 'organised'; in this case the church and the army; Freud, 'Group Psychology', pp. 93–9.

24. Ibid., p. 94.

25. Ibid., p. 116.

26. Ibid., pp. 117–28.

27. Ibid., p. 128.

28. ' "Une formation collective, dit Freud, est charactérisée avant tout et essentiellement par l'établissement de nouveaux liens affectifs entre les membres de cette formation". Ces liens affectifs, il est sur ce point très formel, répondent au besoin d'accomplissement de "tendances érotiques qui, sans rien perdre de leur énergie ont déviés de leurs buts primitifs." Le penchant érotique, en pareil cas cède la place à ce que Freud nomme l'"identification", (phénomène par lequel le moi cherche à se rendre semblable à ce qu'il s'est proposé comme modèle). La foule agissante se characterise essentiellement à ses yeux comme un assemblage d'individus ayant réalisé une identification commune, identification fondée sur une communauté affective.' Breton, *Oeuvres Complètes II*, p. 607.

29. 'Que d'autres se détournent avec horreur de ce tableau assez sombre, libre à eux.' *Oeuvres Complètes II*, p. 608.

30. ' "La coincidence du moi avec l'idéal du moi, produit toujours une sensation de triomphe. Le sentiment de culpabilité (ou d'infériorité) peut être considéré comme l'expression d'un état de tension entre le moi et l'idéal." Nous sommes incontestablement pour le triomphe au sens freudien.' *Oeuvres Complètes II*, p. 609.

31. 'C'est, en effet, la foule de ce second type qui nous intéresse spécialement, c'est cette foule à qui nous voudrions faire avouer ce qui l'anime. Où nous voulons entrer, nous révolutionnaires, c'est dans l'intimité de cette foule qui décapite à son heure les rois et les dieux.' *Oeuvres Complètes II*, p. 608.

32. 'Les foules du 12 février '34, du 14 juilliet '35 et 18 février '36, doivent prendre conscience de leur toute-puissance et balayer ce qui fait encore obstacle à leur domination.' G. Bataille, 'Vers la Révolution Réelle', *Cahiers de Contre-Attaque*, p. 14.

33. Ibid., p. 11.

34. G. Bataille, 'La structure psychologique du fascisme', *La Critique Sociale*, 10 November 1933 and 11 March 1934.

35. 'Avec ou sans effusion de sang chacune d'entre elles a abattu une tête couronnée. Il est nécessaire d'attirer l'attention sur le rôle essentiel et initial joué dans les mouvements historiques violents par les têtes qu'ils ont abattues … Mais lorsqu'une tête couronnée jouée son rôle d'unification des foules insurgées, lorsque la divergence des mouvements ne se produit qu'après le triomphe d'insurrection, à la faveur de l'effervescence qui résulte de bouleversement subie, la Révolution s'approfondit.' Bataille, 'Vers la Révolution Réelle', pp. 7–8.

36. This was clearly at odds with the Popular Front's own view of the utility of history evidenced in the recuperation of figures like Marat and Robespierre to their revolutionary 'Pantheon'. See C. Amalvi, 'Bastille Day'.

37. This was an anniversary that Bataille would continue to mark in the years following the dissolution of Contre-Attaque.

38. 'CONTRE-ATTAQUE, 21 janvier 1793 – 21 janvier 1936, *Anniversaire de l'execution capitale de Louis XVI*, Le mardi 21 janvier 1936 à 21 heures, réunion ouverte au Grenier des Augustins, 7 rue des Grands-Augustins. Metro: St Michel, Object de la réunion: LES 200 FAMILLES, qui relèvent de la justice du peuple. Prendront la parole: Georges Bataille, André Breton, Maurice Heine.' Reproduced in M. Nadeau, *Histoire du Surréalisme II, Documents Surréalistes*, Paris, 1948, p. 334.

39. For a recent account of the phenomenon of the 200 families, see R. Sédillot, *Les Deux Cents Familles* (collections vérités et legends), Paris, 1988. For contemporary accounts see *Les Privilégiés de la Banque de France – La Liste des deux cents familles*, Hayard, Paris, 1935, R. Lannes, *Les deux cents familles ou les maîtres de la France*, Paris, 1940.

40. G. Ollivier's *Les Deux Cents Familles: Encore un coup de la F … -M … !*, Paris, 1943, is a particularly anti-Semitic hate-tract on this subject from the years 1935–6.

41. Zeev Sternhell's groundbreaking *Neither Right Nor Left: Fascist Ideology in France* describes both the roots and public manifestations of the ideological consistencies between extreme right- and left-wing politics in France in the 1930s. Sternhell identifies the history of this situation in exclusively French terms, suggesting that to understand fascism in France it is preferable to concentrate upon the developments of left-wing thinkers in the years leading up to the 1914–18 war than on the import of Italian or German ideas. I draw attention to Sternhell's analysis in this context because I believe that Bataille's interventions for Contre-Attaque raise the issue of the manipulation of the people by politicians whose alleged ideological differences had not prevented them from resorting to identical forms of propaganda. Z. Sternhell, *Neither Right nor Left: Fascist Ideology in France*, trans. D. Maisel, Princeton, 1986.

42. Bataille's scepticism about such scapegoats echoes that of Leon Trotsky writing on 26 March 1936: 'The struggle against the "200 families", against Fascism and War, for peace, bread and freedom, and other magnificent things, is either a lie, or it is the struggle for the overthrow of capitalism.' L. Trotsky, 'France at the Turning Point', *Whither France?*, trans. J.G. Wright and H.R. Isaacs, New York, 1968.

43. Bataille, 'Popular Front in the Street', p. 166.

44. That is, unless the objects and images produced by members of Contre-Attaque for exhibitions or other publications during the lifetime of Contre-Attaque are taken into account. A positive example of such a strategy might be Claude Cahun's object 'Coup d'Oeil', which, as Steven Harris describes, makes use of imagery and language related to the cause of producing a revolutionary popular front, despite having been made for an exhibition of Surrealist objects outside the bounds of Contre-Attaque. S. Harris, 'Coup d'Oeil'.

45. Simon Dell has recently written on the manipulation of images of workers during the general strikes which occurred following the victory of the Popular Front in 1936 (and therefore after the collapse of Contre-Attaque). S. Dell, 'Festival and Revolution: the Popular Front in France and the press coverage of the strikes of 1936', *Art History*, Vol. 23, No. 4, November 2000, pp. 599–621.

46. 'Popular Front in the Street' was given as a speech on 24 November 1935, and appears in translation in Bataille, *Visions of Excess*, pp. 161–8. This extract is from p. 163 of that edition.

47. See 'La Grande Actualité Poétique', *Minotaure* 6, 1934, pp. 61–2.

48. Ibid., p. 62.

49. 'Exhibition of Surrealist Objects', galerie Charles Ratton, Paris, 1936; for a series of photographs of the installation see D. Ades, *Dada and Surrealism Reviewed*, London, 1978, p. 322. There was also a second exhibition including Surrealist objects in 1936 at the galerie Pierre Colle. Breton used an installation photograph from this exhibition to illustrate a later edition of his text, 'The crisis of the object', A. Breton, *Le Surréalisme et la Peinture, Nouvelle edition revue et corrigée*, Paris, 1965.

50. *Cahiers d'Art*, May 1936; *Minotaure* 7, June 1935 and 8, 1936; A. Breton, *L'amour fou*, Paris, 1937.

51. That is, Breton would follow a politics of poetry that permitted him the lassitude to work with Leon Trotsky and Diego Rivera on the 1938 manifesto 'Towards a Free Revolutionary Art', maintaining his position as a poet first and foremost; and changing the context, rather than the content of his literary work.

52. As an indication of the continuities between Bataille's plans for Contre-Attaque and his later agenda for the Collège de Sociologie see the projected publications described in 1935 as 'Cahiers de Contre-Attaque'. The abstracts of these planned essays, which were never completed, are reproduced in Nadeau, *Histoire du Surréalisme II*, pp. 321–30.

53. See for example, the flea-market search and 'woman's glove' in *Nadja*, Paris, 1928, and his *Objet à fonctionnement symbolique*, 1931.

54. A. Breton, 'Situation Surréaliste de l'objet – Situation de l'objet Surréaliste', in Breton, *Position Politique du Surréalisme*, Paris, 1971, pp. 87–120.

55. A. Breton, 'Crise de l'objet', *Cahiers d'Art*, May 1936 and *Le Surréalisme et la Peinture*, Paris, 1965, pp. 275–81.

56. A. Breton, *Mad Love*, trans. M.-A. Caws, Nebraska, 1987, pp. 27–31.

57. A. Breton, 'Equation de l'objet trouvé', *Documents 34 Intervention Surréaliste*, Bruxelles, 1934, pp. 16–24.

58. It is worth noting that 'Surrealist situation of the object – situation of the Surrealist object' also forms part of an explicitly political publication, having been included in Breton's 1935 book, *The Political Position of Surrealism*.

59. See for example, 'L'action immediate', pp. 01–04, signed by the Belgian Surrealist group, 'Vive la grève générale!', p. 06, signed by an A–Z of 84 Paris-based intellectuals, many evidently from outside the Surrealist group, also 'Enquête sur l'unité d'action', pp. 6–8.

60. M. Heine, 'Hommage', pp. 26–7; R. Crevel, 'Tandis que la pointolle se vulcanise la baudriche', pp. 39–43; L. Scutenaire, 'Le Pêle-Mêle de Scutenaire', p. 50 and 'La Justice Immanente', p. 51. It is striking that although orthodox in terms of the types of contribution made, many of the poems, texts and images contained in *Documents 34* relate directly or indirectly to issues of political action. For a more detailed discussion of Scutenaire's collage and the Surrealists' political rehabilitation of Sade, see S. Baker, 'The Unacceptable face of the French Revolution', *Object* 2, London, 1999, pp. 5–27.

61. A. Breton, 'Communication relative au hazard objectif', *Documents 34*, p. 78.

62. As Marguerite Bonnet notes, Breton's original plan was to publish *Nadja*, *Communicating Vessels* and *Mad Love* together as a single volume. A. Breton, *Oeuvres Complètes*, vol. 1, Paris, 1988, p. 1560.

63. Breton, *Mad Love*, '2nd P.S. (1936)', pp. 37–8.

64. Ibid., p. 38.

65. Ibid.

66. Alex Potts describes the Surrealist object as a 'contradiction in terms' precisely because, as he points out, there is a process of viewing and response involved. I am suggesting that so-called 'found' objects exemplify this process, rather than constitute an exception to it. A. Potts, *The Sculptural Imagination: Figurative, Modernist, Minimalist*, New Haven and London, 2000, p. 118.

67. R. Desnos and J.A. Boiffard, 'Pygmalion et le Sphinx', *Documents* 1, 1930, pp. 33–40. See also, D. Ades, 'Photography and the Surrealist text', in D. Ades, R. Krauss and J. Livingstone, *L'amour fou*, London, 1986.

68. See D. Ades, *Dada and Surrealism Reviewed*, London, 1978, p. 322 for a series of these installation shots. The tendency is nowhere more evident than on the wall of Breton's study, which has been 'preserved' and is permanently exhibited in the Pompidou Centre in Paris. This change in register is also described by Briony Fer in her essay 'Surrealism, Myth, Psychoanalysis', in B. Fer, D. Batchelor and P. Wood, *Realism, Rationalism, Surrealism*, New Haven and London, 1993, pp. 221–2.

69. Steven Harris refers to the influence of Man Ray's photographs of assembled objects on the object produced by Claude Cahun for the 1936 exhibition; Harris, 'Coup d'Oeil', pp. 102–3.

70. Krauss makes this point with reference to Breton's collage self-portrait, 'L'écriture Automatique', in the catalogue, *L'amour fou*, p. 25.

71. Brassaï, 'Sculptures Involontaires', *Minotaure* 3–4, Paris, 1933.

72. 'La photographie, en mécanisant à l'extrême le mode plastique de représentation, devait lui porter par ailleurs un coup decisive.' Breton, 'Situation Surréaliste de l'Objet', p. 111.

73. 'Or, dans la période moderne, la peinture, par exemple, jusqu'à ces dernières années, s'était presque uniquement préoccupée d'exprimer les rapports manifestes qui existent entre la perception extérieure et le *moi*. L'expression de cette relation s'est montrée de moins en moins suffisante, de plus en plus décevante au fur et à mesure que, tournant en rond sur elle-même, il lui devenait plus interdit de pretender chez l'homme à l'élargissement, plus encore par definition à l'approfondissement du système "perception-conscience".' Breton, 'Situation Surréaliste de l'Objet', pp. 110–11.

74. Ibid.; see footnote 1, p. 110, where Breton gives the following definition: '"Fidélisme: doctrine substintuant la foi à la science ou, par extension, attribuant à la foi une certaine importance." (Lenine).'

75. 'En art, la recherche nécessairement de plus en plus systématique de ces sensations travaille à l'abolition du *moi* dans le soi, s'éfforce par suite de faire prédominer de plus en plus nettement le principe du plaisir sur le principe de réalité. Elle tend à abattre la barrière qui se dresse devant l'homme civilisé, barrière qu'ignorent le primitif et l'enfant.' Breton, 'Situation Surréaliste de l'Objet', p. 112.

76. Once again, Steven Harris's reading of Claude Cahun's *Object* in his article 'Coup d'Oeil' is helpful here. Harris evokes Breton's notion of 'unchaining' to describe the effect of the production of objects: 'the mind-destroying chain', Harris says, 'will be broken by a disalienated *practice* (the manufacture of objects) and by the poetic mode of thought that is realized in such a practice.' Harris, 'Coup d'Oeil', p. 108.

77. This idea relates directly to an earlier text for *Minotaure*, in which Breton discusses the political effectiveness of poetry. In 'La Grande Actualité Poétique', Breton questions both the meaning of, and the means of achieving, the Marxist goal, 'plus de conscience'. *Minotaure* 6, December 1934, pp. 61–2.

78. Freud, 'Group Psychology', p. 116.

3

Judd's badge

Tim Martin

The romance had shifted ground. The otherwise romantic, elusive uncertainty now seemed tragic.[1]

By 1966 Donald Judd's sculpture and writing were fairly well known. His 1965 essay 'Specific Objects', numerous exhibitions and his renowned self-confidence had secured him a place in an otherwise precarious art world. 'Specific Objects' is an essay of memorable power and persuasion, a concentrated rebuttal of the tacit representationalism of Abstract Expressionism in sculpture – ideas that were strong in themselves. The essay was a way of pushing aside critics such as Clement Greenberg and Michael Fried by exposing their full programme, and of clearing a space for his own conception of sculpture. Judd's strong sense of self-legitimacy drew on his dual position as critic and sculptor. He knew something the critics didn't, and without naming his knowledge, he used it to stunning effect. Highly observational and slowly descriptive, Judd wasn't a swaggering Abstract Expressionist in his demeanour or in his sculpture. His strength was dry, calculated and decisive in calling for powerful, even aggressive work.

Despite his multiple advantages as critic and artist, Judd was in a position from which he could not fully write about his own work. 'Specific Objects' makes no mention of his own work, and it concludes with the curious postscript that, 'The editor, not I, included the photograph of my work'.[2] Judd could impress his full critical focus only on the work of other artists, especially those of whom he approved. In speaking about his own work, reticence was absolutely required by the propriety of his rules, rules that barred any note of self-expression or self-publicity. Judd could, however, encourage others to write about his work. When Judd's closest friend and colleague Dan Flavin mentioned a writerly sculptor named Robert Smithson, Judd became curious. Shortly after, Smithson and Judd met. The sequence of

events that followed is a little-known story of the crossing of paths of two substantial writer–sculptors. It is a story of two essays, a badge, and a deathbed revelation.

The story starts when Judd and Smithson first met in late 1965, after 'Specific Objects' had been written. Judd was ten years older and by far the more successful. He was already, along with Robert Morris, a central figure in Minimalism. Although Smithson had been a moderately successful painter in 1961, he had come to sculpture only in 1964.[3] When Smithson met Judd he was 27 years old and showing work in lesser-known experimental venues like Dan Graham's Daniels Gallery rather than the blue-chip Leo Castelli Gallery. If Smithson had a loquacious, equal rapport with Dan Flavin (they shared a past involvement in Catholicism), he was more passive with Judd. Smithson listened and Judd spoke, curious to hear about what made Judd so powerful, so successful in negotiating male anxiety. This kind of listening and looking, being the ear and eye of the analyst, was not new to Smithson, who had already made many collage drawings that unpacked the repressed libidinous aspects of other artists' work.[4]

The two artists discovered a shared interest in geology and maps, and it seems their initial meetings were convivial. The more Smithson listened, the longer they talked about literature and philosophy. If Judd frowned at Smithson's capacity to be metaphysical, it was redeemed by his impressive knowledge of physics, materials, crystals, optics and linguistics which he delivered with considerable skill, theatricality and philosophical elaboration.[5] In between, they shared notes on the latest paint technology, both enjoying the new range of acrylic-alkyd and zinc fleck paint effects developed for motorcycles and hot rods.

Robert Smithson

A few months into the friendship, Smithson wrote an essay about Judd's work called 'Untitled'. It may have been unsolicited, but it suited Judd's need for a catalogue essay for an exhibition called '7 Sculptors' in Philadelphia (1965–6).[6] This intense but jumbled draft never reached publication. Judd disliked it and asked Smithson to try again, and an entirely different essay by Smithson eventually went into the catalogue.[7] Over the next several months Smithson and Judd continued to meet, and on one occasion (April 1966) Smithson brought his wife to a dance performance in which Judd's wife appeared. Several days later the two couples got together for a car trip to look for crystals in nearby New Jersey quarries. Both men had married fairly recently: Judd to Julie Finch in 1964 and Smithson to Nancy Holt in 1963.

According to Smithson's published account of the trip in 'The Crystal

Land' there was a consciously gendered role-playing. In the speaking and listening of the previous months Judd had taken a more active 'masculine' role and Smithson a more passive 'feminine' listening role; now they were both the husbands of their wives. Together they assuaged the anxiety of their wives, posed by quarry walls that were so cracked and precarious they threatened to fall, until they agreed that the risks of walking in the quarry were worth the experience afforded by the deeply excavated spaces. For an hour 'Don' and 'Bob' did some male bonding by banging incessantly at a lump of lava with hammers and chisels, while Julie and Nancy 'wandered aimlessly around the quarry picking up sticks, leaves and odd stones'.[8] 'The men were men', but uncompetitive and unanxious in the presence of their wives. Only the men walked to the top of the escarpment. At the top with Judd, Smithson spoke of a revelation. Looking down into the quarry and then across to New York City in the distance, Smithson could see the crystalline nature of the earth repeated in the architecture of the city, as if they were both the product of a single mind.

As it happened, Smithson's reputation rose sharply in the months after this trip. He was now included in shows of Minimal art and over the summer he published several well-received magazine articles on Judd and other Minimalists. After years of struggling, Smithson's writing had matured very rapidly, such that his articles were more fluid and readable than Judd's empirical descriptions and Hemmingway-like dryness. Though highly informative and possessing their own merits, Smithson's magazine articles such as 'Entropy and the New Monuments' misrepresented quite a few artists, including Judd.[9] In his attempts to capture a *Zeitgeist* Smithson tended to ascribe motives and interests to artists that they did not recognise as their own. By September of 1966 Smithson was organising an exhibition at the Dwan Gallery, inviting Judd, Morris, Flavin, Andre, LeWitt and Ad Reinhardt among others to take part. Gathering in Virginia Dwan's apartment, the artists rejected Smithson's attempt, in a draft press release, to summarise their ostensibly collective interests. Already irritated by Smithson's draft essay 'Untitled', and the subsequent magazine articles about his work, Judd reacted negatively and aggressively. As a result Judd had some badges made up for the opening of the Dwan exhibition that read 'Robert Smithson is not my spokesman', and gave one to Dan Flavin. It was an awkward moment for Smithson, a public distancing that took place at very close range. Anyone, including Smithson, who spoke to Judd that evening could not have failed to notice. Just in case they did, Judd repeated the comment in a one-line letter to the editor of *Arts Magazine* (Figure 3.1).[10]

In considering Judd's badge, obvious issues of self-interest and competition are clear enough. The two men were both 'A' list artists: experienced, powerful and persuasive. Just in this short time Smithson had

ture: Where Are We?, (See this page. Ed.) Cold Spring, N.Y.
...erstand that you
...at heavily To the Editor:
...l ideas; Smithson isn't my spokesman.
hymn
...your DON JUDD
New York City

To the Editor:
...oncerning Jeanne Siegel's review of my
...ow (ARTS, Dec./Jan.). I am not "the
...okesman for the so-called minimal
...ulptors (Judd, Morris, Flavin, LeWitt)."
...The article Jeanne Siegel mentions in her
43. ...review (*Entropy and the New Monu-*
FLAVIN ...ments, Art Forum, June 1966) was a de-
ring, N.Y. scription of my own experience of their
art and in no way a manifesto.
Artists, especially those mentioned
above, do not need a "spokesman."
ROBERT SMITHSON
ed" titles. New York City

3.1 Letter from Donald Judd to the Editor, *Arts Magazine*, February 1967, and toy car

secured his position in the art world in part with the kudos of writing about Judd. Judd, in turn, just wanted Smithson to stop projecting his own ideas onto his specific objects, and the request was largely obliged. Virginia Dwan recalls that Judd's badge was a matter of jealousy, but this comment remains at the level of obvious self-interests.[11] Though Judd may have wanted to be the spokesman, he was quite accustomed to being misrepresented, so what was so special about silencing Smithson?

Donald Judd could be aggressive on occasion, and after a year he turned on Smithson in a way that ended their friendship and weakened the whole Minimalist circle. I would suggest, however, that Judd had the badge made up not so much because Smithson was misrepresenting him, but because Smithson came rather too close to figuring out a riddle in Judd's identity and desire. Yet if Smithson was not Judd's spokesman, it remains to be seen whether his passivity had been a way of taking the position of the psychoanalyst. Such an unrequested analysis would have made Judd feel uncomfortable, especially given that Judd had no consistent interest in psychology, phenomenology or psychoanalysis other than the empiricist's

questioning of how observation led to cognition. Smithson, on the other hand, had substantial interests in Freud and Jung, and by 1967, Anton Ehrenzweig.[12]

Judd's writings are famously self-confident. Judd, and Minimalism in general, have been over-characterised as replicating 'Money, the Phallus and the Concept as privileged operators of meaning … the face of capital, the face of authority, the face of the father'.[13] Certainly, Judd's early writings emphasised powerful objects rather than the disembodied optical aestheticism of Fried. Judd's masculine identity, when capable of neurosis, was by many accounts more on the obsessional side. But this was not as impressive to Smithson as the *absence* of anxiety in Judd's writing, sculpture and personality. Smithson was fascinated by Judd's contrasts, where, in the words of Alex Potts, 'strict formal analysis coexists with odd passages that are intensely sexual'.[14] Smithson knew well enough that Judd's identity did not manifest itself in the old cliché of sculpture-as-phallus. Judd's solution was not Rodin's solution, as in the erective monument to Balzac. But what was it?

Just at this time Rosalind Krauss was also beginning to suspect that there was something in Judd's work that was not accounted for in his writings. Quoting Merleau-Ponty, Krauss saw that 'the sculpture can be sensed only in terms of its present coming into being as an object given in the imperious unity, the presence, the insurpassable plentitude which is for us the definition of the real'.[15] Hers was an insightful comment, but it did not threaten Judd. Smithson, however, started getting too close for Judd's comfort when he observed, 'In Judd's "Specific Objects", one detects a dissatisfaction with the problem of space'.[16] Krauss was still looking merely at the objects, whereas Smithson was already looking at space for the secret of Judd's identity and desire.

If Smithson was fascinated by Judd's lack of anxiety, it begs the question 'what anxieties?' Was Judd's ego proofed against anxiety from the external world, from castration, or death? Did Judd's desire and identity fascinate Smithson because it was so professionally successful, so resistantly phallic, or because his phallic strength could thwart Thanatos with Eros? Some answers can be found in Smithson's essays.

In 'Untitled' and 'Donald Judd' Smithson started by representing Judd's sculptures in terms of his own fascination with the molecular structure of inorganic matter. Judd's rectilinear boxes were indicative of the architecture of crystalline matter. But they were also, for Smithson, models of the mind, or what he called 'the inorganic matrix of the mind'. Judd's mind was hard and inorganic, and so too were his sculptures. 'His crystalline state of mind is far removed from the organic floods of "action painting". He translates his concepts into artifices of fact, without any illusionistic representations'. This

insight extended to included space, which belonged to 'an order of increasing hardness not unlike geological formations. He has put space down in the form of deposits. Such deposits come from his mind rather than from nature'.[17]

Smithson intended to pay Judd a substantial if unusual compliment. Judd wasn't an anal-expulsive emotive artist who simply recorded conscious feelings; he was emotionally cool and distanced in his ability to observe the world and himself. Because of an acute awareness of the space between his ego and his sensations he was able to observe the ways in which his sense-perceptions of the world turned into cognition.[18] Judd may have appeared to be empirical in his philosophy, Smithson remarked, but 'For Judd subjectivity is the guarantee of objectivity because it is something more than a mere correlation. Indifference to realism and idealism is evident in this "phenomenology of perception"'. Judd, like the phenomenologist, put the observer before the observed in order to model this observing ego in his sculptures.

Between the two essays by Smithson there are two important revelations, the first of which is consistent with the phenomenological theory he was reading at the time.[19] First, Smithson claimed that Judd's sculptures were more than just objects that provided sense-perceptions. The perceptions they provided were rather fragmented and incomplete. What unified these fragments was the ego, and the search for unified forms in Judd's sculptures was a declaration of the unity and clarity of the ego. The sculptures, in effect, modelled the wholeness and segmentarity of the ego, the part of the mind that made sense of raw perception, and controlled his decisions and actions in the world.

Smithson was fairly consistent with the phenomenological theory (Husserl) that he quoted in 'Untitled' in claiming that the ego was structurally defined as much by its spatial and temporal qualities as by its object qualities. The specific object allowed Judd to describe a type of phenomenological consciousness, a subject-ego that could objectively observe itself. For Smithson it involved a process whereby 'The mind reconstructs "a sight" that "looks" at another sight, while diminishing any spatial idea'. Judd's sculptures made the spectator highly aware of their ego, in effect by modelling it with quite hollow forms in an enclosed room. In Smithson's encounter with them, they were metaphysical and phenomenological self-portraits not unlike his own sculpture *Enantiomorphic Chambers* (1965) (Figure 3.2).

If one accepts Smithson's claim that Judd's sculptures allow the ego to see the ego, then what remains is Smithson's observation that it remained a happy experience for Judd. 'Judd cheerfully accepts the most dangerous mental dualisms'.[20] Partly the cheerfulness arose, Smithson thought, because

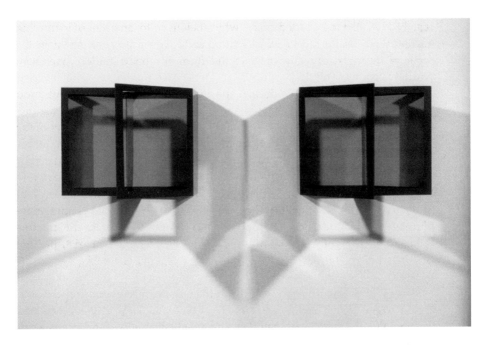

3.2 Robert Smithson, *Enantiomorphic Chambers*, painted steel, mirrors, 2 chambers, 1965

Judd blocked out the deepest areas of the unconscious and the depth of outdoor space. 'The unconscious has no place in his art', and its counterpart in the far horizon was always removed by being placed indoors. In 'Untitled' and 'Donald Judd' Smithson marked out Judd's comfort zone. Judd's levels of anxiety were low because his ego extended only within limited mental space. Judd's hollow forms had the effect of hardening space in much the same way as the ego hardened a part of mental space.

Smithson, on the other hand, rather relished the dramatic anxieties produced by the infinite extension of internal and external space, and the quelling of his discomfort through what he called 'entropy'.[21] What Smithson therefore found curious and indicative of Judd's sculptures was that they were first models of identity and that the most important part of the model was the limited but 'hard' space of the ego. Smithson noted this in Judd's writings too, where a hard ego sat apart from external and mental objects, giving words to describe the objects as they came under its gaze.

But Smithson never tired of suggesting that Judd's cognitive and decision-making ego was in thrall to something deeper. Smithson's second revelation was less phenomenological and more psychoanalytic. The sculptures

revealed a 'feverish arithmetic' that arose from something that lived, uncontrolled, inside Judd's mind. Within Judd there was an id not unlike a mathematician, which came out in the sculptures whether Judd consciously noticed it or not. This id produced 'an ineffectual, intolerable, and feverish arithmetic [that] makes this object "specific"'. Judd may have excluded the space of the unconscious from his work, but that did not stop a part of his nature that was impersonal, inorganic and subject to natural laws from coming out. The laws that Judd's id produced, as Smithson revealed to him on the quarry escarpment, spoke in the feverish language of mathematics that governed crystalline formations, the architectural constructions of New York City, the housing estates of New Jersey, and the specific object alike. This 'something' in him that lived through him was a widely shared unconscious, more ubiquitous than even Jung's 'collective unconscious'. This 'it' was not an amorphous organic libidinous urge, but a calculator of precise equations such as $1 - \frac{1}{2} + \frac{1}{3} - \frac{1}{4} + \frac{1}{5} - \frac{1}{6} + \frac{1}{7} - \frac{1}{8} + \frac{1}{9} - \frac{1}{10}$.[22]

Smithson's second revelation was a more subtle one, and it bore on the use of space in a different way. Whereas Smithson's sculptures induced anxiety in order to quell it, Judd's sculptures produced a feeling of melancholy. 'Points of fixation are struck on the different planes of the object. A general enervation weakens the specific attention span. Infinite melancholy results'.[23] The point of melancholy is that it does not let you forget something, an object, a very 'specific object' that has somehow been lost. Judd's sculptures may have modelled the space of the ego, but they were also surrogates of a lost love object. Smithson was closer to his reading of Freud's explanation of the male ego. Male narcissism can lead to melancholy because it features a process in which a love object, or object-cathexis, is replaced by an object identification (Figure 3.3).[24]

Clarifying issues of space in the structural identity of the ego helped Smithson come back to questions about desire. In observing that Judd's sculptures produced melancholy and were mask-like, what Smithson guessed at was that the sculptures were the product of a very typical male shift from object-cathexis to object identification. More recent critics have commented on this too. For example, Briony Fer's observation that Judd's specific objects are obsessional objects, love objects of the libidinous id, might be added to David Batchelor's observation that Judd's sculptures look like cars.[25] What Fer and Batchelor each suggest in their own way is that the sculptures are psychically motivated – to which Smithson would add: because they allude to a lost love object.

For Freud, the process of male ego maturation occurs when the id's erotic object-choices are brought under control by the ego. The ego performs this by first taking the object away and then assuming the features of the love object. 'When the ego assumes the features of the object, it is forcing itself, so to

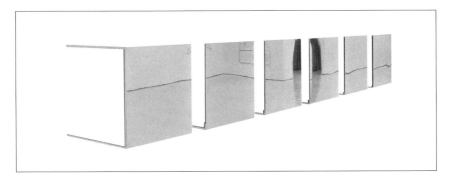

3.3 Donald Judd, *Untitled*, 6 units, each 86.4 × 86.4 × 86.4 cm, brass and red fluorescent plexiglas, 1973

speak, upon the id as a love object and is trying to make good the id's loss by saying: "Look, you can love me too – I am so like the object'".[26] To give a very simple example, it is like the three-year-old boy who, upon losing his favourite toy car, responds to the anxiety by becoming the car and motoring around as if he were the car. The id's object-cathexis is thus taken under control by the ego by making itself into a car, or at least those parts of the car that are libido causing, i.e. the sound, the movement, the shiny paint, the variety of interior spaces, and the translucency of the glass. This is why Smithson listed in detail the chemical contents of the paints he and Judd used in 1966. Thus, for Smithson, specific objects produced a sensation of 'an inaccessible regression [that] enforces a danger-stimulus, to which *no* reaction is appropriate'. Although the object-choice itself regresses to infinity (it's gone), no anxiety results because, as models of the ego, Judd's sculptures retain some of its features.

Freud suggests that the shift from object-cathexis to identification is probably the 'universal road to sublimation' and the very mechanism of male narcissism. This may be why Judd's work seems much more sublimated than the work of John Chamberlain, whom Judd so admired. Chamberlain was closer to the obsessive in that he cut up real cars; coming under attack from the super-ego, the id renounces the object, with a reprieve granted by the ego, which recomposed them into flowering, phallic objects.

The second revelation that Smithson was pressing toward was that Judd did not represent the love objects of the id; he represented the ego masquerading as the love object. As Smithson put it in 'Untitled', 'the basic or absolute abstraction is never revealed to the viewer, and its apparent completeness is a mask. It will be impossible to give any idea of such a mask, for it reveals no obvious features'. Smithson's intuition of a masquerade was,

in the Freudian terms he tended to use, very close to the mark. And it may be why, as Krauss suggested, the work was so surprisingly seductive, such an imperious unity, a presence of such insurpassable plentitude. The nice shiny colours and spaces were sublimated references to the object-choices of the id, and in this way managed to trigger the spectator's own erotic drives.

What, though, of Smithson's revelation that Judd's sculpture maintained a sublimated trace of a desire for certain kinds of space? Freud always suggested that objects were the basis of the shift from cathexis to identification. But Freud also claimed that differences in individual character were due to the fact that object-cathexis could be highly varied and unpredictable, noting that 'the character of the ego is a precipitate of abandoned object-cathexes and that it contains the history of these object choices'. There is room in Freud's theory to assume the existence of a 'space-cathexis'.

Smithson's analysis is not easy to follow because he tended to jumble together his two claims about the structural identity of the ego and his understanding of Judd's object and space-cathexis. To have fully unpacked his analysis would have damaged the aura of the work. He had listened enough to know that Judd was not just thinking in terms of materials and colours of objects; he was thinking just as much or more about space. And without understanding how space worked in the structuring of the psyche and in its transition from id-cathexis to ego-identification, Judd's secret to male anxiety remained opaque. Smithson caught on to this partly because he too used space ('the void') as a factor in the structural analysis of the ego, though in a more hysterical way.[27] Just as Smithson was getting close, Judd made his badge.

Smithson's published and unpublished writings on Judd suggested a direction for an analysis that might be extended and applied, and of all Judd's writings no text fits this analysis better than his last essay, where the charge of libido is moderated by a contemplation of identity in death. Learning in November 1993 that he had only several months to live (he died in February 1994), he wrote 'Some Aspects of Colour in General and Red and Black in Particular'. Judd's last essay was prepared for the occasion of an award for his accomplishments in the use of colour, but it opens with an extended critique of the ways in which space is ignored.

There has been almost no discussion of space in art, nor in the present. The most important and developed aspect of present art is unknown. This concern, my main concern, has no history. There is no context; there are no terms; there are not any theories. There is only the visible work invisible. Space is made by an artist or architect; it is not found and packaged. It is made by thought.[28]

In these remarks, Smithson's claims still hold validity. Judd wasn't an empiricist; he was a particular kind of phenomenologist. His ego had

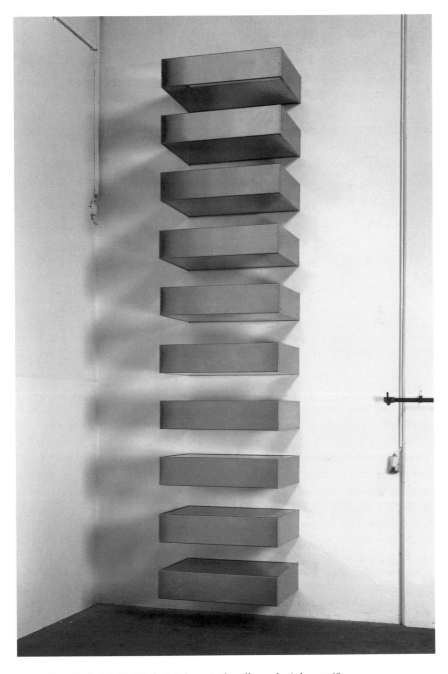

3.4 Donald Judd, *Untitled*, stainless steel, yellow plexiglas, 1968

observed itself as a specific, 'hardened' space, separate from the flows of perception and cognition. Judd had realised that the ego makes itself through a gapping in mental space, and that it also then takes pleasure in doing this in analogous ways in the world, through sculpture and architecture (Figure 3.4).

Later in the same essay Judd makes a quip that would resonate with Smithson's observations about melancholy and object-cathexis. As Judd remarked, 'most people don't miss real space and don't desire it'. As a consequence most people do not take advantage of the anxiety-reducing power and enjoyment of the spatial conflation which takes place in the shift from cathexis to identity.

Judd's comments can be further interpreted in accord with Smithson's claims. Later in the same essay Judd's melancholy surfaces as he identifies himself with immobilised vehicles, a locomotive without tracks and a car that cannot move. He then moves directly to speak of how his enjoyment of space factored into the making of his work. He gives a detailed account of his compositional thinking using an early example, *Untitled* (1962) (Figure 3.5):

There is scarcely an inside and an outside, only the space within the angle and the space beyond the angle. The only enclosed space is inside the pipe. This slight linear space determines the dimensions of the broad planes. The shell of this narrow space passes through the breadth of the inner angle, a definite space through a general space.[29]

Judd's remarks describe a sculpture that has been organised almost exclusively as a pretext for creating types of space. But why, if we just take Smithson's sense of a space-cathexis at work in Judd's sculptures, might such a desire enable him to enjoy an indemnity from a good deal of male anxiety? Speculating within standard Freudian theory, it would seem that space can't easily be castrated, destroyed or lost. In Freudian terms the super-ego and its ego ideal cannot castrate the id's object-choices because the object-cathexis is as much a spatiality as it is an object.[30] Smithson's initial analysis, if pushed a little further in its Freudian theory, then, can lead to the conclusion that Judd's confidence may have arisen from a particularly spatial solution to some types of male anxiety.

Smithson's phenomenological and Freudian interpretations remain just two of many possible readings. The best moments in Smithson's writings on Judd come when he opts to read Judd's early sculptures as a riddle of identity and desire, interpreting Judd's sculpture as a phenomenological model of the ego *and* as an example of a sublimation of an object-choice. This has parallels too with Krauss's analysis of allusion and illusion in the work. For Smithson the interminable riddle of Judd's identity and desire was his cheerfulness in the face of a 'dangerous dualism'. Space was desire-causing, it needed to be

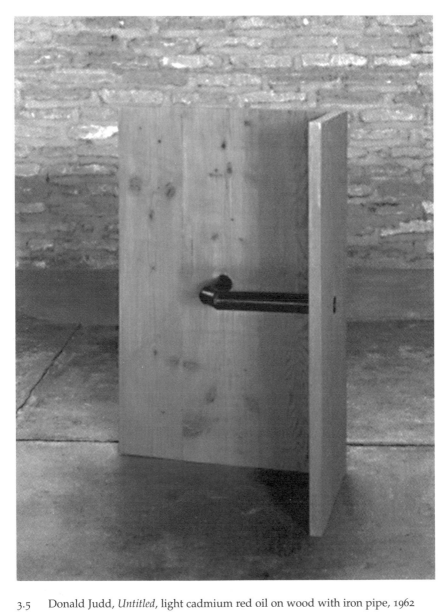

3.5 Donald Judd, *Untitled*, light cadmium red oil on wood with iron pipe, 1962

made in sculpture with the assertive confidence of a strong ego able to jump the space between cathexis and identification, while cheerfully accepting that the ego itself was the product of a gap, fold or void in mental space.

Through the combined lens of phenomenology and psychoanalysis, Judd's sculptures looked to Smithson like mechanical devices that demonstrated that the specificity of desire and the general structure of identity cannot be separated; they transition into each other. As Smithson sensed in Freudian terms, Judd's success in the world came from a strong male ego: his was a desire built on very specific and powerful cathexes and identifications. But the specificities of desire were also locked into a general and perennial structure of identity in which the self-destructiveness of the death instinct and the object-choices of the id must be held together. Judd performed this through the 'imperious unity' of the object and the 'insurpassable plentitude' of its space.

Finally, though, what of the badge? In 1966 Smithson came rather close to revealing Judd's solution to male anxiety, but there was ultimately no firm bond of friendship between them, particularly on Judd's part. So Donald Judd's badge was a breaking of a romance rather than a matter of jealousy. If Smithson was Judd's analyst, there was a failure of transference: the analysand didn't cathect with the analyst. Smithson was attracted to the riddle of Judd's identity and desire, but he did not seduce Judd's id sufficiently to allow the secret to come out. Krauss and Smithson did much to address Judd's identity through phenomenology, but only Smithson applied psychoanalytic literature to draw close to Judd's specific object-cathexis and its solution to male anxiety and desire. Judd rebuffed Smithson because he did not want his psychical life to be revealed, especially in the pages of the art magazines. The outcome of Smithson's limited analysis was a badge. But the consequences for American culture are, in some respects, quite considerable. Land art and Conceptual art formed out of the resulting weakness of Minimalism. Judd's badge announced a decline in Minimalism, and although there is a period of ambiguity immediately after the Dwan exhibition, it eventually leads to a realignment in American culture around very differently structured debates.

Notes

1. Taina Rikala, 'Catherine Bauer and Six Riddles of Modernism', *Journal of Architecture*, Vol. 7, Summer 2002.

2. Donald Judd, 'Specific Objects', *Complete Writings 1959–1975*, Halifax, Nova Scotia, 1975.

3. Smithson attended the Art Student's League while in high school and his first career as a painter included expressionist and intensely religious icons based on the Catholicism of T.S. Eliot and T.E. Hulme.

4. Works by Smithson from 1963 such as *Untitled (Classical Head)* and *Untitled (Hexagonal Center)* typically placed images of sculpture and painting in the center of the image and elaborated on their repressed sexual meanings in the frame.

5. Smithson did not attend university, but worked in a bookshop and read widely among the humanities and sciences.

6. Robert Smithson, 'Untitled', Smithson Archives, Archives of American Art, Smithsonian Institute, roll 3834, frame 687–95.

7. Robert Smithson, 'Donald Judd', *7 Sculptors*, Philadelphia Institute of Contemporary Art Catalogue, 3 December 1965 to 17 January 1966. Reprinted in *Robert Smithson: The Collected Writings*, ed. Jack Flam, Berkeley and San Francisco, 1996, pp. 4–6.

8. Robert Smithson, 'The Crystal Land', *Harper's Bazaar*, May 1966, reprinted in *Robert Smithson: The Collected Writings*, p. 8.

9. Robert Smithson, 'Entropy and the New Monuments', *Artforum*, June 1966.

10. Donald Judd, 'Letter to the Editor', *Arts Magazine*, February 1967, p. 8.

11. James Meyer, *Minimalism: Art and Polemics in the Sixties*, London and New Haven, 2001, p. 303.

12. In making sense of Judd's aggression Smithson had used a 1958 copy of Freud's *Civilisation and Its Discontents*.

13. Anna Chave, 'Minimalism and the Rhetoric of Power', *Arts Magazine*, January 1990, p. 51. Her triad is borrowed from Lyotard.

14. Alex Potts, *The Sculptural Imagination: Figurative, Modernist, Minimalist*, New Haven and London, 2000, p. 272.

15. Rosalind Krauss, 'Allusion and Illusion in Donald Judd', *Artforum*, May 1966, p. 24.

16. 'The Pathetic Fallacy in Esthetics' (1966), *Robert Smithson: The Collected Writings*, p. 338.

17. Robert Smithson, 'Donald Judd', p. 6.

18. In fact, Judd never espoused phenomenology, though he credited it as legitimate.

19. Smithson was reading phenomenological philosophy including Husserl and Heidegger, and an introduction to phenomenology by Marvin Farber, *The Aims of Phenomenology, The Motives, Methods and Impact of Husserl's Thought*, New York, 1966.

20. Robert Smithson, 'Untitled'.

21. For Smithson, space was constantly receding to infinity, making it nearly impossible for any object to fill it. His response was to build sculptures that allowed the eye to travel towards these vanishing points. *Enantiomorphic Chambers* (1965) and *Pointless Vanishing Points* (1968) are two examples.

22. This is a serial equation from L.B.W. Jolley, which Smithson correctly attributes as the basis of many of Judd's sculptures such as *Untitled*, 1966 (DSS/84).

23. Robert Smithson, 'Untitled'.

24. Sigmund Freud, 'The Ego and the Id', *The Freud Reader*, London, 1995, pp. 638–9. First published in 1923, this article is widely regarded as the decisive work of Freud's later years and the definitive statement of his structural theory of the mind. It was in fairly common usage by 1966.

25. David Batchelor, 'Everything as Colour', *Donald Judd*, London: Tate Gallery, 2004, p. 65. Briony Fer, 'Judd's Specific Objects', *On Abstract Art*, New Haven and London, 1997, p. 131.

26. Freud, 'The Ego and the Id', p. 639.

27. Smithson's *Enantiomorphic Chambers* (1965) can be regarded as a model of the psyche. See Tim Martin, 'Enantiomorphic Chambers', *Robert Smithson: Retrospective Works 1955–1973*, ed. Per Bj Boym, Oslo, Norway: National Museum of Contemporary Art, pp. 60–77.

28. Donald Judd, 'Some Aspects of Colour in General and Red and Black in Particular', in *Donald Judd*, ed. Nicholas Serota, London: Tate Publishing, 2004, p. 145.

29. Judd, 'Some Aspects of Colour in General', p. 148.

30. Freud, 'The Ego and the Id', p. 657.

MEANINGS OF ABSTRACTION

4

'Miss Hepworth's stone *is* a mother'

Anne M. Wagner

Barbara Hepworth began her autobiography where most autobiographies start, at the beginning. 'I was the firstborn', she wrote. As a statement of origins the phrase seems unexceptionable: it seeks no controversy, and brooks no denial. Yet however declarative, it is also clearly incomplete; it is only the beginning of the story, after all. I shall let Alan Bowness, writing in an introductory note to the most recent edition of the autobiography (he dated his contribution 'July 1993'), pick up the thread:

> Barbara began, but found she had neither time nor inclination to write a long text, and so the concept of a pictorial autobiography was born. She looked out some family photographs, but this made the book too personal for her tastes, so she asked me to help. I added the art historical material, and this helped to give the book a more rounded character – more work than life, which was what she wanted.[1]

If 'more work than life' *is* what Hepworth wanted, she has got it, yet Hepworth studies have paid a certain price for that art-historical rounding out. Let me try to explain what I mean. The *Pictorial Autobiography* does make a special, perhaps unprecedented, mix between two modes. Photographs of the artist and her dogs, cats, babies, studios, spouses and friends are there flanked by sculptures and texts and documents, with that second set of images – the sculptures and texts and documents – acting as a kind of art-historical leaven: they are the ingredients of a 'profession', as supplied by a professional, after all. And while there are connections among the various images, the looseness – the banality – of the main organising principle seems to function to keep the personal rather firmly under control. It is never more than an image, a way-station on a smooth route from life to work. On one page is the artist with her tools, on the next a photograph of a sculpture: then that same photograph is shown being put to prompt use, illustrating the pages of a book or catalogue. Thus the sculptor's life and

work enter 'art' and 'art history'; it happened, we learn, with very little fuss or ado.

The logic of these illustrations seems, in its elisions, much like that of the too-brief written text. Take for example these phrases: 'This was a wonderfully happy time. My son Paul was born, and, with him in his cot, or on a rug at my feet, my carving developed and strengthened'.[2] What could be simpler? Read next to the photographs these phrases flank – illustrations entitled 'With son Paul' and 'Carving of *Infant*, Burmese wood' – they direct us to a happy and inevitable conclusion. The transition from the 'life' to 'art' domain is made easy through omission, and again the illustrations pick up the slack. We see that the infant Paul, whether tucked up in his crib or wriggling on his rug, was not just a talisman or tutelary deity; he was a subject for art, from which a small deity might be fashioned, fat legs, round head and all (Figure 4.1). But the context also insists that what the work stands for or means concerns only its role in the 'development' and 'strengthening' of Hepworth's art.

The odd and remarkable thing about Hepworth's reputation is that the *Pictorial Autobiography*, far from sparking speculation about the personal resonances of her art, seems to have forestalled it. This is 'self-curating' (as it is called nowadays) at its most efficient – though 'assisted self-curating' might actually be the better term. We continue to get 'more works than life': the two seem mostly to cohabit in criticism in a familiar, even conventional way. Stylistic changes and influences still sit cheek by jowl with the other circumstances of Hepworth's life, their deeper connections, like those among the photographs, still largely unexplored. The result is that while we may know something about the artist's trips to Happisburgh and Paris and St Rémy, or recognise that there is a question as to who first pierced the sculptural block, we know much less about what these events have to do with what or how her art might be said to mean in other than formal or narrowly historical terms.

In the light of this lacuna, it seems ironic that the *Autobiography* reprints, as visual objects in their own right, two texts – the only texts – which speak with some authority to suggest that her sculpture – or some of it, at least – can be seen to have meanings rather different in kind and scope. One is the brief foreword written by Herbert Read for the catalogue of her 1932 show at Arthur Tooth's. The other, a year later, was Adrian Stokes's review of her Lefevre Gallery show – certainly the most notorious review he wrote.[3]

Maybe once turned into pictures, Read's and Stokes's words seemed no longer to signify. But if they were to be given some credit as texts, I think that the balance between work and life would have to be totted up anew. While nothing could wipe clean our sense of these authors' real interest in Hepworth's formal revisions of her art – their conviction that her work

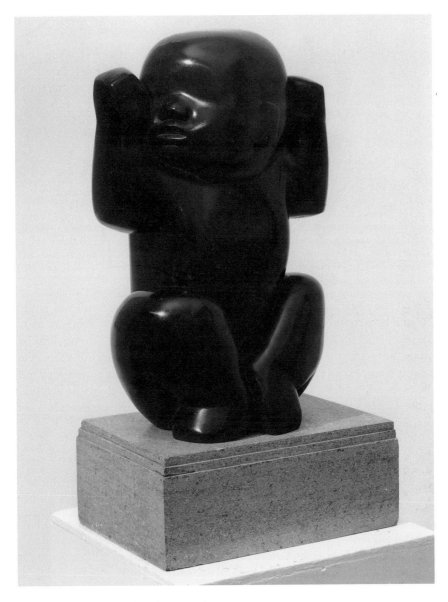

4.1 Barbara Hepworth, *Infant*, wood, 1929

demonstrated, to borrow Read's terms, the 'two essential principles of sculpture: the organisation of masses in expressive relation and the revelation of the potentialities of the sculptured material'[4] – interest or conviction alone is not a guarantee of particularly original thought. As Penelope Curtis has shown, this was the contemporary critic's catechism where new sculpture was concerned.[5] So let me cite Read a bit further to find a more venturesome thesis: 'Beyond these essentials', he continued 'so appealing to our immediate senses, there is a fantasy which should awaken subtler delight in the imagination and memory'. 'Should' here seems the operative word, for it quickly occurred to Read that the offer of fantasy might well not arouse in readers the anticipated sensation of 'subtler delight'. So he elaborated, bent on reassurance, though not quite succeeding:

> ... that some of Miss Hepworth's creative conceptions should recede into a symbolic world of abstractions is not a feature that should deter the disinterested spectator; art is a servant (and a redeeming sanction) in any sphere of the human spirit – and not least in this marginal world between consciousness and unconsciousness from which emerge strange images of universal appeal.[6]

Could the spectator, however impartial, feel much bucked up? We read a Read who betrays odd uncertainty about aspects of this art: above all about the way it seems to slip away from its vaunted immediacy – from sculptural materiality and the senses – to enter an elusive nether-world of abstraction and symbol, a realm somewhere on the psychic margin. The viewer may well be deterred, not least because Read's assertion of art's positive role in all this – the willingness and ability of its strange images to provide redemption and universal appeal – has to be taken mainly on faith.

Remember that Read is writing about abstract art, but not in the abstract. He is aiming to address the workings of Hepworth's art in 1932 – he was speaking of pieces like *Profile*, and *Two Heads*, two sculptures carved that year and visible in the Arthur Tooth show. As the author of a 1925 essay, 'Psychoanalysis and the Critic', he knew what his terms meant (by then he had read Freud, Jung and Adler, as well as Ernest Jones) and cannot have used them casually.[7] On the contrary, Read's usage is more purposeful than casual: he had long since put his faith in the sub-Freudian notion that, as he put it, 'the artist is initially by tendency a neurotic, but ... in becoming an artist he as it were escapes the ultimate fate of his tendency and through art finds his way back to reality'.[8] To grasp neurosis, Read followed an Adlerian adage: 'every neurosis can be understood as an attempt to free oneself from a feeling of inferiority in order to gain a feeling of superiority'.[9]

Such hybrid views became the main tenets of Read's notion of art as social therapy – meanwhile a catalogue puff was hardly the appropriate place for real analysis of Hepworth's neuroses, the 'marginal symbolic' world from

which art comes: surely this is one reason he made do with suggestions and generalities.

That another reading of Hepworth's work was once possible, however briefly, is further attested by the response of Adrian Stokes. 'Miss Hepworth's Carving' is still the single most suggestive piece of writing on Hepworth – so much so that I know I will not do it justice here.[10] I cannot hope, for a start, to make it emerge with much particularity as a piece of writing by Stokes – that is, with at least some of its protocols and commitments having been supplied by his emerging critical project, rather than by Hepworth's art. By this date Stokes had already begun, as he said, 'to write of stone', to 'exhibit stones the opposite of barren', and to find in carving the great organising principle of his aesthetic, to which modelling, its counterpart and sometime antithesis, would only ever play a subordinate role.[11] Carving would be paired in his mind with Melanie Klein's notion of the depressive position, in which the ego achieves a certainly measure of integration. By these lights the carver, to use Richard Wollheim's words, 'in respecting the integrity and the separateness of the stone, celebrates the whole object with which he characteristically enters into relation and also the integrated ego that he projects'.[12]

In 1933, however, Stokes was still in the early stages of his analysis with Klein, while Klein's own work had thus far concentrated on mapping the phases in the infant's fraught incorporation of a relationship to the maternal body, first as part, then as whole. By 1933, in other words, aesthetics and psychoanalysis had not yet been – could not have been – so sweepingly synthesised. Both are present in Stokes's essay, to be sure; it is just that they do not yet make a consistent theoretical whole.

To address Hepworth's carving in the singular – carving, not carvings – made of the term the principle of her art; it meant, for a start, that Stokes speaks only of 'stone shapes', ignoring her work in wood. And in those shapes, he senses a 'vast certainty' which stems from their evident belonging to a particular substance – they are stone-shapes, once again. In the rubbed form, however thinned and flattened, a deep and incontrovertible roundness can still be seen: an echo of nature, it is the note which, paradoxically, the subtractive work of the carver is able to sound. Carving, in other words, engineers through its absences a contradictory return to natural form and value, and embodies them to and for vision. 'The stone', Stokes wrote, 'through the medium of the figure, has come to life'.[13]

Life and birth and infancy were for Stokes 'the underlying subject' of Hepworth's art in 1933, as indeed they were, to his mind, where all great carving was concerned. In the case of Hepworth, he was clearly thinking most of the lost alabaster *Figure (Mother and Child)* (Figure 4.2). And I believe he was also thinking of Klein, whose work on the maternal imaginary had already begun. Consider this passage:

This is the child which the mother owns with all her weight, a child that is of the block yet separate, beyond her womb yet of her being. ... It is not a matter of a mother and child group represented in stone. Miss Hepworth's stone *is* a mother, her huge pebble its child. A man would have made the group more pointed: no man could have treated this composition with such a pure complacence.

Stokes's interpretative conviction is absolute and specialised; I say this in the knowledge that the reviews in *The Listener* and *The New Statesman and Nation* saw fit to mention neither mother nor child – even though in the former the selfsame group is actually reproduced.[14]

I do not think that either Hepworth or Stokes would have been long detained by the problems which arise when his description is backed up against another of his contemporary accounts of the carver, the block, and their progeny. For perhaps it now goes without saying that carving and modelling are gendered, in Stokes's lexicon, so as to echo another, more familiar order. 'Man, in his male aspect', Stokes wrote in *The Stones of Rimini* (in press in November 1933; the book appeared in January 1934),

is the cultivator or carver of woman who, in her female aspect, moulds her products as does the earth. We see both the ultimate distinction and the necessary interaction between carving and moulding in their widest senses. The stone block is female, the plastic figures that emerge from it are her children, the proof of the carver's love for the stone.[15]

The problem arises because while Hepworth was said to be a carver, she was also a woman – the risk was that she might only merit the modeller's rank.[16] Even though Hepworth herself was sure both that she carved and that she did so from a certain bodily compulsion, her unforgettable formula, 'A sculptor carves because he must', declares these convictions – and the paradox which results from their espousal.[17] Her urges as a carver could nevertheless not logically be thought to play the necessary fertilising role. Her 'love for the stone' would apparently demand parthenogenesis to get results; based on principles of similitude, rather than difference, it would be narcissistic at best. There might even be a certain auto-eroticism involved – though not according to Hepworth, I hasten to add. When asked why she went in for direct carving rather than modelling, she replied: 'I have always preferred direct carving to modelling because I like the resistance of the hard material and feel happier working that way. Carving is more adapted to the expression of the accumulative idea of experience ...'[18] Note that if the block is here still understood as female, then this woman's pleasure comes from working away at the resistance of a feminine-coded thing – at least I shall later argue this case.

Lodged at the interpretative heart of Stokes's essay on Hepworth are traces of this predicament concerning gender. There is the carver to account for; there is the mother; and there is the child. These are all key terms for

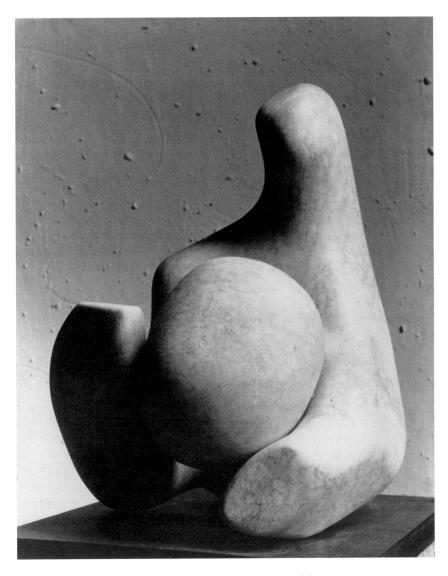

4.2 Barbara Hepworth, *Figure (Mother and Child)*, grey alabaster, 1933

Stokes, if in different ways. Yet used in this particular context to speak of Hepworth and her work, they are immediately and awkwardly conflated, since she herself is carver, mother and (necessarily) child. (Remember that it is Stokes who invents the Kleinian adage 'The Infant is mother to the Man' to name the determinant continuities between adult and child.[19] We might

usefully rephrase it for our purposes: 'The Infant is mother to the Woman' – and even, 'to the Mother'.) What is more, were these conflations to be pursued and understood as having an objective, material site, they would overlap in (or on) Hepworth's body, since it is simultaneously that of the sculptor, the female, the mother and the child.

I think that Stokes's essay betrays a certain anxiety about these conflations at its interpretative heart, in the kinds of assertions it uses, and in the contradictions it aims to refute. Let me give the key sentences again: 'In this case at least the abstractions employed enforce a vast certainty. It is not a matter of a mother and child group represented in stone. Miss Hepworth's stone *is* a mother, her huge pebble its child'. Is it not Stokes's language, more than Hepworth's abstraction, that is aiming to enforce certainty? That emphatic *is* ('Miss Hepworth's stone *is* a mother') insists on a literal meaning that otherwise would be hard to secure.

Miss Hepworth's stone *is* a mother. The phrase should be the equivalent to something like 'Juliet is the sun', but the insistent *is* (it is the *is* of identity) literalises the metaphor and in so doing puts the brakes on the free play of its meanings. As a result, what William Empson calls the 'pregnancy' of metaphor is terminated, and its potential circuitry of meaning effectively closed down.[20]

Why? In discouraging imagination as to what the stone and mother might mean, to say nothing of what they might mean for Hepworth, Stokes seems to me to be doing nothing so much as fending off a more thoroughgoing Kleinian reading of her art. Rather like Read, he stands at the margin of interpretation, unwilling or unable to ruffle the surface of his need for 'vast certainty' and 'pure complacence' as the terms of her achievement. This was his definition of carving: he would not admit that it did not really apply to Hepworth's art (at least not when its imagery is seen in a Kleinian light). Yet also like Read he knew that something else, however inadmissible, was afoot.

Might it not be salutary to take Read and Stokes seriously? – to see their uncertainty and insistence as having something – however backhanded – to say about Hepworth's art? Such a resolution would have at the very least the purpose of offering an antidote to the normalising impulses which have had her life and art so firmly in their grasp.

So here is my central hypothesis. Both Stokes and Read encountered Hepworth's art at its most urgently autobiographical moment, in the early 1930s – the moment of her espousal of a special, bodily abstraction. They wrote of it, in other words, at just the juncture when its maker was carving a set of objects with quite particular weight and resonance where fantasy and symbol, maternity and infancy are concerned. Looking at these works – at their sheer formal extremity – it is safe to say that their maker seems to have laid claim to a whole spectrum of resistances, including those of the

block, both identifying them and identifying *with* them, in a notably original way.

Why should this add up to autobiography? For a start, it is claimed as such by the artist herself, written onto the surface of the stone as a telling inscription: I am speaking of Hepworth's practice, in the early 1930s, of transcribing into the stone a precisely delineated profile, a real auto-graph. This is also an art-world move, of course: an identification of her art with the painting of Picasso, and of her sculpted forms with his painted women of the late 1920s – with the 1927 *Seated Woman*, for example. The analogy speaks, it would seem, to the odd disjointed ponderousness and presence which, in both cases, characterise their range of form. But it is also a usage with a source and reference that come much closer to home: Ben Nicholson had adopted the same device himself to depict Hepworth in a series of works done around 1932. In them her profile serves as a metaphor for art. His canvas *1932 (profile–Venetian red)* is a good example: it uses both oil and pencil, but privileges the latter, taking it as the vehicle to trace her features and make their elusive contour emerge (paradoxically) as the focus of the whole. While the profiles differ from one image to the next, it is certain that Hepworth is always meant to be depicted, and love recorded; it is as if Nicholson is updating the story of Dibutades, the Corinthian maiden who invented drawing for just this purpose.[21] Moreover, in a 1932 photogram – a self-portrait in her as-yet-unpublished archives – Hepworth herself adopts a parallel strategy, staging a position between the omissions of the cloudy outlined profile and the particularity of the realist trace, the strands of her hair. Both effects were the result of a single process – she laid her head on a piece of photo paper, then exposed it to light – but the impact of the work *as a portrait* is lodged in the profiled line.

To claim that for Hepworth, carving, at least at this moment in her career, involved an act of self-inscription – an identification with the stone – is a way of beginning to think of these works as representations of female bodies – even, perhaps, as representations of a single one. That the terms of the identification are both fragile – mere traces – and in a real sense provided – or borrowed – from Picasso's art does not undermine that claim: how else, out of what materials, we might well ask, do most self-identifications come about? Nor is it to be expected that the sign and the body marked by it necessarily cohere to form a unified whole. Hepworth's incised conventions – those provided symbols for female person-hood – mostly fail to discipline the stone curves and swellings on which they sit. We read past the inscriptions to bodily meanings the profiled trace can neither contain nor obscure. And we discover that her stones are remarkable for the range and consistency of their concerns. What can be known or said of the female body exactly? For which of its real or imagined properties can a sculptural

embodiment plausibly be found? To what realm of the viewer's experience or understanding should that embodiment aim to appeal? These are the kinds of questions which should accumulate around Hepworth's carvings of the early 1930s – between 1931 and 1934, she made about twenty-five in all. They are also, I submit, the kinds of questions which helped bring them to be.

Such a judgement needs specific interpretations to back it up. Let me provide them for at least a few of the sculptures in question – the 'symbolic' and 'maternal' works on which Read's and Stokes's responses were based. Take, for two examples, *Figure* and *Reclining Figure* (Figure 4.3), both alabasters done at just this time. Each proposes a notion of the body as singular – the *Figure* is a miniature monolith, after all, its parts kept within a continuous contour – and that sense of unity is maintained even given the greater complexity of the other work. Convexities and concavities are linked in loosely matching pairings, formal correspondences which seem to urge the sensation of a dense and continuous whole – a whole in each instance that by virtue of its very density can be understood to have no contents. Instead it is reassuringly all of a piece.

This rhetoric of dense coherence is repeated in other figures, but the forms of those repetitions – as in *Sculpture with Profile* (1932) and *Carving* (1933), for example – have something important to say on their own. It is that Hepworth's proposal concerning the female body announces more than its coherence and unity. It is a body which can be as abrupt as it is unified, can seem as stunted as it is continuous. It becomes less a body than an object – and a threatening one at that. Hepworth seems to have sought out her figures' analogies to other bodies and objects – to primitive weapons and the phallus and to phallic weapons. In one signal instance – the uncanny *Two Forms* (Figure 4.4) – far from being contained, the body has split into parts, amputees or fragments which mime a grotesque and fruitless intercourse.

Much of this bluntness and incompletion survives in the shapes which Stokes, remember, took to be most complacent: the works Hepworth called *Compositions*, the pieces which have come by now to be known mostly as 'Mother and Child'. I think Stokes was wrong about their tone. Granted that in them the artist was concerned with principles and degrees of closeness and separation between two forms, and consequently with the kinds of relationships and analogies which might be established between them. The result, however, it that ideas of unity, of part and whole, inside and out, are put under even greater investigative stress. This is the case with the white marble *Figure* of 1933, for example, in which the stone widens out to form a carefully rounded base. There seem to be real nuances here, clefts and curves in the stone which demonstrate that the main issue is not the essential or material principles of the medium (a dowel was used to keep the thing upright). The message is the thing: mother and child are held together in a

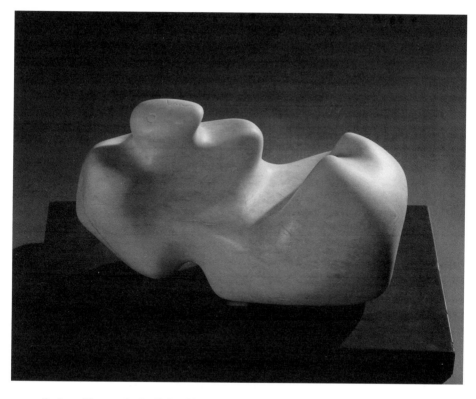

4.3 Barbara Hepworth, *Reclining Figure*, alabaster, 1933

single block. Their relationship is a fundamental identity – they are made materially closer than the linkage signalled by the sign for a hand scratched in the stone – but it is achieved by sacrificing the structural probity of the whole. The 'carving' ethos, in other words, does not speak to the real instability of the work.

When the 'mother' and 'child' are separated, as they are in the piece Stokes took as his main example, that resolution does not serve to ease the discomfort of the forms. The pebble sits heavily on the limbs of the mother stone, pinioning them with its weight, and 'her' limbs themselves seem painfully extended, elongated only to be abruptly curtailed. And that sense of distressing incompletion persists, even when, in an alabaster 1934 *Mother and Child*, principles of complementarity and analogy have been convincingly secured (Figure 4.5). The degree of likeness between the two forms, and the pleasure to be taken in their shapes, still do not entirely displace the awkward knowledge of the larger body as an amputated form. Desire for these shapes seems regressive, a return to some founding category

4.4 Barbara Hepworth, *Two Forms*, alabaster on limestone base, 1933

4.5 Barbara Hepworth, *Mother and Child*, alabaster, 1934

of form: to faeces as much as to a pebble, to the redundancy of the mirror more than to adequately individuated selves.

If further evidence is needed of Hepworth's enquiry into the related and separable status of the maternal and infant body, it is provided by two drawings that the 1994 Hepworth retrospective made public for the first time.[22] The two sheets come to us as studies for sculpture by virtue of their subject matter, and also because one places three of its figures on sketchy bases. The other sees its figures from different points of view, giving them both a front and side, thus projecting for them a place in three dimensions. Both are convincingly dated *c.* 1932. But if they are studies for sculpture they are nonetheless imagined in a notably hypothetical way. The drawings operate under the sign of Surrealism, as much as of sculpture: that the surreal means Picasso is clear from the strangely tusked figure in the upper right of the smaller sheet. This figure seems to have served to license Hepworth's further speculations about the female form: hence the other sketches, which expand and amplify its forms. In them the body is overlaid with circles of various densities and scales: navel and breasts and wombs both full and empty proliferate; they are sometimes contained within the

basic scaffolding of the body, and sometimes pull against or out from the figural core.

Such speculations are continued in a different way on the other sheet. Here the overlap concerns the intimate relationships between the bodies of mother and child. They are all too easily conflated. In the two sketches at upper left and centre, the child may actually be within the mother's body; its organs seem like hers, its parts hook up and into her core. I think it was to put that risky visual possibility to rest that Hepworth then drew the more reassuring profile view, one which serves finally and decisively to prise them apart.

In the kinds of emphases I have built into my interpretations – emphases on the ways in which Hepworth's carvings present an experience of parts and wholes, and on the ways those experiences might be seen to be charged in various measure with pleasure and discomfiture – I have been consciously employing a vocabulary indebted to the theories of Melanie Klein. My use of this language may have something of a rough and ready flavour; it is not yet the same thing as a full-fledged Kleinian analysis of her art – indeed, examples of such interpretations are still rather few and far between. Yet reading Klein has offered me the only tools I have so far encountered to make more than superficial sense of Hepworth's art – to speak to its intensity, above all. This is why I want to draw attention to the various ways Hepworth's works stand for the female body, symbolising not merely the whole body but its parts or fragments as separable sites and sources of visual response. These are bodies made into objects which may present dangers or threats, or themselves be threatened. Together they act as answers to a series of founding questions about the female form. What are its contents and boundaries? What does it hold or do? How might it best be joined to other bodies and forms? That the limits of Hepworth's bodies are not those of biology, however, does not mean that they are wildly inclusive in their referential range. They add up to a testing and verification of a limited range of fantasmatic fears and hopes concerning the female body's presence, its contents and its voids. Their tone is simultaneously investigative and intimate – their handsized scale sees to that – yet for all their variety, I do not see their tone or purpose as involving much sense of play.

Nowhere are these factors more evident than in Hepworth's various efforts to pierce the stone. They began in 1931 with the destroyed *Abstraction*, a casualty of World War II.[23] It is a work which has the status of a demonstration: the form is pierced – the form is a body, needless to say – and with eminently reassuring results. Look, there is nothing inside, no babies or faeces or penis: out of the absence will come a reassuring w/hole. The resistances of the (feminine) block have been made to yield to the most basic possible enquiry about its contents; as a result, the practice of sculpture was no longer to be quite the same.

It is a tribute to Hepworth's powers as an artist that the hole in the block was so promptly and satisfyingly incorporated into sculpture, as in the Tate Gallery's 1934 alabaster *Mother and Child* (Figure 4.6). The hole was made aesthetically whole, rather than remaining the wilful, even compulsive gesture it first seemed to be. We can still trace the stages in that process – for example, the eventual alignment of the hole with the space under the breasts, in the 1933 *Figure*, and its use, in the 1932–3 lignum vitae *Seated Figure*, to detach arm from torso.[24] The Tate *Mother and Child* profits from and revises both these works. To discover how a hole might paradoxically leave a body aesthetically intact is to offer a practical and material demonstration of one's successful integration of the emotions and issues involved. It is only on reflection, or perhaps, on seeing the work in the flesh (so to speak) that the tense balance of all of this becomes clear. The form of the baby is not really balanced; it has been glued into its precarious place on the mother's knee.

When Stokes wrote so insistently 'Miss Hepworth's stone *is* a mother', the phrase was, among other things, a way of *not writing* 'Miss Hepworth is a mother', which of course she then was and would soon be again (her son Paul had been born in 1929; triplets appeared in October 1934). As was Klein herself, I might add; this may be one reason that the analyst brought to her professional work a salutary lack of concern with prescribing maternal duties and obligations, especially of a kind it would be hard for a professional woman to meet.[25] She focused instead on the needs, hostilities and aggressions of infantile structuring of an internal fantasy world, and even when faced with a particularly damaged child, as in the case of the near-autistic little Dick, remarks only in passing that 'though he had every care, no real love was lavished on him, his mother's feeling being from the very beginning cold'.[26] Klein's purpose in analysis was to deal with circumstances, rather than judge them, to provide a set of symbols which her young patients could use to advance towards integration and personhood. Those symbols, she thought, never lost their force.

But to stick with Hepworth: the imagery of her work seems to back up the Kleinian claim. It seems clear that by 1934 she did arrive at symbols which both aesthetically and personally might be said to mark a fragile resolution. That year's carvings achieve a kind of management of the recalcitrant topics they had explored: she had worked away at 'resistances' with some success. Yet exactly how this success connects with her decision a month after the birth of triplets to place them in the care of nursing sisters seems unlikely. She did so to keep on carving, replacing one bodily obligation for another; remember, 'The sculptor carves because he must'. And the domestic change coincided with a stylistic one: the body was summarily banished from her art for more than a decade – on this she and her critics have always been agreed.

We might call Hepworth's decision a personal one. Maternal duties clearly

4.6 Barbara Hepworth, *Mother and Child*, Cumberland alabaster 1934

conflicted with artistic ones, so she took the steps necessary to realign them. It seems that she saw the triplets once a week until their return home at the age of two; Paul meantime spent much of his time with his father, John Skeaping. Yet though personal, these child-care arrangements also have a social dimension; after all, maternity has always sparked – and continues to spark as hotly as ever – public concern and attention in the modern state. In this particular instance, the intersection is mimed with breathtaking directness. Has it ever been noticed that Stokes's 1933 *Spectator* column ran next to the week's broadcast schedule for BBC Radio? Half an hour on November planting and Bartok playing Bach and programmes scrutinising 'The National Character – [by] A Parson' and 'My Place in Commerce: by a Colliery Undermanager'. On Friday, the day the *Spectator* appeared, was a broadcast billed as 'Common Sense and Infant Feeding: By a Doctor. These practical health talks have an interest not only for mothers of young babies but for those who are in any way trying to influence or educate public opinion on these lines'.

Public opinion evidently needed considerable influencing, given that in the 1930s the birth rate in Great Britain hit an all-time low: 1933 saw only 14.4 births per thousand, against 25 per thousand thirteen years earlier.[27] By then officials had given up promoting childbirth as a means to increase the capital of the state, since the population had proved so unwilling to oblige.[28] More characteristic of social policy were the many instances of governmental – not to say patriarchal – interest in infant feeding and maternal bonding,

reproductive concerns which assert their broad relationship and relevance to the public good. These were concerns with which, let it be said, middle-class women aligned themselves: they took up the cause of bringing them to the working class. All these efforts – even the radio doctor's practical chats – represent the climate in which Hepworth left infant feeding to others so as to negotiate her female, professional and maternal roles. And she gave body to the complexity of those issues by yoking them to various formal concerns. The 'resistance of the block', she called them, but other resistances, which concern the objective and fantasmatic guises of the female body – of that body as mother – are tackled there as well.

The risks in speaking of personal circumstance in addressing art and artists are several: the speaker may seem somehow to sit in judgement on the past, or to cast representation as the reflection of a maker's 'personal' concerns. This is not my purpose. I do not think Hepworth's motivations or imagery *mirror* the personal; in any case the personal is only legible as art if it is given artistic form. Nor was the fact that Hepworth was herself a mother single-handedly able to make of maternity a culturally valuable, culturally negotiable theme. The interest in sculpting mothers and infants was widespread in the 1920s and 1930s; the old theme (paradoxically) became a vehicle for the new. Henry Moore's preoccupation with the topic pre-dates that of Hepworth by some five years; it goes back at least to 1922, the year of a now-lost *Mother and Child*.[29] And from the outset his work aimed determinedly at its revitalisation, proposing new bodies and bodily relationships. At first these were positively pneumatic, pumped full of confidence that mother and child can be animated and integrated anew, given specially weighty stature and an unaccustomed force. His work stands as the best demonstration, if not the only one, that the topic Hepworth took up in her carved bodies was not merely or simply personal in its purpose and charge. On the contrary, it was a central metaphor, gauging prosperity, imperium and their reproduction, on the one hand, and on the other indexing artistic value and ambition. I remember in this context how much an imagery of birth haunts Stokes's writing: when the carver polishes stone, he 'slaps the newborn infant to make it breathe'; when the modeller unmoulds his figure, it is like ripping it from a womb.[30] What is remarkable is not that such metaphors flourish, however, but that at this particular moment in history – around 1930 in England – they take on such uncanny, and *pace* Read, such desublimated life.

That special vitality, I am suggesting, is not limited to Hepworth's art. In demonstration of that claim, let me produce a work by Moore: a cast concrete figure of 1927, it represents a suckling child (Figure 4.7). The mother, we might say, has been reduced to a mere object, and a purely Kleinian one at that – she is a single breast at which the infant pulls. The side view makes it

4.7 Henry Moore, *Suckling Child,* cast concrete, 1927

clear that she is only that breast: indications of other forms – the much-flattened second breast and chest wall – are elliptical at best. But this very absence of the mother – her reduction to her best part – presents the viewer with an unexpected result. Viewer and mother become one – the elision is unavoidable – and now together make up a special, unprecedented whole. And the child's dependence on this hybrid mother/viewer is notably urgent and demanding; there is none of the improbable erectness and independence Hepworth attributes to her *Infant* (Figure 4.1) despite his suckling state.[31]

I think that Moore quickly backed off from this remarkable conception, and from its circuitry of identification above all. The loss of the mother's body and its simultaneous relocation in and as that of the viewer seem to have needed reconsideration: the rethinking involved both hyperbole and, ultimately, considerable toning down. When in a drawing of about 1930 he returned to the figure of the suckling child, he did so under the sign of his first conception – he drew a small reprise of it at the lower right – but as sketched now it is caricatural and disturbing (Figure 4.8).[32] Its eyes are

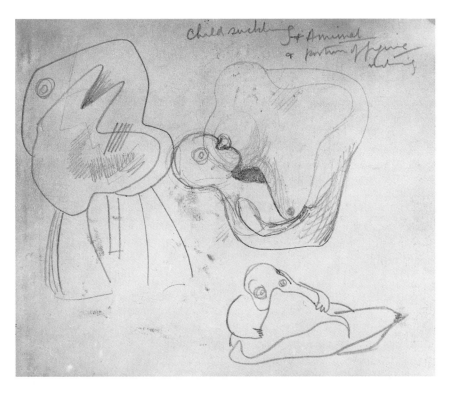

4.8 Henry Moore, *Ideas for Sculpture: Page from No 1 Drawing Book*, 1930–1

bizarrely emphasised as if to deflect, rather than attract, the gaze, and in the sketch pencilled just above it, which imagines a second version of the group, this same feature contributes to a distressing quasi-foetal formlessness. The infant's body is now entered by one nipple (indeed by the line of the breast as a whole), while that same nipple also stands for a second eye. The mode is hyperbolic, as I say, and in the sculpture that followed this sheet, a small alabaster work of 1930, bizarrerie has been put aside in favour of another kind of formlessness.[33] Now the careful uniformity of the whole, in which the smooth surfaces of both breast and infant are rubbed as a glowing similitude, arrests any desire for identification on the viewer's part. The soft skin works instead to objectify the work, while effecting a kind of aesthetic completion. Moore meant to make of the new group an independent artistic whole, to give it a kind of euphony of treatment declarative of its nurturing theme. This is part of a wider purpose: Moore wanted sculpture to nurture and aimed to produce an art that could be made to play that role.

This is not a purpose I think it right to attribute to Hepworth's art, at least

around 1930. Her sculpture of that moment had neither the complacency nor the distance such an ambition seemed to demand. Complacency and distance about what? About the feminine, of course, and the female: about the ways her sculpture might negotiate a topic which her ambitions as an artist made unavoidable, but which by virtue of personal circumstance was inevitably highly charged. Her stance seems to have been edgy and investigative, declarative and mistrustful. Her art is full of proposals about the female body, without achieving much pleasure or comfort with its terms. We might explain the tone of her work by the fact that she was a woman, though our reasoning would not seem forceful or sufficient, since this was self-evidently the case. But if there is satisfaction to be found in this explanation, partial as it is, it lies in the fact that as a woman, Hepworth was able to represent the ambivalences and ambiguities of the maternal bond and state. And she incorporated them in and as sculpture. So much for the femininity of the sculptural block.

Yet I do not think that Hepworth would have been much pleased with my account of her work's achievement. On the contrary, she seems later in life to have been bent on securing a specially untroubled account of her maternal history, so much so that the particular version she offered in the *Pictorial Autobiography* appears purposeful to say the least: hence all those family snaps. Do they not seem to have a case to plead? At the very least they give a vivid idea of the constitutive importance of maternity in the making of this particular sense of a public self. Yet they do so by forgetting or erasing the formative concerns of her sculptural art.

That this topic once had for Hepworth a more vital and complex role to play – that it played a role in the development of her art – is an idea shored up by a work which falls outside the period considered here, the years from 1927 to 1934. A *Madonna and Child* of 1954, it is her memorial to her firstborn child, the son called Paul; it is in St Ives Parish Church (Figure 4.9). It makes a notable contrast to the anguished wooden crucifix carved and burned into being by his father, John Skeaping. Though it says nothing particular about Paul, it evidently meant to index its maker's grief at his loss.[34] For Hepworth, by contrast, all the affect and interest the subject once carried have long since been laid to rest. Her work is an exercise in archaism, its drapery as flat and linear as a Hellenistic imitation of a distant Hellenic past. The group seems uttered as if by rote, as if feeling could not be allowed to find its way back into its folds. Its very flatness throws into high relief the fact that both motherhood and carving had once had a profoundly different status for Hepworth. A sculptor and a mother, she first conceived of sculpture and 'mother' as demanding more original – and more troubling – forms, and she did so at a moment of what we might call overvaluation of the maternal by both her profession and her state. Her work took shape as an Imaginary of the body, as

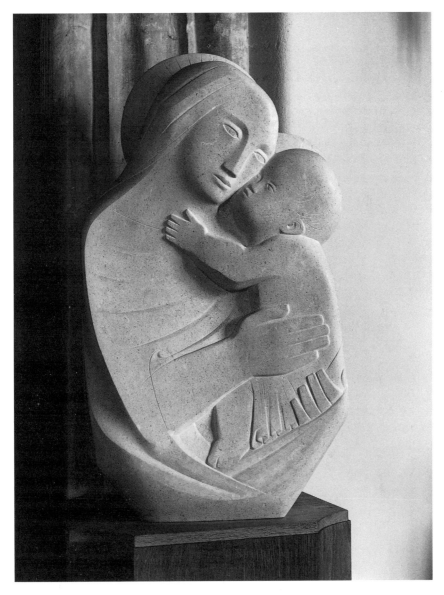

4.9 Barbara Hepworth, *Madonna and Child*, bianco del mare, 1954

the infant might envision it – or better, as a mother who was once an infant might feel it – given her purpose of regrounding sculpture as an advanced and authentic art. In such circumstances Hepworth conjured a body that could be and contain everything and nothing at all – little wonder she did not go on.

Notes

This essay was first published in David Thistlewood, ed. *Barbara Helpworth Reconsidered. Tate Gallery Liverpool Critical Forum Series*, vol. 3 (Liverpool University Press and Tate Gallery, Liverpool, 1996), pp. 53–74; a revised and expanded version appears in Anne Middleton Wagner, *Mother Stone: The Vitality of Modern British Sculpture* (New Haven and London: Yale University Press, 2005).

1. A. Bowness, 'A Note on the 1993 edition', in *Barbara Hepworth, A Pictorial Autobiography*, London: Tate Gallery Publications, first published 1970, revised 1978, unpag. [p. 4].

2. Ibid., p. 17.

3. H. Read, 'Foreword', *Carvings by Barbara Hepworth, Paintings by Ben Nicholson*, London: Arthur Tooth & Sons, 9 November–3 December 1932; see *Pictorial Autobiography*, p. 21. A. Stokes, 'Art: Miss Hepworth's Carving', *The Spectator*, 3 November 1933, p. 621; see *Pictorial Autobiography*, p. 29. Also reprinted in A. Stokes, *The Critical Writings of Adrian Stokes: Volume 1, 1930–37*, London, 1978, pp. 309–10.

4. Read, 'Foreword'.

5. P. Curtis, 'Barbara Hepworth and the Avant-Garde of the 1920s', in P. Curtis and Alan G. Wilkinson, *Barbara Hepworth: a Retrospective*, Liverpool: Tate Gallery Liverpool 1994, pp. 11–30.

6. Read, 'Foreword'. Note that Read is not the only critic to suggest that the 1932 Tooth show might dismay its public. In his review, Paul Nash produced a brief vignette of a Tooth employee, one Mr Keene, 'imploring a lady and gentleman, obviously slightly suffering from shock, to abandon at once any idea of looking in the work before them for anything they expected to find'. P. Nash, 'Goings On: a Painter and a Sculptor', *The Weekend Review*, 19 November 1932, p. 613.

7. H. Read, 'Psychoanalysis and the Critic', *The Criterion*, Vol. III, 1924–25, pp. 214–30. Note that Read included as number 4 in the questionnaire he prepared to stimulate the Unit 1 artists to reflect on their art and intentions, the straightforward query 'Have you studied the theories of Freud?' See *Unit 1. The Modern Movement in English Architecture, Painting and Sculpture*, London, 1934, p. 14.

8. Read, 'Psychoanalysis and the critic', p. 225.

9. Ibid., p. 224. Read is citing A. Adler, *The Practice and Theory Individual Psychology*, English edn, London, 1924 p. 23.

10. See Alex Potts, 'Carving and the Engendering of Sculpture: Adrian Stokes on Barbara Hepworth', in D. Thistlewood (ed.), *Barbara Hepworth Reconsidered*, Tate Gallery Liverpool, 1996, for direct and helpful attention to Stokes's text.

11. R. Wollheim (ed.), *The Image in Form: Selected Writings of Adrian Stokes*, Harmondsworth, 1972, p. 36. From *The Quattro Centro* (1932), pp. 7–8.

12. Wollheim, *The Image in Form*, p. 27.

13. A. Stokes, *The Stones of Rimini*, London, 1934, p. 110.

14. A. Bertram, 'Artists Indoors', *The Listener*, Vol. X, No. 251, 1 November 1933, pp. 660–1, repro. p. 661. See also (1933), 'Plays and Pictures', *The New Statesman and Nation*, 4 November, p. 551.

15. Stokes, *Stones of Rimini*, p. 110.

16. Despite the differences in our interpretations, my discussion acknowledges with interest L. Tickner, 'Now and Then: the Hieratic Head of Ezra Pound', *Oxford Art Journal*, Vol. 16, No. 2, 1993, p. 59.

17. B. Hepworth, 'The Aim of the Modern Artist', *The Studio*, No. 2, 1932, p. 322.

18. Ibid.

19. A. Stokes, *The Invitation in Art*, London, 1965, p. 4.

20. As cited in S. Cavell, *Must We Mean What We Say? A Book of Essays*, Cambridge, 1969, p. 122.

21. Nicholson evidently identified his uses of Hepworth's profile with his reflections on the relative

status of drawing and painting, and their claims to address the real. Indeed, it seems safe to claim that he used his images of her as a means for that reflection.

22. For reproductions of these works, see Curtis and Wilkinson, *Barbara Hepworth*, Figs 88, 92, pp. 49–50.

23. In C. Harrison, *English Art and Modernism 1900–1939*, London and Bloomington, 1981, p. 266, Harrison points convincingly to the evidence of its importance to Hepworth's view of her sculptural achievement.

24. For illustrations of these works, see J.P. Hodin, *Barbara Hepworth*, Boston, 1961, Nos 46, 47.

25. This is the hypothesis of J. Doane and D. Hodges, *From Klein to Kristeva: Psychoanalytic Feminism and the Search for the 'Good Enough' Mother*, Ann Arbor, 1992, p. 18.

26. J. Mitchell (ed.), *The Selected Melanie Klein*, Harmondsworth, 1986, p. 100.

27. P. Thane, 'Visions of Gender in the Making of the British Welfare State', in G. Bock and P. Thane (eds), *Maternity and Gender Policies: Women and the Rise of the European Welfare State*, London, 1991, p. 100.

28. For histories of pronatalism in England see A. Davin, 'Imperialism and Motherhood', *History Workshop Journal*, No. 5, Spring 1978, pp. 9–65, and J. Lewis, *The Politics of Motherhood: Child and Maternal Welfare in England 1900–1939*, London and Montreal, 1980.

29. D. Sylvester (ed.), *Henry Moore, Vol. One: Sculpture and Drawing 1921–1948*, 4th edn, London, 1957, No. 3.

30. Stokes, *Stones of Rimini*, pp. 112, 126. Note that in both of these usages the 'female' block (so called) is almost instantly elided – it (she) is subordinated to the sculptural product – to the 'child'.

31. I thank Lisa Tickner and Beth Dungan for conversations about Hepworth's *Infant*.

32. The drawing was published in D. Mitchinson, *Henry Moore: Unpublished Drawings*, New York, 1972, Pl. 86. Mitchinson reproduces (Pl. 35) another closely related sheet from the same sketchbook, which is dated 1930–31. The same sheet, along with another from the same notebook (the No. 1 Drawing Book) is discussed by Alan Wilkinson, *The Drawing of Henry Moore*, London: Tate Gallery with Art Gallery of Ontario, 1977, pp. 83–4.

33. For a reproduction of this work see Sylvester, *Henry Moore, Vol. One*, No. 96. The 1927 cast concrete *Suckling Child* is No. 42.

34. For a reproduction of this work see J. Skeaping, *Drawn from Life: an Autobiography*, London, 1977, p. 128.

The dark chaos of subjectivisms: Splitting and the geometry of fear

David Hulks

[T]hough seeming to deal with aesthetic problems, it [modern art] is really performing a work of psychological education on the public by breaking down and destroying their previous aesthetic views of what is beautiful in form and meaningful in content. The pleasingness of the artistic product is replaced by chill abstractions of the most subjective nature which brusquely slam the door on the obligatory love for the object. This tells us, in plain and universal language, that the prophetic spirit of art has turned away from the old object-relationship towards the – for the time being – dark chaos of subjectivisms. Certainly art, so far as we can judge it, has not yet discovered in this darkness what it is that could hold all men together and give expression to their psychic wholeness.[1]

In this passage from Carl Jung's 'The Undiscovered Self' (1957), the psychoanalyst seems to be reworking an already well-established notion represented by Herbert Read's term, the 'geometry of fear'. The term 'geometry of fear' was applied by Read to a set of heterogeneous sculptural works gathered together at Venice for the Biennale in 1952.[2] The term originally, however, derived from psychoanalytic speculation rather than political or art-critical discussion: 'geometry of fear' reversed a much less well-known construction that Read called the 'geometry of love'.[3] This version of the term referred to the commonly expressed psychoanalytic idea that beauty in art – in traditional art at least – worked largely on the basis of sexual appeal. The new development of 'geometry of fear' art, however, seemed to represent an entirely different kind of artistic endeavour. The 'fear' version of the term was devised so as to describe the shift that Read perceived: away from 'the old object-relationship', as Jung put it, instead to a practice based on what he called, after Woltereck, the 'eudemonistic response'.[4]

For those who were not cynical about modern art, as Jung seems to have been, the new situation showed evidence of hope and saw the artist in an

heroic role. To work in the new way that Read described was to work responsibly and in an attempt to improve rather than damage the psychological 'health of the nation'. In the new circumstances, it was nothing less than the artist's duty, Read and his followers argued, to face society with its 'darkest imaginings'. As another Jungian, Erich Neumann, put it: given the circumstances (the neurotic environment that Jung diagnosed but that Read and others had described more fully and more favourably), the socially responsible artist was forced 'not only to represent the highest values of his culture, but also to give shape to the compensatory values and contents of which it is unconscious'.[5]

It was not, then, that artists were exhibiting symptoms of their own psychosis. It was rather that they were involved in 'sublimation': they were converting the symptomatology of psychosis into the civilising substance of art. 'Geometry of fear' sculpture was not in any simple way representing real mental illnesses, either intentionally or inadvertently. There does, however, appear to be a strong connection between how artists and viewers saw these particular works and how clinicians viewed and analyzed patients suffering from schizophrenia. Before the 1950s, psychoanalysts had avoided schizophrenics, thinking their problems too intractable. However, a growing confidence and interest, particularly amongst Kleinians, in the nature of the schizophrenic condition did prompt a small number of analysts to begin visits to psychiatric hospitals or to invite schizophrenic patients to visit them in their private clinics.[6] As a result, new theories of the schizophrenic condition started to feature in a wider cultural and aesthetic debate, so that it is hardly surprising to find 'geometry of fear' artists reflecting this discourse on schizophrenia in work first showcased at the Biennale in Venice.

Most artists, however, did not simply depict the schizophrenic condition as objectively observed. Another possibility was to look at the world from the patient's perspective so as to generate what might be called a 'schizoid vision'. This shift from an 'exo-psychic' to an 'endo-psychic' perspective again seems to have been paralleled in clinical practice with the attempt to develop with schizophrenic patients a greater closeness and empathy by engaging with their hostility to treatment. A further possibility is that artists exploited another idea expressed in the psychoanalytic literature, namely 'schizoid linguistics'. This was the notion that schizophrenic patients, as 'abnormal' individuals, produced a strangely complex and devious verbal logic that could be isolated and studied in its own right. The identification of 'schizoid linguistics' seems to have suggested to certain artists the possibility of emulating or exploiting somehow a transgressive, oppositional language for the purpose of advancing artistic modes of expression.

But, before exploring the wider dimensions of these various possibilities

and positions, I want first to draw an analogy between the setting of the art gallery and the setting for an imagined psychiatric or psychoanalytic encounter between the medical clinician and the schizophrenic patient. The clinical nature of the art gallery is often remarked upon, and in fact is usually taken for granted. Here, however, I want to make the analogy much more explicit by arguing that the circumstances of 1950s Britain favoured a very close connection between the gallery and the clinic, a situation that makes the connection I am suggesting between the 'geometry of fear' and 'schizophrenia' seem more than plausible.

Pathological Sculpture and its Clinical Containment

For the Kleinian art critic, Adrian Stokes, modern art had become so volatile and potentially harmful that it could only operate benignly if surrounded by what he called 'a self-supportive *mise en scène*'.[7] Stokes's view was that the gallery had to be regarded as fundamentally separate from the wider social environment. An undesirable and yet fascinating yawning divide had opened up between art and society. Artists were necessarily producing a 'schizoid content', since 'cultural symbolic systems cannot be applied now [in the context of Cold War] to the order or, rather, the lack of order, of things'. The art gallery, therefore, was a unique place for the meeting of fundamentally antagonistic worlds. It was a clean and well-ordered environment for deep contemplation of complex and seemingly troubled works, a place for the quiet but intense study of what Stokes referred to as 'the dented meteorites of our own time'. Stokes did not explicitly state any overlap between the gallery and the clinic. Yet many of his papers suggest – and increasingly suggest – just such an overlap.[8] Due to personal circumstances, he was very familiar with post-war psychoanalytic and psychiatric settings, so that an objection might be that if Stokes confused the gallery with the clinic, it is not so surprising.[9] But Stokes offers us more than a personal, idiosyncratic perspective. Rather, he seems to have been tuned in to a situation out of which flowed real consequences both for the production and for the reception of modern abstract art. The post-war art gallery was more than clinically sterile. As Stokes increasingly realized, it was also a place for the clinical observation of regressive and occasionally psychotic symptoms revealed through art. We might further add that it was a place for the safe containment of pathological objects, where the 'dark imaginings of the soul' were put on display for the purposes of clinical as well as aesthetic scrutiny.

The gallery as a clinical setting for the examination of apparently pathological objects can be observed in the photographic record of 'geometry

of fear' displays (Figure 5.1). The photographs of the British Pavilion at Venice (1952) show a clean, white, modernist space, with dark, spiky, organic sculptures mounted in a highly organized way on white supportive plinths. Such a clinical, well-ordered, highly controlled presentation contrasts with the much more chaotic and colourful ways in which Venice Biennale shows are generally presented to us today. The tidiness of the surrounding environment in 1952 seems to reinforce the grittiness and controlled *dis*order of earthy sculptural expression offered up on pedestals. We can tell a lot from these photographs about how sculptors would have designed their works for display, as well as how curators mediated the public reception of these works in a highly stage-managed, clinically ordered and well-administrated fashion. Artists at this time would doubtless have been fully aware of the way the 'dark chaos of [their] subjectivisms' was going to be brought into line with the objective purposes of officialdom. They would have been conscious that the rough, usually black or seemingly dirty, encrusted surfaces of their works would ultimately have had to survive in a white, modernist gallery environment. Artists would not, though, necessarily have been resistant to this clinical treatment. In fact, they may have realized that an almost medical containment of what were commonly regarded as potentially aggressive and psychotic sculptural works was more likely to increase any perceived pathological imprint than it was to erase it.

The fact that sculptors at this time were highly attuned to the way that their works would often be regarded as displaying symptoms of psychosis can be deduced from the writings of Henry Moore. Moore, of course, was one of the few artists who managed often to escape the containment of the clinical gallery by making works that could be displayed out of doors. Even outside the gallery, however, Moore seems to have looked at his works as though they were patients released into a world generally hostile to physical and psychological abnormality. His writings reveal the extent and nature of this process of after-care. Moore seems unusually concerned, for example, for the physical and psychological well-being of *Standing Figure* (1950) installed by a lake at Battersea Gardens. Although 'delighted', he nevertheless describes the work as 'a gaunt figure rising in agitated verticals from the verge of a calm, flat sheet of water'.[10] The figure's 'agitated' state conveys the idea of psychological instability contrasted with the horizontal calmness and quietude of the water. Moore's description of the same figure is no less proprietorial and quasi-clinical when he describes *Standing Figure* again, this time relocated to Scotland and 'the bleak and lonely setting of a grouse moor' (Figure 5.2). In its new setting, *Standing Figure*'s condition moves even further away from simple agitation, now into a state of psycho-social withdrawal and distress. The work has now become, he says, 'an image of loneliness … as if stripped to the bone by the winds of several centuries'. It was after this

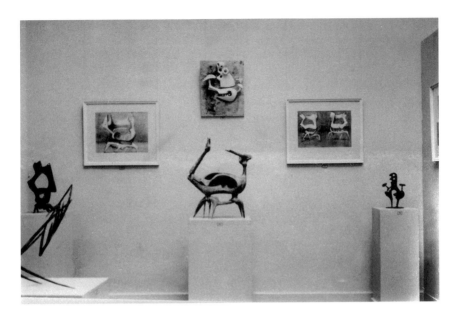

5.1 'New Aspects of British Sculpture', Venice Biennale, 1952, showing Bernard
Meadows' sculpture and drawings

assessment that the sculpture was returned to the studio to be drastically re-
worked. It re-emerged for the 1952 'geometry of fear' exhibition at Venice as
Double Standing Figure (1952), Moore having cast a replica figure that he
placed in close relationship to the first so that *Standing Figure* now had a
double personality, a classic schizoid trait. Moore's idea was that doubling
would produce greater cohesion and stability. This was achieved, however,
only at the price of potentially increasing the impression of some incurable
psychiatric disorder.

It was this aspect of Moore's work that most likely suggested to a younger
generation the idea of producing sculptures that even more explicitly – and
more exotically – seemed to exhibit symptoms of neuroses or even
entrenched psychiatric disorders. Read's suggestion that the 'geometry of
fear' is about 'despair, or defiance' therefore has insufficient scope.[11] The
range of psychological variables available for sculptural depiction was
rapidly multiplying, the known traits of 'abnormal psychology' offering a
richer palette for young sculptors than the usual polarities of psychological
good health. The new generation lost no time in exploring fresh artistic
possibilities based on pathological description. Lyn Chadwick's giant,
lumbering work, *Fisheater* (1951), for example, has tripod 'legs', a heavy iron
'body' and, perched precariously on the 'neck', a colossal iron-wire 'head'

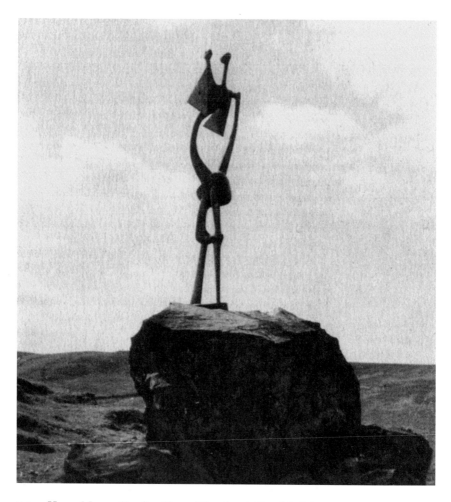

5.2 Henry Moore, *Standing Figure* (Shawhead, Dumfries), bronze, 1950

(Figure 5.3). The figure clearly represents 'abnormality' in one way or another, its condition probably more psychiatric than to do with physical disability. The 'head' (representing the mind) is comprised of two long strips of heavy, seemingly torn sheet metal that begin together but, half-way along, split sharply apart, bending away from one another in dramatic curves. In the space opened up by this (schizoid) split, short rods, welded at their ends, are used to create a network of outward-branching, forking pathways. At the ends of these thought processes – as they seem to be – Chadwick has added Calder-like hanging mobiles that contain further splits but also illustrate a certain delicacy and poise, representing perhaps the imaginative ends of an

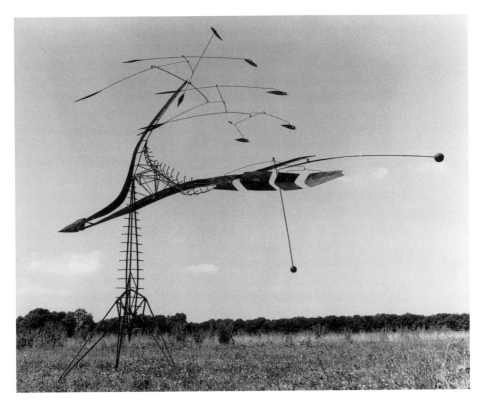

5.3 Lynn Chadwick, *Fisheater*, iron and copper, 1951

abnormal intelligence. The overall impression, however, is of potential hostility. The head threatens to disengage from the body due to the apparent fragility of the neck. And, because of this, the viewer is almost literally threatened as he or she bravely confronts unfathomable strangeness as well as the thought that the structure might easily and dangerously collapse.

Another example is Geoffrey Clarke's *Complexities of Man* (1951) (Figure 5.4). *Complexities* is much less precariously balanced, although the tiny legs and feet hardly offer stable support for the body. Like Chadwick's *Fisheater*, the 'body' of Clarke's *Complexities of Man* is also based on iron rods welded together, although this time arranged in vertical, parallel straight lines to form a cylindrical cage around a slight and apparently withered inner form – the subject's 'spirit', Clarke has explained.[12] At the 'head', however, the pathways split away from one another, representing, we are told, a release of 'mental activities'. Divergent thought, however, is promptly capped, Clarke fixing small iron balls to the end of each line of divergent thought. These 'full

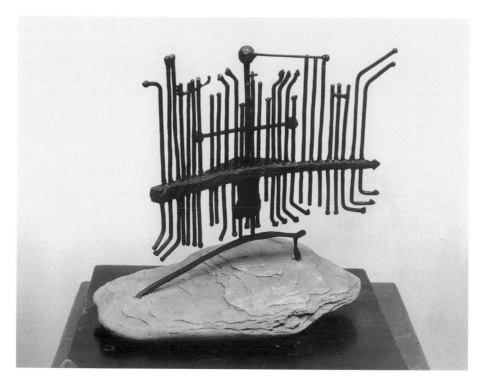

5.4 Geoffrey Clarke, *Complexities of Man*, iron, 1951

stops' were intended to represent the way Cold War officialdom was suspicious of free expression, and instead preferred to insist upon 'civilized restraint'. *Complexities of Man*, then, depicts a troubled individual who finds that in conservative Britain his spirit is caged and his mental eccentricities held firmly in check. The crucial factor here is Clarke's evident wish not just to illustrate mental divergence but rather to narrate it. Both *Fisheater* and *Complexities* refer to ideas that derive from theories of 'abnormal psychology'. Neither, however, are purely clinical models of schizophrenic suffering, since the final intention is to tell a kind of story, to produce a metaphorical or allegorical content. There is, therefore, no simple translation of medical description, since these are works that might begin with psychoanalytic description but end in symbolism and mythography. Nevertheless, clinical descriptions of schizophrenia do seem to have inspired these works, a point that can be demonstrated by comparing this work to psychoanalytic writing on the nature of psychological disorders.

The 1950s was the heyday of psychoanalysis, particularly in Britain. Such was the confidence at this time in the validity and power of the analytical

method that the 'talking cure' was offered not only to traditional types of patient but also now to those with more entrenched disorders. This was not only so as to support colleagues in psychiatric medicine who were increasingly looking for non-drug-based treatments for their schizophrenic patients; it was also an initiative aimed at providing a better understanding of what it might mean exactly to describe oneself as the converse of schizophrenic, that is psychologically healthy. In Britain, the concept of 'splitting' became established as a fundamental process in the early formation of the human personality and something that all individuals had perpetually to recover from. In the still relatively new Object Relations School of clinical thought, it was argued that infants, in order to progress towards adulthood, first had to survive a 'schizoid' stage, which would entail splitting their perceptual and emotional worlds into 'multiple shards'.[13] What followed from this was the idea that it was the purpose of the human organism always to repair and cohere the ego in a perpetual process of recovery from 'psychic dispersal'. To err in the opposite direction, towards further fragmentation, was to regress to a primitive, infantile, quasi-schizophrenic state. To work the other way, however, was to build from the human 'capacity to love'; it was to organise the ego into a coherent pattern, stabilizing the sense of self and allowing socialisation to commence. There was, it seemed, a general principle of oscillation between order and chaos, or psychodynamically between cohesion and fragmentation. Mental fragmentation was not only a personal problem for the individual sufferer; it was also a socio-political problem, since 'reconstruction' was not only about re-building the physical environment, it was also about constructing a more cohesive society, 'stabilising' the electorate.[14]

It was to this national effort at improving the psychic health of the nation and maintaining stability under Cold War conditions that psychoanalysts were increasingly asked to contribute. What Kleinian analysts specialized in, in particular, was the understanding of anxiety and the tackling of both internal and external psychological threats. Such threats were both real and imagined, but their source was usually thought to derive from 'primary anxieties' experienced in early childhood – the most primary of which was 'fear of annihilation', which was said to precede even 'fear of castration'.[15] Klein argued that 'fear of annihilation' always had to be confronted, 'since the struggle between the life and death instincts persists throughout life'.[16] It was the primary fear of annihilation, she further reasoned, that caused the subject to enact the extreme defence of 'psychic dispersal', equivalent to Freud's 'splitting of the ego'.[17] 'Splitting', Klein insisted, was a violent but necessary act of primary mental disintegration. It represented a dramatic self-harming moment; yet simultaneously it produced the conditions necessary for 'normal' mental health. After primary splitting in the 'paranoid-schizoid'

position the ego would begin to come together again, repairing itself in another necessary stage, the remorseful position that Klein referred to as the 'depressive'. If subjects avoided somehow the necessary psychological pains of the 'depressive' position, then it was likely that splitting would continue, producing 'multiple splitting' and the unwelcome and highly destructive end result of schizophrenia in adulthood.

There was a flaw, however, in Klein's reasoning, or at least a paradoxical logic that needed to be explained. The Kleinian model assumed that a destructive force, splitting, somehow produced its opposite, cohesion – which did not seem to make sense. Klein in *Envy and Gratitude* (1957) realizes this potential difficulty and endeavours to explain how such a seemingly paradoxical situation might actually come about. The primary split that creates 'good' and 'bad' aspects of the first object, 'the breast', is not simply destructive, she argues. Rather it is a process that will be managed by what she refers to as the subject's innate 'capacity for love'.[18] Capacity for love versus capacity for greed becomes the new oppositional logic structuring the last phase of Klein's psychoanalytic thinking. The subject's capacity for love, she explains, holds the twin aspects of the split ego in a productive, stabilising relationship. It is the cohesive operation of capacity for love that allows further cohesion around the fundamentally 'good' core created by the primary split. Klein, in other words, substantially moderates her idea of the violence of the primary split so that splitting is now less about the destructive creation of extremes, more about an essential primary dynamic arrangement, one that is dependent upon a controlled violence directed at all times by the essentially cohesive operations of the capacity for love.

This modified conception of an organized rending, followed by cohesive, reparative processes presents a seemingly more accurate model of the pathogenesis of schizophrenia in adults. In the 1950s, Kleinism offered not only a model for understanding so-called abnormal conditions; more than this, it also suggested ways of thinking about a wider 'mass neurosis'.[19] Klein's work seemed to support a growing suspicion in the wider psychoanalytic community that diagnosed schizophrenia represented only the tip of a much larger iceberg. If the schizophrenic condition derived from a surplus of envy and greed, then these qualities seemed characteristic of Cold War culture as a whole. It was possible, therefore, that a whole schizoid range might be identified, making the condition, not an isolated phenomenon, but potentially one of epidemic proportions. Klein taught that what had gone wrong in the case of schizophrenics was that the primary split had been enacted too violently and had not been repaired. But all adults, she also insisted, had begun life battling with psychic dispersal, and this would persist in adulthood regardless of whether or not they had 'worked through' the anxieties of the depressive. There was always, therefore, the persistent

threat of devastation and loss of self. It was this rather pessimistic picture that tended to be absorbed by the wider intellectual community and conveyed to those involved in the production of art. It was the mythological, indeed tragic, dimensions of Klein's argument that seem to have appealed to the wider art fraternity and the sculptors of the 'geometry of fear'.

The hypothesis would be, then, that the detail of Klein's theories was used by the geometry of fear, yet used for broader allegorical purpose in order to generate metaphors for the wider Cold War cultural condition. We can demonstrate this process by returning to the key works already discussed. *Fisheater*, for example, seems to incorporate at a structural level not only the primary split but also subsequent multiple splitting. Hence the bifurcating complexity of the fundamentally split head, which can also be seen in Moore's *Standing Figure* in the form of 'agitated verticals'. *Complexities of Man* is rather different, however. The split nature of his thought seems far less 'agitated'. Both title and work seem to allude not to the abnormalities of diagnosed schizophrenia but rather to splitting in the wider 'mass neurosis' sense, where there is both capacity to love and capacity for envy and greed. The split, abnormal condition of 'man' is indisputable, yet the condition is far less entrenched. It is as though 'man's' condition is being carefully managed, either by his own efforts or by acceptance of treatment. Although there is no coming together at the split ends of his psyche, there is some hope in the organization of his body where further dispersal will be prevented. Yet, there is no mistaking the abnormality of 'man's' condition: he and society are clearly fundamentally unwell.

The Schizophrenic Perspective and Use of Schizoid Linguistics

'Geometry of fear' art did not stop, however, at depicting schizophrenic otherness or expressing the wider split nature of society as a whole. Another fruitful strategy was actually to occupy the schizophrenic position – in other words, not to depict the sufferer but, rather, to depict the sufferer's point of view. Reg Butler's sculptural project, for example, can be described as an attempt to produce or fix 'schizoid vision'. His transition to this kind of work began around the time of the Festival of Britain, for which he produced *Birdcage* (1951), an insectoid tripod structure similar in type and appearance to Chadwick's *Fisheater*. By the following year, however, Butler had moved away from this kind of work by shifting from working in iron to working in bronze. With iron, depictions of the 'schizoid other' seem to have been almost unavoidable. Bronze welding, however, suggested an altogether different direction for the work to go in. The new material and methodology produced a more gnarled and organic figure, a typical example being *Oracle* (1953) (Figure 5.5) made for the foyer of the new technical college at Hatfield. Even

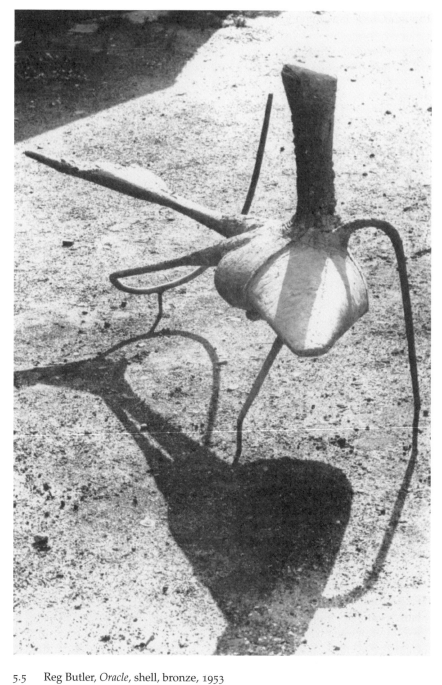

5.5 Reg Butler, *Oracle*, shell, bronze, 1953

though *Oracle* was intended for a highly technological setting, it no longer towered over the viewer, as *Birdcage* did; rather, it seemed to crawl horizontally, crab-like, over the ground. The inspiration is likely to have been the imagery proliferating at this time of microbiological worlds. The ICA exhibition 'Growth and Form' (1950–1), for example, showcased the cellular formations revealed by modern developments in science, but re-interpreted this imagery for use as artistic and cultural metaphor.[20] *Oracle*, as one of many objects deriving from the growth-and-form aesthetic, seems to represent an internalization of the medical perception of the human condition. It visualizes, not an external perception of the human body, but rather the body's insides. This interpretation, however, fails to do justice to the clearly monstrous, hostile aspects of the sculptural object, produced by the scaling-up of a cellular object to anthropomorphic proportions. Contemporary viewers might have been reminded, not of mental synapses, but rather of invading viruses or cancerous tumours, the horrors of bacteriological disease.

Butler's further development saw him increasingly representing fears, threats and extreme physical or psychological pain. As the artist shifted again, this time away from abstraction now to a more figurative idiom, none of the psychopathological content was lost; the 'disturbed' nature of the work was only further exaggerated. The important point here, though, is that Butler's highly sexualized, straining female figures, tortured, flayed and worryingly contorted, cannot be described as portraits of psychiatric ill health. They might though be the victims of psychiatric perception, the objects of an obsessive interest. In fact, Butler seems to reflect in his later work the tendency to demonize the schizophrenic sufferer, who was often thought of as hostile and dangerous. Thus he invests in his sculptures an unmistakable sado-masochistic content, as though the work represents a working-through of salacious fantasies and obsessions.[21] Yet, Butler's 'retreat from publicity into a private world', as Richard Calvocoressi has described the apparent onset of an obsessional neurosis, does not necessarily indicate the artist's personal decent into actual mental anguish or ill health. Butler's work more plausibly represents a very deliberate and canny 'determination'. His move away from the earlier 'iron image' instead to pursue what he called a 'double image' brought him into line with a 'Surrealist pattern of remote archaic presences with multiple associations'.[22] By creating a 'schizoid vision', Butler seems to have been consciously intending to produce an ambivalent, or even hostile, reactive response.

But why would he want to do this? There was a parallel shift at this time in the approach that some psychoanalysts decided to take with respect to their encounters with schizophrenic patients. One of the leading theorists in this field, Wilfred Bion, argued that what was required for the treatment of schizophrenic patients was a more empathetic but also a more

confrontational approach. There emerged in the records that he published of his work with schizophrenic sufferers a far darker picture of what being schizophrenic might be like, and what engaging with the schizophrenic patient might actually entail. Bion was particularly interested in the problematic nature of the analyst-schizophrenic relationship. He endeavoured to work towards an 'endo-psychic perspective', but found schizophrenics to be extremely uncooperative and evasive – further evidence, he thought, of the entrenched nature of their illness and the innate envy and greed he supposed had caused it. With schizophrenic patients, Bion discovered, problems of 'transference' and 'counter-transference' were highly exaggerated.[23] It was par for the course that schizophrenic analysands would project onto their analysts that which the French theorist, Lacan, had referred to as 'imputations of noxiousness'.[24] Patients would use the full gamut of hostile projections as Lacan described them: 'distortion of intention', 'appropriation of secrets', 'violation of intimacy', 'spying and intimidation', and so on. They did this in order to wrong-foot the analyst, self-destructively preventing any therapeutic benefit, so much so that the analyst was compelled, Bion thought, not to ignore these 'imputations' but rather to return a schizoid attack with an equally strong, but therapeutic, counter-attack. In a typical encounter, Bion noted that his patient was getting more and more agitated: the patient's fists were clenching 'till the skin over the knuckles became white'.[25] But, in accordance with new his theory of the possible therapeutic value of projections of aggression, Bion let the tension mount until, at the crucial moment, he delivered his own well-timed withering repost, heading off actual violence by the aggression of his own unsympathetic, indeed punishing reply. 'You have been pushing into my insides the fear that you will murder me', Bion suggested to the hostile patient bearing down on him; 'you took your fear that you would murder me back into yourself … you are now feeling afraid'.

Bion's descriptions of the analyst-schizophrenic relationship supply a set of strong images that may indeed have caught the eye of British sculptors interested in exploring both physical and psychological violence. In Bion's description, the patient becomes an aggressive monster who lurches towards the analyst, recklessly projecting his or her fragmented thought with the clear intention either of harming him or of gaining position. The schizophrenic refuses sympathy, and so both needs and demands an aggressive response. Therapy, if it did not descend into actual violence, was transformed by Bion and others into a highly electric engagement conducted between two, as it were, fencing partners. Even just a casual familiarity with the psychoanalytic literature would have been enough to give the impression of a dramatic psychological battle being waged in the psychoanalytic consulting room. A more detailed reading would have shown protagonists utilizing ever more

ingenious applications of counter-accusation and threat, verbal thrust and parry. In such a scenario, the schizophrenic changes from a pathetic figure into a kind of anti-hero. Certainly Bion found the schizophrenic patient to be a more than capable adversary. In fact, the schizophrenic's deftness with hostile linguistic projections impressed the analyst so much that he began taking an interest in the unusual thought processes that schizophrenic language-use seemed to reveal. Often thought to be simply irrational and dysfunctional, Bion instead found that schizophrenics had an unusual ability to formulate and project their disjointed thoughts. This was evidence, he thought, not of language breakdown, but rather of a 'determination ... to be as many people as possible, so as to be in as many places as possible, so as to get as much as possible – in fact timelessly'.[26] It was the patient's own determination that had produced someone who was not only damaged, greedy and infantile, but who was also a skilful conceptual strategist – a linguist, in other words, with a warped, but impressive and intriguing, intelligence.

This new picture of the schizophrenic, not as a 'sufferer' but as an adversary, not only produced a more dangerous, yet appealing, image of the schizophrenic, it also made 'schizoid linguistics' a new object of study. This seems to have extended to art practice, where 'schizoid linguistics' became a viable artistic strategy and a last reconfiguration within the 'geometry of fear'. Perhaps the best example of this can be found in the setting of 'This is Tomorrow' (1956), an exhibition installed at the Whitechapel Galleries in South London. At the heart of 'This is Tomorrow' four artists erected a diffuse and afocal piece that matches the descriptor 'schizoid' on several counts. Designed by the architects Alison and Peter Smithson, the photographer Nigel Henderson, and the sculptor Edouardo Paolozzi, it was given the plain, yet intriguing, title 'Patio and Pavilion' (1956) (Figure 5.6).[27] With its dishevelled and tacked-together appearance, 'Patio and Pavilion' was instantly recognizable as 'oppositional', an 'outsider' piece. Rather than a positive contribution, in tune with the exhibition's aims, 'Patio and Pavilion' instead seemed to go against the exhibition's famous light-hearted and visionary spirit. In fact, like *Oracle*, 'Patio and Pavilion' might be described as a tumourous invasion, so that a fellow exhibitor even went so far as to describe it later as 'ludicrously antediluvian'.[28] Group Six did not deny their antagonism to mainstream art and architectural expression, but they simultaneously claimed to be in line with the exhibition's 'future' theme. 'Patio and Pavilion', however, was an alternative vision of the future. It was intended as 'a reminder of other values, other pleasures', which, the group felt, had been forgotten or neglected in the rush to advance the so-called Brutalist aesthetic.[29]

Rather than Brutalism, Group Six advocated the adoption of their 'As

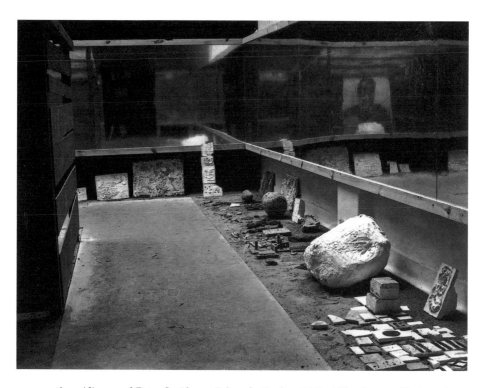

5.6 Alison and Peter Smithson, Eduardo Paolozzi, Nigel Henderson, 'Patio and Pavilion', installed at the exhibition 'This is Tomorrow', 1956, Whitechapel Art Gallery, London

Found' principle, 'where the art is in the picking up, turning over and putting with'. By selecting and scattering natural and discarded objects, the group sought to create a 'random aesthetic' that incorporated, not only mankind's aspirations and technological ambitions, but also his 'irrational urges'. 'Patio and Pavilion' was not so much 'designed', the group claimed, as 'willed to happen'; 'design' in fact 'was a dirty word'. The intention was to represent, not technical achievement and images of perfection, but rather natural chaos and technical dysfunctionality. This extended even to the idea of working in a team. In an essay that the Smithsons wrote much later, they reflected on how their 'collaboration' with Paolozzi and Henderson was a demonstration of 'another attitude to "collaboration"' – not teamwork but anti-teamwork – so that at every stage of the process, the group worked against a cohesive principle and instead welcomed a fragmentary, subjectivist approach. This extended even to the team's use of language: Paolozzi and Henderson were often 'excruciatingly funny, especially in word-play and cross-reference'.

That this was an outsiderist, oppositional, *a rebour* piece therefore seems beyond question. But to further suggest that 'Patio and Pavilion' was an exercise in 'schizoid linguistics' requires further demonstration. This is to hypothesize that the aggressive, primitivist and disjointed visual and verbal linguistics of 'Patio and Pavilion' can be likened to the schizophrenic language patterns and content observed and recorded in the psychoanalytic literature. First, we should remind ourselves of the 'normal' patterns of language that the 'abnormal' pathological work sets itself against. The other 'This is Tomorrow' exhibitors took the analyst's position: commercial 'New Elizabethan' society lurched, as it were, towards them, and they responded by normalizing apparent chaos. Group Six, however, worked from the analysand's position. Rather than looking at the shiny new signifiers of modern living, instead the group looked at what commercialism had discarded or overlooked. The catalogue introduction claimed that 'Patio and Pavilion' described 'the fundamental necessities of the human habitat',[30] yet the choice of 'necessities' seemed deliberately arbitrary rather than 'fundamental'. Margaret Garlake has gone further: she regards the symbolism of 'Patio and Pavilion' as 'largely unintelligible', reminding her of 'the finely balanced blend of existential *angst* and black humour that sustained Vladimir and Estragon'.[31] Vladimir and Estragon were the two down-and-out protagonists of Beckett's popular post-war play, *Waiting for Godot* (1952). Garlake's suggestion, therefore, is that 'Patio and Pavilion' is unintelligible in a Beckettian sense. She is not for one moment suggesting that the work is meaningless, rather that there is no simple closure of meaning, only endless, pointless, darkly amusing complexity.

Black humour, Bion might have observed, is frequently employed by the schizophrenic as another weapon in his or her armoury. In 'Language and the Schizophrenic' (1955) Bion describes how a patient once came into the consulting room, shook the analyst warmly by the hand, looked 'piercingly' into his eyes, and spoke in a characteristically disjointed fashion. He began: 'I think these sessions are not for a long while but stop me ever going out'; followed by: 'How does the lift know what to do when I press two buttons at once?'[32] Bion's interpretation of these two seemingly disconnected utterances is that the first statement was used to 'split the analyst', while the second – the riddle of the lift – symbolizes the splitting action that had just been employed. 'Pressing two buttons at once' is actually a very apt description of what is supposed to happen in the schizoid attack. It describes perhaps the 'double image' that Butler was aiming to achieve or the primary split that Chadwick almost literally illustrated. The effect of employing language in this way is to create a feeling of consternation in the recipient. Just as the lift will struggle to know which direction to travel in when both buttons are pressed, so the analyst will feel similarly torn, making him- or herself vulnerable to further splitting attacks.

'Patio and Pavilion' similarly seems to present us with a visual symbolism comprised of a string of disjointed double-images delivered in rapid succession:

the head – for man himself – his brain & his machines ... the tree-image for nature ... the rocks & natural objects for stability & the decoration of man-made space ... the light box – for the heart & family ... artefacts & pin-ups – for his irrational urges ... the frog & the dog – for the other animals ... the wheel & aeroplane – for locomotion & the machine.[33]

Each symbol is disarmingly explained and seems simple enough. But the doubling of the image along with its stream-of-consciousness delivery is enough to give the impression of unintelligibility. What does it all mean, and – more importantly – what is it trying to do to me? As Garlake found, further contemplation of the philosophical intentions of the artists only increases the sense of paradox and puzzlement. How can a team not be a collaborative? How can design work not be designed? How can modern living be lived out in a ramshackle environment? The trick, Bion reasoned, was not to answer such questions directly, not to dissect in the usual analytic fashion the schizoid utterance as though it represented normal rational thought. Rather, he suggested, we should recognize its utter abnormality and the hostility that such a reckless use of language represents. Bion's suspicion (which echoes the level of suspicion felt towards 'Patio and Pavilion' at the time) was that what the patient was really attempting to do was split the analyst. The use of schizoid linguistics, in other words, was not only aggressive; it also indicated an intention to extend schizophrenic perception to others.

If Bion is to be believed, the user of schizoid linguistics is intent on spreading illness and abnormality. We have said a similar thing about Butler's intentions. If Butler set out to occupy a schizophrenic perspective, to produce a schizoid vision, then what he was also doing was inviting the viewer to share in the schizoid condition. The use of schizoid linguistics in installed works seems to represent a further widening and deepening of this splitting strategy. In the case of installation work, objective viewing is no longer available, since an external perspective does not reveal the work adequately; only an endo-psychic perspective is effective. As a result, the viewer becomes absorbed in the work and the schizoid engagement begins. In the case of 'Patio and Pavilion', absorption in the work is achieved by the use of a mirror strip around the inside walls. This would not only have had the effect of 'opening up' the space; more importantly, it would have created a kind of split perception, causing the multiplication of an already schizoid vision and the endless repetition of an already indecipherable script. The use in 'Patio and Pavilion' of mirrored walls, in other words, can be regarded as further evidence of schizoid greed; it reveals the 'determination' that Bion

talked about 'to be as many people as possible, so as to be in as many places as possible … in fact timelessly'.

Notes

1. C.G. Jung, 'The Undiscovered Self' (1957), in H. Read, M. Fordham and G. Adler (eds) *The Collected Works of C.G. Jung*, vol. 10, *Civilization in Transition* (1964), trans. R.F.C. Hull, London, 1964.

2. H. Read, 'New Aspects of British Sculpture', *The XXVI Venice Biennale, British Pavilion*, exh. cat., London, 1952.

3. H. Read, 'Psychoanalysis and the Problem of Aesthetic Value' (1951), in *The Form of Things Unknown*, London, 1960, p. 90. I discuss this topic in greater detail in 'Despair or Defiance: the double inflection in Herbert Read's geometry of fear' (2004), in M. Paraskos (ed), *Seizes Power: Papers from the Herbert Read Conference*, forthcoming.

4. H. Read, 'Realism and Abstraction in Modern Art' (1950), in *The Philosophy of Modern Art*, London, 1964, p. 97.

5. E. Neumann, *The Archetypal World of Henry Moore*, trans. R.F.C. Hull, New York and Evanston, 1959, p. 158.

6. Pioneering figures include Herbert Rosenfeld (1910–86), who in the 1950s began making hospital visits, and Wilfred Bion (1897–1979), who preferred to see patients at his Harley Street clinic.

7. A. Stokes, *Reflections on the Nude*, London, 1967, p. 29.

8. See, for example, A. Stokes, 'The Luxury and Necessity of Painting' (1961), in *Three Essays on the Painting of Our Time*, London, 1961, pp. 1–24.

9. Stokes had a brother, Geoffrey, who was hospitalized due to shell-shock, and a daughter, Ariadne, who was initially diagnosed with schizophrenia. See J. Sayers, *Kleinians: psychoanalysis inside out*, London, 2000, pp. 69–90.

10. P. James (ed), *Henry Moore on Sculpture*, London, 1966, pp. 108–9.

11. Read, 'New Aspects of British Sculpture', unpaginated.

12. Quoted by L. Alloway, 'Britain's New Iron Age', *Art News*, Summer 1953, extract in P. Black, *Geoffrey Clarke, Symbols for Man: sculpture and graphic work 1949–94*, exh. cat., London, 1994.

13. Particularly important in the development of this theory was the Scottish analyst Ronald Fairbairn (1889–1964). See J.S. Grotstein and D.B. Rinsley (eds), *Fairbairn and the Origins of Object Relations*, New York and London, 1994.

14. See E. Trist and H. Murray (eds), *The Social Engagement of Social Science*, vol. 1, 'The Socio-Psychological Perspective', London, 1990.

15. 'Fear of annihilation' appears early on Klein's post-war writings, but Freud's 'fear of castration' is not taken issue with until 'Envy and Gratitude' (1957). See M. Klein, *Envy and Gratitude & Other Works 1946–1963*, New York, 1975.

16. M. Klein, 'On the Theory of Anxiety and Guilt' (1948), in *Envy and Gratitude & Other Works*, p. 29.

17. S. Freud, 'Splitting of the Ego in the Process of Defence' (1940), *Standard Edition*, Vol. 23, pp. 271–8.

18. M. Klein, 'Notes on Some Schizoid Mechanisms' (1948), in *Envy and Gratitude & Other Works*, p. 16 ff.; further developed in M. Klein, 'Envy and Gratitude' (1957), pp. 191 ff.

19. The psycho-social idea of 'mass neurosis' was developed in the 1950s by a range of psychoanalytic thinkers, from Erich Fromm to R.D. Laing. It derived from the 'mental-hygiene' movement of the 1920s and the pioneering work of Wilhelm Reich. See M. Higgins and C.M. Raphael (eds), *Reich Speaks of Freud*, London, 1967, pp. 76 ff.

20. The 'growth and form' aesthetic, which produced the exhibition 'Growth and Form', was based on the writings of Sir d'Arcy Wentworth Thompson (1868–1948).

21. Calvocoressi talks of a 'mania for precision', and says that Butler 'was a perfectionist who clearly grew obsessive towards the end of his life'; R. Calvocoressi, *Reg Butler*, exh. cat., London, 1983, p. 27.

22. Calvocoressi, *Reg Butler*, p. 20.

23. For explanation of this problem, see M. Klein, 'The Origins of Transference' (1952), in *Envy and Gratitude & Other Works*.

24. J. Lacan, 'Aggressivity in Psychoanalysis' (1948), trans. A. Sheridan, *Ecrits: a selection*, London, 1977.

25. W. Bion, 'Language and the Schizophrenic' (1955), in M. Klein et al. (eds) *New Directions in Psychoanalysis*, London, 1955, p. 224.

26. Bion, 'Language and the Schizophrenic', p. 223.

27. Group Six's 'Patio and Pavilion' was in fact installed at the far end of the galleries, but was sixth in a series of twelve installations intended to be read in sequence.

28. Colin St. John Wilson in a BBC Radio Third Programme arts review panel discussion, broadcast 17 August 1956; transcript in the Tate Gallery Archive.

29. A. and P. Smithson, 'The "As Found" and the "Found"', in D. Robbins (ed), *The Independent Group: postwar Britain and the aesthetics of plenty*, exh. cat., Los Angeles, 1990, p. 201.

30. Group Six catalogue entry, 'This is Tomorrow' (1956), reproduced in Robbins (ed), *The Independent Group*.

31. M. Garlake, *New Art, New World: British art in post-war society*, New Haven and London, 1998, p. 143.

32. Bion, 'Language and the Schizophrenic', p. 226.

33. Facsimile reproduction, in Robbins (ed), *The Independent Group*, p. 155.

INSTALLATION AND PERFORMANCE

Jean-Jacques Lebel: Anti-sculpture and anti-psychiatry

Alyce Mahon

In 1994 the Centre National d'Art et de Culture Georges Pompidou in Paris organised an exhibition entitled 'Hors Limites: L'Art et la Vie 1952–1994'. It was a group exhibition of artists whose work demonstrated a particular need to bring art and life together, specifically to give form to their radical political attitudes.[1] The exhibition included the work of Vito Acconci, Ben, Guy Debord, Dick Higgins, Allan Kaprow, Carolee Schneemann, Daniel Spoerri and Nam June Paik. All these artists chose to work in diverse art media in a defiant challenge to cultural and social orthodoxy. Many had been key players in the cultural and political revolution of May 1968.

It was fitting that an exhibition which paid homage to the artistic generation of 1968, and to its antecedents and heirs, should be housed in the Centre Pompidou, a project born of that turbulent year. The Pompidou, a spectacular contemporary building designed by Richard Rogers and Renzo Piano for modern art, design and cultural events, is a space which might be said to embody the tensions between art and society which that generation of artists battled with. Founded by President Georges Pompidou in 1972, it was an official site of French cultural nationalism, and yet it was built in Les Halles, the market quarter of Paris, which, as Simon Sadler has explained, was one of the key sites of the revolutionary events of May 1968.[2] The Pompidou filled a void at the centre of Paris's 'psychogeographic' map when it was first opened. Paradoxically, it institutionalised culture on behalf of the state on precisely the spot at which the anti-institutional struggles of May 1968 had been most intense. Yet, as a building and an art institution it took on an architectural form and a cultural policy that embraced the principles of 'flexibility' and 'participation' which Guy Debord and others had promoted in their cultural practice.[3] Many of the works on exhibit in the 'Hors Limites' show spoke to this paradox: as part of a historical retrospective at the

Pompidou where they were chosen to represent the radical agendas of an era, one could argue that they were institutionalised and canonised in the process, and yet as art-works their forms and themes were intended to wreak havoc on all concepts of order, categorisation and orthodoxy.

Perhaps more than any other single artist whose work was exhibited at 'Hors Limites', Jean-Jacques Lebel epitomised the radical innovation of form and politics associated with 1968 in the sculptures and 'Happenings' for which he became known. Lebel's art is particularly revealing of the engagement with the tensions between art and life, avant-gardism and political activism, which concerned his generation. Two of Lebel's sculptures exhibited at 'Hors Limites', *Portrait of Nietzsche* (1962) (Figure 6.1) and *Monument to Félix Guattari* (1994) (Figure 6.2) – straddled some thirty years of his artistic production and dated from the high points of modern and postmodern art practice respectively. The former was a large 'changeable sound sculpture', and a collage of personal memorabilia, games, jokes and literature. The latter was a gargantuan installation, made up of an automobile, bed, televisions and a huge metal heart. These two works, and an earlier sculpture whose central figure was made of a found piece of tree trunk, a skull and a wig, *Monument for Antonin Artaud* of 1959 (Figure 6.3), will provide the main focus of this essay, in which I hope to show that Lebel's sculpture has been at the forefront of politically committed art practice since the late 1950s, particularly in its dissolving of the boundaries between sculpture and performance.

These works typify Lebel's contribution to sculpture's loss of fixed form and its traditional high-art status after World War II and its turn in new, performative directions. Each work was a 'monument' to a major figure in twentieth-century intellectual thought – Nietzsche, Artaud and Guattari – but rather than present us with monoliths, Lebel portrayed all that these three men stood for through fragmented, multimedia sound sculptures which demanded the participation of the spectator for their completion. Lebel's *Monument for Antonin Artaud* and *Portrait of Nietzsche* articulate the distinctive cultural radicalism of the 1960s, a decade which marked the beginning of the end of modernity and of the avant-garde. His *Monument to Félix Guattari* articulated an attempt to recoup that radicalism in the 1990s as a reminder of art's political responsibility, despite the stultifying mass consumer culture which all too often goes unchallenged in the anything-goes pluralism of the postmodern era.

Of course, Lebel's career has been characterised by his own chameleon-like pluralism: as well as being a sculptor, he is a painter, performance artist, orchestrator of Happenings, a filmmaker, writer and curator. His defiant individualism, 'lack' of formal discipline, and artistic nomadism have meant that he has all too often been neglected in the history of modern sculpture.

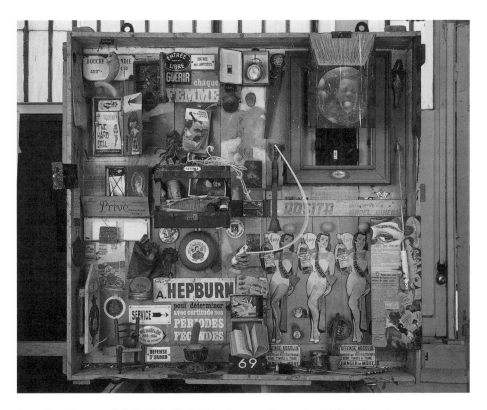

6.1 Jean-Jacques Lebel, *Portrait of Nietzsche*, sound, wood, metal, antler, glass, paper, leather, feathers, electricity and green cactus, 1962

Though both *Monument for Antonin Artaud* and *Portrait of Nietzsche* are separated by thirty years from *Monument to Félix Guattari*, each work, in its own way, pushed the limits of sculptural practice, using space as a creative medium and engaging the spectator in radically new ways. Moreover, all shared a thematic preoccupation with *desire*, a concept which has informed all Lebel's work: not romantic, idealistic desire, but a highly politicised desire considered as a means of articulating the repressiveness of bourgeois society and its institutions, the poverty of mainstream western culture, and the problems of modern alienation and postmodern fragmentation. When faced with a sculpture by Lebel, the spectator has to reconsider the very concept of the work of art, and appreciate, formally and ideologically, the liberating powers of confusion, incoherence and multiplicity. The spectator has to abandon traditional artistic expectations and open his or her mind to a seemingly irrational collection of objects, texts and sensory details which happily defy any narratival or formal cohesion.

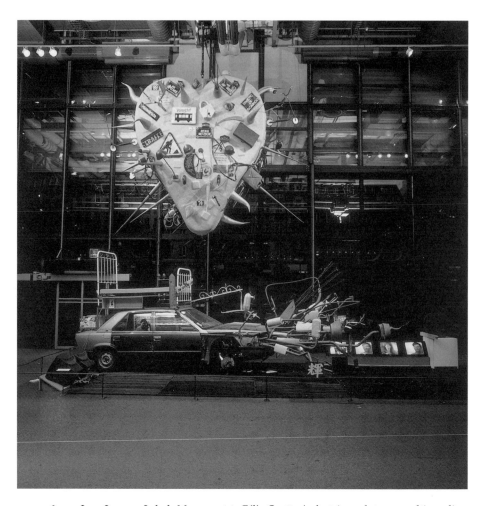

6.2 Jean-Jacques Lebel, *Monument to Félix Guattari*, electric sculpture, multi-media machine, 1994

A little biographical background allows us to begin to locate Lebel within a historical frame. He was born in Paris in 1936, but spent part of his childhood in New York as his parents fled there during the War. It was in the United States, as a young teenager, that he was exposed to the ideas of John Cage and the music of Dizzy Gillespie. Lebel's artistic practice, which he himself views as 'Neo-Dadaist', was born of a great respect for Francis Picabia and Marcel Duchamp and their fusion of the mechanical and the erotic, chance and subversion.[4] Recognising, in his own words, that 'since Picabia, Duchamp and their friends put culture on fire, the words *art* and

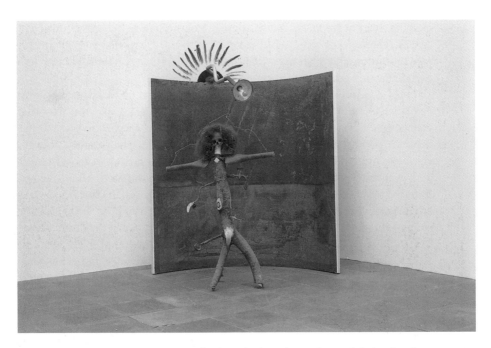

6.3 Jean-Jacques Lebel, *Monument for Antonin Artaud*, wood, metal, hair, electric light bulb and painted skull, 1959

crisis have designated one and the same phenomenon', Lebel has been concerned to liberate art from formal and metaphysical constraints and to abolish the barrier between art and society.[5] Picabia and Duchamp were not abstract figures for the young Lebel: his father, Robert Lebel, penned the first monograph on Duchamp, published in 1959.[6] Lebel had the opportunity to meet his father's friends and both Duchamp and André Breton were like father-figures to him as a young man. The first art movement Lebel was affiliated with was the Surrealists (including José Pierre, Jean Schuster and Jean-Claude Silbermann), from 1956 to 1960. Surrealism became a key part of his artistic vision, introducing him to new artists, writings and psychoanalytic theories, and he participated in the Surrealists' international exhibition dedicated to EROS in the Cordier Gallery in Paris in 1959. Lebel's drawing–collage entitled *André Breton et Guillaume Apollinaire (rêve du 30 juin 1956)* reveals his early explorations of many of the psychoanalytic themes of Surrealism as well as his attempt to remain true to the absurdism of Dada. The drawing–collage was inspired by a dream and depicts Breton in the guise of a wolf (a cut-out) and a loosely drawn portrait of Apollinaire, alongside the ominous words 'la vie est courte, je ne veux pas le dire tout de suite' (life

is short, I do not want to say it immediately). Here Lebel teases out Dada tropes (chance, cut-outs, word–image play) and Surrealist tropes (dream, psychic automatism, bizarre juxtaposition of images), while all the time demonstrating an Oedipal struggle with his mentors.

Lebel was more inclined towards direct political action than the Surrealists or Dadaists, however. His other influences lay in the theatre: the absurdist, collage-like approach to design and performance of Kurt Schwitters' 'Merz theatre', based on 'equality in principle of all materials, equality between complete human beings, idiots, whistling wire netting, and thought pumps'; and Antonin Artaud's theatre of 'total liberty', initiated when Artaud founded the Théâtre Alfred Jarry with Roger Vitrac in 1927, and later advanced in his conceptualisation of a 'theatre of cruelty' in which Artaud proposed a theatre 'as bloody and as inhuman as dreams'.[7] Lebel's exposure to new performance art in New York in the 1950s, much of it informed by Artaud – for example, Claes Oldenburg's Ray Gun Theater and Julian Beck and Judith Malina's Living Theatre – also propelled him towards bold, confrontational means of theatrical expression. Likewise, Lebel's exposure to Beat culture in the 1950s, notably to William Burroughs and his 'sensory-overload' writings and to Allen Ginsberg's individualised 'protest poetry' such as his ground-breaking 'Howl' poem of 1956, drew him towards new means of word and sound expression.

These influences tended to move Lebel away from Surrealism and, combined with his political involvement with anarchist groups supporting the Algerian anti-colonialist struggle, to make him more and more radical and increasingly removed from the Parisian art scene (to avoid conscription in the Algerian War of 1954–62 Lebel spent most of his time during that period outside France). He claimed he was 'liberated' when he was excommunicated by the Surrealist group in a tract entitled 'A Vous de Dire' which was published against him on 9 February 1960. Signed 'for the Surrealist movement' by Jean-Louis Bédouin, Robert Benayoun, André Breton, Alain Joubert, Gérard Legrand, José Pierre, Jean Schuster, and Jean-Claude Silbermann, here the Surrealists took issue with Lebel's anarchy and individualist revolt, and his insistence on concrete political action.[8] In their opinion, he had moved too far from the Surrealist group and its 'intellectual preoccupations and moral engagements'.[9] They were right.

Once 'liberated', Lebel decided his art was about 'poésie directe', a term derived from the anarchist notion of 'action directe', in which Lebel aimed to practise his art without the restraints of traditional notions of creativity.[10] Here again, he was influenced by Artaud. In Le Théâtre et son double (1938), which includes his writings on a 'Theatre of cruelty', Artaud had written of a metaphysical theatre which would link the spectator and the spectacle in a radically new way, establishing the theatre as the modern-day space of

(mythic, religious) ritual and dream.[11] Artaud saw the theatre as a site of resistance, a space and experience which could assault the spectator and lead to spiritual purging. His stance on theatre was influenced by a visit to Mexico in 1936 to study the society of the Tarahumara Indians. In his account of his visit to Mexico, *D'un Voyage au Pays des Tarahumaras* (1945), Artaud had written of the mind-altering experience of the Tarahumara Indian ceremonies, especially one in which goats were slaughtered and grated peyote (a form of mescaline) was handed out.[12] The drug, used by the Tarahumara since long before Columbus, produced fantastic colour hallucinations. This experience inspired Artaud to insist that society needed to have 'an active culture', a culture that was like 'a kind of second wind growing within us like a new organ' and that theatre should use 'all languages (gestures, words, sound, fire and screams)'.[13] Artaud argued for the need to change the traditional spectator–actor relationship by placing the audience *within* the spectacle. Lebel wanted to push the boundaries of art and life in similar ways.

In Lebel's 1959 *Monument for Antonin Artaud*, produced some ten years after Artaud's death in an insane asylum, we find a sculptural homage to Artaud and his radical ideas. The sculpture is mostly an assemblage: its 'body' is made from a tree stump and looks like a three-legged humanoid; the head is a real, found human skull in a state of decay, painted fluorescent pink, and wearing a long-haired wig. The stomach and the sex of the sculpture identify this sacrificial totem as Artaud himself. In its stomach we see a pair of eyes and a syringe: the former refers to the physical pain and suffering which overwhelmed Artaud in his later life (he died of cancer of the intestine); the latter refers to his use of drugs to escape the 'real' world, and to deal with his pain. The figure's multicoloured penis reminds the spectator that for the last twenty-five years of his life Artaud abstained from sex in order to, as he saw it, preserve his creative and psychic powers for the struggle against society. It also reminds us that, his abstinence notwithstanding, Artaud's art and writing were loaded with sexual frustration and desire. The figure is set on a 'stage', standing against a rusty iron backdrop and in front of a naked red light which flashes on and off as a signal of danger. Altogether the sculpture is a bizarre juxtaposition of the primitive icon and the modern-day machine. Lebel's own hallucinatory experiences at the time, his mescaline 'trips', lent the work an angst-ridden, paranoid edge. Attempting to share the disorientating experience of hallucinogenic drugs with the spectator, Lebel hoped his art would have a mind-altering power of its own: 'Thanks to art', he said 'the multiple states of the human being must, in spite of everything, become liveable possibilities. The only reality in art is furnished by the hallucinatory

experience, around which crystallise (ephemeral) rites, and around which our mythic thoughts express themselves'.[14]

In *Monument for Antonin Artaud*, Lebel turned away from collective *poeisis* towards *praxis* – that is, towards an activism which would become an increasingly characteristic trait of avant-garde artists in the 1960s. As Kristine Stiles has explained, in writing about the Fluxus movement, such praxis was 'the therapeutic practice of a specific system of agency. It include[d] actions in public or political life, and acts aimed at the recovery of something'.[15] Lebel wanted to reclaim primitive inhibition for an age that blindly worshipped the machine. He recognised, as did Artaud, that pre-logical or primitive peoples had much to offer so-called civilised peoples, and that the modern-day primitive, the artist, was all too often pacified, or 'suicided', by civilised society.[16] In keeping with Artaud's 'theatre of cruelty', Lebel was searching for an art that was true to the idea of 'theatre in the round', a theatre that mediated between art and life and insisted on illogicality in a moralising, repressive world. Lebel was also not alone in his celebration of an Artaud-like assault on culture at this time: even in critiquing 'the overrated cadaver of Antonin Artaud', the Lettrist International (a splinter group from Isidore Isou's Lettrist group, founded in 1952 by Gil J. Wolman, Jean-Louis Brau, Guy Debord and Serge Berna) had revealed its awareness of the influence of Artaud and his writings on the post-war generation.[17] However, going beyond the Lettrists' largely linguistic interest in Artaud, Lebel would seek to deploy Artaud's 'cruelty' in his art in a manner which would be politically charged, but without being politically prescriptive. As he and other young artists, such as his friend the Icelandic artist Erró, became increasingly disillusioned with the society in which they lived and its political and cultural bureaucracy, they 'were not doing social realism or even politically committed art' but they 'remained completely independent of all power structures'.[18] They increasingly felt a need for political action. As Lebel has explained, 'I believed that society could and should be completely reinvented without falling into Stalinist–Leninist ignominy – that was the whole starting point of my world outlook'.[19]

Lebel's *Portrait of Nietzsche* (1962) announced this shift. For Nietzsche, culture was something which had to be *lived* rather than learned or taught:

[Culture is] before all things the unity of artistic style, in every expression of the life of a people. Abundant knowledge and learning, however, are not essential to [culture], nor are they a sign of its existence; and, at a pinch, they might co-exist much more harmoniously with the very opposite of culture – with barbarity: that is to say, with a complete lack of style, or with a riotous jumble of all styles.[20]

Hence Lebel's homage to the philosopher is inclined towards the barbarous and the jumbled: it is a changeable sound sculpture which invites

participation from the viewer in several ways, extending the spectator's appreciation of the work, offering multiple interpretations, and defying any one reading or meaning. The sculpture combines literature, poetry, music, games and children's educational projects. Kitsch images, street signs and tourist-like ephemera are juxtaposed, while potted cacti, pieces of string, little boxes and other pieces of recovered 'junk' invite the spectator to interact through playing with them. An extract from a newspaper features a reproduction of a suggestive photograph of Nietzsche with the Russian intellectual Louise von Salomé and the Jewish philosopher Paul Ree (the three briefly shared a *menage à trois*). The photograph, orchestrated by Nietzsche, was taken by the Swiss photographer Jules Bonnet, and shows von Salomé half-kneeling in front of a small farmer's cart, holding a whip, while Ree and Nietzsche stand in front of her, tied to her by ropes. The photograph reminds us of Nietzsche's maxim (spoken through the person of an old woman in *Thus Spake Zarathustra*), 'Are you visiting women? Do not forget your whip'.[21] To reinforce the idea, Lebel attaches an actual whip to his sculpture, which the spectator can touch and even use. A copy of Nietzsche's *Par delà le bien et le mal* (Beyond good and evil) is nailed to the sculpture above the label 'GÉNIE' (genius) and under the signs 'GUERIR' and 'chaque FEMME' (cure ... every woman)! The work includes objects which function to make sound: a saw, a bell, small doors, and a white toilet-flushing cord. In the centre of the piece, a small blue suitcase with the label 'LETTRES' (letters) juts towards the spectator. It contains the sculpture's 'secrets' – invitations, hand-written poems, private letters, a doctored postcard of the Mona Lisa, photographs, keys and personal memories – and it evokes Duchamp's infamous *Boîte-en-valise* (1935–41), a 'portable museum' in a box in which Duchamp presented miniatures of his own original works of art as a kind of ironic self-retrospective. It also reminds us of Fluxus games – for example, chess played on a backgammon board, cards played with a deck of 52 jokers, or Ben Vautier's macabre *A Flux Suicide Kit* consisting of a plastic bag containing a shard of glass, a razor, a fishing hook, matches, an electrical plug, a pin and a ball bearing. The ludic theme and encouragement of spectator participation continued in other details of Lebel's sound sculpture, notably the 'thermomètre Rimbaud', a thermometer which the spectator is invited to take from its vertical holder to measure his/her temperature and note it on a sheet of paper before placing the paper in the blue suitcase.[22] Instructions were available beside the thermometer. Other details were intended to evoke 'the sacred and the profane': according to Lebel, the horns of a goat, an artist's brush and an alarm clock.[23]

Altogether, *Portrait of Nietzsche* presents a playful critique of modernism and its elevation of genius, originality and value, through a celebration of the mass-produced, the banal, the discarded. It also stands in direct opposition to

the high finish of celebrated Pop sculpture of the time and its glossy, kitsch evocation of contemporary culture. Lebel examined key cultural-intellectual icons – Rimbaud, Picabia and Nietzsche – not key consumer icons such as Campbell soup cans or Brillo pads for which Andy Warhol was famous at the time. Of course, Pop artists' appropriation of consumer culture has led to both their condemnation and defence by art historians, depending on whether its exploration of 'signboard culture' is viewed as celebratory or subversive, but Lebel's art leaves no room for such debate. Where Lebel does draw on consumer kitsch in *Portrait of Nietzsche* – in three images of a pin-up girl in a yellow swimsuit – he juxtaposes it with electric warning signs stating in black 'DÉFENSE ABSOLUE' (absolute prohibition) and in bold red 'DANGER de MORT' (danger of death). In this way, high and low culture, the popular and the political, are never segregated. Ultimately, *Portrait of Nietzsche* is a monument to Nietzsche's promotion of the Dionysian over the Apollonian in art, as expressed in his analysis of Greek tragedy, *The Birth of Tragedy* (1872): through its allusions to sexual violence (the whip, the nail) and sexual consumption (the pin-up girls); through its interactive eroticism (Nietzsche saw all artistic creation as an expression of unfulfilled desire); and through its near-anarchistic defiance of visual 'closure' and its insistence on art as life.

At the same time as Lebel produced *Portrait of Nietzsche*, he became increasingly involved in political activity. He had published *Front Unique*, a poetry protest magazine in Milan from 1956 to 1960, and in 1961 he produced a vast canvas (4 × 5 metres) against the Algerian war entitled *Grand Tableau Antifasciste Collectif* (with Enrico Baj, Roberto Crippa, Gianni Dova, Erró and Antonio Recalcati) and exhibited it at 'L'Anti-Procès' in Milan that year, a manifestation and exhibition against the war in Algeria and against the use of torture by the French authorities there.[24]

Lebel also launched his own version of the Happening, a radical new form of art which brought together theatrical performance and installation art. For Lebel, art could no longer be 'stuck to a limited, flat surface', as it was in Abstract Expressionism, the epitome of 1950s art; it had to take over space itself in keeping with a 'Neo-Dadaist' agenda.[25] Where Abstract Expressionists such as Jackson Pollock had made the bodily gesture a key component of fine art in the aftermath of the war, the Happening made space itself the canvas and allowed several bodies to make their gestural mark on and in it. In keeping with Duchamp's and the Surrealists' use of space to simultaneously fascinate and disorientate the spectator in their major international Surrealist exhibitions from 1938 to 1965, the Happening staged spaces of heightened tension, energy and anxiety.[26] The Happening went further than Lebel's Surrealist and Dada mentors: with it the traditional space, or safe distance, between artist and spectator was not simply challenged; it was done away with.

Indeed, the cultural historian Peter Wollen has described the 1960s as a whole as a 'performance eco-system' which witnessed the blossoming of a diversity of intuitive, multimedia approaches to performance in both the United States and Europe.[27] While Guy Debord led Situationism into the streets of Paris, encouraging the 'playful–constructive behaviour' of *dérive* (drift), Allan Kaprow was developing performance art, leading the way with *18 Happenings in 6 parts*, the first 'official' Happening, which he presented in October 1959 at the Reuben Gallery on Fourth Avenue in New York.

For Lebel, the collage-like approach of his sculptures logically extended into the actual living collages of the Happening, which sought to bring physical gesture and Dadaist assault together: in Lebel's words, as a means to the 'revolutionisation of desire': 'I knew that the "revolutionisation of desire" wasn't going to happen because of anything like mini-skirts, going topless or Timothy Leary's psychedelic bacchanalia. So around 1960 I got involved in something very libertarian, very "wild" that Allan Kaprow called Happenings'.[28]

The first European Happening, entitled *Enterrement de la chose* (Burial of the thing), was orchestrated by Lebel in 1960 in Venice with the participation of Gregory Corso, Pilar Pellicer, Alan Ansen and Frank Amey. During the 1960s, Lebel would organise numerous Happenings, performances and actions internationally, working with such artists as Kaprow, Erró, Carolee Schneemann, Yoko Ono, Nam June Paik and others; many were held at the Workshop of Free Expression, which he ran in the American Center in Paris from 1964 to 1966.[29]

Enterrement de la Chose addressed the violent death of Lebel's friend, the artist Nina Thoeren, who had been raped and strangled a few days before in Los Angeles. It evoked taboo and transgression and brought avant-garde theatre and sacred ritual together as a means of addressing both her violent death and contemporary political issues. It began in a dark hall with Lebel announcing Thoeren's death before a congregation gathered around the 'thing' of the Happening's title – a metallic body covered by golden drapes. The scene was lit by chandeliers and the action involved the reading of erotic prayers by two mourners, the playing of tapes of Dada sounds, and the dramatic sound of people crying (Figure 6.4). Then Lebel read a passage from the writings of the Marquis de Sade, announcing that Christian religion would be banned and all taboo allowed; then a gong was sounded, applause ensued and the smell of sewage was released into the air. To add profane insult to sacred injury, a passage from Joris K. Huysman's biography of the child-murderer Gilles de Rais, entitled *La Bas* (Down There), was read before the metallic body was picked up and a procession begun as the mourners embarked on gondolas and dramatically continued their ritual up the Grand Canal, scattering white flowers in the water en route (Figure 6.5).[30] The

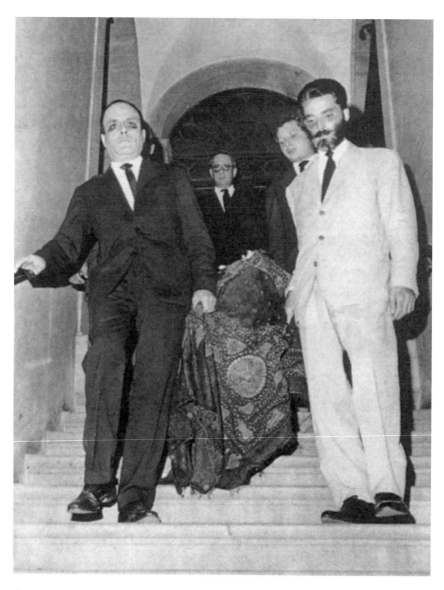

6.4 Jean-Jacques Lebel, *Enterrement de la chose*, Happening, Venice 1960

metallic body acted as a signifier of the deceased Thoeren in a collective performance which was a spiritual monument to a lost friend. The whole performance was a symbolic rite of passage to mark the difference between artistic creation and revolution (symbolised in the Marquis de Sade) and the actual obscenity of the real, murderous world. The very streets of the city

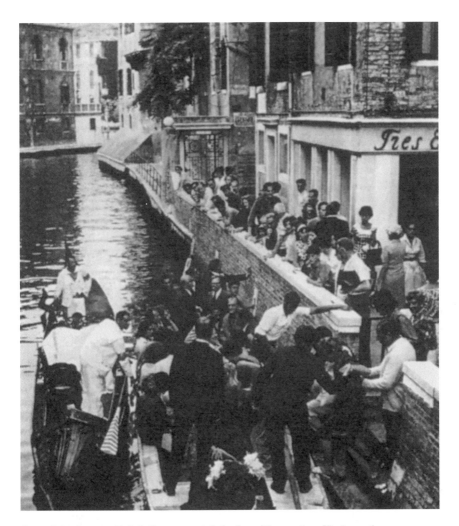

6.5 Jean-Jacques Lebel, *Enterrement de la chose*, Happening, Venice 1960

acted as a canvas and a stage for the artist, and sculpture was no longer confined to stasis. However, Lebel defied the label 'obscenity' often held against his generation's embrace of sexual liberation by using the Happening as a means of exposing the pretences of civilisation and the harsh reality that real obscenity lay in man's inhumanity to his fellow man, not in sexual desire and its expression. In this way the performance demonstrated Lebel's particular idea of the Happening as an event that was 'not just giving people something to look at, we have been giving them something to do, something to participate in and create with. We are giving them a language for their

hallucinations, desires and myths'.[31] Lebel lived as he preached, pushing the boundaries of his self as much as of art. As Barry Farrell wrote of Lebel's Happenings in *Life Magazine* in 1967:

[Lebel] serves as a psychic test pilot for his circle of friends and admirers, and he goes through his festivals tuned up to electric sleeplessness by the steady ingestion of various psychovitamins. He comes down from these periods giddy and totally debilitated, like a man gone miles outrunning a pack of dogs. His Happenings reach a pitch of demonic energy that can touch and trace all the ancient animal movements of the mind, and on stage Lebel is a witch doctor, a man of big magic. Away from it, though, the footing grows more treacherous and, at 28, he lives, as he says, 'on the verge of physical extinction, like a suicide or a criminal'. He preaches the movement's manifesto: that art should alter a person's idea of himself.[32]

The works discussed so far might be described as examples of art-works which are 'open', to use the concept developed by Umberto Eco in his ground-breaking 1962 book *The Open Work*. Eco explains the 'open work' as a 'work in movement': he gives the example of Alexander Calder's mobiles which 'continuously create their own space and the shapes to fill it'.[33] In literature, he gives the example of Stéphane Mallarmé's unfinished *Livre*, whose 'grammar, syntax and typesetting introduced a plurality of elements, polymorphous in their indeterminate relation to each other'.[34] The permeable and mobile characteristics of Lebel's sculptures allow them too to be categorised in Eco's terms: indeed, Lebel drew on Eco's concept in his own *Lettre ouverte au regardeur* (Open letter to the viewer), which was published in Paris by the English Bookshop in 1966.

Eco offers an analysis of the open work in the 1950s and early 1960s that is particularly revealing for our appreciation of Lebel's strategic use of many traditional art elements (paint, canvas, collage) to political effect. Eco writes of art produced at the time as having an openness that was 'intentional, explicit, and extreme – that is, based not merely on the nature of the aesthetic object and on its composition but on the very elements that are combined in it'.[35] Movement, vitality, metamorphosis – this is the stuff of openness. In *The Open Work*, Eco also insists that '[E]very reception of a work of art is both an interpretation and a performance of it, because in every reception the work takes on a fresh perspective for itself'.[36] He identifies the importance of *ambiguity* for the open work, recognising it as a trait which, as David Robey summarises it, is 'the product of the contravention of established conventions of expression: the less conventional forms of expression are, the more scope they allow for interpretation and therefore the more ambiguous they can be said to be'.[37] Meaning is not ascribed by the artist, rather each spectator can read into the work. In the process, the work is liberated from the artist and enters the world of the public. More importantly, for Eco, in its element of unpredictability, this openness and ambiguity deny conventional views of

the world, leading to an 'organic fusion of multiple elements' and a sense of 'alienation' which forces us to reach beyond our Self and to actively try to understand the world. The open work challenges us in this way but also allows us to then challenge the world in a similar manner – art becomes a key weapon in the transformation of the world. Lebel too insists on the element of multiplicity, plurality or polysemy in art, and the need for the spectator to be actively involved in the creative process. His art – from the monuments to Artaud and Nietzsche to his use of space as a sculptural medium in his Happenings – embodies this explicit openness. Lebel, like Eco, sees 'form as a field of possibilities'.[38]

The 'anti-psychiatrist' Félix Guattari (1930–92) recognised the open qualities of Lebel's art. Guattari's anti-psychiatry was a radical stance against Freudian psychoanalysis and what he saw as the 'imperialism' of its Oedipal framework which contained or neutered desire by keeping it within the family, refusing to allow it to spread out into the world. He argued against orthodox psychiatry, insisting on the need to liberate desire into the world. With the philosopher Gilles Deleuze (1925–95), he offered an anti-Oedipal, anti-hierarchical model of 'schizoanalysis' which resists psychoanalysis as a tool of bourgeois repression and promotes revolutionary 'desiring-machines' instead. Guattari recognised a fellow spirit in Lebel. He described Lebel as an artist who 'paints in order to construct himself through the emergence of his work'.[39] He saw Lebel's art not as a continuation of traditional forms such as painting but as a process of self-representation through a 'transversal interpenetration of the aesthetic, social and affective forms of application'. Guattari claimed that Lebel's art was not about 'the Self' but 'the fact that subjectivity is held captive in the ups and downs of an epoch'.[40] This process of self-representation is, for Guattari, one of 'blossoming' through the various 'means of communication' which constitute Lebel's sound sculptures and Happenings.[41] Guattari's reading of Lebel is not dissimilar to Eco's earlier description of openness, though Guattari codes 'openness' in terms of the discourse of 'becoming' which he had developed with Deleuze in the now-seminal texts of schizoanalysis: *Anti-Oedipus: Capitalism and Schizophrenia* (1972) and *A Thousand Plateaus: Capitalism and Schizophrenia* (1980).

Guattari's praise of Lebel is not merely intellectual. He and Deleuze were close friends of the artist – Deleuze from the mid-1950s and Guattari from the mid-1960s. The friendship of the three men was mutually influential and inspiring. Robert Fleck has written of the similarities between Deleuze and Guattari's theories and Lebel's practice, while Kristine Stiles has remarked that we should not only consider these similarities but also the importance of Lebel as a 'vector' for Deleuze and Guattari themselves.[42] In 1975, Lebel made a trip to the United States with them and introduced them to key

countercultural figures including the Beat writers William Burroughs and Allan Ginsberg, and the musicians Bob Dylan and Joan Baez.

Deleuze and Guattari's concept of the 'rhizome' (literally a horizontal, root-like stem, but a term they used figuratively to denote anti-genealogy, acentred systems, and non-hierarchical networks) seems to share much with the spirit of the Happening.[43] A rhizome does not begin and end, but is always in the middle, between things, inter-being. The Happening is a free-flow situation which incites spontaneous gestures and actions and is concerned with overthrowing ontology and hierarchies. In *A Thousand Plateaus*, Deleuze and Guattari show their debt to Lebel by specific reference to writers and artists they befriended through him. They admire William Burroughs's 'cut-up method' in writing as an example of the rhizome in action, and John Cage for his experimentation in music and performances 'against all structure and genesis' and 'against any kind of interpretation'.[44]

Many of these characteristics of Burroughs, Cage and Lebel were also those articulated by Deleuze and Guattari in *Anti-Oedipus*. For Michel Foucault, these included, first, the development of 'action, thought, and desires by proliferation, juxtaposition and disjunction, and not by subdivision and pyramidal hierarchization'; and, second, 'the connection of desire to reality (and not its retreat into the forms of representation)' as a 'revolutionary force'.[45] For Foucault, the two philosophers posed questions which were

less concerned with why this or that than with how to proceed. How does one introduce desire into thought, into discourse, into action? How can and must desire deploy its forces within the political domain and grow more intense in the process of overturning the established order? *Ars erotica, ars theoretica, ars politica.*[46]

Lebel posed similar questions in his art. His sculptures and Happenings were informed, like the theories of Deleuze and Guattari, by what Foucault identifies as 'Non-Fascist Living': that is, an opposition to the historical fascism of the 1930s and 1940s, and to the contemporary fascism of institutions of power and regimes of knowledge in western society.[47] As Deleuze and Guattari sought to counter what they saw as the restrictive binarism and Oedipal obsession of psychoanalysis, so Lebel's interest in the performativity of desire was not about the mapping out or unveiling of the 'unconscious', but about its anarchic and aesthetically immediate celebration.

Of course, as was the case for many intellectuals and artists in France and elsewhere, much of the steam went out of this celebration after 1968. In subsequent years, Lebel largely withdrew from the art world, setting up a commune in Normandy. From 1979, he devoted his energies to a new project which continues to this day, POLYPHONIX, in which he has organised international gatherings of artists, filmmakers, musicians, poets and others,

and which, for Guattari, was 'one of the only remaining counter-institutions in the spirit of May '68' (Figure 6.6).[48] Lebel began to exhibit art again in 1986, but his real return to the visual arts scene, after almost a thirty-year retreat, came in 1994 in the form of the sculptural homage to Guattari which Lebel produced in response to his friend's death in 1992. As the critic Robert Fleck has reported, many people thought that Lebel had gone artistically underground for good until they came face to face with his *Monument to Félix Guattari* in the foyer of the Centre Pompidou during the course of the 'Hors Limites' exhibition in 1994.[49]

The monument was a 'changeable sound sculpture', which consisted of Guattari's own Renault 25 automobile, its seats covered with vegetation, an old iron bed on its roof, discarded bits of wrought iron exploding out of its engine, and eight televisions arranged around it, each playing television programmes intercut with video recordings of Guattari reading poetry.[50] Suspended over the car was a massive metal heart pierced with metal spikes, children's scooters and petrol canisters, and labelled with numerous signs, including the mock-street signs 'Quai Antonin Artaud', 'Avenue Nietzsche' and 'Rue de Condé'. A recording of a verse by Mallarmé put to music by Gabriel Fauré played constantly in the background. Finally, a banner was suspended beside all these sculptural elements: a blown-up reproduction of a drawing, *Aristotle and Phyllis* (1503), by German painter Hans Baldung Grien (*c*. 1484–1545), in which the wise philosopher is shown to have fallen prey to the young maiden's charms as she literally rides him like a horse around a garden.[51] This monstrous multimedia machine defied all sculptural conventions and was greeted with surprise, curiosity and amusement by locals and tourists, students, art critics and homeless people who strolled into the Pompidou Centre during the several months it was on show.

On a formal level the *Monument to Félix Guattari* was a puzzling sculptural exercise: a car invaded by the natural world (leaves, grass, flowers and photographs of Guattari outdoors) that seemed to bring into a postmodern world Salvador Dalí's famous *Rainy Taxi* installation that had been staged outside the International Surrealist Exhibition at the Galerie Beaux Arts in Paris in 1938. Yet, as with all postmodern works, Lebel's installation introduced new elements of thought within its apparent pastiche of the past. This was not just an inverted sculpture (Dalí too put water, cabbages and live snails in his *Taxi* to bring the exterior world into the supposedly dry, safe world of the car). In juxtaposing the Renault, an icon of bourgeois France and French industry, with an old iron bed, Lebel brought the public/machine and the private/boudoir into dangerously close proximity. And he went further: in adding exploding scrap iron, television, the suspended pierced heart and the suspended erotic drawing, the installation became a Duchampian *machine célibataire*, exposing the tantalising gap between the mind and the body,

6.6 Jean-Jacques Lebel, Lawrence Ferlinghetti, and Félix Guattari, 2nd
International POLYPHONIX Festival, Paris 1980

desire and violence, love and destruction, the human and the machine. The
tension between the supposedly controlled world of media and the
uncontrollable world of *amour fou* was made visible.[52]

Lebel's *Monument to Félix Guattari* also acknowledged the need for
constant battle against all forms of fascism, signified by 'relics of suffering'
such as the juxtaposition of Nazi, American and Red Army helmets from
World War II.[53] It also made a statement about what Lebel saw as the urgent
need to recapture the anger and political agency of the 1960s – not out of
nostalgia but in the name of liberty itself. In evoking Dalí and Duchamp, and
in refusing to give the public a single, accessible narrative, the *Monument to
Félix Guattari* revealed its Neo-Dadaist agenda. It took aspects of collage
(composition of borrowed and original material) and assemblage
(composition consisting of an arrangement of miscellaneous objects or found
materials) and made space itself the sculptural work. It was both
'polytechnic' and 'polymorphous', involving video, painting, sculpture,

music, poetry and gardening; and it was 'polysemic' in so far as all these activities were in process at the same time, making for a fractured, disorientating and multi-layered sensory experience in which the spectator was an active participant.[54] In this manner, it typified Lebel's creative and philosophical outlook. Where most monuments act as memorials to historical events or people, this monument succeeded in venerating Guattari's philosophical outlook without venerating the concept of an artistic memorial in the process. Rather than present a monolithic sculptural statement about the deceased philosopher, Lebel allowed Guattari himself to appear and speak – literally, as a video recording of him was played on the televisions, and metaphorically, as the explosive postmodern world was staged in an installation that defied order and attempted to visualise the psyche at work. The monument seemed to stage a dialogue between two like minds, Lebel and Guattari, and their dialogue, in turn, with the spectator. Indeed, the spectator was not just invited to look, listen and think, but also to respond, literally, by posting his/her comments in a designated box in the installation.

In a letter to Lebel about the *Monument to Félix Guattari*, Gilles Deleuze explained that he viewed its suspended heart as 'a reference to an indescribable painting = volume' and its 'collective arrangement' as producing a machine which was 'incredibly powerful'.[55] Certainly, with this installation, Lebel succeeded again in the aim of bringing art and life together, defying boundaries (cultural, political, social, linguistic), and poking a finger in the eye of establishment values. That defiance continues in his work today.

Notes

I thank Jean-Jacques Lebel who has been kind enough to share his views and recollections with me during many interviews and conversations in the course of researching this essay.

1. *Hors Limites: L'Art et la Vie 1952–1994*, Jean de Loisy (ed.), exh. cat., Paris: Centre Georges Pompidou, 9 November 1994–23 January 1995.

2. Simon Sadler, *The Situationist City*, Cambridge, Mass., 1998, p. 64.

3. Ibid., p. 66.

4. Picabia's film *Entr'acte* (1924), for example, might be seen to presage Lebel's art forty years later in its wonderful exploration of sexual taboo, wit, ritual and theatricality.

5. Jean-Jacques Lebel, 'On the Necessity of Violation', *Happenings and Other Acts*, Mariellen R. Sandford (ed.), London, 1995, pp. 268–84, p. 271.

6. Robert Lebel, *Marcel Duchamp*, New York, 1959.

7. Kurt Schwitters, 'To All the Theatres of the World I demand the Merz Stage', cited in Rose Lee Goldberg, *Performance Art, from Futurism to the Present*, London, 1988, 1996 edition, p. 71; Antonin Artaud, 'The Theatre of Cruelty (First Manifesto)', *Collected Works of Antonin Artaud*, Vol. 4, trans. Victor Corti, London, 1974, pp. 68–76, p. 70.

8. Jean-Jacques Lebel, unpublished interview with the author, Paris, 15 May 1996.

9. 'A Vous de Dire', 9 February 1960, in *Tracts Surréalistes et déclarations collectives, Tome II* (1940–69), José Pierre (ed.), Paris, 1982, p. 183.

10. Jean-Jacques Lebel and Arnaud Labelle-Rojoux, *Poésie Directe*, Paris, 1994, p. 13.

11. Antonin Artaud, *Le Théâtre et son double* (1938), trans. Victor Corti as *The Theatre and its Double, in Antonin Artaud, Collected Works*, Vol. 4, London, 1974, pp. 1–110.

12. Antonin Artaud, *D'un Voyage Au Pays des Tarahumaras*, Paris, 1945.

13. Antonin Artaud, 'Theatre and Culture', preface to *The Theatre and its Double*, in *Antonin Artaud, Collected Works*, 1974, p. 2 and p. 5.

14. Lebel, 'On the Necessity of Violation', *Happenings and Other Acts*, p. 273.

15. Kristine Stiles, 'Between Water and Stone', *In the Spirit of Fluxus*, exh. cat., Minneapolis: Walker Art Center, 1993, pp. 62–99, p. 93.

16. Here I allude to Antonin Artaud's influential essay, 'Van Gogh, le suicidé de la société', Paris, September 1947.

17. Sadler, *Situationist City*, p. 106.

18. Jean-Jacques Lebel, in 'Jean-Jacques Lebel, oppositionnel, interview par Catherine Millet', *Art Press*, May 1996, no. 213, pp. 20–7, p. 24.

19. Ibid., p. 22.

20. Friedrich Nietzsche, 'David Strauss, the Confessor and Writer', *Thoughts out of Season*, cited in Frederick Copleston, *Friedrich Nietzsche, Philosopher of Culture* (1942), 2nd edn, New York, 1975, p. 32.

21. H.F. Peters, *My Sister, My Spouse: A Biography of Lou Andreas-Salomé*, New York, 1962, pp. 101–3.

22. The title of the thermometer was a reference to a painting by Picabia in his periodical *391*.

23. *Jean-Jacques Lebel, Bilder, Skulpturen, Installationen*, Uli Todoroff and Sophie Haaser (eds), exh. cat., Vienna: Museum Moderner Kunst Stiftung Ludwig, 1998, p. 198.

24. The *Grand Tableau Antifasciste Collecif* parodied the institutions of the State and Church and had a copy of the 'Déclaration sur le droit à l'insoumission dans la Guerre d'Algérie' of 1961 – a protest against the Algerian war signed by 121 intellectuals – pasted on it. Unsurprisingly, it was seized by the authorities and kept for some twenty-four years.

25. Lebel, 'Jean-Jacques Lebel, oppositionnel', p. 22.

26. For more on the Surrealists' radical use of the exhibition, see my essay 'Staging Desire', in *Surrealism: Desire Unbound*, J. Mundy and D. Ades (eds), London: Tate Publishing Ltd, 2001, pp. 277–91, and my *Surrealism and the Politics of Eros, 1938–1968*, London and New York: 2005.

27. Peter Wollen, 'Little Stabs at Happiness', *frieze*, issue 16, May 1994, p. 44.

28. See Sadler, *Situationist City*, p. 77; and Lebel, 'Jean-Jacques Lebel, oppositionnel', p. 22.

29. For more on Lebel's Happenings, see my essay 'Outrage aux bonnes moeurs: Jean-Jacques Lebel and the Marquis de Sade', in *Jean-Jacques Lebel, Bilder, Skulpturen, Installationen*, pp. 93–112.

30. Gilles de Rais was the infamous 'Black Magician' and child murderer who was reputed to have tortured, killed and raped some 500 children for Satanic purposes.

31. Jean-Jacques Lebel, 'A Point of View on Happenings from Paris', *ICA Bulletin*, London, 1965, reproduced in *Jean-Jacques Lebel: Retour d'Exil*, exh. cat., Paris: Galerie 1900–2000, 1988, pp. 68–9, p. 69.

32. Barry Farrell, *Life Magazine*, 7 February 1967, reproduced in *Jean-Jacques Lebel: Retour d'Exil*, p. 75.

33. Umberto Eco, *The Open Work*, trans. Anna Cancogni, introduction by David Robey, London, 1989, p. 12.

34. Ibid., p. 13.

35. Ibid., pp. 39–40. Eco cites *Art Informel* – the art of Wols or Jean Dubuffet, for example – as exemplifying the radical departure for the open work in the post-World War II period. *Art Informel* is hailed by Eco as 'open in that it proposes a wider range of interpretative possibilities, a configuration of stimuli whose substantial indeterminacy allows for a number of possible readings, a "constellation" of elements that lend themselves to all sorts of reciprocal relationships'. See Eco, *Open Work*, p. 84.

36. Ibid., p. 4.

37. David Robey, Introduction to Eco, *The Open Work*, p. xi.

38. Ibid., p. 103.

39. Félix Guattari, 'Jean-Jacques Lebel – Painter of Transversality' (1988), in *Jean-Jacques Lebel, Bilder, Skulpturen, Installationen*, pp. 39–40, p. 39.

40. Ibid., p. 39.

41. Ibid.

42. See Robert Fleck, 'Art as Rhizome', in *Jean-Jacques Lebel, Bilder, Skulpturen, Installationen*, pp. 27–34; and Kristine Stiles, 'Beautiful, Jean-Jacques', in *Jean-Jacques Lebel*, Milan, 2000, pp. 7–30.

43. Deleuze and Guattari offer many descriptions of the rhizome, including: 'Let us summarize the principal characteristics of a rhizome: unlike trees or their roots, the rhizome connects any point to any other point, and its traits are not necessarily linked to traits of the same nature; it brings into play very different regimes of signs, and even nonsign states. The rhizome is reducible neither to the One nor the multiple. It is composed not of units but of dimensions, or rather directions in motion.' See Gilles Deleuze and Félix Guattari, *A Thousand Plateaus: Capitalism and Schizophrenia*, trans. and foreword by Brian Massumi, London, 1988, p. 21.

44. Ibid., p. 6 and p. 267, respectively.

45. Michel Foucault, 'Preface' to Gilles Deleuze and Félix Guattari, *Anti-Oedipus, Capitalism and Schizophrenia*, trans. Robert Hurley, Mark Seem and Helen R. Lane, London, 1984, pp. xi–xiv, p. xiii and pp. xiii–ix, respectively.

46. Ibid., p. xii.

47. Ibid.

48. Guattari, quoted by Jean-Jacques Lebel in a letter to Kristine Stiles, as cited in Stiles, 'Jean-Jacques Lebel's Phoenix and Ash', in *Jean-Jacques Lebel, Works form 1960–1965*, exh. cat., London, 2003, pp. 3–15, p. 12.

49. Fleck, 'Art as Rhizome', p. 29.

50. The initial inspiration behind this installation was a dream that Guattari had about his car morphing into a garden of earthly delights.

51. According to Henri d'Andeli's thirteenth-century account, *Lai d'Aristote*, this act was Phyllis's revenge on Aristotle as he had advised his pupil Alexander the Great to give her up: having won Aristotle's attention she agrees to satisfy his desire providing he satisfy hers first – he agrees to let her ride him around the garden, not knowing that she has arranged it for Alexander to witness the scene. See Maurice Delbouille, *Le Lai d'Aristote de Henri d'Andeli*, 1951.

52. Jean-Jacques Lebel, 'Entretien avec Catherine Millet et Paola Ugolini', in *Rue Rossini, Les Rencontres Rossiniennes di Jean Jacques Lebel*, exh. cat., Galleria di Franca Mancini, 1996, p. 11.

53. Lebel, 'Jean-Jacques Lebel, oppositionnel', p. 26.

54. Lebel, 'Entretien avec Catherine Millet et Paola Ugolini', p. 11.

55. Gilles Deleuze, letter to Jean-Jacques Lebel, 23 September 1994, excerpt reproduced in *Jean-Jacques Lebel, Bilder, Skulpturen, Installationen*, p. 34.

Pregenitality and *The Singing Sculpture*: The anal-sadistic universe of Gilbert & George

Grant Pooke

Perspectives must be fashioned that displace and estrange the world, reveal it to be, with rifts and crevices, as indigent and distorted as it will appear one day in the messianic light.

(Adorno, *Minima Moralia*)

We have to re-value ideas all the time. I think that is what life is all about. Re-value for the world.

(Gilbert)

Gilbert (Proesch) and George (Passmore), or rather the coded externality which is 'Gilbert & George', have remained at the cusp of the international avant-garde since the first performance of *The Singing Sculpture* in 1969. In that work, both artists, their faces painted a sculptural bronze, mimed along to a taped recording of the Hardy and Hudson version of Flanagan and Allen's 1932 vaudeville piece *Underneath the Arches* (Figure 7.1). With Gilbert & George, the Derridean play of the author's temporal and spatial relationship to the text has been writ large: both artists have been delineated and magnified in the act of production and through the resulting objectification of their own images. Arguably, nowhere was this dramatic relationship more compelling and sustained than in *The Singing Sculpture*, now a canonical work within their oeuvre.

Since that performance, Gilbert & George's aesthetic has been increasingly typified by the production of large and commercially successful pictographs and photographic montages. Ironically, perhaps, *The Singing Sculpture* has become intrinsic to the Gilbert & George 'brand' and has in turn underscored the homogeneity of their aesthetic. While it might be said that their subsequent work has traded upon *The Singing Sculpture*'s avant-garde status, both have variously conflated the performative, the photographic and the sculptural as part of a wider aspiration towards spectacle and self-becoming.

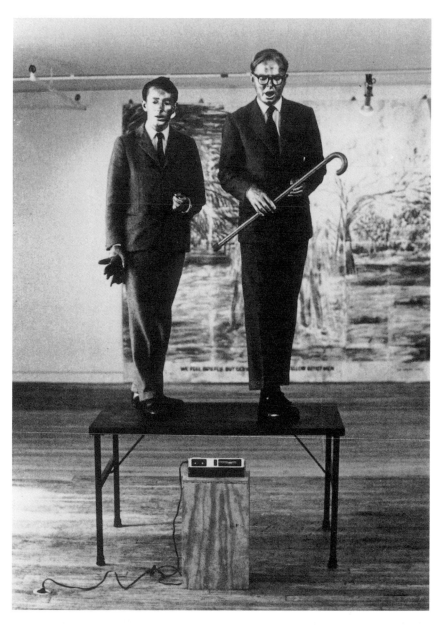

7.1 Gilbert & George, *The Singing Sculpture*, 1971

For this reason I would suggest that *The Singing Sculpture* continues to have significant resonance. For Gilbert & George it was 'the biggest discovery we ever made. Art into life. To become the artist and the art',[1] an intervention which has since defined the collaborative nexus of their enterprise as it has signified the sheer exteriority of their aesthetic as stage 'personae'. More generally, this strategy can be said to have restated the centrality of the body as sensorium in the process of the aesthetic, as well as in the making of some contemporary art. It can be identified as the point of departure for Gilbert & George's subsequent aesthetic as well as a stage of reference for the art practice of one-time assistants Jake and Dinos Chapman. More recent interest in the body by artists like Mark Quinn, Sarah Lucas and Marcus Harvey might reasonably be said to have variously shared, or at least internalised, aspects of Gilbert & George's aesthetic.[2]

Using *The Singing Sculpture* as the point of reference, and some perspectives taken from a psychoanalytic framework, this essay attempts to offer one context for some puzzling or obtuse aspects of Gilbert & George's work more generally; the selective references to personal biography before their self-invention in 1969; the doubling of artistic agency and the personae of the dandy; the elision of women within their work; their persistent self-representation within their own images; and the determined use of coprophiliac and physiological imagery which has increasingly characterised their aesthetic since the 'Naked Shit Pictures' exhibition of 1997.[3] One of the principal points of reference will be Janine Chasseguet-Smirgel's study of pregenitality and the aesthetic, although mention will also be made of the binary construct of masochism, and interventions which consider the Nietzschean Apollonian/Dionysian duality. While it is not intended to reprise a performance history or historiography of *The Singing Sculpture* as such, for purposes of explanation a brief survey of the context and format of the piece will be offered.[4]

Frank Popper's *Art – Action and Participation* remains a useful exploration of the wide-ranging avant-garde practices which arose in the late 1960s and early 1970s as part of the reaction against what was alleged by some as an archaic and formulaic Modernism. Popper's conviction was that claims to innovation by these new avant-gardes rested on the combination of two aesthetic aspects seen to have been elided in Modernist accounts of art: first, a revised and permissive sense of environment, and second, the presumption of an active spectator.[5] In so claiming, Popper questioned the Modernist insistence on the primacy of the art object *per se*. For Modernists, aesthetic judgements were self-grounding and ultimately irreducible: a qualitative response to a work's self-referentiality, interiority and self-sufficiency. By implication, the viewing subject must in one sense at least 'come' to the Modernist work, engaging it on its own terms, rather than, as Popper

suggests in relation to conceptual art practice, becoming an active interpreter and mediator – a process which might actually ground the aesthetic and social significance of the work. As an example of the performance art genre, Gilbert & George's *The Singing Sculpture* can be seen as part of an aesthetic response initially concerned with resisting the commodification and cultural appropriation associated with late Modernism. For instance, its apparent non-commerciality and exteriority were conceded by Gilbert, who in an interview, noted that 'the form was difficult to survive on – financially even. There was no system for making money out of it. ... *The Singing Sculpture* was very limited: what you can do with it, say with it, express with it'.[6]

As a corollary to Popper's idea of the active viewer, Gilbert & George's *Guide to the Singing Sculpture*, sub-titled *Six Points (towards a better understanding)*, states the rubric of the work. It is:

Essentially a sculpture ... we carve our desires in the air ... Together with you this sculpture presents as much contact for experiencing as is possible ... Human sculpture makes available every feeling you can think of ... It is significant that this sculpture is able to sing its message with words and music ... It is intended that this sculpture brings to us all a more light generous and general art feeling.[7]

While changing comparatively little in choreography or literal performance over the years, *The Singing Sculpture* was regarded much later by Gilbert & George as a touchstone for their aesthetic as well as an opportunity to solicit response and reflection from its viewers. In this regard, too, it shares Popper's description of performance art as 'spectator' inclusive as it does aspects of the wider ontology of the late 1960s conceptual art avant-garde.[8] George said at interview: 'We say that our art is the life of the viewer in relation to the picture they are looking at. The work in relation to the viewer's feelings on the subject. That is the art, really'.[9]

So what did (and does) *The Singing Sculpture* consist of? Gilbert & George's first public appearance and formal collaboration as a living sculpture, initially entitled *Our New Sculpture*, was a performance at St Martin's School of Art in January 1969. Recalling this early performance and some of the artifice involved, George noted:

It was made initially as just *Our New Sculpture* and presented as a piece of sculpture at various schools of art. We just played the record twice on one side (*Underneath the Arches*). It was turned twice to give the illusion we were turning the record, which wasn't true. And there was a short speech before and a short speech after.[10]

Subsequent performances see small changes in the choreography, but this description from *Gilbert & George: The Singing Sculpture* explains the mechanics of the performance:

As the song plays, Gilbert & George, one holding a stick, the other a glove, rotate with fluid, mechanical movements and gestures, singing along as they turn. At the

song's end, whoever is holding the glove steps down and restarts the cassette, then returns to the table. They exchange the stick and the glove, and the song begins again, they begin again.[11]

Carter Ratcliff's preface to the 1980 Eindhoven exhibition catalogue notes the robotic continuity, composure and control which characterises the performance:

Their heads are always metallised. One of them bears a glove, the other a cane. Singing and sketching a pattern of mechanical gestures in the air, they arrive at the end of the song, whereupon Gilbert one time, George the next, rewind the tape as rigidly sculptural as ever.[12]

As a preliminary to exploring some psychoanalytic observations, there are various points to be made. First, the physical endurance necessary for the performance of the work – or what one interviewer described as the 'sheer wilfulness of the project'.[13] On one occasion, Gilbert & George recalled eight-hour performances on several days over two consecutive weeks; at the Stedelijk an apparently impromptu appearance in 1969 resulted in the piece running for five hours:

It [the 1969 performance at the Stedelijk] was semi-official. We weren't invited exactly; it was sort of tolerated, and it turned into a sensation. It went on for five hours. Some people spoke to us; a lot of people took photographs; some Germans threatened us with a knife. It was a sensation.[14]

Duration, and the apparent masochism of the performers, became intrinsic to both the piece and the historiography which grew up around it. The New York magazine *Art News* recorded in November 1971 the increasingly expansive nature of its staging:

two days of 8 hours each at the Kunsthalle; ten almost consecutive 8-hour days in Cologne, Aachen and Krefeld in October 1970; five sequential 7-hour days at Nigel Greenwood's Gallery, November 1970, in London; and ten 5-hour days at Sonnabend's in New York ... plus a couple of one-night 2-hour stands in between.[15]

The physical and dramatic effort involved here is predicated as much on performance as it is on the device of repetition. Nietzsche's principle of 'eternal recurrence' stresses the value of the present and the implications of our own future actions, the consequences of which may return to us again and again. It may not be too fanciful to suggest that *The Singing Sculpture* at least parodies this repetitive principle through self-conscious theatrical stasis.

Second, there is a meticulous sense of surface, composure and control evident in *The Singing Sculpture*. Most obviously, it is the dress style adopted by the artists: the habitual, reciprocating identity of two-piece sixties suits and ties soon became their leitmotif and the obligatory point of departure for interview and satire. Gilbert & George are self-confessed dandies; latter-day flâneurs who populate their metropolis with self-images (Figure 7.2).

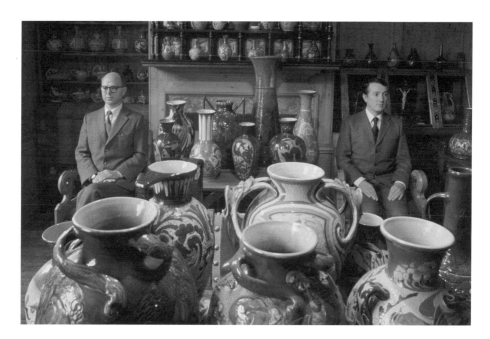

7.2 Gilbert & George, the artists at home in Fournier Street

Arguably it is this eloquent sense of appearance, surface and immediacy which signifies their aesthetic as one not only of hermetic self-characterisation as stage personae but one of sustained theatrical spectacle. Interviewed by Wolf Jahn, they recalled:

we had these distinctive, ordinary suits. Everybody was wearing kaftans and muslin dresses – nobody had a normal suit like we had … The make-up [metallic face paint] takes you away from the normal person and makes you special. That's it. It makes you a god in some way – a sculpture in fact. It wouldn't have worked without make-up.[16]

Third, while *The Singing Sculpture* can in one sense be placed within the conceptual performance dynamic of the time, its genesis nevertheless coincides with explicit antipathy to other avant-garde interventions with which it was contemporaneous. As Gilbert noted:

In Europe, there was a Fluxus movement going on that we didn't like, because we felt that it was based on dirt. It was muck. There were experimental happenings – that were a little more like Fluxus. But we hated that, because we wanted to do just static sculptures. [George] We wanted to be tidy, clean and good, not alienate 90% of the public. Most people who went to a Fluxus thing would be offended by it and walk out.[17]

This aversion to dirt and a sense of introjected authority informs another interview comment made to Wolf Jahn:

We didn't want to do this grubby, fake serious stuff. I remember we were very against the Arts Lab, where they did Happenings, because Happenings were disgusting. They were just rolling around with toilet paper, wires, beds falling down, rubber. Always dirty.[18]

The vogue at St Martin's School of Art where Gilbert & George were enrolled was for large-scale, floor-based metal sculpture. George said:

The School was famous at that time for formalist sculpture; Caro, King and Tucker. They would talk of a sculpture, its weight, its pressure, in a way that no one outside the college would understand. They were making a private language of their own. It had no connection with life ... But within the college there were a small elite of students, of which we were a part, who were not involved in that aesthetic at all.[19]

Included within this 'small elite' were Jan Dibbets, Bruce McLean, Richard Long, Hamish Fulton and Barry Flanagan. Within the loosely collaborative environment of the art school, Gilbert & George's *The Singing Sculpture* can be said to have shared the communicative intent which characterised much of their peers' work. Noting this context, Robert Rosenblum has described the performance vogue for 'theatrical spectacles that blurred the familiar boundaries between artists and their art'.[20] In this regard, the designation of *The Singing Sculpture* as sculpture might be said to have implicated debates both within and beyond St Martin's. The Modernist deference to a certain kind of sculpture gave the term 'sculpture' a loaded and contested relevance. For Fried, the value of work by Caro, Noland and Olitski resided in its 'anti-literal, anti-situational character ... an index at once of their radical abstractness, and of their deep antagonism to the theoretical in all its current forms and manifestations'.[21] Although an equally allusive and complex work, Gilbert & George's *The Singing Sculpture* can be situated as signifying a different and more transgressive etiology.

One further characteristic within the Gilbert & George aesthetic which this performance work introduces and elaborates is the progressive elimination of objects other than the artists and their own visual and literal (self-) identification. In this regard, *The Singing Sculpture* idea is alleged to have arisen from a collaborative project undertaken while students at St Martin's School of Art where specific individual sculptures where shown, at first, as distinct, object-based pieces. Gilbert:

First we made objects of our own and showed them together, then we did one object together – one mask, a head. I would put in whatever I wanted, and then George ... and so on. ... [*The Singing Sculpture*] happened by mistake. Because at the end of the year we posed with our objects, holding our sculptures. [George]: And then we did the same without our sculptures. We realised we didn't need the objects anymore. It was just us.[22]

The concept of the double and of duality is literally and corporeally omnipresent within the Gilbert & George oeuvre and within *The Singing Sculpture* especially so: duality is the organisational metaphor and iconographical signature of their entire aesthetic. Whilst the cosmology and historiography of the double is interesting in its own right, of specific relevance here is Freud's theory (*vide* Otto Rank) of the relationship of the double to narcissism and self-love.[23] Rank's description of the double within the narrative of the novel is echoed with Gilbert & George. *The Singing Sculpture* delivers them as dioscuric twins of mixed paternity; a Romulus and Remus, symbolically abandoned at St Martin's and, in Gilbert's words, 'born on the steps of the Stedelijk'.[24] Rank goes on to note the historic fear of 'primitive' peoples in the capturing of likeness by photography as a stealer of souls – one trait, at least, not shared by Gilbert & George.

John Lash's *Twins and the Double* records that 'the most compelling examples of twinhood occur in the absence of physical resemblance'.[25] Throughout the various world cosmologies, the narrative significance of the double is rarely that of exact resemblance, but rather the complex dissimilarity which characterises the complexity of interaction. This interaction is not only choreographed mimetically within *The Singing Sculpture*, but also shown in the consistent pattern of complementarity within interviews since 1969. Within the extant interview material, I can find no examples of flat contradiction or disagreement between the Gilbert & George personae. The overall performance is that characterised by Lash in another context as one of 'errant near-symmetry'. *The Singing Sculpture* further dramatises and re-enacts this 'companionate' and binary structure as theatrical spectacle. Lash continues:

To twin is a powerful action, and twinning permeates all of physical nature as well as all of our common and intimate activities of will, emotion and thinking. Doubling or replication is the active mode of duality.[26]

Furthermore, the actual choreography of *The Singing Sculpture* exists in apparent stasis; a spectacle to reification. Robert Rosenblum has noted its 'singular, timeless and tireless' qualities and has described its performance as an opportunity for 'layered retrospection'.[27] Similarly Carter Ratcliff described its 1991 Sonnabend Gallery reprise:

Two decades later, in the same room and the same autumn season, the artists redid the piece, and thus marked off a stretch of time. I saw the work presented in 1971, and detected no difference in the reprise. The changes were in the artists, not in the sculpture.[28]

Although the performance location has varied over the years, the format and choreography have remained the same. However, the piece has been re-titled several times: *Our New Sculpture* at the Royal College, Camberwell

School of Art and the Slade; *Underneath the Arches* at the Slade, Cable St, E1, and the Düsseldorf Kunsthalle; and later the *Red Sculpture* (New York).[29] As such it has followed Walter Benjamin's evocative description of fashion as 'sameness in difference'. In this sense the piece is reassuringly non-developmental and unchanging: a dramatised stasis. Wolf Jahn has noted the unchanging 'props' used:

The stick, as an allusion to walking, stands for the (unending) time component of the act: marking time, endless stasis, eternal monotony. Movement here does not represent progression but its antithesis, staying put. The glove stands for the interchangeability of the artists. A three-dimensional object, it is nevertheless completely hollow, like them.[30]

Turning now from the performative to the directly psychoanalytic context, I should like to consider Janine Chasseguet-Smirgel's clinical delineation of the pregenital universe. The pregenital or anal-sadistic universe is one based on the annihilation of intergenerational and sexual difference: a realm before sexual individuation.[31] Integral to this state is the subject's self-identification and the elimination of the repressed other. One of the behavioural characteristics which signifies such self-identification is narcissism. Whilst this trait can be clinically manifest in various forms, it is necessary to rescue the term from some of the pejorative connotations arising from more generic usage. Freud elaborates the concept into its primary and secondary stages with primary narcissism defined as the sexual or libidinal complement of the ego's instinctual drive towards self-preservation.[32] Understood in this sense, narcissism is a necessary part of the human libido which assures and assists survival.[33] This state of symbiosis, according to Freud, changes with the onset of individuation as libidinal investment shifts from the ego to external objects. As the ego develops, Freud identifies the concept of the ego-ideal as a compensatory mechanism for the relocation of libido.[34]

Chasseguet-Smirgel identifies three typical 'Luciferian' characters who might be seen to represent behaviour consistent with pregenitality and in whom there is a somewhat more pathological and aberrant form of narcissism within their personality formation. They are cited as the Roman Emperor Caligula; the fictional character Dr Moreau and the late artist, Hans Bellmer.[35] Caligula is noted for his deified self-image and the demiurgic fantasies chronicled by Seutonius and redramatised by Robert Graves.[36] The second example is taken from the novel *The Island of Doctor Moreau* (1896) by H. G. Wells. Dr Moreau, although not replicating life in a literal or biological sense, does so via the dependent simulacra inhabiting his island, thereby addressing a desire for visual self-objectification and omnipotence.[37]

With Hans Bellmer, so it is suggested, the non-biological replication of life, and the arrogation of power through which to achieve this, is mediated

aesthetically through the artist's contorted mannequins and dolls.[38] In all three cases, Chasseguet-Smirgel identifies a pregenital or anal-sadistic character pathology within the imperatives which motivate them. Behaviourally, this pathology is also reflected in a desire to control both the outcome of that which is objectified and its projection: in the case of Caligula through deified fantasy and ritual; or in quasi-scientific and aesthetic invention in the cases of the fictional character Dr Moreau and the artist Hans Bellmer.[39] Chasseguet-Smirgel suggests that one of the historical figures best placed to demonstrate the pregenital universe and its transgressive possibilities is the eponymous Marquis de Sade, who, within the complex narrative structures and carefully choreographed sequences of his works, 'endlessly repeats the idea that Nature might be a crucible, a melting pot … in which the chemical fusion takes place … The Sadian hero identifies with her, a cruel and almighty mother, taking over the role of the originator of all creation, that of God himself'.[40]

The Sadian universe is conceived as a simulacrum of the actual one – a realm of endurance and spectacle in which the subject's hubris arrogates divine power to 'create a new reality, to level all differences … to amalgamate objects which are not made to be together, to deviate the purpose of substances, ideas and things'.[41] Each Sadian character creates a virtual world, 'a universe of sacrilege',[42] one in which ritual and ceremony are inverted for self-deification. It is the premise of this essay that there are at the very least some arguable parallels between this pregenital etiology and the self-representations (and self-becoming) evident within *The Singing Sculpture*. Gilbert & George's aesthetic universe is also self-created and self-identical; its visualisation is also controlled, both in the meticulous care given to presentation and preparation, but also in the concern and interest taken with its mediation through literature, in the galleries and in the press.[43] For such a self-created and self-identical universe to be sustainable it must be consistently presented: an aesthetic of both duration and presence.

Central to the pregenital universe characterised by Chasseguet-Smirgel is the denial of patrilineal authority and the evacuation of the father, since it is he who signifies genital difference and defies demiurgic fantasy. In the case of Hans Bellmer, Chasseguet-Smirgel quotes Jean Brun's reading of his work, *The Doll* (1933) in just such a way:

The engineer's tool [Hans Bellmer's father was an engineer], so familiar that it made the son sick, is then used in an irremediably compromising way. The father is vanquished. He sees his son holding a hand-drill, securing a dolly's head between his brother's knees, and telling him: 'Hold on to her for me, I've got to pierce her nostrils'. Pallid, the father goes out, while the son eyes this daughter, now breathing as it is forbidden to do.[44]

Like Bellmer's dolls, Gilbert & George reprise *The Singing Sculpture* as mannequins: slow-moving automata, objects which both evoke and conceal simultaneously. Furthermore, the choreographed and controlled continuity of *The Singing Sculpture* in which the body is re-objectified and redramatised recalls Bellmer's observation that 'The body can be compared to a sentence inviting one to disarticulate it for its true elements to be recombined in a series of endless anagrams'.[45] It could be conjectured that the elision of the genital universe signifying difference is coded within Gilbert & George's oeuvre by the absence of any female depiction. Although this is invariably presented by the artists as a deliberate and systematic strategy to resist the objectification of women, it can also be seen as consistent with just such pregenitality.

One further characteristic of the pregenital universe is the extent to which it may invoke or invent a cosmology through either religious or secular rituals. At the pregenital stage the subject may arrogate to himself the authority and power of the ultimate creator: the 'faulty identification with the father – the subject wanting to become God'.[46] Consider, for example, the excremental discipline and other punitive strictures which regulated behaviour at the Marquis de Sade's Castle of Schilling in the *120 Days of Sodom*.[47] There are a number of striking parallels in 'Laws of the Sculptors' promulgated by Gilbert & George from the time when they both left St Martin's. Among their first co-authored statements, a kind of secular liturgy has been frequently restated by the artists:

Always be smartly dressed, well groomed relaxed friendly polite and in complete control. Make the world believe in you and pay heavily for the privilege. Never worry assess discuss or criticise but remain quiet respectful and calm. The lord chisels still, so don't leave your bench for long.[48]

These strictures are suggestive of commandments: binding and specific codes of conduct through which power and control is arrogated to a shared divinity located in the dual personae of Gilbert & George. Consider, for example, an interview comment made to Andrew Wilson: 'We are searching for the truth. There is a human God and we are it. We have got to do it, if not we are all lost'.[49]

Further parallels to dual and multiple cosmologies are suggested in the strongly Trinitarian feel to the 1986 'What Our Art Means' manifesto which formed the preface to the catalogue for the major retrospective 'Gilbert & George: The Complete Pictures 1971–1985'. Under the fourth paragraph sub-heading 'The Life Forces' runs the listing:

The Head
The Soul
The Sex[50]

The invocation of cosmology has, in fact, continued quite explicitly throughout their aesthetic, as has the identification of both artists with the authority it signifies. Throughout the 'New Cosmological Works', 'The New Testamental Pictures' and 'The Naked Shit Pictures' there are clear references to a personal cosmology and to self-identification with Judaeo-Christian iconography, noted by reviewers at the time to include re-explorations of the Pietá and Expulsion from Eden motifs in the works *Ill World* (Figure 7.3) and *Naked Eye* respectively.[51] On the other hand, and referencing two images from the last-mentioned exhibition, the critic Wolf Jahn has identified a humanist stance:

Recognising himself as dust makes man call for God in the Bible. For the artists, in contrast, it is man's call for his fellow man and fellow sufferer. With a brotherly almost self-assuring gesture, he lays his arm around the shoulders of the others (*Human Shits*) or saves him like someone drowning in the sea (*Ill World*). Intimacy is sought where the certainty of human need is the greatest.[52]

Dramatised earlier by *The Singing Sculpture*, these transformative practices imply the demiurgic fantasy and projection of the pregenital universe. Chasseguet-Smirgel identifies a further feature of pregenitality in Gilbert & George's tendency towards aestheticization. In relation to the creative act, it is argued that aestheticization arises from sublimation:

Sublimation makes use of the same instinctual energy as that which is directly released through perverse sexual activity. In both cases, it is pregenital libido. Pregenital instincts are the essential – and probably the sole – raw material of sublimation.[53]

In relation to the creative subject, the exclusion of the father as the ego-ideal has been referenced earlier, but such character pathology becomes reinforced over time as the genital focus of peers becomes increasingly evident. Chasseguet-Smirgel suggests that the compulsion to idealise accounts for 'obvious affinities for art and beauty' which define the aesthete or the dandy:

The resulting identification gaps constitute a major obstacle to a real sublimation process. Idealization tends more towards aestheticism than creation, and when creation nevertheless develops, it often bears the stamp of aestheticism.[54]

At the outset of this essay it was noted that *The Singing Sculpture* manifested an attachment to spectacle, surface, presentation and texture. The world which it evokes, that of the down-at-heel bohemian tramp, is strangely retro: a kind of music-hall picturesque. Similarly, the use of (Dionysian) masks or personae and the (Apollonian) mantra of control and composure might be seen as at least consistent with such aestheticised pregenitality. Arguably such clinical pathology had its culmination in the increasingly excremental iconography of subsequent and more recent work such as the 'Rudimentary Pictures' and the 'New Horny Pictures',[55] in which a failure to

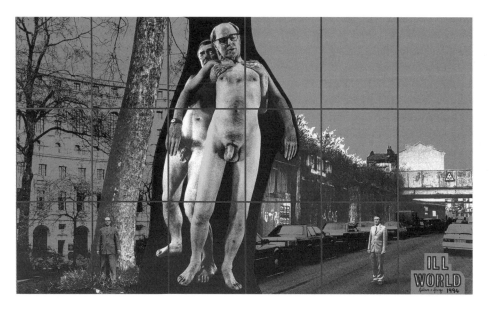

7.3 Gilbert & George, *Ill World*, 1994

sublimate could be seen in exhibitionism, fetishism and fantasy. A recurrent feature of both exhibitions, aside from the scale and size of the photographic works overall, was the sheer homogeneity and repetition of motif (within each picture or within the whole series) – whether bodily fluids, coins, magnified map illustrations, self-portraits or personal advertisements (Figure 7.4).

Critics have noted also that Gilbert & George's aesthetic has an eloquent sense of surface: an aura akin to 'stained glass'.[56] The meticulous care and attention invariably given to the way in which their pictographs are composed and re-presented has resulted in images which are visually arresting, almost iconic.[57] The jewel-like brilliance of their work and indeed the immaculate Arts & Crafts interior of their Fournier Street house in Spitalfields confirm an elegant, aesthetic sensibility. A taste for original furniture by A.W. Pugin, Charles Lock Eastlake and Christopher Dresser typifies their surroundings; interiors are lined with leather-bound editions including Pugin's *Floreated Ornament* and Owen Jones's *Grammar of Ornament*. Gilbert & George's collection of Dresser vases is possibly among the finest in private hands.[58] Both take a genuine connoisseur's delight in the sensuous materiality of such *objets d'art*: surface, contour, definition and colour are intrinsic to an aesthete's pregenitality. Consider two illuminating comments made by Gilbert & George at interview:

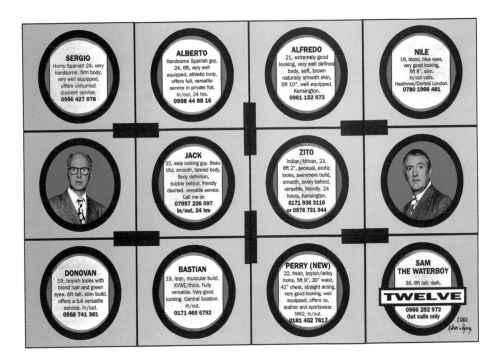

7.4 Gilbert & George, *Twelve*, 2001

We are dandies, in some way. We like the idea of Oscar Wilde. He was a gentleman who dressed up, and inside suffered totally.[59]

We think that they [aesthetes] were the first true subversives because they were saying one thing in order to get away with doing something entirely different. Wilde is the best example of that. He said everything was all just pleasure – and one puff of a cigarette, and one lily that lasts all day – in fact, he was getting away with murder at the same time … He created a world which is entirely different. We would not be here if it hadn't been for Oscar Wilde.[60]

Gilbert & George's self-presentation as the cosmopolitan dandies of *The Singing Sculpture* is as much part of a pregenital etiology as it is a self-consciously fashioned part of their personae. Like Baudelaire and the Goncourt twins who claimed the iconography of Haussmann's Paris as their milieu, Gilbert & George have fashioned themselves as postmodern flâneurs within a distinct historical and literary tradition. Similarly, they make proprietorial claims to the environs of Spitalfields, as they do to the ubiquity of Milton Keynes, as witnessed in the 'Rudimentary Pictures' exhibition. Camille Paglia describes Baudelaire's prose work *The Painter of Modern Life* as an interpretation of the dandy as the ideal male persona and the 'epitome

of personal style'.[61] Dandyism, as a Romantic 'cult of the self' with pretensions towards 'a new kind of aristocracy', is reprised in *The Singing Sculpture*. Paglia's description of the dandy offers further parallels with Gilbert & George's self-characterisation:

Baudelaire's dandy is an Apollonian androgyne, drawing a sharp line between himself and reality. The dandy with aristocratic superiority of mind aims for distinction above all things. Distinction is aboveness and apartness. The dandy's vocation is elegance, incarnating the Platonic idea of beauty in his own person. He is an artificial personality. The self, sculpted by imperious Apollonian contour, has become an object or *objet d'art*.[62]

Paglia goes on to cite the fictional and reclusive character Des Esseintes from the Huysmans novel *A Rebours* (1884), who, in keeping with this character pathology, 'creates a ritual cult of sharply defined *objets d'art*, because decadent aestheticism is the most comprehensive system of aversion to female nature devised by western culture'.[63] The construct of the dandy as an integral part of the pregenital universe can also demonstrate a tendency towards the masochistic and the introjection of authority. Nick Mansfield's study *Masochism: The Art of Power* (1997) cites it as a tendency powerfully situated 'between aesthetics, power and subjectivity'.[64] To explain the elision of the (Dionysian) female nature, reference is made to Gilles Deleuze's essay 'Coldness & Cruelty' (1969). Mansfield writes:

masochistic fantasy revolves around the figure of the mother, specifically the 'cold' oral mother who unites and redeems all maternal imagoes. The oral mother thus provides an alternative source of psychosexual authority to the father, and the phallic power of the paternal is expelled from the masochistic universe.[65]

A metaphorical example of such expulsion with Gilbert & George has been the selective deployment of biographical reference regarding their lives before St Martin's and their subsequent aestheticisation as art objects. Both are on record as having disparaged, avoided or discouraged biographical speculation in the past. It could be conjectured that such joint elision was a symbolic act of patricide, necessary for, and consistent with, the pregenitality of the anal-sadistic universe. Biographical data which Gilbert & George have shared with an audience are striking, both for their comparative sparseness and for their elisions. The first book to offer an informative memoir was *Gilbert & George: A Portrait* by the long-time friend and late contemporary Daniel Farson, although here the recollections of Gilbert & George's lives before 1968 and St Martin's are provided exclusively by the artists without any other corroboration. One of the two texts distributed at early performances of *The Singing Sculpture* had contained the following statements:

I, George was born in Devon in 1942. My father is, I believe, a carpenter. I met him

for the first time in 1966 and I have not seen him since. My mother married now for the third time lives still in Devon, also my only brother Alex who is an evangelist.

I, Gilbert was born in a small Dolomite village in September 1943. I am the son of a shoemaker and I began sculpting at the age of eight. There I have a house, a mother, 3 sisters and one brother that I like very much.[66]

Although subsequently elaborated in the Farson interviews, these recollections appear to stress the maternal influence as both determining and resonant. Consider George's initial recollection of his father: 'Maybe he left us before I was born. No memory. I was not allowed to say "Dad" or "Daddy" at home'.[67] Interviewed a couple of years earlier by Martin Gayford, Gilbert's comments on his absent father are also worth noting: 'My father was never very interested, but my mother yes, because she always wanted us to do exactly what we wanted. She was a big force behind us'.[68]

The comparative elision of the paternal, for whatever ostensible or conscious motive, is consistent with aspects of the pregenital etiology sketched in this essay. Indeed, the apotheosis of the pregenital universe and the etiology it signifies is given explicit visual expression in the 'Naked Shit Pictures' of 1995 and the 'New Testamental Pictures' of 1998 in which faeces (presumably the artists') is a major and recurrent iconographical feature (Figures 7.5, 7.6). In a Sadean inversion of ceremony and ritual, all difference is homogenised in a visually explicit aesthetic of pure (and literal) self-identity as shit. Characterising the will to power evident within the pregenitality of the anal-sadistic universe, Chasseguet-Smirgel writes:

This, in essence, is the universe of the sacrilege. All that is taboo, forbidden or sacred is devoured by the digestive tract, an enormous grinding machine disintegrating the molecules of the mass thus obtained in order to reduce it to excrement ... To reduce the universe to faeces, or rather to annihilate the universe of differences (the genital universe) and put in its place the anal universe in which all particles are equal and interchangeable.[69]

As the artists themselves have said:

the first piece of art you ever do – as a baby even – is to form a shit. In fact, it's the only sculpture that exists naturally in the world; it's modelled in that way. It's people's first adventure in form. It's the first clay that you have.[70]

In asserting anality and the pregenital of which it is part as a defining paradigm for life and the aesthetic, Gilbert & George have situated the collapsing of difference as both a personal and, by implication, a wider cultural pathology. The homogeneity of appetite and of excremental discipline, presaged in *The Singing Sculpture*, signifies the abject as the circumvention of symbolic law. Its pregenitality is 'the dark side of narcissism ... precisely what Narcissus would not want to have seen as he gazed into his pool ... the moment of narcissistic perturbation'.[71]

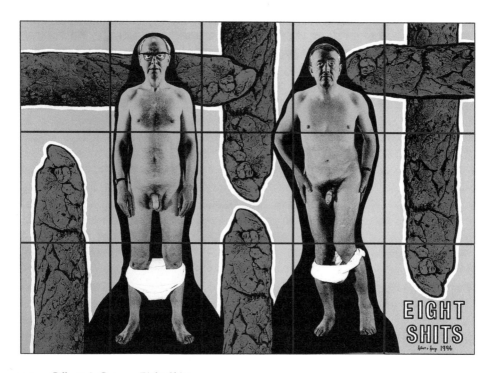

7.5 Gilbert & George, *Eight Shits*, 1994

To conclude: it has been suggested that aesthetics is a discourse born of the body and justified only by reference to its materiality.[72] Lea Vergine's *Body Art & Performance: The Body as Language* (2000) records Giulio Carlo Argan's observation that 'among Nietzsche's inebriations on art, the image of the artist-as-body was far from the most deleterious'.[73] Gilbert & George's *The Singing Sculpture* presents nothing less than the etiology of the body as a paradigm for the aesthetic, and a locus of the will to power: Gilbert & George as Sadean *Übermenschen*. As a canonical work, its dramatic performances have marked the start of the pregenital and of the Dionysian personae within both their aesthetic and their self-aestheticisation.

In one register at least, *The Singing Sculpture* can be meaningfully characterised as a *tour de force* of the pregenital; the urine, shit, sperm, sweat and blood of their subsequent aesthetic is traceable to this canonical piece. The physical intensity of its performance, the choreography, precision and apparent deferment of gratification signifies the bounded nature of the Apollonian as surely as its masochistic deployment suggests the Dionysian disavowal of order and patriarchal law. Its schematic Apollonian authority of control and composure signifies the cold imago of the 'oral mother',

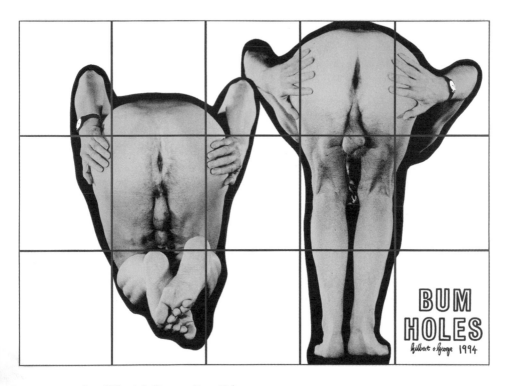

7.6 Gilbert & George, *Bum Holes*, 1994

introjected as the silent surrogate for the (vanquished) father. It is such absence (and presence) which contours the anal-sadistic universe and codes the visual prohibitions of Gilbert & George's aesthetic.

Hegel conceived truth in the radical otherness of the Dionysian image. The metallised personae of *The Singing Sculpture* recall the robed and masked Maenads depicted in glyptic form on the Dionysus column. They are melancholy hedonists ensnared in the 'sombre madness' of a tragic drama.[74] It is perhaps this that was being referenced when Rosenblum described its mood as one of 'ironic retrospection'. In this work, Gilbert & George have created a microcosm *à deux*: one in which the binary construct of masochism and pregenitality finds expression as legitimate and wholly reciprocated forms of human subjectivity. Adorno once said of the frail, utopian impulse of Modernist culture that it was a promissory note awaiting redemption. But, in more Brechtian vein, if the real beginning of the good life is to see things as they are (and not as we would desire them), then Gilbert & George's *The Singing Sculpture* by its sheer exteriority and externality remains an imperfect testament to the desirability of a more radical and perhaps authentic self-becoming.

Notes

1. Interview with the author, 12 February 1989, Fournier St, London, E1.

2. Consider for example the sculpted and choreographed bodies by Jake and Dinos Chapman exhibited in *Apocalypse: Beauty and Horror in Contemporary Art*, exh. cat., Royal Academy of Arts, London, 2000, pp. 212–25.

3. For further examples see 'Gilbert & George, The New Testamental Pictures', Galerie Thaddaeus Ropac, Paris, Salzburg, 1998 and 'Gilbert & George: The Rudimentary Pictures', Milton Keynes Gallery, 2000.

4. For a more detailed exploration of the wide-ranging conceptual practices and theories at play here, see William Wood's essay 'Still You Ask For More: Demand, Display and the "New Art"', *Rewriting Conceptual Art*, eds Michael Newman and Jon Bird, London, 1999, pp. 66–87.

5. Frank Popper, *Art-Action and Participation*, London, 1975, p. 7.

6. Quoted in the 1995 Wolf Jahn interview in *The Words of Gilbert & George: With Portraits of the Artists from 1968 to 1997*, London, 1997, p. 242.

7. Ibid., p. 21.

8. In addition see Peggy Phelan, *The Politics of Performance*, London and New York, 1993.

9. Interview with the author, 12 February 1989, Fournier St, London, E1.

10. Gilbert & George, interview with Anne Seymour, *The New Art*, Hayward Gallery exh. cat., London, 1972, and reprinted in *The Words of Gilbert & George*, pp. 43–4.

11. *Gilbert & George: The Singing Sculpture*, London, 1993, p. 14.

12. Carter Ratcliff, *Gilbert & George 1968 to 1980*, exh. cat., Municipal Van Abbemuseum, Eindhoven: 1980, p. 10.

13. Robert Pincus-Witten's review of Gilbert & George, Sonnabend, *Artforum*, December 1971, reprinted in *Gilbert & George: The Singing Sculpture*, p. 57.

14. *The Words of Gilbert & George*, p. 240.

15. Review by Barbara Reise in *Art News* (New York), November 1971, reprinted in *Gilbert & George: The Singing Sculpture*, pp. 54–5.

16. Interview with Wolf Jahn, *The Words of Gilbert & George*, p. 241.

17. Ibid., p. 260.

18. Ibid., p. 241.

19. Interview with the author, 12 February 1989, Fournier St, London, E1.

20. See Robert Rosenblum's essay in *Gilbert & George: The Singing Sculpture*, p. 7.

21. Michael Fried, cited in Paul Wood, Francis Frascina and Charles Harrison (eds), *Modernism in Dispute: Art Since the Forties*, New Haven and London, 1993, p. 91. This quotation is from M. Fried, 'Caro's Abstractness', *Artforum*, Vol. IX, no. 1, 1970, p. 33.

22. Interview with Jahn, *The Words of Gilbert & George*, p. 239.

23. See Otto Rank, *The Double: A Psychoanalytic Study*, trans. and ed. H. Tucker Jnr, Chapel Hill, 1971.

24. Interview with Jahn, *The Words of Gilbert & George*, p. 240.

25. John Lash, *Twins and the Double*, London, 1993, p. 5.

26. Ibid., p. 6.

27. *Gilbert & George: The Singing Sculpture*, p. 4.

28. Ibid., p. 29.

29. Ibid., pp. 4–7.

30. Wolf Jahn, *The Art of Gilbert & George: An Aesthetic of Existence*, London, 1989, p. 75.

31. J. Chasseguet-Smirgel, *Creativity and Perversion*, London, 1984, p. 3.

32. Sigmund Freud, 'On Narcissism: An Introduction', in *Standard Edition of The Complete Psychological Works of Sigmund Freud*, trans. and ed. J. Strachey, London, 1957, pp. 67–102.

33. It should be noted here that the positive connotations of the term have been the subject of considerable investigation. One example is Marjorie Taggart White's 'Self-Relations, Object Relations and Pathological Narcissism', in the *Psychoanalytic Review*, New York, 1994, Vol. 67, pp. 4–23. White suggests that the ambivalence accorded to the concept is largely attributable to Greco-Roman constructs of civic self-sacrifice which may in fact result in the abrogation of self, paradoxically a 'masochistic, pathological condition'.

34. C.F. Alford, *Narcissism, Socrates, Frankfurt School and Psychoanalytic Theory*, New Haven and London, 1988, pp. 205–6.

35. Chasseguet-Smirgel, *Creativity and Perversion*, pp. 13–14.

36. See Robert Graves, *I Claudius*, Harmondsworth, 1988. This account used material from sources such as Suetonius. Chapters 29–33 provide an intriguing account of Caligula's personality traits and alleged behaviour, dramatic licence notwithstanding. See Suetonius, *The Twelve Caesars*, Harmondsworth, 1982, pp. 153–84.

37. Chasseguet-Smirgel, *Creativity and Perversion*, pp. 18–20.

38. Ibid., pp. 20–22.

39. Ibid., pp. 22–23.

40. Ibid., p. 5.

41. Ibid., p. 15.

42. Ibid., p. 4.

43. Gilbert & George make no secret of their willingness to support the production and publication of books such as Jahn's *The Art of Gilbert & George* and *Gilbert & George: The Singing Sculpture*.

44. Chasseguet-Smirgel, *Creativity and Perversion*, pp. 20–21.

45. Ibid., p. 21.

46. Ibid., p. 22.

47. See Stuart Hood and Graham Crowley, *Introducing Marquis de Sade*, London, 1999, pp. 78–84.

48. 'Laws of the Sculptors' was one of two texts written to accompany the *Shit and Cunt Magazine Sculpture*, 1989. See *Gilbert & George: The Singing Sculpture*, p. 50.

49. 'Interview with Andrew Wilson', *The Words of Gilbert & George*, p. 193.

50. The last two principles might appear to suggest the Cartesian division of body (sex) and the soul, although the inclusion of the 'Head' could be a specific recognition of Apollonian rationality with the inclusion of the 'Sex' coding the Dionysian. Gilbert & George, *The Complete Pictures 1971–1985*, London, p. 39.

51. See Jonathan Glancey, *Independent* (Weekend Supplement), 26 August 1995, p. 3.

52. Wolf Jahn, *Gilbert & George: The Naked Shit Pictures*, exh. cat., South London Gallery, p. 1.

53. Chasseguet-Smirgel, *Creativity and Perversion*, p. 89.

54. Ibid., p. 92.

55. Gilbert & George, *The Rudimentary Pictures*, pp. 19–57; and Gilbert & George, *The New Horny Pictures Catalogue*, exh. cat. White Cube (2), London, 2001, pp. 1–14.

56. Frank Whitford, interview with the artists, on the *Third Ear Programme*, Radio 3, broadcast 11 May 1990.

57. The photopieces from the Serpentine Gallery exhibition of *The Dirty Words Pictures, 1977* (6 June–1 September 2002) were no less impressive for being predominately black and white.

58. Interview with Glancey, *Independent*, August 1995.

59. Interview with J. Elizabeth, *Mail on Sunday* (Lifestyle Section), July 1999.

60. Interview with Glancey, *Independent*, August 1995.

61. Camille Paglia. In the context of this essay, see Camille Paglia's *Sexual Personae: Art and Decadence from Nerfertiti to Emily Dickinson*, London and New Haven, 1990, p. 428.

62. Ibid., pp. 428–9.

63. Ibid., pp. 432–4.

64. N. Mansfield, *Masochism: The Art of Power*, London, 1997, p. 1.

65. Ibid., p. 71.

66. Robert Violette and Hans-Ulrich Obrist (eds), *The Words of Gilbert & George: With Portraits of the Artists from 1968 to 1997*, London, 1997, p. 17.

67. Daniel Farson, *Gilbert & George: A Portrait*, Paris, 2000, pp. 1–2.

68. *The Words of Gilbert & George*, p. 253.

69. Chasseguet-Smirgel, *Creativity and Perversion*, p. 4.

70. Interview with Dave Stewart quoted by Farson, *Gilbert & George: A Portrait*, p. 140.

71. John Lechte, *Julia Kristeva*, London, 1990, p. 160.

72. See Terry Eagleton, *The Ideology of the Aesthetic*, Oxford and Cambridge, 1990, p. 13.

73. Lea Vergine, *Body Art and Performance: The Body as Language*, Milan, 2000, p. 289.

74. See Walter F. Otto, *Dionysus: Myth and Cult*, trans. R.B. Palmer, Texas, 1993, p. 51.

Eva Hesse: A note on milieu

Mignon Nixon

'One notices a milieu less when one is plunged in it; more so when it is rather briskly altered or when one leaves it'. After all, as the psychoanalyst Jean Laplanche further observes, 'One ends up getting used to a milieu'.[1] The Minimalist and Post-minimalist generation of artists developed this insight as a structural principle of their art, which radically altered the viewing situation. For the milieu changed fundamentally when the art was suddenly, as in Carl Andre's floor tiles, under foot. Or when, as in Robert Morris's four facing *Mirrored Cubes* (1965), the 'surrounding environment' – to borrow Laplanche's description of *transference* – became, in the relay of reflection, an integral but ungraspable dimension of the piece.[2] One artist who intensively explored the milieu of art – art's surrounding environment understood as a space of transference – was Eva Hesse. In the brief span of time between her turn from painting to sculpture in 1965 and her death in 1970, Hesse continually devised new ways of making and displaying a work, all concentrated on sustaining a level of instability in the milieu.

In psychoanalytic discourse, transference describes the relation between the analyst and the analysand, a relation that is informed by other intimate contacts, by the analysand's experience of parents and siblings, for example. Transference, however, also opens onto a cultural field, for transferences are brought into the analytic setting from outside. 'Perhaps we are looking the wrong way round', Laplanche observes: 'we wish to transpose the model of clinical transference onto what lies beyond it (psychoanalysis "outside the clinical"), but maybe transference is already, "in itself" outside the clinic'. Transference is extramural, outside the clinic; analysis brings it in, only to return to the site of culture. 'Perhaps the principal site of transference, "ordinary" transference, before, beyond, or after analysis, would be the multiple relation to the cultural, to creation or, more precisely, to the cultural

message', Laplanche proposes.[3] In this account, the viewer or reader (the 'recipient') is the one who 'welcomes in, gathers up, the cultural work'.[4] Crucial for Laplanche is the enigmatic character of the work, which appears on the horizon of its recipient's attention like a message in a bottle, 'without having been explicitly addressed to him'.[5]

As critics have consistently noted, Hesse's work confronts the viewer with enigmatic objects (Figure 8.1): objects that bear the imprint of corporeality without actually representing the body; objects of a type that, as Leo Bersani has observed in another context, 'act symbolically' without being fully legible as symbols.[6] Take Untitled, or Not Yet (1966), a sagging cluster of nine nets weighted with membranous plastic-wrapped sacs, that subsides against a wall. Or Vertiginous Detour (1966), a papier-mâché ball suspended from the ceiling in a net bag that, under the gravitational pressure of the sphere, assumes a teardrop shape, trailing strands of cord suggestive, as Lucy Lippard once observed, of a 'hairy testicle'.[7] Or Several (1965), a spray of seven long, snaky tubes, stiffened with papier mâché, that hangs from the ceiling and trails along the floor. Hang Up (1966), which Hesse regarded as her first 'important statement', projects from the wall into the space of the room, seeming to trip the viewer up, as in a Duchampian Trébuchet, with a noose around the feet (Figure 8.2).[8] It marks out a space between wall and floor where, from then on, Hesse's work would increasingly congregate, hung or propped against the wall, placed flat on the floor or scattered across it. Later works, including Right After (1969) and Untitled Rope Piece (1970), bring the studio situation itself into the gallery, underscoring the provisional character of works that now seemed to occupy a social space between the studio and the gallery as much as a physical space between, for example, the wall and the floor.

An installation photograph of Hesse's 1968 'Chain Polymers' exhibition at the Fischbach Gallery in New York shows works sparsely arranged, the rubber mats of Schema (1967) and Sequel (1967–8) hugging the floor, while another latex square, Stratum, stippled with rubber threads, hangs, billowing and dented, against the wall (Figure 8.3). Sans I (1967–8), as one critic observed, began on the wall and ended up on the floor.[9] Hesse's art both reiterates the frame of the gallery – its walls and floor, its corners and surfaces, its height and depth – and intersects with the viewer's body as it moves through that terrain. By altering the milieu of art – by constructing a space in which objects appear, or are offered, at unexpected sites – Hesse's work engages the body, as Laplanche suggests culture invades it, saturating it 'from head to foot' in a manner that is 'by definition intrusive, stimulating and sexual'.[10]

Surely one of the most imposing challenges for the curator of any exhibition of Hesse's work therefore must be to evoke its treatment of the milieu. For when Hesse altered the viewing situation through her particular

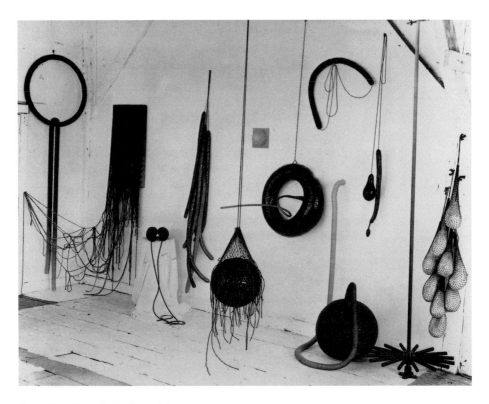

8.1 Eva Hesse's studio, 1966

use of materials, and by situating works in a contingent relation to the body of the spectator, these techniques ran counter to the expectations of an audience formed by the distanced protocols of late modernism – an audience, in short, very different from the one that encounters Hesse's work today. Now, Hesse's work addresses viewers conditioned to being solicited by the object, 'recipients' primed to explore the interface between the body and the work. For the viewing of Hesse's art at present is informed by the phenomenologically driven experience of installation, and by the expectation that the crucial relation to be explored is that between the body and the surrounding environment constituted by the work.

'Symbolic determinations of sculptural materials', Benjamin Buchloh has observed, depend not only on the 'professional idiosyncrasies' of the artist, but also on 'the audience's expectations: whether the specific materials and the production procedures allow for projective identification and seem in fact to embody the viewer's physical being in the world'.[11] In 1967, Hesse hit upon latex. 'Its possibilities are endless', she wrote, and experimented with

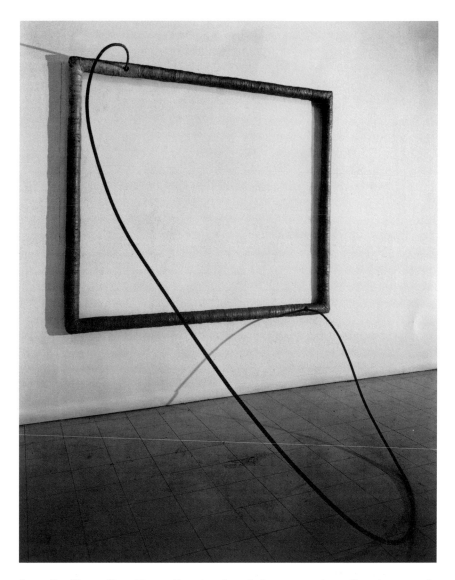

8.2 Eva Hesse, *Hang Up*, acrylic painted on cloth over wood; acrylic paint on cord over steel tube, 1966

applying it directly as well as using it as a casting material.[12] In *Schema* and *Sequel*, she employed both techniques, casting a repeated element, the demispheres, and applying coats of latex to produce, in the case of *Schema*, a syrupy, translucent surface. With *Area* (1968), she exploited a splitting at the level of process through which the discarded mould of one work could be

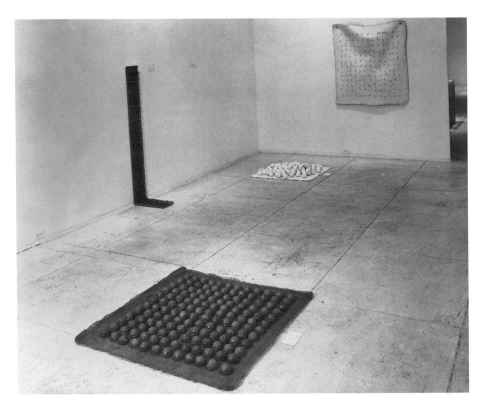

8.3 Eva Hesse, 'Chain Polymers', Fischbach Gallery, New York, 1968

recycled into the matrix of another: a pleated ribbon that trails along the juncture of wall and floor, *Area* is the by-product of another work, *Repetition Nineteen III* (1968), generated from the 'insides' of the cylindrical moulds used to make that work.[13] Hesse's use of flexible casting materials facilitated a self-perpetuating logic of production, her so-called process art. By turning one thing into another – a cast-off mould into a flat sheet, for example – Hesse however also investigated what Rosalind Krauss has called the 'condition of edge'.[14]

Krauss uses the visual model of anamorphosis to describe the structure of Hesse's work, which activates an experience of 'eclipse' as one term (painting) is displaced by another (sculpture), and vice versa, so that 'the gravitational field of either painting or sculpture is always experienced as shifting'.[15] When, in 1968, in her solo show at the Fischbach Gallery, Hesse exhibited four works in fibreglass and four in latex, most were displayed on the wall or floor, or articulated the join between the two. This emphasis on

interstitial space – on the boundary between painting and sculpture, or the seam between wall and floor – extended and intensified Minimalism's analysis of the experience of embodiment. But Hesse's work now also seemed to address the viewer as a psychic subject through an interrogation of limits. Krauss, for example, writes with marked affective intensity in describing the condition of edge, or anamorphosis, in Hesse's work: a 'condition in which form and matter are given the real possibility of eclipsing one another, and within which one experiences the pity and terror of that eclipse'.[16] She suggests that Hesse's repeated invocation of the edge so disrupts the conventions of an aesthetic form – so fundamentally contests the division of painting and sculpture, form and matter, subject and object, even life and death – that we are compelled once again to notice the milieu of art.[17]

Many critics responded to the 1968 'Chain Polymers' show in a tone of elation, underscoring the psychic resonances of the work, which some described appreciatively as 'demoralized'.[18] This reaction is bound up with a powerful trend toward the unmaking of late modernist sculpture in the mid- to late 1960s, resulting, as Buchloh has noted, in 'aesthetic shock and subsequent relief' at its collapse.[19] The audience's expectations, to return to Buchloh's observation about the historical specificity of sculptural materials, now leaned in the direction of the floor, facilitating projective identification with a dispersed and decentred materiality. For Hesse's exhibition constructed a spatial environment in which loss – the loss of permanence, the loss of medium itself – did not prove to be depressing, and for many was even a relief. In the historical reception of Hesse's work, however, the susceptibility of the latex works in particular to deterioration has assumed an oppressive metaphorical significance. The fate of her art has been to attract the melancholic projection not only of curators and historians but also of artists. To put it another way, Hesse's work has been absorbed into other milieux, other transferences.

The 1992 Hesse retrospective, at the Yale University Art Gallery (and in particular its catalogue), constructed an 'abject' Hesse whose oeuvre, bound up with bodily suffering, resonated with a moment of deep cultural anxiety about illness, death and mourning, and about the decimation of a generation of young artists.[20] At the level of display, the Yale exhibition evoked a studio milieu, presenting works such as photographs show them in the artist's loft, hanging together like so many possibilities, so many propositions to be picked up and, as Hesse so often did, expanded, inverted, reworked. Such an installation can hardly be imagined today. Not only has this Hesse been displaced in the critical literature by a mature artist of more embracing historical significance, but the requirements of lenders and insurers for such accoutrements as protective plinths and cases dictate a more formal, museal presentation.[21] Too often, these barriers actively disrupt the physical

continuity between the viewer and the work that is so fundamental to Hesse's art. In a roundtable discussion published in the catalogue of the 2002 retrospective, curated by Elisabeth Sussman at the San Francisco Museum of Modern Art, Sol LeWitt takes up the question of preservation, which has become a central theme of Hesse studies. There, LeWitt, who assisted Hesse with the making and installation of some works, calls for particular pieces to be refabricated, underscoring the value of seeing works 'as they were meant to be seen, and not as mummified fragments'.[22]

Against the trend of conservationist zeal, the 2002 retrospective did manage to encompass both the immediacy of Hesse's work in the late 1960s and the aesthetic import of its subsequent deterioration, the slippage from one milieu to another that is a distinctive feature of its historical legacy.[23] For while the abjectification of Hesse's art in the 1990s and the intensive, almost fetishistic, concentration on materials and conservation in more recent scholarship might represent, as LeWitt suggests, a double failure to see the work as it was meant to be seen, these interpretations also demonstrate how, in its very concentration on the surrounding environment as an integral part of the work, Hesse's art exposes itself to the conditions – physical and social, historical and cultural – of transference. This is a body of work that, in altering the milieu of art, also accepts that the milieu will alter it in turn. 'Life doesn't last; art doesn't last. It doesn't matter'.[24] Such was Hesse's comment on her extensive use of latex, 'a medium known to be impermanent'.[25] And while it is possible to read this statement on the works' susceptibility to the effects of time as tacit permission to remake them, it is also possible to suggest that, for Hesse, the instability of the work of art was simply a consequence of altering the milieu.

Hesse's art operates on Laplanche's principle that one notices a milieu less when one is immersed in it; more so when it is altered or when one leaves it. The persistent pressure Hesse's work once exerted on the medium and on the conventions of display, however, is less keenly felt by viewers today. The photographic dissemination of Hesse's work itself militates against these strategies. Works composed of modular elements – the crumpled buckets of *Repetition Nineteen* scattered across the floor, the gutted fibreglass wrappers of *Tori* (1969) piled in a dishevelled heap, or the fifty translucent tubes of *Accretion* (1968) propped at irregular intervals along a wall – are so well known from contemporary documentation that to follow the artist's instructions for random placement requires the curator to overcome a powerful photographic superego. Yet the effect of even modest adjustments can be telling. Seldom exhibited at the Whitney Museum of American Art where it resides, *Untitled* (*Rope Piece*) (Figure 8.4) is known primarily through photographs showing the tangle of latex-dipped cord installed in a corner, as it was in Hesse's studio. In the 2002 retrospective in San Francisco, this work

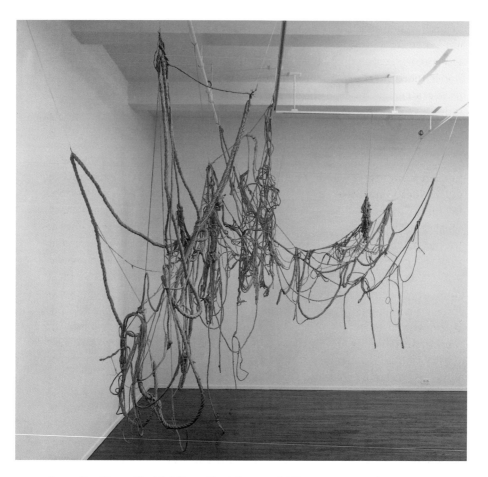

8.4 Eva Hesse, *Untitled* (*Rope Piece*), latex and filler over rope and string with metal hooks, completed March 1970

occupied an open corner of the final room. Slicing into the corner not only offered a new perspective on the work – enabling the viewer to look at the piece from two sides – but also freed it from the indelible frame of the photographic image, and so altered the milieu.

The question of how, and even whether, to display some works held a central place in the debates that informed both the San Francisco exhibition and its subsequent 2003 presentation at Tate Modern. At the level of installation, the construction of protective plinths for floor pieces, like the use of prophylactic perspex cages to cover the open cubes of the *Accessions*, preventing viewers from leaning over their densely tufted interiors, inhibited works from being seen as they were meant to be seen. However, LeWitt's

metaphor of mummification, and the unease that has greeted his proposal to remake particularly fragile works, exposed a problem that Laplanche's account of transference may help to address: how might it be possible to keep transference from stalling, or becoming fixated (on the abject, on death, on preservation) as works become assimilated into the museum, and into the museum without walls?

When Laplanche describes transference as the surrounding environment of the analytic scene, he refers not to the context or the real world – terms criticism often falls back on when trying to consider the milieu of an art practice – but instead to a dynamic tension between the analytic situation and others that impinge upon it. These other scenes or relationships, so-called lateral transferences, exist alongside the analysis. Here the analysand enacts what cannot (or cannot yet fully or directly) be addressed in the analysis. The task of analysis is to draw such relationships back into the analytic setting, to make them part of its milieu.[26] This process by which transference moves in and out of the analysis itself – spirals away from it, is drawn back into it, ultimately separates from it – is what Laplanche calls a 'transference of transference'.[27] In Laplanche's account, then, the movement between inside and outside, between the analytic scene and what lies 'before, beyond, or after analysis' is critical. The aim of analysis is to keep the transference moving, to discourage fixation and foster new symbolic relations: 'If we interpret a transferential movement', he explains, 'it is not to attack it as a defence, nor to resolve it; it is in the end to make it evolve, to help in its evolution'.[28] Hesse's process-based art – anamorphic, interstitial and shifting – instigates movement in the transference, while also demonstrating how exacting a task it is to keep transference moving, even within a contemporary artistic practice. The historical reception of her work manifests the challenge of making transference evolve.

Transference, for Laplanche, may be 'filled in' or 'hollowed out', may be replete with apparent meaning or as hollow as 'the originary infantile situation'.[29] What analysis offers, he contends ('and perhaps in this it is allied to the site of culture') is to reopen 'the dimension of alterity', the unknowability of the other and of the self, which is hollowness.[30] Laplanche's spatial metaphors invite comparison with Hesse's. For her art, too, alternates between filling in and hollowing out, but moves inexorably toward the hollow, or, to borrow Hesse's term, toward nothing.[31] Other artists of the Minimalist and Post-Minimalist generation also gravitated toward such hollowness. Robert Smithson even proposed that 'a museum devoted to different kinds of emptiness could be developed'. 'The emptiness', he suggested, 'could be defined by the actual installation of art. Installations should empty rooms, not fill them'.[32] Smithson's own work invoked this principle through the Nonsite, a displacement of material such as rock, dirt

and sand to the gallery, which was not filled by the maps and geological specimens in which the installations consisted, so much as emptied by them. For Smithson's Nonsites reoriented the visitor to other sites. In Smithson's own terms, the value of a site is not its plenitude by comparison with the gallery or museum ('visiting a museum', he writes in 'Some Void Thoughts on Museums' of 1967, is 'a matter of going from void to void'), but precisely the site's emptiness.[33] As he explains in contemporary conversation with Allan Kaprow, his interest is in 'what's not happening, that area between events which could be called the gap. This gap exists in the blank and void regions or settings that we never look at'.[34] The obscurity and emptiness of the site, its resistance to mental mapping – its hollowness – refer back to the void of the gallery or museum. In Laplanche's terms, Smithson inverts the filled-in transferences the museum activates when it is understood as a rich collection of artefacts, or a reconstructed history, by concentrating instead on the museum's 'nullity', and on the hollowed-out transferences the museum-as-void can elicit.[35]

To return, then, to the analytic scene (but remembering that, for Laplanche, 'the principal site of transference … would be the multiple relation to the cultural'), Laplanche describes transference as the situation in which analysis takes place: 'Let us say that on the whole we have moved from the analysis *of* transference to analysis situated *in* transference. This implies a "basic" transference, which would be in the end the very *milieu* of analysis, in the sense of its surrounding environment'.[36] In this account, transference is not the object of analysis, but its very condition. ('It is often noticed even before the beginning of the treatment, for instance in a dream'.) The analysand brings the capacity for transference into the analysis from outside, so transference forms the surrounding environment of the treatment. The task of analysis, however, is to reveal the peculiarity of this process by concentrating it. The structure of the analytic scene – the 'essential dissymmetry in the relation' in which one speaks while the other listens, one lies down while the other sits upright – enables the analysand to notice the milieu, to analyse the transference in which she or he is habitually immersed.[37]

Laplanche suggests that analysis offers the subject a hollow: 'The analysand can place there something "filled-in" or "hollowed-out". If it's something filled-in, he empties his pouch into it; if hollowed-out, *another hollow*, the enigma of his own originary situation, is placed there'.[38] The hollowed-out thing is the enigma of the other. First encountered in infancy as the maternal body, the enigma is filled in, covered over by language. Analysis, however, has the potential to hollow out transference: 'Analysis offers – and perhaps in this it is allied to the site of culture – a reopening of the dimension of alterity'.[39] For Laplanche, then, access to the enigma of

origins is opened up by analysis, but also by the cultural message. The hollow is the originary infantile situation that is filled in by culture. Yet to occupy that place again, the subject does not withdraw from culture (does not regress from the symbolic), but instead exchanges a position of mastery for one of unknowing. And this unknowing opens up the dimension of alterity that is always already present in the other and in culture, but that, filled in, may go unremarked. Laplanche makes no distinctions among cultural messages, but is sure that, as in the analytic situation, particular artistic practices, developed at specific historical moments, are more concentrated on the dimension of alterity, and on offering the viewer a hollow.[40] To the extent that art is enigmatic – not filled in but hollowed out – it may provoke hollowed-out transference.[41] The work of Hesse's and Smithson's generation is distinctive in its focus on this condition.

In Smithson's terms, Hesse's art emptied rooms rather than filling them. The space that artists including Andre, Morris, Smithson and LeWitt had cleared with their installations created a situation comparable to the analytic scene as Laplanche describes it, a hollow that can receive another hollow. It is often observed of Hesse's work that the traces of the figure eradicated by Minimalism resurface there, but in a form resistant to symbolism. In 1966, Lucy Lippard organised 'Eccentric Abstraction', a group exhibition at the Fischbach Gallery, to demonstrate this point. Conceived as a repertory of 'erotic alternatives to a solemn and deadset Minimalism', the show included works by Hesse, Louise Bourgeois and Bruce Nauman, among others.[42] Arguing for a dissident bodily materiality shorn of Surrealism's 'literary pictorial associations' and minus its 'known and stereotyped Freudian symbolism', Lippard declared: 'a bag remains a bag and does not become a uterus, a tube is a tube and not a phallic symbol, a semi-sphere is just that and not a breast'.[43] This disavowal of symbolic meaning was a pressing critical concern. For Hesse's work was, in Laplanche's terms, moving inexorably toward the hollow. And with the hollow, Laplanche insists, 'we are sent back to the originary infantile situation'.

The origin of Hesse's sculptural production is precisely the infantile situation. 'A dumb thing which is three-dimensional … like breast and penis', was her description, in a letter to Sol LeWitt, of her first relief sculpture *Ringaround Arosie* (1965).[44] As if in commemoration of their epistolary exchange over Hesse's first sculpture, and LeWitt's injunction to 'do more', in 1966 Hesse was to present LeWitt with the gift of a similar object (Figure 8.5). Composed of two protuberant nippled demispheres, a small stacked above a large, *Ringaround Arosie* is modelled in papier mâché and encased in concentric loops of cloth-covered wire, its chalky surface painted in aureoles of orange and pink. Lippard would remark that 'in fact both rosy-nippled circles look like breasts – a little one on top of a big one, forming a sort of

8.5 Eva Hesse, *Untitled*, acrylic paint and cord over papier-mâché on wood, 1966

doubly female figure'. The larger demisphere, with its raised centre, resembled, as she further observed, 'a kind of breast-within-a-breast'.[45] And this reading of *Ringaround Arosie* as a doubled breast, in which one demisphere is itself a breast-within-a-breast, contains its own explanation as to why Hesse might have thought of both breast and penis. For a breast-within-a-breast suggests a fantasmatic construction in which a penis might logically be nippled, or twinned, or borne in the breast: in which breast and penis might be conflated, concatenated, or confused – as if the difference between them were a distinction less of kind than degree of protuberance.

For Laplanche, the breast is an enigmatic signifier. Embodying the

mysterious desire of the other, it puzzles the infant and so precipitates the child into questioning. Laplanche's infant dwells in the hollow: 'What does the breast want from me?' it wonders, 'apart from wanting to suckle me, and come to that, why does it want to suckle me?'[46] 'The sexual enigma', writes Laplanche, 'is presented to the child by the other as an *address*, and this address is enigmatic in so far as the other (the one who sends it) does not entirely know what he is saying: he is other to himself.'[47] The condition of being other to oneself, this 'primordial split', is what the analyst offers the analysand. *The other is other* – not only to me, the analysand, but to him- or herself ('external reality refers back to internal alterity'). In the transference situation, this primordial split, this alterity of the other to the other, is the hollow into which the analysand can slip another hollow.

Hesse's work activates an intrusive, stimulating and sexual solicitation of the body in the cultural domain, but also contains it. As such, it instigates a dynamic that, as Laplanche observes, is structural to the praxis of psychoanalysis. In the analytic scene, the trend toward unbinding (the 'zero principle' of dissolution) is counterbalanced by 'the constancy of a presence, of a solicitude, the flexible but attentive constancy of a frame'.[48] This frame is, as Laplanche emphasizes, 'all the more necessary in that we encourage or induce an unbinding discourse'.[49] Hesse's work similarly uses the frame – an actual frame, as in *Hang Up*, or the frame of the gallery itself as in the installation of 'Chain Polymers' – to contain the unbinding that is enacted precisely there, at the interface of the body and the surrounding environment. The terms Laplanche uses to evoke these countervailing trends find repeated echoes in Hesse's art, in its combinations of binding and loosening, knotting and unravelling, hanging and gathering, ordering and scattering. This body of work, in Laplanche's terms, both 'guards the enigma and provokes the transference'.[50] It acts on the viewer as a proposition, but one that is enigmatic, a proposition that provokes transference because it is enigmatic. Hesse's work altered the milieu of art by hollowing it out.

Notes

1. Jean Laplanche, 'Transference: Its Provocation by the Analyst', in *Essays on Otherness*, ed. and trans. John Fletcher, London, 1999, p. 217. A previous version of the present essay, 'Eva Hesse Retrospective: A Note on Milieu', was published in *October*, Vol. 104 Spring 2003 as a response to the 2002 Hesse exhibition at the San Francisco Museum of Modern Art.

2. On the perceptual structure of Morris's *Mirrored Cubes*, see Rosalind Krauss, 'The Mind/Body Problem: Robert Morris in Series', in *Robert Morris: The Mind/Body Problem*, exh. cat., New York: Solomon R. Guggenheim Museum, 1994, p. 12: 'Trapped in the cross fire of the mutual reflections set up by the surfaces of the four facing blocks, the gestalt itself is absorbed by the constantly delayed experience of its presence as it seems to depart into infinite regress'.

3. Laplanche, 'Transference', p. 222.

4. Ibid., p. 224. The critic, according to Laplanche, is the recipient–analyst who produces another cultural work based on interpreting the one s/he receives.

5. Ibid.

6. Leo Bersani, 'Death and Literary Authority: Marcel Proust and Melanie Klein', in *The Culture of Redemption*, Cambridge, Mass., 1990, p. 17. Here Bersani considers Melanie Klein's 1923 essay 'Early Analysis' and its account of sublimation, in which 'the displacement of libido onto other object and ego activities can be called symbol formation only if we specify that these objects and activities *act symbolically without symbolizing anything external to them*' (emphasis in original). See also Briony Fer, 'Bordering on Blank: Eva Hesse and Minimalism' (1994), in *Eva Hesse*, ed. Mignon Nixon, Cambridge, Mass., 2002. Fer makes a strong distinction between 'symbols' as such, which Hesse resists using, and 'the symbolic procedure at work' in Hesse's art (p. 58).

7. Lucy Lippard, *Eva Hesse*, New York, 1976; rept. New York, 1992, p. 60.

8. Quoted in Cindy Nemser, 'A Conversation with Eva Hesse' (1970), reprinted in *Eva Hesse*, p. 7. *Trébuchet* (Trap) of 1917, is a set of clothes hooks Duchamp nailed to the studio floor. The term is used in chess to refer to a pawn used to trap an opponent's piece.

9. Emily Wasserman, 'New York: Eva Hesse, Fischbach Gallery', *Artforum*, January 1969; reprinted in Richard Armstrong and Richard Marshall (eds), *The New Sculpture 1965-75: Between Geometry and Gesture*, exh. cat., New York: Whitney Museum of American Art, 1990, p. 94.

10. Ibid.

11. Benjamin H.D. Buchloh, 'Michael Asher and the Conclusion of Modernist Sculpture' (1980), in *Neo-Avantgarde and Culture Industry: Essays on European and American Art from 1955 to 1975*, Cambridge, Mass., 2000, pp. 4–5.

12. Hesse to Dorothy James, September 1967, as quoted in Lippard, *Eva Hesse*, p. 106.

13. Nemser, 'A Conversation with Eva Hesse', p. 14.

14. Rosalind Krauss, 'Eva Hesse: Contingent' (1979), in Nixon, *Eva Hesse*, p. 32.

15. Ibid.

16. Ibid.

17. It is worth quoting an extended passage in full: 'The most powerful and continuous element of Eva Hesse's work comes from the way it concentrates on the condition of edge, the way it makes the edge more affective and imperious by materializing it. In this way, the edge that is displayed by Hesse is not focused on the boundaries *within* a painting or a sculpture, but rather on the boundary that lies *between* the institutions of painting and sculpture. In the language of anamorphosis, we could say that we are positioned at the edge from which the meaning of death is understood literally as the condition of the world disappearing from view' (Krauss, 'Eva Hesse: Contingent', p. 32). The reference to the world disappearing from view is to the appearance, via anamorphosis, of a skull as a *memento mori* in Hans Holbein's *The Ambassadors*.

18. Emily Wasserman notes 'a principle of demoralizing form' in *Repetition Nineteen III*. Hilton Kramer, reviewing Hesse's show for the *New York Times* on 23 November 1968, takes exception to a 'kind of demoralized geometry just barely rescued from complete dissolution by formal improvisations of an eccentric order'. The critical reception of Hesse's 1968 exhibition at the Fischbach Gallery is summarized in Lippard, *Eva Hesse*, p. 132.

19. Buchloh, 'Michael Asher and the Conclusion of Modernist Sculpture', p. 10.

20. Helen A. Cooper, *Eva Hesse: A Retrospective*, with essays by Maurice Berger, Anna C. Chave, Maria Kreutzer, Linda Norden and Robert Storr, New Haven: Yale University Art Gallery and Yale University Press, 1992.

21. The historical construction of Hesse is the subject of Anne Wagner's 'Another Hesse' (1996), in Nixon, *Eva Hesse*.

22. Quoted in 'Uncertain Mandate: A Roundtable Discussion on Conservation Issues', in *Eva Hesse*, ed. Elisabeth Sussman, San Francisco and New Haven, 2002.

23. On the exhibition's aim to present Hesse's work as directly as possible, see Elisabeth Sussman, 'Letting It Go as It Will: The Art of Eva Hesse', in *Eva Hesse*.

24. Quoted in Nemser, 'A Conversation with Eva Hesse', in Nixon, *Eva Hesse*, p. 18.

25. Lippard, *Eva Hesse*, p. 210.

26. On this point see also Luciana Nissim Momigliano, 'The Psychoanalyst Faced with Change', in *Continuity and Change in Psychoanalysis*, trans. Philip P. Slotkin and Gina Danile, London, 1992.

27. Laplanche, 'Transference', p. 214.

28. Ibid., p. 217.

29. Ibid., p. 229.

30. Ibid., p. 230.

31. Briony Fer notes that Hesse 'liked the way *Right After* "looked like a big nothing"', and suggests that 'Hesse's "big nothing" points to something in the work that I would want to describe as a kind of blankness.' Fer, 'Bordering on Blank: Eva Hesse and Minimalism', p. 58.

32. Robert Smithson, 'What Is a Museum?' (1967), dialogue with Allan Kaprow, in *Robert Smithson: The Collected Writings*, ed. Jack Flam, Berkeley, 1996, p. 44.

33. Smithson, 'Some Void Thoughts on Museums' (1967), in *Robert Smithson: The Collected Writings*, p. 41.

34. Smithson, 'What Is a Museum?', p. 44.

35. 'I think the nullity implied in the museum is actually one of its major assets, and that this should be realized and accentuated. The museum tends to exclude any kind of life-forcing position. But it seems that now there's a tendency to try to liven things up in the museums, and that the whole idea of the museum seems to be tending more toward a kind of specialized entertainment ... So, I think that the best thing you can say about museums is that they are really nullifying in regard to action, and I think that this is one of their major virtues'; Smithson, 'What is a Museum?', pp. 43–4.

36. Laplanche, 'Transference', p. 216.

37. Ibid., p. 228.

38. Ibid., p. 229.

39. Ibid., p. 230.

40. On the question of how the 'communicational dimension' of psychoanalysis – as a dialogue between individuals – might be projected into a cultural matrix, see Peter Osborne, 'Dialogue with Psychoanalysis', in *Philosophy in Critical Theory*, London, 2000. Osborne identifies Laplanche as the psychoanalytic theorist most profoundly engaged with this question today.

41. The relation between the enigma of the maternal body and the museum is intensively explored in Mary Kelly's *Post-Partum Document* (1973–9). Describing the project in a conversation with Paul Smith in 1981, Kelly observed that she had always thought of the museum, and in particular the natural history museum – a site of investigation she shares with Smithson – as 'a vast metaphor for the exploration of the mother's body'. 'No Essential Femininity: A Conversation between Mary Kelly and Paul Smith', reprinted in *Mary Kelly: Imaging Desire*, Cambridge, Mass., p. 63.

42. Lippard, *Eva Hesse*, p. 83.

43. Lippard, 'Eccentric Abstraction', *Art International*, 10 November 1966, pp. 57–8.

44. Hesse to LeWitt, March 1965, as quoted in Lippard, *Eva Hesse*, p. 34.

45. Ibid., p. 38.

46. Jean Laplanche, *New Foundations of Psychoanalysis* (1987), trans. David Macey, Oxford, 1990, p. 126.

47. Laplanche, 'Transference', p. 229.

48. Ibid., p. 227.

49. Laplanche, *New Foundations of Psychoanalysis*, p. 159.

50. Laplanche, 'Transference', p. 227.

Inside out: Rebecca Horn's extimate monument

Brian Grosskurth

The steel and plexiglass structure stands tottering at the edge of the sea. Rising precariously like a fragile stack of blocks, its rough assemblage is a strange presence among the white sand and elegant palm trees. Only the nearby one-storey buildings bricked up for demolition possess a distant resemblance to the box-like parts of this odd construction towering above the swimmers and sunbathers (Figure 9.1). Approaching the structure across the littered beach, one comes close enough to peer through stained and cloudy windows, to glimpse what appear to be disused equipment and fluorescent tubes winding up to the ceiling of a floorless interior. Outside, the trace of a door has been incised upon the steel surface. An inscription reads: 'El lucero herido, Rebecca Horn, 1992' (Figure 9.2).

'El lucero herido' – 'the wounded falling star': this title is doubled by another, *Homage to Barceloneta*, on a plaque some distance from the work, by the road on the beachfront. This doubling of the title appears to provide the key to a work which is both opaque and transparent, open and closed. If the work is indeed a homage to Barceloneta, the district on the Barcelona waterfront, the second title, *The Wounded Falling Star*, becomes a type of commentary on its more legible designation. For Barceloneta is itself 'the wounded falling star', disfigured by the urban transformations undertaken at the time of the 1992 Olympic Games, and the beach, which the sculpture now haunts with its abandoned, phantom-like presence, is a recent product of those changes. The bricked-up buildings which the work resembles form a stark contrast to the Olympic Tower and redesigned shoreline built for 1992. In this light, one might view Rebecca Horn's *Homage to Barceloneta* in relation to the urban transformations which it laments and deplores. Completed by the German artist in 1992, the work mourns the loss of an entire neighbourhood.

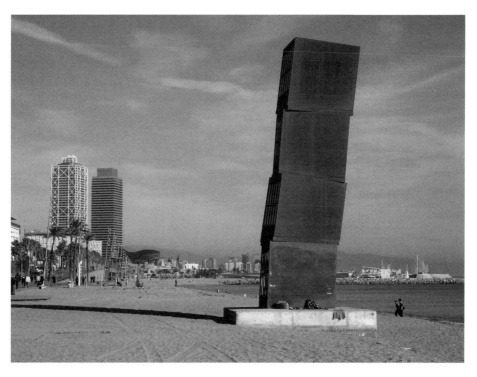

9.1 Rebecca Horn, *Homage to Barceloneta*, iron, glass and mixed materials, 1992

Yet this reading is complicated by an unsettling supplement which blurs the boundaries between public and private, between social spaces and secret interiors. In 1993 Rebecca Horn published a book of writings and photographs in which *Homage to Barceloneta* is reproduced with an accompanying text.[1] At the conclusion of *La lune rebelle*, two photographs of the sculpture appear alongside a poem by the artist herself. Equally significantly, these images and their corresponding text are preceded by a series of fragments which map the city of Barcelona within an explicitly autobiographical context. *Homage to Barceloneta* becomes grafted onto a fractured narrative of which the artist herself is the elusive subject. While such a twist hardly eliminates the social and historical connotations of the work – connotations which Rebecca Horn's poem explicitly confirms – the autobiographical text in which the work is resited adds a supplementary dimension that significantly complicates its topological siting. Rather than simply occupying one homogeneous space, the sculpture oscillates – as if on a mobile Moebius strip – within a shifting interplay between linked yet heterogeneous domains. In this essay, I wish to deploy Lacan's concept of

9.2 Rebecca Horn, *Homage to Barceloneta* (detail), iron, glass and mixed materials, 1992

extimité to negotiate a way through this terrain. From this anamorphic perspective, Horn's sculpture is neither secret nor public. Instead, it is an *extimate monument* harbouring a hollow space, a strange void which spans the poles of interiority and exteriority.

One's first encounter with this enigmatic work appears to solicit Lacan's concept of 'the Thing'. 'The Thing' is the embodiment of extimate logic in which inner and outer interweave, where the interior secret assumes the guise of a foreign body, out of place and unassimilated. What is a 'Thing'? In his seminar on ethics, Lacan intriguingly claims that 'das Ding' is the secret itself.[2] In venturing into this field, Lacan invokes the Freudian notion of the 'Nebenmensch', the pre-Oedipal Other who is both the external provider for the infant's needs and, at the same time, internalised and incorporated as radical alterity within the psyche. This unforgettable 'prehistoric Other' is lodged in the self as a 'foreign body', a paradoxical form of internal exclusion. Its place within the psychic structure is not an unproblematically 'intimate' interiority, but an 'extimate' mode of inner expropriation.[3]

In Lacan's presentation, 'the Thing' initially embodies the space of desire

as the field of the lost object. As the external provider, the source of fulfilment of the infant's needs, 'the Thing' can be perceived through the child's gaze as either traumatic absence or as an imposing presence of hostile refusal, an obstinate force of aggressive withholding. As the preliminary site of radical lack, 'the Thing' traces a primordial and unpresentable void around which the objects of substitution appear and vanish.

Sublimation, according to Lacan's redefinition, represents 'the object raised to the dignity of the Thing'. As in Freud's problematic, sublimation obeys a law of substitution. But whereas Freud argued that elevated ideals and high pursuits displace the raw urgency of primitive drives, Lacan proposes a more abstract logic of absence and presence. In the void of 'the Thing', something tangible appears. The object stands as the visible substitute for that which is blocked from the space of the image. 'The Thing' is always veiled and hidden: it must be represented by something in its place.[4]

The problematic of 'the Thing' has direct consequences for Lacan's conception of art. As an unpresentable void, 'the Thing' can never appear 'in person' within the field of sculpture. Nevertheless, art is structured around this empty core. Invoking the example of the vase, Lacan argues that objects must be seen as signifying structures created and shaped in relation to a void. Through the vase, an inner, blank space is fashioned within the world. Lacan views this relation as directly analogous to the way in which 'the Thing' itself is traced *retroactively* through a dense structure of multiple signifiers. The emergence of a symbolic order defines the excluded, pre-symbolic, extimate field of 'the Thing'.

The example of the vase functions in Lacan's discourse as a model of the work of art in general: art is sited around the void of 'the Thing', while the objects which enter the space of representation appear as substitutes for the unpresentable. In this sense, the production of art is literally creation *ex nihilo*, the drawing of form around a space of nothingness.

In architecture, the void is central: its relation to 'the Thing', according to Lacan, constitutes architecture's 'true meaning'. Temples and palaces, houses and huts, shelter an unpresentable core of absence. In this context, Lacan suggests that an entire history of art could be proposed in terms of structure and void, image and emptiness. Prehistoric cave paintings, he notes, were created in *caves* – unlit, interior, *empty* spaces occupied only by 'the Thing'. The dazzling images, flickering in darkness, formed an enveloping skin around that which could not be represented.[5]

In the subsequent development of western art, this void was alluded to more discreetly, more elusively. The rich proliferation of pictures from the Renaissance onward masked the emptiness which formed their core. In every work of art, Lacan contends, it is always a question of encompassing,

encircling and enclosing 'the Thing'. Paintings may represent particular objects, but that is not their ultimate goal. In one sense, the imitation of the object is only a feint: it is always the unpresentable 'Thing' which lurks behind depiction. Cézanne's apples are one example cited by Lacan: the painted fruit, rendered delicately in touches of orange, green and transparent red, indirectly indicate that which lies beyond appearance: the unseen void which cannot be represented.[6]

Earlier, Lacan singled out the anamorphosis in Holbein's *The Ambassadors*, the way in which a formless shape at the base of the picture suddenly becomes a legible image when viewed from the side. This work, he argued, is a striking example of the unseen, unsettling void of 'the Thing'. Although in later years he was to reinterpret the same painting as the site of the equally extimate, equally unpresentable *objet petit a*, Lacan reads the work somewhat differently in the seminar on ethics. At the moment when the viewer leaves the painting, he or she turns back for a final glimpse. The viewer then sees the unreadable shape, the grey blot on the pristine floor, assume 'its sinister truth' as a skull. At an oblique angle of vision, the death's head appears with shocking suddenness. Among the array of polished objects – of musical instruments, maps and compasses – the skull intrudes as a formless stain.[7] But despite the suggestion that the image of death is the truth of 'the Thing', it is in fact this initial formlessness which is the truth of the fleetingly legible, visible skull. Nevertheless, the space of 'the Thing' possesses an essential relation with death. In the work of art, beauty acts as a type of barrier in the face of the death drive, of desire as 'the field of absolute destruction beyond putrefaction'. The beautiful acts as a veil of radiance concealing the ugly truth of desire as death. Yet beauty also disarms desire and resists all outrage. Its implicit command is 'Do not touch me!' Lacan defines this limit in terms of negation, as an absolute border where beauty appears as lustrous splendour.[8]

In addressing the spectral 'Thing' within Rebecca Horn's sculpture of 1992, one notes that the double title of the work betrays its extimate character as it foregrounds the impossibility of naming. Before 'the Thing' as an apparition ghostly and phantom-like, Lacan contends that one cannot voice a proper name. Similarly, the double title of the sculpture – *Homage to Barceloneta* and *The Wounded Falling Star* – divides and fractures the work's identity. In traditional terms, a title is not simply a marginal flourish, an additional, final embellishment, but literally the work's *heading*. In this sense, the title bears a double function: both as the designating name and as a principle of authority. The title *precedes* the work and acts as its guarantee of meaning. But Rebecca Horn's sculpture has been given *two* titles. It is impossible to elevate one to the status of principal designator and, correspondingly, to relegate the other to a secondary level. The relation

between the two is undecidable. Certainly, one can assert that *Homage to Barceloneta* designates the historical, social and political dimensions of the work. It names and identifies the site in which the sculpture is located. *The Wounded Falling Star*, in contrast, possesses a more secret dimension. If one were to approach this title in conventional terms, one would ask what *proper identity* the metaphor of 'the wounded falling star' tropes. One response is Barceloneta itself. This reading appears to be supported by Rebecca Horn's own text in *La lune rebelle* and should not be dismissed. Yet on another plane, can such a *decision* ever be *authorised*? The inscription, 'El lucero herido', appears on the work itself followed by the artist's proper name and, for this reason, it is more than a secondary subtitle. Conversely, the title *Homage to Barceloneta* is registered on a plaque some distance from the sculpture and, although it seems to be endowed with official status, can this alone give it a position of primacy? A logic of double supplementation produces an oscillating relation between the two titles. And this oscillation, in turn, demands that the work be read on at least two levels.

Such supplementation raises crucial questions. It must be asked whether it is justifiable to consider references to the artist's 'autobiography' as material which can be drawn upon in interpreting the work. If the terms of the question are understood in a literal sense, then the response must be negative: it would be misleading to read *La lune rebelle* as a factual confession or transparent gateway to the artist's psyche. Instead, the book is a heterogeneous construct, a text weaving the motifs of desire, disappearance, loss and death into the form of broken narratives. Yet autobiographical reference is not ruled out. The photographs of Rebecca Horn as a child and adult flanking the beginning and end of the book appear to invite a reading of the text as autobiography, however fictional its forms may be.

It is a text which traces a complex space of desire. In this sense, *Homage to Barceloneta* can be mapped onto a site produced by the intersection of at least two fields: the domain of history and social change, and a text of desire in which the artist appears as a divided point of singularity. Nevertheless, this intersection delineates a space in which the two elements cannot be related through simple juxtaposition. Instead, an intricate superimposition occurs through which desire, loss and social history are inextricably knotted together. Yet even this complication of the topology in which *The Wounded Falling Star* can be positioned is not sufficient. It is necessary to stress the radical displacements within these superimposed spaces, dislocations which in turn provoke a radical placelessness. In this complex site, the sculpture stands like a phantom, a strange spectre neither present nor absent.

La lune rebelle opens in an arresting manner. Embedded within the first splintered narrative is a crucial statement. The narrator expresses the wish that, in articulating the initial fragment, she may be able to go on to tell her

story. The statement recalls 'the talking cure' and, more specifically, Lacan's early conception of the significance of recollective speech. In the 'Rome Discourse' of 1953, Lacan argued that the role of memory in analysis is important only to the extent to which the subject is able to channel recollection into speech or, more precisely, into the *epos* by which he brings back into present time the origins of his own person.[9] It is not the accuracy of memory which is the crucial issue here for Lacan, but 'the intersubjectively intelligible narration of the past in the form of a tale or even an epic … of origins'.[10] For this reason, truth can assume the guise of fiction, as it is not a correspondence between discourse and past reality which is at stake, but the metonymic articulation of desire through language itself. In the 'Rome Discourse', this truth is assigned a narrative form: 'in psychoanalytic anamnesis, it is not a question of reality, but of truth, because the effect of full speech is to reorder past contingencies by conferring on them the sense of necessities to come, such as they are constituted by the little freedom through which the subject makes them present'.[11]

Lacan situates the fictional articulation of truth in a teleological narrative with both a beginning and an end. Between these two poles, the story unfolds in all its necessity. The patient renders the truth of her 'own' desire present in speech, and, in doing so, makes her identity her 'own' despite the division of the subject through language. The goal is 'full speech'. As one commentator remarks: 'The analytic dialogue has achieved an important part of its purpose when the analysand can successfully narrate an answer to the question, "Who or what am I?" – an answer that manages to cast the analysand himself as a subject who has a history.'[12] And this can be achieved only through 'la parole pleine'.[13]

In Derrida's controversial reading, Lacan's concept of 'full speech' inevitably has philosophical premises. Identity, presence, subjectivity, teleology and truth are all seen as organising notions in Lacan's initial view of the 'talking cure'.[14] Yet Lacan was to distance himself, at least in part, from this problematic through an increasing emphasis on the dimensions of fantasy and the real. The extimate concepts of 'the Thing' and the *objet petit a*, in particular, splinter the homogeneity of 'full speech'.

In this context, the heterogeneity of the *objet petit a vis-à-vis* the order of the signifier must be stressed. The *objet petit a* is a form of excess beyond the limits of the symbolic system. Its relation to the signifying chain, however, is not one of simple exteriority. It emerges as a type of residual surplus, a remainder which haunts the system as an elusive point of alterity. It lacks the literal order of connection which links the individual signifier whose differential singularity confers logical consistency upon the signifying chain as a whole. The *objet petit a*, in contrast, is a heterogeneous product, eliminated as a remnant from the symbolic and marked by a different logic.

It is one of the undecidable traits of this *objet* that it can be at once defined as remnant, surplus and void. It marks a hole within the system, an active hollow rather than an immobile, inert gap. Yet in its very heterogeneity, it confirms the systematic homogeneity and consistency of the symbolic order from which it is excluded. And as the cause of desire, the object functions as a magnetic pole which maintains the entirety of the signifying chain in motion.

If this last trait gives a systematic stamp to the *objet petit a*, however, its very evasiveness accentuates its undecidability. As an *objet*, it remains strangely elusive. It is both exterior and interior. In the analytic session, it is neither simply present nor absent: it is rather, in Lacan's own formulation, present everywhere but, at the same time, radically imperceptible. Its vanishing traits indelibly mark the structure of fantasy.

 Fantasy embodies the identification and fusion of the subject with the object which, in its very *difference*, designates it as a point of longing and fascination. The unconscious fantasy possesses a structure in which there are four basic elements: a quasi-theatrical scene; a set of actors; a dominant emotion; and a specific part of the body around which the action turns. It is this fourth element which indicates the site of the *objet petit a* as the mobile void provoking desire.

In returning to *La lune rebelle*, one notes structural elements of the various narratives which, fragmented and dispersed, traverse the text. One could analyse the components of fictional fantasy which are represented and, in this way, seek to locate the evasive, extimate marks of the *objet petit a* as heterogeneous remainders. Such a reading would avoid the impossible task of finding a coherent story of origins in the book. And it would recognise that, in its fissured language and images, there can be neither 'full speech' nor an identifiable subject of desire.

Rebecca Horn's text opens with a family scene. The narrator and her estranged father meet in Barcelona. Partially reconciled, they embark together on a sea voyage on which her father dies. The narrator returns to Barcelona. There, a scruffy waiter, his shoes covered in sawdust, takes the narrator to a dingy hotel.[15] In another fragment, the narrator has sex with a man without feet who nimbly leaps onto the bed with feline agility.[16] In reading such brief texts, one might isolate traits corresponding to the impossible position of the *objet petit a*. In this sense, the various elements or, alternatively, their disconcerting absence, would seem to invite such a reading. A structural examination of the work would enumerate such components while, at the same time, avoiding unfounded links between narrative, narrator and artist.

For both Freud and Lacan, fantasy was initially linked with the ego. In 'Daydreams and their Relation to Creative Writing' of 1907, Freud proposed

that the fantasy is a daydream in which the self appears as an omnipotent figure who fulfils all erotic and heroic ambitions. Most crucially, for Freud, artists deploy the same egocentric orientation of fantasy: art represents the imaginary realisation of daydreams. Despite his 'neurotic flight from reality', however, the creative artist, if commercially successful, eventually achieves 'honour, power and the love of women', as his readers see their fantasies mirrored in his fictions.[17] In Freud's early arguments on fantasy, Lacan's imaginary is implicitly present. The daydream is a type of mirror on which the ego projects its idealised image. Similarly, in the case of writer and public, success is determined by a specular relation: fantasies are reflected in the work of art.[18]

In this early theory, fantasy is conceived of as a *mise en scène* of the subject's body, an enveloping figure for all forms of desire. In the fantasy, the ego enjoys the illusion of total freedom as a master of desires and their realisation. In this way, the ego denies its subjection to alienating structures.

For the early Lacan, fantasy is rooted in the domain of the imaginary.[19] The symbolic order, in contrast, disrupts such illusions. It underlines the subject's lack of autonomy through subordination to the letter. And because Lacan initially links fantasy with the imaginary, it is given only peripheral significance.[20]

In the 1960s, however, Lacan followed Freud's later developments by redefining fantasy in terms of an unconscious logic rather than as a specular projection of the ego. In this essay of 1919, 'A Child is Being Beaten', Freud had argued that the fantasy unfolds in the transformation of a phrase: 'A child (whom I hate) is being beaten' … 'My father is beating me' … 'I am beating a child'. In this process of transformation, the subject occupies a succession of different positions, both in the scenario and, above all, in the phrases themselves. Both subject and fantasy become subordinated to the order of language. Moreover, because certain transformations such as 'my father is beating me' remain unconscious, both subject and fantasy are structured by repression. In this theatre of permutations, it is not the ego but the subject of the unconscious which is in question. The subject appears as radically divided *vis-à-vis* the object, while the fantasy emerges as a montage of grammar to which the drive is tied. Through fantasy, the drives assume signifying structures within the displacements of desire.[21]

Lacan's final conceptualisation of the fantasy involves a redefinition of the cause of desire as the *objet petit a*. Seen as primarily imaginary in the early 1960s, the *objet petit a* is relocated between the imaginary and the real by Lacan in his seminars and writings in the following years. In this final stage of his teaching, Lacan defines the *objet petit a* as an alluring fragment of the unrepresentable. The fantasy which had been successively situated in terms of the imaginary and symbolic is now given a central relation to the real.

Such a change had practical consequences. The psychoanalytic cure was no longer considered exclusively in terms of the tension between the imaginary and symbolic. Most crucially, the cure was viewed as a function of the real: it exceeds the order of the signifier. This final emphasis is closely linked with the conceptualisation of fantasy as the conjuncture of two heterogeneous elements: the subject produced by both the signifying chain and the object beyond the structure of language. The attempted fusion of the subject with the *objet petit a* in fantasy is inevitably a story of failure: through the radical heterogeneity of the paired elements, the two terms never meet. Immersion in the domain of fantasy involves futile denial of this irreducible otherness.[22] Yet the aim of the cure is to stress such alterity within the dimension of lack and loss.

In tracing Lacan's shifting stances, the French critic Jean-Michel Ribettes focuses on the relation between fantasy and art. The work of art, he argues, installs an imaginary object to fill a gap in the symbolic order. Yet despite this apparent primacy of the imaginary, it is the real which is crucial. The inertia of the real is another name for the limits of language. Unrepresentable, traumatic and brutal, they mark the void at the heart of all representation. And the most significant task of the work of art is to designate this unpresentable space.[23]

At first glance, there appears to be a contradiction in Ribettes's dual emphasis on the imaginary and the real. A closer reading, however, indicates that Ribettes is drawing a distinction between exceptional works and the fantasmatic logic of minor art.[24] Only the former seize on the unpresentable, drawing upon its traumatic space. Lesser works, in contrast, cover over the real, filling the hole in the symbolic order with imaginary screens.

In the recently published seminar on anxiety of 1962, Lacan emphasises that the *objet petit a* has no relation to the object as it has been traditionally defined within western philosophy. Lacking the attributes of substance and presence, the *objet petit a* is marked by a falling, withdrawing, vanishing movement.[25] As François Baudry has remarked, the *objet petit a* can be defined at once as object, void and fractured remnant. As an object, it is both the cause and supplement of desire in its movement of endless substitution. As a void, it marks the very gap in the signifying order which it is called upon to fill. And as remnant or remainder, it is the detachable element of the subject which cannot be contained within the logic of the signifier and the space of language. In this way, the *objet petit a* occupies a place of neither presence nor absence in its site of impossible undecidability. Indeed, it is this very undecidability of the *objet petit a* which renders it incapable of filling the hole in the symbolic order, of patching the rupture produced by the real. In the structure of the fantasy, however, it is summoned to accomplish precisely this task. Its role is to hide trauma, blankness and loss. In his essay

'The Bird of Ruins', Baudry develops the question of trauma by noting that it involves the radical disappearance of the subject.[26] Topologically, what is at issue are holes in the weave of the symbolic and the impossibility of a viable trajectory in its perforated field. In this punctured domain, one trauma can hide another.

In mapping this space within Rebecca Horn's work, it is useful to ground the incidence of the extimate 'Thing' and the *objet petit a* in *La lune rebelle* and *Homage to Barceloneta* within a general 'spectral logic'. What is a 'spectral logic'? In a recent text, Derrida suggests that the spectre involves a paradoxical incarnation. Above all, the spectre, like Lacan's 'Thing', is difficult to *name*: it is neither body nor spirit, real nor immaterial, present nor absent, but instead occupies a strange, intermediary region which spans both poles. The spectre displays an odd logic in which the concepts of presence, stability, substance, identity and objectivity are radically destabilised and suffer displacement and dislocation. Although the spectre *appears*, it is also haunted by disappearance, absence and death. In its very appearance, it withdraws and recedes. In this disquieting oscillation, the spectre embodies that which cannot be named. One does not know what or even if it is.[27]

Far from being abstract ciphers, however, these same traits mark the historical memory and amnesia which hovers around and within Rebecca Horn's sculpture. In this context, it is important to recall that the construction of Barceloneta in the eighteenth century was the direct result of brutal political repression. It was a space already marked by death, destruction and dislocation. Having taken the side of France against Madrid in the War of Spanish Succession, Barcelona surrendered to the centralist forces on 14 September 1714 after a long and painful siege. Defeat was followed by summary executions and the public display of General Moragues' severed head during the ensuing decade as a macabre warning. As part of the campaign of military and political control over the rebellious city, Madrid erected a colossal fortress, the Citadel, to house a permanent army of occupation. Its task was to suppress all traces of insurrection. In constructing this real and symbolic site of centralist repression, the army razed the traditional seafront neighbourhood, the Ribera, without any compensation to the inhabitants. More than one thousand houses, hospitals or convents were arbitrarily destroyed.

In the late nineteenth century, the poet–priest Jacint Verdaguer evoked the obliteration of the Ribera in the following lines:

Around, around lie the great mansions,
the monasteries, the schools, the shelters,
the church and the hospital:
row by row the shacks are flattened into sand
and the happiest quarter of Barcelona is erased
like a number drawn on a beach

When, like water drained away, no trace remains
of these stones, the bones of the beloved city
they build a fortress ...[28]

In Verdaguer's elegiac poem, the notions of erasure and trace are explicitly stressed. The beach is metaphorically evoked as an unstable surface of writing effaced by the forces of repression. Yet although 'no trace remains', the Citadel itself was haunted by the dead. In a popular vein, one song pictured the images of violence and death associated with the fortress:

I've seen, I've seen, I've seen
up on the Citadel
how the hanged man swung
from a crooked cross.[29]

In this atmosphere, an entire mythology grew up concerning the spectres of the victims of centralist oppression. Their uncanny presence was invoked as a strange trace still hauntingly active, although their remains were buried in a mass grave next to the church of Santa Maria del Mar. Such images conjured up the shadowy phantoms of Catalan resistance whose resurrection was only temporarily deferred by Madrid's presence within the city.

The displaced inhabitants of the Ribera were originally intended to be transferred and rehoused in Barceloneta – the 'little Barcelona' planned in 1715 by Verboom, the Dutch architect who was also responsible for the grim design of the Citadel. Nevertheless, this development on the northern side of the city's port was not begun until 1753 under the supervision of the military engineer Juan Martin Cermeno. Yet although Barceloneta was first conceived in an atmosphere of military repression, certain aspects of the neighbourhood stubbornly superseded these sinister origins. Certainly, the 25-acre space was organised according to a model of strict rationality with a rigid grid system and uniform buildings. Nevertheless, the lively working-class character of the neighbourhood complicated this initial vision along with the less benign contribution of unscrupulous developers. With the coming of the Olympic Games, Barceloneta underwent further modifications. The entire harbour area was redesigned and the dingy, grey beach was replaced by white sand and tall palm trees. Equally importantly, the site on which *Homage to Barceloneta* now stands was cleared of its small restaurants in order to make way for the new sand and sunbathers.

It is this transformation which is explicitly evoked in Rebecca Horn's poem on her sculpture:

A soft voice whispers
the names of all
the people who had to
leave this place

Sacrificed for the new palm trees
and new white sand.[30]

In these lines and in the work itself, a spectral relation is established with the transformed space. *Homage to Barceloneta* literally stands on the former site of the demolished restaurants and displaced inhabitants. While its phantom-like presence encloses a secretive void, its surrounding space is scarred by the traces of obliteration and dislocation.

On a descriptive level, this unsettling aspect of the work is accentuated by a number of details. The dilapidated air of the sculpture itself and its floorless, interior space produce a strange temporal dimension. The effect is one of abandonment. The inaccessibility of the interior space recalls the blocked-up windows of the buildings slated for demolition – an effect reinforced by the proximity of surviving but closed restaurants. They are destined, like their vanished neighbours, for imminent destruction. Yet the relation between the work and the adjacent buildings is not one of simple representation. The chaotic, jumbled piling of block-like forms traces associations with the inner section of Barceloneta where developers erected high, narrow buildings. But the work does not merely replicate this effect. Instead, *Homage to Barceloneta* resists any immediate naming. What was this space? What was its function? Who was it for? Who was there?

Yet if the work appears out of place during the daylight hours, among the sunbathers and palm trees, at night its identity remains equally obscure. Whether fluorescent tubes flash or whether the work stands enveloped by nocturnal darkness, it remains opaque to identification. Even its very activity, its occasional and unforeseeable signs of life, situate the work in an odd, intermediary space between the active and inactive, between use and disuse, between life and death, between the public space and the secret interior. This strange region is marked by a logic of haunting. Through its unsettling and unpredictable activity, that which has vanished returns as apparitions, phantom images in the night. The obliterated Barceloneta reappears as an extimate spectre.

Homage to Barceloneta is a work of mourning. If mourning can be defined as the effort to address loss through the idealisation and internalisation of memory, then there can be only a failed, incomplete 'half-mourning', somewhere between remembering and forgetting. The vanished Other can never be restituted. Death's radical otherness resists strategies of idealisation.[31] Yet this alterity is not simply exteriority. That which is mourned inhabits the mourner as an extreme limit which is both external and internal. In *Homage to Barceloneta*, the vanished Barceloneta is not represented within the work's interior space nor reproduced in its external features. Similarly, the scattered narratives of the autobiographical narrator of *La lune*

rebelle can find no stable voicing here. The unidentifiable and disused equipment inside the structure stands as testimony to the futility of such incorporation. What occurs is a spectral return, a complex echoing through which multiple spaces, both 'private' and 'public', haunt the sculpture. The traditional nineteenth-century funeral monument, in contrast, presupposed the possibility of successful mourning and commemoration. It assumed the *identity* of both itself and those whom it represented. Yet in *The Wounded Falling Star* (or *Homage to Barceloneta*), assumptions of identity are radically suspended. If the sculpture must be defined as a monument, then its intricate relation to what it commemorates must be considered. The work is a *haunted* monument. A recalcitrant otherness unsettles its frame.

This same vein of spectral logic recurs in Horn's other Barcelona works. In the temporary 1992 installation, the *Hotel Peninsular* series, a former brothel evicted and closed for the Olympic Games plays host to ghostly spaces. In the witty yet disturbing *Room of Lovers*, a multitude of violins were attached to the walls, ceiling and furniture of a dingy hotel room. The unexpected placement produced an immediate effect of disorientation as the familiar became unfamiliar in the face of those bizarre instruments. The substitution of violins for former lovers unleashed comical overtones as well as an array of phantom-like presences. Related effects appeared, although in a more sombre key, in other rooms within the same series. *The Room of Mutual Destruction* was dominated by an unmade bed, two guns and mirrors whose very blankness conjured up an absent drama: the specular reflection of the empty room had a doubling effect of menace and confrontation. In the other works, a similar haunting became accentuated. Empty, *deserted* spaces recurred. A complex structure of absence was staged again and again, with striking variations. Here, a room was radically reversed. There, a bed, disconcertingly, was attached to a ceiling.

The complex links connecting *La lune rebelle* with *The Wounded Falling Star* and these other works are not assured by a story of origins. A radical splitting divides the spaces. Yet a spectral logic forms a bridge linking the two heterogeneous fields of autobiography and social history. In the first test of *La lune rebelle*, the narrative evocation of the haunting melody of a violin installs an unstable structure of repetition. Within its wavering field of reiteration, the narrator's story quickly unravels. Her father dies, but she does not mourn. She moves from place to place, shadowed by certain recurring figures. Yet the father's death does not command the narrative as a master signifier, but appears and vanishes within an entire series of traumas. At the conclusion of this broken sequence, *Homage to Barceloneta* does not emerge as a culminating point of pathos or a generalized metaphor for subjective loss. Instead, it is the point of exit from the book, its opening onto a real space of exteriorty traversed by other forms of spectral logic, by yet

more incarnations of loss and trauma. The destroyed Barceloneta maintains a radical otherness which the work cannot assimilate. Despite its doubling of the vanished buildings, *Homage to Barceloneta* remains following their obliteration. It is not merely a bottle washed up on the shore, a secret message which no one can read. In the place of incision from which its own space emerged, a spectral trace remains.

Notes

1. Rebecca Horn, *La lune rebelle*, Frankfurt, 1993, pp. 81–5.

2. Jacques Lacan, *The Ethics of Psychoanalysis 1959–60*, trans. Dennis Porter, London, 1992. In arguing that the Freudian term 'das Ding' has no adequate equivalent in French, Lacan consistently uses the German term (ibid., pp. 43–4). However, Slavoj Zizek convincingly established that 'the Thing' is indeed a compelling and adequate translation of Freud's German, not least of all in its echoes of Hollywood horror movies and other products of mass culture (see Slavoj Zizek, *The Sublime Object of Ideology*, London, 1989, pp. 119–20).

3. Lacan, *Ethics of Psychoanalysis*, pp. 43–70.

4. Ibid., pp. 101–13.

5. Ibid., pp. 139–42.

6. Ibid., p. 141.

7. Ibid., p. 135 and p.140.

8. Ibid., pp. 237–9.

9. Jacques Lacan, *Écrits. A Selection*, trans. Alan Sheridan, London, 1977, pp. 46–7.

10. Jonathan Scott Lee, *Jacques Lacan*, Boston, 1990, p. 42.

11. Lacan, *Écrits*, p. 48.

12. Lee, *Jacques Lacan*, p. 78.

13. '... the analysand's empty speech becomes full – and the analysand assumes his true role as psychoanalytic subject – when this speech takes the form of an intersubjectively intelligible narration of his past in the form of a history of origins'. Lee, *Jacques Lacan*, p. 78.

14. Jacques Derrida, *The Post Card. From Socrates to Freud and Beyond*, trans. Alan Bass, Chicago, 1987, pp. 413–96.

15. Horn, *La lune rebelle*, pp. 6–8.

16. Ibid., p. 45.

17. See Jean-Michel Ribettes, 'La troisième dimension du fantasme', in *Art et Fantasme*, Paris, 1984, pp. 185–213 for a discussion of these issues and pp. 187–8 for an analysis of the initial conceptions of fantasy in Freud and Lacan. For a more recent analysis of fantasy in Lacanian theory, see Slavoj Zizek, *The Plague of Fantasies*, London, 1997, pp. 3–44.

18. Ribettes, *La Troisième Dimension*, p. 188.

19. Ibid., pp. 188–9.

20. Ibid., pp. 189–90.

21. Ibid., pp. 190–1.

22. Ibid., pp. 194–6.

23. Ibid., pp. 196–8.

24. Ibid., p. 196.

25. Jacques Lacan, *L'Angoisse*, Paris, 2004, pp. 104–5.

26. 'On peut sans doute le rapporter (trauma) à de l'insubjectivité, et dans insubjectivité en fin de compte à l'insubjectivable'. François Baudry, *L'Intime – études sur l'objet*, Montpellier, 1988, pp. 11–12.

27. 'On ne le *sait* pas: non par ignorance, mais parce que ce non-objet, présent non-présent, cet être-là d'un absent ou d'un disparu ne relève plus d'un avoir'. Jacques Derrida, *Spectres de Marx*, Paris, 1993, p. 26.

28. Cited by Robert Hughes in *Barcelona*, London and New York, 1992, p. 191.

29. Ibid., p. 192.

30. Horn, *La lune rebelle*, p. 84.

31. See Jacques Derrida, *The Work of Mourning*, Pascale-Anne Brault and Michael Naad (eds), Chicago and London, 2001, pp. 5–14.

MATTER AND PROCESS

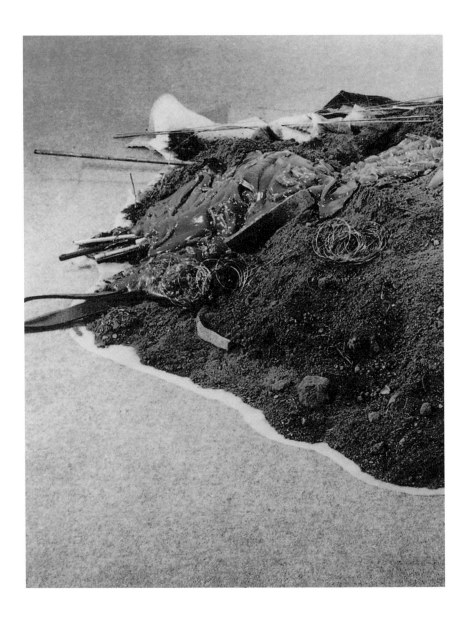

The order of material: Plasticities, *malaises*, survivals

Georges Didi-Huberman

In relation to material, it seems to me that the art historian is divided. On the one hand, material belongs to an order of concrete and direct evidence, in so far as it is the physical quality of every work of art: it tells us, quite simply, what the art object is made of. On the other hand, this concrete evidence is already contradicted by a *spontaneous philosophy* that underlies the art historian's training without his or her even recognising it. Panofsky made such a philosophy quite explicit when he subjugated the entire history of the concept of art to the authority of the Idea. He imagined that history as a pure and simple extension of Platonic questions: 'It was Plato who established the metaphysical meaning and value of Beauty in a universal and timeless way, and whose theory of Ideas has become ever more significant for the aesthetics of the plastic arts [*der bildenden Künste*].'[1] No doubt Panofsky was historically correct to emphasise the character of the matrix of intelligibility that could be taken, throughout the centuries, as Platonism – with its 'metaphysics of Beauty' and 'theory of Ideas' – in the development of 'the aesthetics of the plastic arts'. But today we can ask ourselves what sort of presupposition informs the problem, obviously crucial to all art objects, of material itself. We can deduce from the philosophical polarity Matter/Form (ubiquitous in Plato, revived by Kant, and no doubt necessary to the art historian for the formulation of stylistics), or we can infer from the polarity Matter/Spirit (ubiquitous in Plato, revived by Kant, and no doubt necessary to the art historian for the formulation of an iconology) – that in each case material would be, in the best philosophical tradition, 'secondary', 'potential', or even 'indeterminate'.

Such has been the 'spontaneous philosophy' of art history even at the very moment of its origin: hadn't Vasari spoken of matter as the 'subject' [*sugetta*] of form, that is to say its Idea? As offering the more or less indeterminate

receptacle of drawing [*disengno*] and of the intellect?[2] Close even to the point of non-being, of disorder, of dispersal; always waiting for a 'form' which could redeem it, which alone could provide a dignified outward appearance. At worst, material would be formlessness – an insurrection *against* form – at best it would be an example of passivity, of subjection *to* form.

Yet when we speak of the 'plastic arts', we suppose implicitly, etymologically, that the visual arts do not want this passivity which matter offers to the action of forms. 'Plastic art' means first of all plasticity of material, which in turn means that matter doesn't resist form – that it's ductile, malleable, can be put to work at will. In brief, it humbly offers itself to the possibility of being open, worked, carved, put into form.

Let us speak about wax (to reflect on 'matter' in general is to never understand matter since it is to make a simple 'idea' into a fatal abstraction).[3] Why wax? First because it is ductile material, plastic material *par excellence*. With a piece of wax in the hand, the old or the philosophical question of the rapport between form and matter – even the rapport between spirit and matter – assumes consistency and a sort of very tangible warmth. It is not just by chance that sudden, compelling appeals to the paradigm of wax left their mark on several significant moments in the history of these questions. First in Plato, where it is the originary wax that might be modelled in the same way as clay by the demiurge.[4] In *The Laws*, it is 'soft' virgin wax that is compared to the newborn child, whom his mother will 'roughly form' before the City finishes 'modelling' him.[5] It is also the wax of desire which becomes the metaphor for the danger confronting 'the hearts of even those who believe themselves austere' – beneath the caresses that might make men almost melt.[6] It is especially the wax of memory that appears in the *Theaetetus* under the rubric of a hypothesis: 'suppose, therefore, for the sake of argument, that we had in our souls an impregnatable wax …'[7] We know the fate of this same metaphor in Aristotle's hands, where *memory* has as its object the thing seen *through the image*: it is *the impression in the wax* that will henceforth serve as the operative model for sensation itself:

Sensation stamps in, as it were, a sort of impression of the percept, just as persons do who make an impression with a seal. This explains why, in some people, through disability or age, memory does not occur even under a strong stimulus; just as no impression would be formed if the movement of the seal were to impinge on running water; while there are others in whom, owing to the receiving surface being decayed, as happens to old walls, or owing to the hardness of the receiving surface, the requisite impression is not implanted at all. Hence both very young and very old persons have poor memories; they are in a state of flux, the former because of their growth, the latter owing to their decay. Similarly, neither those who are too quick nor those who are too slow have good memories. The former are too moist, the latter too hard, so that in the case of the former the image does not remain in the soul, while on the latter it is not imprinted at all.[8]

A material fantasy of wax is here set in motion for the long term. It will culminate in the Cartesian analysis where the piece of wax is made to illustrate the distinction between matter and spirit,[9] and at last, in the Freudian model of the *Wunderblock*, the 'mystic writing pad',[10] which itself contributed to the critical *reversal* of this entire range of distinctions. For the moment, let us keep in mind the extent to which, in the passage from Aristotle, the development of the material image depends on an extraordinary theoretical focus upon questions of the substratum – of the material: in material that is too runny, too quick, too 'young,' too wet, a form will not 'set' – just as if 'the movement of the seal were to impinge on running water'. Neither will a form 'take', for the opposite reason, in material that is too brittle, too 'old' or too dry. As usual, Aristotle has posed here, in the very quality of his examples, the crucial question.

The question of plasticity is very much the issue here: in order that a *form* set or take – so that as a rule an individuation can occur – matter must proffer that subtle quality of being neither too dry nor too liquid, neither too hard nor too soft. By thus introducing the evaluation of material qualities as the very framework of his conceptual reasoning, Aristotle opens up a field that we need to examine more closely. Which is to say that we must go beyond the metaphorical uses of wax – without losing sight of the theoretical and conceptual foundations of wax – so that we may study more thoroughly the problem of plasticity by giving a voice not just to philosophers of matter, but also to technicians of matter. Wax-workers themselves evoke many qualitative categories above and beyond the three or four criteria put forward by Aristotle – softness and hardness, dryness and humidity – and speak instead of far more than 'wax', but rather of the dizzyingly infinite number of 'waxes' revealed in working the material:

> Wax is not one wax alone, for there are so many waxes! … There are hundreds and hundreds of waxes, and they all merge into one another … What makes the difference between them? The way one mixes them, the way one works the various types of wax, and the compositions one makes of them.[11]

The man speaking here is Girolamo Spatafora, one of the last wax-workers of Sicily, supplier of ex-votos and other figurines for nativity scenes, in a 1991 interview with an ethnologist. His entire discourse is suspended between, first, a sense of *extinction* – because no one seems to want these rotting, outmoded objects, and so the very profession of wax-working is dying out – he is, he says, forced to repair washing machines to earn a living – and second, a sense of *survival* characteristic of the material itself, a durability that is due, precisely, to the extraordinary *plasticity* of wax: 'It's marvellous. Everything can be made from it. It even moves' ['*Meravigliosa. Tutto si può fare … Si muove pure*'], he confides between two disillusioned remarks about the

scarcity of orders.[12] By simultaneously evoking not only extinction and survival, but also the marvellous [*meraviglio*] plasticity of wax – a plasticity that is the result of the manifold uses to which the material lends itself as well as to that sort of 'life' it demonstrates through its very pliability – the Sicilian craftsman articulates what is perhaps the essence of the historical, anthropological, and aesthetic problems raised by the strange constellation of objects fabricated in wax.

Furthermore, without realising it, the wax-worker revives the mythico-technical discourse of Pliny the Elder, whose *Natural History* described those 'plastic' and 'marvellous' characteristics of a material of rather mysterious origins. Putting aside the question of how bees, in the secrecy of the hive, fabricate wax 'from flowers', Pliny insists upon the multiplicity of the 'practical purposes' wax might 'serve in people's lives' [*ceras mille ad usu vitae*].[13] And he clarifies this idea with a phrase in which, and not just by chance, are linked together the notion of *similitudo*, or likeness, and the antiphrasis where the word *mortales*, or mortals, is made to designate living humanity (humanity that is living but fated to take charge symbolically of its own mortal condition. And as we will have cause to reiterate, wax presents the most appropriate material for such a responsibility): 'by the use of paints it is made to assume various colours for forming likenesses of, and for the innumerable uses of, mortals …'[14]

The 'likenesses of mortals' evoked in this text must, of course, be understood in relation to the Roman practice of *imagines*, those masks of coloured wax made by taking an impression of the faces of the dead, and whose genealogical function emerges as fundamental throughout the history, in the West, of the likeness of the image.[15] But besides this radical meaning suggested by '*similitude mortalium*', we need to acknowledge the 'innumerable uses' of wax evoked by Pliny, among which we find mixed together apiary techniques, medicinal uses, artistic works, and folk creations such as wax models that, in merchants' windows, represented fruit or other perishable food products (we still find them today in some restaurant windows, although wax has been almost universally replaced by thermoformed plastic).[16]

These 'innumerable uses' constitute an extraordinary anthropological sedimentation of this material: magical wax (such as Egyptian dolls or figurines of medieval sorcery); votive wax (rustic effigies from Cyprus, naturalistic portraits from Western Europe, dolls representing children, anatomical ex-votos such as teeth and ears, and votive representations of internal organs such as the lungs and heart); funerary wax (such as the death-masks of Fra Angelico, who died in 1455, or Saint Philip of Neri, who died in 1595); liturgical wax (candles and reliquaries with *Agnus dei*); the wax of popular devotion (reliquaries with statuettes, figurines under glass, little

animals, pieces of wax modelled to look like pieces of wood); artistic wax (the wax created for casting bronze, wax usually *lost* but which subsists in a few examples of failed castings, the wax of the preserved models for works by Michelangelo, Giambologna, or those of other studios in sixteenth-century Florence); and artisanal wax, as well as anatomical wax (which pushes to the limits the notion of the *écorché*; for example tracing the analysis of a face all the way to its very decomposition, or in which the innermost recesses of the womb are given a special exhibition value); and finally carnival wax (after being displaced from the church, and religion, to the museum, and art, and then to the scientific cabinet, the exhibition value of wax is ultimately downgraded to the world of wax museums, fairs and the public boulevard).

We might add a few more items, in no particular order and without attempting to be exhaustive – since, after all, the *Encyclopedia* of Diderot and D'Alembert itself acknowledges that 'we would never be able to list how many uses have been made of wax since the beginning of time':[17] wax for painting (encaustic wax) and textile wax (for batik); household wax and sealing wax; shoe wax and industrial waxes; adhesive waxes and cosmetic waxes and so on.[18] It's obvious: a *plasticity* of material means a *multiplicity* of functions. More precisely, plasticity *facilitates* multiplicity, sanctions it, is its very medium, and (who knows?) even invents it. How is this so? Perhaps thanks to the absolutely extraordinary accumulation of material qualities that wax, intrinsically, brings together. Given how varied the kinds of wax seem at first glance, these innumerable uses thwart any attempt to seek a coherence in their functions. Nevertheless, by looking at the wax itself, we might perhaps be able to discover the underlying structure of this multiplicity.

What does the plasticity of wax consist of? Can plasticity, strictly speaking, consist of anything? When one reads the technical writings of people who work with wax, one comes away with the strange impression that wax is characterised only by being uncharacterisable: each time we recognise a material quality in wax, we immediately see another material quality that is exactly the opposite. Wax emerges therefore as a material that is insensitive to the contradictions of its material qualities. Wax is solid, but it may easily be liquefied. It is impermeable, but it may easily be dissolved in water (it takes only the slightest modification to do so).[19] It may be sculpted, modelled, or cast, and is thus insensitive to the contradictions as well as to the traditional hierarchies in the plastic arts.[20] It may be worked either by hand or by means of all kinds of tools. It may be painted or tinted as a block, and given either a matte or polished finish. It can be either opaque or transparent, either smooth or sticky. Its consistency may be transformed indefinitely by the addition of the most varied resins.[21] It is a fragile and temporary material, but most often used, because of the very richness of its textures, for the fabrication of objects intended to last. In her book *Wax as Art Form* (1966), Thelma Newman counted

twenty-three physical characteristics of wax, giving this conclusion of an aesthetic nature: 'Its plasticity makes possible spontaneous expression but also an accuracy of detail.' This range of ambivalent physical characteristics is first of all what the plasticity of wax 'consists of'.[22]

This plasticity itself consists, therefore, of a *paradox of consistency*, linked, of course, to the fact that wax – whether it is liquid, pasty, solid, or even brittle – remains wax. No one can ever decide which is its 'primary' or 'principal' state (while by comparison one can say, for example, that the 'primary' state of water is its liquid state: when water is solid, frozen, it is suddenly not water but ice). This elementary phenomenology already gives us some information about the nature of the paradox in question, and will allow us to begin to qualify that paradox.

In one sense, *plasticity* means *malleability*. For this reason, wax is recognised as the exemplary material of *resemblance*: it is the material of 'true forms' and of 'accurate forms'. Pliny the Elder tells how Lysistratus of Sicyon, the first Greek artist to have introduced 'the practice of giving likenesses' [*similitudines reddere instituit*], was, at the same time and in the same process 'the first person who modelled a likeness in plaster of a human being from the living face itself, and established the method of pouring wax into this plaster mould' [*e facie ipsa … expressit ceraque in eam formam gypsi infusa*].[23] Wax-workers and historians alike insist on the natural aptitude of wax as the 'plastic' material that serves the immemorial passion of human beings for fabricating those 'things which resemble' which we call images.[24] Not only does the pliability of the material permit the rendering of the smallest detail, but moreover, through the addition of the appropriate mineral solutions or colourings, its textural qualities allow the perfect imitation of bronze, alabaster, lead or flesh.[25]

In another sense, inseparable from the first, *plasticity* means *instability*. There is nothing more unstable, nothing more changeable, than the physical state of a piece of wax: I take a brittle substance in my hand, but in a matter of seconds my body heat renders it malleable and allows me, more easily than with any other material, to reproduce accurately the delicate shapes of a body or face. It takes, however, the proximity of only the smallest flame for such a 'true' form to melt away, to disfigure, to liquefy. The 'paradox of consistency' imposed by the plasticity of wax may therefore be understood as the possibility – inevitably disturbing – of a coming and going between resemblance and formlessness. A coming and going no longer linked to the world of the *disegno* – the drawing or the design – and of the *idea*, but to the intrinsic properties of the material. When we watch a piece of wax 'live', we are very quickly forced to suspect a kind of censorship at work within the traditional hierarchies of form and matter.

Plasticity, consequently, need no longer mean *passivity*. The piece of wax

remains, of course, submissive in my hand. It will take the form that my 'design' prescribes; but it will also keep, without my even thinking about it or wishing it, the impression of my fingers and the traces of my most unwitting movements. The submissiveness of the material is so complete that, for a moment, it reverses itself and becomes the *power* of the material. But how can we characterise it? Maybe by means of a notion that certain modern philosophies have opposed, and not by chance, to the old polarity of matter and form: that of *viscosity*. It happens paradoxically – and we need to try to figure out why – that this notion gained its meaning *through the elaboration of the psychoanalytic field*. In 1929, Georges Bataille wrote that a relevant notion of matter could not expect anything from scientistic 'abstractions' or from 'artificially isolated physical phenomena'. One had, according to Bataille, to look to Freud to find what matter meant, at the very moment when Freud was trying to define his most 'metapsychological' concept – the drive – in the symmetrical terms of 'plasticity' [*Plastizität*] and of 'viscosity' [*Klebrigkeit*].[26]

Like Aristotle's, Freud's theoretical use of material qualities forces us to implement that phenomenological attention that art historians may rightfully call on when confronted with the objects of their study. In 1929, Aurel Kolnai, a young Hungarian psychoanalyst and disciple of Husserl, published an essay about 'objectal phenomenology' on the problem of *disgust* (a problematic from which wax can hardly be excluded): he spoke there of materials living and dead, of materials viscous and plastic, always conceived of as *psychically sovereign*.[27] Bataille read this essay carefully,[28] as did, most likely, Jean-Paul Sartre who, fourteen years later, would bring together the psychical and phenomenological theme of *viscosité* in a much-anthologised passage that practically concludes *Being and Nothingness*. Sartre there calls 'material quality' as 'revelatory of being', and deploys an entire network of meanings linked to the paradox of a matter that might be neither liquid nor solid, that nevertheless haunts the psyche like a nightmare of metamorphoses:

The viscous appears as already the outline of a fusion of the world with myself. What it teaches me about the world, that it is like a leech sucking me, is already a reply to a concrete question; it responds with its very being, with its mode of being, with all its matter … A viscous substance like pitch is an aberrant fluid. At first, with the appearance of a fluid it manifests to us a being which is everywhere fleeing and yet everywhere similar to itself … The viscous reveals itself as essentially dubious [*louche*] because its fluidity exists in slow motion; there is a sticky thickness in its liquidity; it represents in itself a dawning triumph of the solid over the liquid … This fixed instability in the viscous discourages possession … Nothing testifies more clearly to the dubious character of a 'substance in between two states' than the slowness with which the viscous melts into itself … The honey which slides off my spoon on to the honey contained in the jar first sculpts the surface by fastening itself

onto it in relief, and its fusion with the whole is presented as a gradual sinking, a collapse which appears at once as a *deflation* ... and as *display* – like the flattening out of the full breasts of a woman who is lying on her back.

In the viscous substance which dissolves into itself there is a visible resistance, like the refusal of an individual who does not want to be annihilated in the whole of being, and at the same time a softness pushed to its ultimate limit. For the *soft* is only an annihilation which is stopped halfway ... The viscous is like a liquid seen in a nightmare, where all its properties are animated by a sort of life and turn back against me ... In the very apprehension of the viscous there is a gluey substance, compromising and without equilibrium, like the haunting memory of a *metamorphosis*.

To touch the viscous is to risk being dissolved in sliminess ... The horror of the viscous is the horrible fear that time might become viscous, that facticity might progress continually and insensibly ... as a symbol of an *anti-value*: it is a type of being not realized but threatening, which will perpetually haunt consciousness as the constant danger which it is fleeing.[29]

There is no doubt that wax does not have the sticky sliminess characteristic of honey or of pitch; no doubt that wax does not have the direct power of a 'leech' or 'bloodsucker' that Sartre evokes in his text. But the wax object – because of the way it is fabricated as well as through the phenomenology of our 'approaching consciousness' of it – offers just as well that unfamiliar make-up of *plasticity* and *viscosity* that makes it 'everywhere fleeing and yet everywhere similar to itself', that establishes it as 'fixed instability' and as a 'substance in between two states'. The wax object certainly offers the ambivalence of the 'heavy flight' described by Sartre: both 'visible resistance' at the same time as the possibility of a 'deflation', of 'a spreading out', or of a 'flattening', in short, an 'annihilation which is stopped halfway'. This is why wax, more so than honey or pitch, has been invested as haunting, threatening, nightmarish, metamorphosing and fleeing. This is why it is perhaps a material 'which holds me and which compromises me', a *material trap* 'whose every property is animated with a kind of life and is turned against me'. This is what Freud understood so well – Sartre seems here to forget it – through recourse to the concept of '*das Unheimlich*', or 'the uncanny':[30] we encounter it at almost every step of our path through the territory of wax.

What does this preliminary look at the material of wax teach us? First, that its *plasticity* cannot be reduced to the canonical *passivity* of Madame Matter enduring the thrusting – and the pounding of seals – that Mister Form would forever subject her to.[31] The reality of the material proves more disturbing: it possesses a *viscosity*, a kind of *activity* or intrinsic power, which is a power of metaporphosis, of polymorphosis, of insensibility to contradiction (particularly to the abstract contradiction between *form* and *formlessness*). Sartre states extremely clearly that this activity of the viscous, this 'kind of life', can only be symbolised or socialized as an *anti-value*.

Suddenly we are better equipped to understand the cleavage that marks the epistemic position of the art historian confronted with the material. On the one hand, technical evidence is the business of restorers and, more fundamentally, of a 'science of materials':[32] no one doubts its legitimacy or its benefits. On the other hand, the philosophical prejudice of the *Idea* – invented in a Platonic context, popularised by Vasari at the very moment of birth of the academic discourse called art history and finally transported into the twentieth century by Panofskyian neo-Kantianism – creates an *anti-value* of material in general, and particularly of that unstable material, of that 'substance between two states' that is wax. Significantly, it is the museums of 'minor arts', of 'applied arts' or of 'decorative arts' – such as the wonderful Victoria and Albert Museum in London[33] – that have been able to escape censoring the anthropological as well as the aesthetic value of wax.

Censorship exists only where there is also *uneasiness* or *discontent*: wax is an aesthetically viscous material in the sense that, 'everywhere similar to itself' yet 'everywhere fleeing', it dedicates its own function of resemblance to the simultaneous uneasiness of deterioration and excess. In both cases, it is disaster that threatens the ordinary concepts of form and imitation. Wax, in the matter of resemblance, always *goes too far*. It is capable of rendering the details that are 'the most delicate in all of nature'.[34] It adjusts itself malleably to the smallest recesses of the plaster mould into which it is poured. It can express every range and every tiny difference in texture. But it always adds a subtle and unspeakable excess – something that arouses uneasiness, that adulterates and falsifies identity, that suddenly seems *mauvais genre*, bad taste, vulgar, even criminal.

Hort Janson suggested that this *resemblance through excess*, linked to 'mechanical' procedures of casting and to malleable and tintable materials such as wax, results in the ruin of any concept of style and even of any authentic realism – better: artistic realism – which he called a 'realism of animation'.[35] As for Ernst Gombrich, the two lines of his *Art and Illusion* mentioning wax are condemnatory: 'before the proverbial wax image we often feel unease because it oversteps the boundaries of symbolisation'.[36]

Gombrich does not explain openly what he means by 'overstepping the boundaries of symbolisation'. But we can infer it from an example he offers a few lines earlier. In the presence of a marble bust, 'we do not as a rule take it to be a representation of a cut-off head'. This is, we should assume, the sphere of 'symbolisation'. Uneasiness arises in the presence of the same bust if it 'has been slightly tinted', and even more so if it has been modelled in coloured wax: therefore, 'some will register a shock, not necessarily of pleasure',[37] in the presence of something which is necessarily vulgar, which is perhaps called in art history 'overstepping the boundaries of symbolisation'.

'Shock' and 'unease' are two words with strong psychological, if not

psychopathological, echoes. Gombrich never hid his belief that a history of art, given its very object – visual images – could not do without a psychology: it is not against this principle that we would argue, but rather against the particular choice of psychology. For aren't 'shock' and 'unease' in the presence of a tinted wax bust connected to the *psychic return* of that evidence of a 'cut-off head' that the marble bust, itself, manages so easily to 'symbolise' – which is to say that it manages so easily to repress? How can we forget that our actual wax museums – Madame Tussaud's in London, or the Musée Grévin in Paris – have their origin in the revolutionary period, in those decapitations by the guillotine, which were then consciously modelled in plaster for the making of wax effigies having the function of quasi-relics? In which case, we have to acknowledge that wax is a *psychically viscous* material. Wax is – to take up Sartre's phrases one last time – 'essentially dubious' [*essentiellement louche*], 'essentially suspect', 'discouraging possession' at the same time as it phantasmically 'holds me and compromises me', dooming me to the haunting memory of metamorphosis and to an 'annihilation which is stopped halfway'.

The two dismissals expressed by Janson and Gombrich do not mean exactly the same thing. They nevertheless make up a system that seems to me representative of the epistemological situation of Anglo-Saxon art history of the post-war period and to what Panofsky himself called an art history of 'transplanted Europeans'.[38] Janson dismissed the *loud* side of 'bad-taste' resemblance – the kind represented by Madame Tussaud's or the Musée Grévin – in the name of a very powerful hierarchy between objects which are 'art' objects (objects of the history that bears that name) and those which are not (among which are included most wax objects). Gombrich, in turn, dismisses the *morbid* or deadening, indeed cadaverous side of resemblance that situates itself 'beyond the boundaries of symbolisation'. The art history extolled by Janson is therefore an *art history without anthropology*, which would rather cling to marble busts and ignore the 'dubious' taste of works formed of polychrome, even if they date from the Quattrocento.[39] The art history praised by Gombrich calls for a psychology, but it remains an *art history without metapsychology* in the Freudian sense – specifically an art history without the death drive.[40]

Janson was the direct disciple of Panofsky: his choice confirmed in reality the implicit rejection by post-war art history of that person whose disciple Panofsky is supposed to have been. I mean, of course, Aby Warburg.[41] To exclude from art history the 'excessive realism' of wax sculpture – from the votive statues of the Middle Ages, to Madame Tussaud's mannequins, to Duane Hanson's effigies[42] – was to dismiss without a word the anthropology lesson given by Warburg in his 1902 essay on the Florentine portrait.[43] On the one hand, Warburg there proposed an art history capable of expanding its

corpus beyond the choices – and therefore the censorship – carried out by art museums from the time of Vasari (who, as is well known, contributed enormously to the creation of the Uffizi Museum). This is the reason for Warburg's erudite appeal to the Florentine archives, especially intended, as much as possible, to 'give voice back' to a number of vanished images. On the other hand, Warburg had discovered, by means of the '*bòti*' of the Santissima Annunziata, what could be considered a veritable missing link for the entire history of the visual culture of the Renaissance.

This practice of votive realism was long described by historians as a singularity, an exception, a simple 'historical curiosity'.[44] Warburg was the first to understand that one needed to see this singularity as a veritable hinge – anthropologically, historically and aesthetically. As a result of doing justice to this forgotten phenomenon of Florentine civilisation, every schema of intelligibility in which, since Vasari, the very notion of the Renaissance had been imagined, was turned upside down: the *bòti* imposed the reality of a 'hyperrealism' – what Alessandro Parronchi later called 'the complete naturalism of the early Quattrocento' [*naturalismo integrale del primo Quattrocento*][45] – that was non-humanist, medieval, devotional, artisanal, and produced by means of impressions.[46] Therefore that Florentine Renaissance was an *impure* reality. And it was a reality in which we need to give a rightful place to wax as a plastic tool. This therefore is very much what Janson, the practitioner of an iconology thought of as a 'humanist discipline', was trying to distance from the work of an artist like Donatello.

Gombrich's judgement – his repudiation – is even more significant. Before being the official 'Warburgian' we know him to have become, Gombrich was the disciple in Vienna of Julius von Schlosser.[47] We might remember that Schlosser was not only the great historian of the textual sources of art history, the grand historian of *Kunstliteratur*. In his extraordinary book on the wax portrait (1911), he also invented a history where the *point of view of genre* (reassuring to the traditional art historian) had a kind of 'bad encounter' with the point of view of the material, with the vulgar matter [*matière mauvais genre*] which is wax. Schlosser confessed, in the first lines of his 'Preface', that the 'genre' here – a word written in his text in French, by way of reference to Ferdinand Brunetière – would make way for something Schlosser called a 'methodological construction' [*ein methodisches Präparat*].[48] This would therefore be a problematic history, a paradoxical history created from births but also from abortions, from accomplishments but also from deteriorations, from natural deaths but also from ghostly phantoms. A *necessarily non-natural history* – and for that reason a history to construct methodologically.[49] A history where the material itself, the wax, is put in the position of being a critical tool. Critical of what? Critical of history envisaged according to Vasari, that is teleologically. Critical of an art envisaged according to

academic models, hierarchical, aesthetical. One understands that *art history* itself could not survive such a critique.

In what way does the point of view of the material transform our stance in relation to history? Nietzsche, I believe, anticipated the Schlosserian stance when he affirmed, in the second *Inactuelle*, that history must constantly test its own limits in the face of something that he called a *plasticity* – the 'plastic force of becoming and of life'.[50] Warburg also anticipated Schlosser's answer when he pitted the complex concept of *survival*, of *Nachleben*, against all Vasarian historical teleologies. (We could, in this sense, regard Donatello's portraits as a conscious survival, a kind of revival, a *renaissance* on the same scale and in the same material as those patrician Etrusco-Roman effigies that Pliny had earlier described and praised for their demonstration of the civic dignity of the image.) Schlosser will thus talk about survival and he will do so, at the beginning of his *History of the Wax Portrait*, by insisting on wax's capacity, as a plastic material, for long-term endurance. Think, for example, of ex-votos, their forms extraordinarily resistant to all historical 'progress'; better even than funerary effigies, they demonstrate the astonishing capacity of wax images to retain in history their own first condition, their own archaism – which is to say, to talk like Warburg and like Schlosser, their own animism and magic:

> We are dealing here with an artistic genre that, in our time, we hardly ever meet except in a sphere that is almost completely divorced from art as we customarily define it ... we find it in fair stalls, in the shops of hairdressers and tailors, in a sphere that, after all, has flourished for two thousand years, all the way up to our own era, and that has an astonishing past. There is nothing exceptional in itself about the endurance of an ancient cultural product in the lower ranks of the social structure as the 'survival' of a developmental process that has run its course. More than one tool that sprang out of the hard battle for the survival of primitive humanity, for example the slingshot, the bow, or the rattle, became, in our own cultural world, a child's toy. The ancient literature of romance, which was the reading-matter of knights in medieval courts, no longer survives except in the lowest strata of Germanic and Latin societies, in the form of popular novels made of pulp paper and bound with gaudy covers and sold at fairs ... [51]

In Schlosser's use here of the English word 'survival' we recognise easily his debt to the ethnological studies of Edward B. Tylor. The latter had, in 1871, consecrated several chapters of his book *Primitive Culture* to the concept of survival, citing, among many other illustrations, the same example of tools of war that vanish as such but survive elsewhere as children's toys.[52] We should indeed be interested, and for more than one reason, in the way that Schlosser – following Warburg – rendered that idea operative for the field of art history.

In the first place, the notion of *survival* gives us access to a powerful counter-model to Vasarian historicity: it allows us to place in a dialectical

relationship the *history of art* with another temporality which I will call the *anachronism of the image*. This anachronism implies a sedimentation and an overdetermination of time. It implies a memory that does not reduce itself to identifying recollections, a memory made of indestructible truths, impressions that survive archaeologically in spite of their disappearance from the surface of things. Rather a memory made from endless deformations, effacements and sudden eruptions, a memory made of periods of latency and of shattering events, of stases and of symptoms. We can recognise, in these suggestions alone, all the theoretical richness of the Freudian model in which wax created the wonder of inscriptions on the *Wunderblock*, the 'mystic writing pad'.[53]

Warburg and Schlosser were Freud's contemporaries. They had no need to 'apply psychoanalysis' to art to share with its founder a conviction that no history is possible – even if it is, like the history of art, a history of objects – without a theoretical stance in relation to the subject, in other words a *metapsychology*. (Recall that Warburg even defined himself as a psycho-historian'[54]). Warburg and Schlosser therefore shared with Freud a certain conception of the impression, of the inscription, of forgetting, of memory's reversals. The enormously 'sexualised' iconography practised today is without a doubt the worst lesson to have been drawn from Freudianism. However, the models of time implied by the concept of the unconscious should allow us to explore further – difficult, it is true – what 'survival' might mean beyond the evolutionism of a theorist like Tylor. The Warburgian *Nachleben* was developed at the same time as certain Freudian notions which might – this is my hyposthesis – clarify and further extend it: for example, the notions of abreaction [*Abreaktion*] and deferred action [*Nachträglichkeit*], of latency [*Latenz*] and repetition [*Wiederholung*], of repression [*Verdrängung*] and regression [*Regression*], of working through [*Durcharbeitung*] and the return of the repressed [*Wiederkehr des Verdrängten*], of the memory trace [*Erinnerungsspur*] and screen memory [*Deckerinnerung*].

We can at last understand in what way this point of view profoundly transforms our stance in relation to *art* itself. Warburg and Schlosser, here again, extend the implications of Nietzsche who, citing Semper, wrote in his fragments of 1869 that 'the smoke of carnival candles is the true atmosphere of art'.[55] The plasticity of becoming, according to Nietzsche, implies a constant downgrading of that which the past believed was stable. In the eternal return, it is not the same that returns, but its ambivalent condition and movement, its constantly deformation downwards; hence the Apollonian harmony could never 'return' or 'survive' without what Nietzsche called a 'fearsome reversal'.[56] With regard to wax sculpture, Schlosser states clearly that all survival implies a downgrading 'into a sphere that is almost divorced from art as we [customarily] define it'.[57] Thus the votive effigy itself survives

in the form of children's dolls, and the royal portrait survives in the carnival mannequin.

Consider then how wax itself – from the point of view of the material – not only downgrades the academic idea of genre; it also downgrades the academic idea of art in general. Schlosser, concerned to overturn the Vasarian ideology of 'progress in the arts' and the normative aesthetics of Neo-Kantianism, could only imagine the downgrading as a lowering of class.[58] We nevertheless need to recognise that the notion of *déclassement* has to break with all teleologies, even negative ones. The royal portrait changes into the carnival mannequin, but the great art of Edgar Degas or of Schlosser's contemporary Medardo Rosso – unfortunately unknown to him – was able, reciprocally, to *regrade* the trivial effigy: to disorient it, to reconfigure and to open, by means of that disorientation, the heuristic field that we call … modern art.

[Translated from the French by Jann Matlock and Brandon Taylor]

Notes

1. E. Panofsky, *Idéa. Contribution à l'histoire du concept de l'ancienne théorie de l'art* (1924), trans. H. Joly, Paris, 1983, p. 17.

2. G. Vasari, *Les Vies des meilleurs peintres, sculpteurs et architectes* (1550–68), trans. A. Chastel, Paris, 1981–7, pp. 119, 149. Cf. G. Didi-Huberman, 'L'image-matière. Poussière, ordure, saleté, sculpture au XVI siècle', *L'Inactuel*, no. 5, 1996, pp. 63–81.

3. Georges Bataille characterised this as 'idéalisme de la matière', a particularly stupid philosophical position in his eyes. Cf. G. Bataille, 'Matérialisme', *Documents*, no. 3, 1929, p. 170, which I commented upon in *La Ressemblance informe, ou le gai savoir visuel selon Georges Bataille*, Paris, 1995, pp. 268–80.

4. Cf. L. Brisson, *Le Même et l'autre dans la structure ontologique du* Timée *de Platon*, Paris, 1974, p. 54.

5. Plato, *Les Lois, VII*, 789e, ed. and trans. E. des Places, *Oeuvres complètes, XII-1*, Paris, 1956, p. 13.

6. Plato, *Les Lois, I*, 633d, ed. and trans. E. des Places, *Oeuvres complètes, XI-1*, Paris, 1951, pp. 13–14.

7. Plato, *Théétète*, ed. and trans. A. Diès, *Oeuvres complètes, VIII-1*, Paris, 1926, p. 232. The passage is commented upon by V. Goldschmidt, *Les Dialogues de Platon. Structure et méthode dialectique*, Paris, pp. 85–7. Before finishing, Plato would develop the image of wax pure or impure, humid or dry, etc. Cf. *Théétète*, 192a–195a, pp. 233–7.

8. Aristotle, *De la mémoire et de la réminiscence*, 450a–b, trans. J. Tricot, *Parva naturalia*, Paris, 1951, pp. 60–61, rendered into English here in the light of the translation by W.S. Hett, Harvard & London, 1957 [ed.].

9. C. Descartes, *Méditations* (1641–42), *Oeuvres complètes*, ed. C. Adam and P. Tannery, Paris, 1964 (new edn), VII, pp. 23–4 (Latin text), and IX-1, pp. 18–26 (French translation).

10. Freud, 'Note sur le "bloc-notes magique"' (1925), trans. led by J. Laplanche, *Résultats, idées et problèmes, II* (1921–38), Paris, pp. 119–24.

11. R. Cedrini, 'Il sapere vissuto', *Arte popolare in Sicilia. Le tecniche, i temi, i simboli*, dir. D. D'Agostino, Palermo, Flaccovio, 1991, p. 177: 'La cera non è una sola, ce ne sono tante … Centinaia e centinaia e si combinano tra loro … – In cosa consiste la differenza? Nella miscelazione, nella lavorazione dei vari tipi di cera, nelle composizione che si fanno.'

12. Ibid., pp. 178–80.

13. Pliny the Elder, *Histoire naturelle, XI*, 11 and 14, ed. and trans. A. Ernout, Paris, 1947, pp. 32–3. Cf. equally *Histoire naturelle, XI*, 18, pp. 34–5. On the anthropology of practical bee-keeping, see, among others, the work of P. Marchenay, *L'Homme et l'abeille*, Paris, 1979 (rev. edn 1984).

14. Pliny the Elder, *Histoire Naturelle, XXI*, 85, p. 57: *variousque in colores pigmentis trahitur ad reddendas similitudines et innumeros mortalium usus* (translation modified).

15. Pliny the Elder, *Histoire naturelle, XXXV*, 1–14, ed. and trans J.-M. Croisille, Paris, 1985, pp. 36-42. Cf. G. Didi-Huberman, 'L'Image-matrice, Généalogie et vérité de la ressemblance selon Pline l'Ancien', *Histoire naturelle, XXXV*, 1–7, *L'Inactuel*, no. 6, 1996, pp. 109–25; and *L'Empriente*, Paris, Centre Georges Pompidou, 1997, pp. 38–48.

16. Pliny the Elder, *Histoire naturelle, VIII*, 215, ed. and trans A. Ernout, Paris, 1952, p. 99, also *Histoire naturelle, XXI*, 83–5, pp. 56–7.

17. Article: 'Cire', in D. Diderot and J.L.R. d'Alembert, *Encyclopédie ou dictionnaire raisonné des sciences, des arts et des métiers*, III, Paris, 1973, p. 471. On the uses of wax in antiquity, cf. E. Saglio, 'Cera', *Dictionnaire des antiquités grecques et romaines*, 1–2, Paris, 1887, pp. 1019–20.

18. The most complete inventory of wax technologies is the two monumental volumes – a life's work, financed by a German industrial firm – of R. Bull, *Das grosse Buch vom Wachs. Geschichte – Kultur – Technik*, Munich, Callwey, 1977. We shall list here works on particular aspects of wax to which I shall not specifically return: T.R. Newman, *Wax as Art Form*, London, 1966, p. 14 and pp. 202–92 (wax as material of restoration and reinforcement, notably used by Titian for his own works); T. Brachert, 'Die Tecniken der polychromierten Holzskupturen', *Maltechnik*, III, 1972, pp. 153–78 (encrustations of wax in medieval sculpture); J.-B. Lebrun and M.D. Magnier, *Nouveau Manuel complet du mouleur en plâtre, au ciment, à l'argile, à la cire, à la gélatine, suivi du moulage et du clichage des médailles*, Paris, 1926, pp. 169–94 (wax casting). M. Duhamel du Monceau, *L'Art du cirier*, Paris, 1762, and L.S. Le Normand, *Manuel du chandelier et du cirier, suivi de l'art du fabricant de cire à chacheter*, Paris, 1827 (craftsmanship in wax); F. Margival, *Les Cirages: encaustiques, cires à frotter, modeller, cacheter, crèmes pour chaussures, mixtures pour entretein des cuirs*, Paris, 1922 (practical wax); H. Bennett, *Industrial Waxes*, New York, 1975 (industrial and chemical wax).

19. Newman, *Wax as Art Form*, p. 11 and pp. 99–104.

20. The best synthesis available is without doubt W. Wittkower, *Qu'est-ce que la sculpture? Principes et procédures*, 1977, trans. B. Bonne, Paris, 1995.

21. Cf. J. Murrell, 'Methods of a Sculptor in Wax', *Le ceroplastica nella scienza e nell'arte. Atti dei I Congresso internazionale*, ed. B. Lanza and M.L. Azzaroli, Florence, II, pp. 709–13. On the chemical identification of waxes, cf. H. Kuhn, 'Detection and Identification of Waxes, Including Punic Wax, by Infra-Red Spectography', *Studies in Conservation*, V, 1960, pp. 71–81. On the additives to beeswax used in sculpture, cf. S. Colinart, 'Materiaux constitutifs', *Sculptures en cire de l'ancienne Egypte à l'art abstrait*, ed. J.-R. Gaborit and J. Ligot, Paris, 1987, pp. 41–57, which examines some recipes using tallow (beef and mutton fat), lard (pork fat), olive oil, turpentine (Venetian in particular), flour, starch, and so on. See also the more general remarks of J.C. Rich, *The Materials and Methods of Sculpture*, New York, 1947, pp. 52–6, and of N. Penny, *The Materials of Sculpture*, New Haven and London, 1993, p. 215.

22. Newman, *Wax as Art Form*, p. 20.

23. Pliny the Elder, *Histoire naturelle, XXXV*, 153, p. 102 (translation modified).

24. Cf., notably, J. Labarte, *Histoire des arts industriels au Moyen Age et à l'époque de la Renaissance*, Paris, 1984, p. 330. 'La matière molle de la cire se prêtait trop bien à la plastique pour n'avoir pas été employée par les sculpteurs dans les temps les plus reculés', G. Le Breton, 'Histoire de la sculpture en cire', *L'Ami des monuments et des arts*, VII, 1893, p. 150: 'La cire est la matière plastique, malléable et fine par excellence, qui se prête le mieux aux délicatesses de l'ébauchoir. Elle obéit à la moindre pression du doigt du sculpteur qui lui communique la chaleur et la vie; aussi n'est-il pas surprenant que, dès la plus haute antiquité, les artistes s'en soient servis pour exécuter leurs modèles dans la représentation de la figure humaine, ou des objects les plus délicats de la nature'.

25. Notably S. Anderson, 'Basic Techniques for Modelling Plants and Animals in Wax', *La ceroplastica nella scienza e nell'arte*, II, p. 578.

26. G. Bataille, 'Matérialisme', p. 170; 'Le matérialisme sera regardé comme un idéalisme gâteux dans la mesure où il ne sera pas fondé immédiatement sur les faits psychologiques ou sociaux, et non sur des abstractions, telles que les phénomènes physiques artificellement isolés. Ainsi c'est à Freud, entre autres ... qu'il faut emprunter une représentation de la matière.' Cf. S. Freud, *Introduction à la psychanalyse* (1916–17), trans. S. Jankelevitch, Paris, 1970, pp. 389–407.

27. A. Kolnai, *Le Dégoût* (1929), trans. O. Cossé, Paris, 1997. The expression 'phénoménologie objectale' is to be found on p. 48.

28. G. Bataille, margin notes of 'L'abjection et les formes misérables', *Oeuvres complètes*, II, Paris, Gallimard, 1970, pp. 438–9. It was in 1929 that Georges Bataille began his own theoretical reference to the *informe*. Compare 'Informe', *Documents*, no. 7, 1927, p. 382.

29. J.-P. Sartre, *L'Etre et le néant. Essai d'ontologie phénoménologique*, Paris, 1943, pp. 652–7; rendered into English here largely in accord with the translation by Hazel E. Barnes, London, 1969, pp. 606–11.

30. S. Freud, 'L'inquietante étrangeté' (1919), trans. B. Feron, *L'Inquiétante étrangeté et autres essais*, Paris, 1985, pp. 209–63.

31. It is a commonplace of Aristotelian embryology that the father is form (sperm) and the mother (maternal blood) 'coagulated', 'formed' by the sperm. Cf. Aristotle, *De la génération des animaux, II*, 1, ed. and trans. H. Carteron, Paris, 1926–31, I, p. 49, where it is said that matter desired form 'like the female desires the male, and the ugly the beautiful'.

32. Cf. notably the collection printed in *Techné*, no. 2, 1995, pp. 29–82.

33. For the collection of waxes in the museum, see J. Pope-Hennessey and R. Lightbown, *Catalogue of Italian Sculpture in the Victoria and Albert Museum*, London, 1964, II, pp. 417–32, 467–74, 556–60, 632–7.

34. G. Le Breton, 'Histoire de la sculpture en cire', *L'Ami des monuments et des arts*, VII, 1893, p. 150.

35. H.W. Janson, 'Realism in Sculpture. Limits and Limitations', *The European Realist Tradition*, ed. G.P. Weisberg, Bloomington, 1982, pp. 290–301.

36. E.H. Gombrich, *L'Art et l'illusion. Psychologie de la représentation picturale* (1959), trans. G. Durant, Paris, 1971, p. 86.

37. Ibid., p. 84.

38. Cf. E. Panofsky, 'Three Decades of Art History in the United States. Impressions of a Transplanted European' (1953), *Meaning in the Visual Arts*, Chicago, 1982, pp. 321–46.

39. Or the rejection, by Janson, of the celebrated polychrome bust in terra cotta, called Niccolò da Uzzano, now attributed to Donatello by a majority of specialists. Cf. H.W. Janson, *The Sculpture of Donatello*, Princeton, Princeton University Press, 1957, pp. 237–40. Cf. G. Didi-Huberman, 'Portrait, Individual, Singularity. Remarks on the Legacy of Aby Warburg', *The Image of the Individual: Portraits in the Renaissance*, eds N. Mann and L. Syson, London, 1998.

40. Cf. E.H. Gombrich, 'Psychanalyse et histoire de l'art' (1953), trans. G. Durand, *Méditations sur un cheval de bois et autres essais sur la théorie de l'art*, Mâcon, 1986, pp. 65–89, where he addresses questions of 'symbolisation' and 'aesthetic pleasure'.

41. On the implicit rejection, cf. G. Didi-Huberman, 'Pour une anthropologie des singularités formelles. Remarque sur l'invention warburgienne', *Genèses, Sciences sociales et histoire*, no. 24, 1996, pp. 145–63; also 'Savoir-mouvement (l'homme qui parlait aux papillons)', preface in P.-A. Michjard, *Aby Warburg et l'image en mouvement*, Paris, 1998.

42. Janson, 'Realism in Sculpture', pp. 291–4.

43. A. Warburg, 'L'art du portrait et la bourgeoisie florentine. Domenicho Ghirlandaio à Santa Trinita. Les portraits de Laurent de Médicis et de son entourage' (1902), *Essais florentins*, trans. S. Muller, Paris, 1990, pp. 101–35.

44. Cf. G. Mazzoni, *I bòti della SS. Annunziata di Firenze. Curiosità storica*, Florence, 1923.

45. A. Parronchi, 'Il naturalismo integrale del primo Quattrocento' (1967), *Donatello e il potere*, Florence-Bologna, 1980, pp. 27–37.

46. Cf. G. Didi-Huberman, 'Ressemblance mythifiée et ressemblance oubliée', pp. 417–32; and 'Pour

une anthropologie des singularités formelles. Remarque sur l'invention warburgienne',
pp. 145–63.

47. Cf. E.H. Gombrich and D. Eribon, *Ce que l'image nous dit. Entretiens sur l'art et la science*, Paris, 1991, pp. 25–30.

48. J. von Schlosser, *Histoire du portrait en cire* (1911), trans. E. Pommier, Paris, 1997, p. 7.

49. Von Schlosser, *Histoire*, pp. 7–8.

50. F. Nietzsche, *Considérations inactuelles, II, De l'utilité et des inconvénients de l'historie pour la vie*, trans. P. Rusch, Paris, 1990 (edn 1992), p. 97, pp. 165–6.

51. Von Schlosser, *Histoire*, p. 8.

52. E.B. Tylor, *Primitive Culture: Researches into the Development of Mythology, Philosophy, Religion, Art and Custom*, London, 1871, I, pp. 1–22, 63–144. The example of the children's game occurs on pp. 65–75.

53. S. Freud, 'Note sur le "bloc-notes magique"', pp. 119–24. On the question of the inscription, cf. the commentary of J. Derrida, 'Freud et la scène de l'écriture', *L'Ecriture et la différence*, Paris, 1967, pp. 293–340.

54. E.H. Gombrich, *Aby Warburg. An Intellectual Biography*, London, 1970, p. 303.

55. F. Nietzsche, *Oeuvres philosophiques complètes*, I-I, eds G. Colli and M. Montinari, trans. P. Lacoue-Labarthe, M. Haar and J.-L. Nancy, Paris, 1977, p. 164.

56. Ibid., p. 277.

57. Von Schlosser, *Histoire*, p. 8.

58. This was understood some years later by the Russian formalists. See B. Eikhenbaum, 'La théorie de la "méthode formelle"' (1925), trans. T. Todorov, *Théorie de la littérature. Textes des formalists russes*, Paris, 1965, p. 69. Cf. also the celebrated work of M. Bakhtin, *L'Oeuvre de François Rabelais et la culture populaire au Moyen Age et sous la Renaissance*, trans. A. Robel, Paris, 1970.

Revulsion / matter's limits

Brandon Taylor

One notices, at a certain point in twentieth-century art and literature, a pronounced interest in matter itself: raw, unvarnished matter that evokes *revulsion* in the viewer, or takes on negative moral and affective qualities so powerfully as to be almost independent of the viewer. Both the viewer's revulsion in such cases, and matter's obscene overspilling of its limits, seem at such moments to be two sides of a single coin. Here, I try to sketch some of the psychological mechanisms involved, and speculate on the historical circumstances that seem to have brought them into being.

For reasons that will become apparent, the small number of instances in modern sculpture where revulsion played a significant part are those where the intimate connection between 'form' and 'matter' began to fall apart. To begin with a well-known case: the upheaval in post-war sculpture known as Minimalism contained a singular experiment by the American artist Robert Morris that resulted in a meltdown of hard, determinate objects into nearly formless matter. In the years leading up to publication of his celebrated essay 'Anti Form' in April 1968, Morris staged a number of assaults on the very concept of 'form'. Having subtracted all internal (and particularly Cubist) relationships from the sculptural work in his first gallery-based blocks, units and volumes of the years 1964–6, Morris introduced soft material, notably industrial felt, into 'works' that hung or drooped under their own weight or which sat in piles in the gallery space, in a vivid demonstration of what he called 'openness, extendibility, accessibility, publicness, repeatability, equanimity, directness, and immediacy ... formed by clear decision rather than groping craft'.[1] The sculptural Gestalt, as he put it, had given way to what he called 'new forms of perceptual relevance' in which traditional sculptural qualities like shape, light, proportion and symmetry had all but disappeared from the work. Works completed in the late part of 1967 such as

Untitled (Tangle) and *Steam* appeared to stage a melancholy descent into a phenomenal world beyond well-formed matter, one requiring a sort of desperate negation of both identity and durability. While *Untitled (Tangle)* collapsed its felt material into an undifferentiated heap, the latter work channelled it beneath a specific urban site: *Steam* took its matter from the city's underground pipes, to produce an amorphous white cloud that billowed in the air, finally dispersing according to the vagaries of wind and local weather (Figure 11.1). In the 'Anti Form' essay Morris maintained that 'making itself', not final form, was the issue:

Only Pollock was able to recover process and hold on to it as part of the end form of the work … the stick that drips the paint is a tool that acknowledges the nature of the fluidity of paint … unlike the brush, it is in far greater sympathy with matter because it acknowledges the inherent tendencies and properties of that matter.[2]

Morris had arrived here at a term – 'fluidity' – that was in a certain way almost synonymous with the objective of 'closeness to matter'. Using the body's energy, matter was to be programmatically subjected to the action of its own physical properties. The Washington painter Morris Louis 'was even closer to matter in his use of the container itself to pour the fluid'. His and Pollock's paintings 'resulted from dealing with the properties of fluidity and the condition of a more or less absorptive ground. The forms and order of their work was not *a priori* to the means'.[3] For Morris at this stage, then, 'closeness to matter' and 'fluidity' had alerted the advanced artist to a new phenomenological universe. Form was hardness, durability, gestalt. Anti-form was fluidity – and a new kind of work for the psyche to do.

But the crisis of durable form was not new in 1967. My guess is that Morris's investigation into 'closeness to matter' owed some of its ancestry to a fashionable text by Jean-Paul Sartre, *La Nausée* (1938), published in English as *The Diary of Antoine Roquentin* in 1949 and again under its real title, *Nausea*, by Penguin Books in 1963. Towards the end of Roquentin's diary we see him radically distrusting the conventional descriptions of things, and recasting them phenomenologically as the qualities they really are. The sea in springtime, conventionally described as 'a breviary … [with] delicate colours, delicious perfumes, springtime souls', becomes transformed under an alternative gaze: 'the *real* sea is cold and black, full of animals; it crawls underneath this thin green film which is designed to deceive people … I see underneath! The varnishes melt, the shining little velvety skins, God's little peach-skins, explode everywhere under my gaze, they split and yawn open'. The tram seat on which Roquentin sits 'could just as well be a dead donkey, for example, swollen by the water and drifting along, belly up on a great grey river, a flood river; and I would be sitting on the donkey's belly and my feet would be dangling in the clear water'. Both are instances of revulsion at

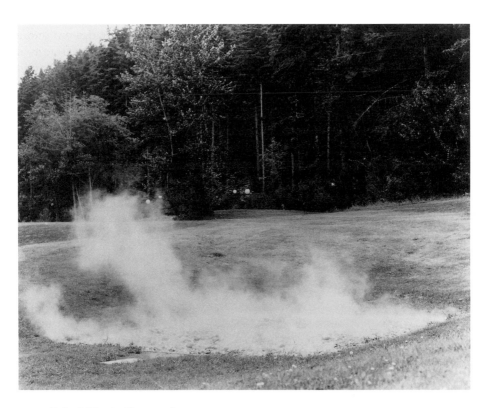

11.1 Robert Morris, *Steam*, 1967

matter which is close to hand, and in both, the image of fluidity seems essential. Matter has become somehow overwhelming too. As Sartre writes through his anti-hero, 'Things have broken free from their names. They are there, grotesque, stubborn, gigantic ... Alone, wordless, defenceless, they surround me, under me, behind me, above me ... I'm suffocating: existence is penetrating me all over, through the eyes, through the nose, through the mouth ...'[4]

Matter itself as absurd, repulsive, superfluous: we shall see in a moment how for Morris in the later 1960s, if not for other anti-form sculptors of his generation, the artist's work consisted of delving deep into the phenomenology of liquid matter in such a way as to redraw completely – at least for a significant moment in time – the boundaries of the art object and the conventional frames through which it was presented and seen. In subsequent works such as *Dirt* (1968) (Figure 11.2) or *Untitled (Threadwaste)* (1968) (Figure 11.3) the conventional expectations of viewing, such as the possession by the work of a clear silhouette, a determinate physical volume,

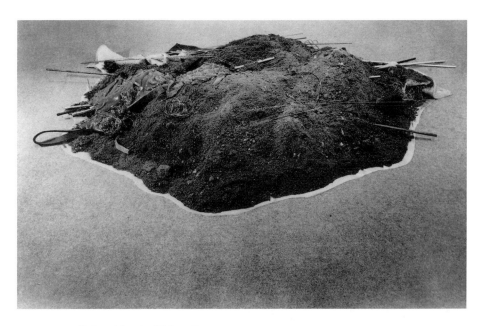

11.2 Robert Morris, *Dirt*, 1968

and a coherent line of demarcation separating the 'work' from the viewer's space, were largely recast, or else ignored. The viewer's 'closeness to matter' would to an extent duplicate that of the artist who made it.

Visceral revulsion, however, for Morris, was not at this stage a fully realised objective. If he had read or been told about Roquentin's misadventures as he walked by the sea or rode in a tram, he chose to echo them only distantly in the physical arrangements and in the titles of his new works. Both 'dirt' and 'threadwaste' are labels that evoke only mildly negative sensory experiences. Furthermore the physical boundaries of the works were still more or less cogently signalled, still just tentatively in place. Though 'closeness to matter' was achieved in *Dirt* by removing from the work any compelling sense of an outline, silhouette, or solid interior (it in fact consists of a pile of earth, grease, moss, brick, steel, copper, aluminium, brass, zinc and felt, dumped on the gallery floor), the artist was careful to situate the thing on a polythene sheet that just served to separate it from the viewer's reality; while *Untitled (Threadwaste)* was to be viewed in the studio in which it was made, yet remained demarcated physically from the viewer's space by a barrier that designated the beginning of the work. The viewer had to look inside from without. At least three distinct but related ideas are now converging upon Morris's thinking and his practice. As he says in a further

11.3 Robert Morris, *Untitled (Threadwaste)*, 1968

article 'Notes on Sculpture: Part 4', published in April 1969, if the foreground–background distinction is put aside and one attends to objects equally within the visual field, what emerges is

a heterogeneous collection of substances and shapes, neither incomplete nor especially complete ... some new art now seems to take the conditions of the visual field itself (figures excluded) and uses these as a structural basis for the art ... Physically, it amounts to a shift from discrete, homogeneous objects to accumulations of things or stuff, sometimes very heterogeneous.[5]

The related statement involves modulating that model of 'substances' as akin to the visual field into a psychoanalytic register. Citing Anton Ehrenzweig from his book *The Hidden Order of Art* (1967) to the effect that 'our attempts at focusing must give way to the vacant all-embracing stare', Morris explicates the process by saying that 'the art under discussion relates to a mode of vision that Ehrenzweig terms variously as scanning, syncretistic, or dedifferentiated – a purposeful detachment from holistic readings in terms of gestalt-bound forms'[6] – a type of perception that

Ehrenzweig believed formed one pole of the rhythmic creative process. The third idea is a noticeable concern with substance as such – with 'closeness to matter'. For as Morris points out, although most recent work (his own included) was still a spread of substances clearly marked off from the rest of the environment, in which overall wholeness, if it can be perceived, is a secondary consequence of the contingent limits of the containing space, 'it is only with this type of recent work that heterogeneity of material has become a possibility again: now any substances or mixtures of substances and the forms or states these might take – rods, particles, dust, pulpy, wet, dry etc, are potentially usable'.[7]

The implication carried by Morris's writings and sculptures of 1969–70 is that the absence of a physical frame for the art-work buys the advantage of 'closeness to matter' in the form of full psychic and physical immersion. He had already proposed that the restructuring of boundaries in *Untitled (Threadwaste)* and similar works had offered the possibility of what he describes as 'an almost effortless release of a flood of energetic work'.[8] Does he mean psychic or physical work? And work on the part of the maker, or the viewer? Morris's groping yet concise explorations of the twin concepts of 'closeness to matter' and psychic work now lead him in several directions at once: both into the affective past, but also into the sculptor's immediate future.

The Sartrean background, first of all, is most conveniently filled in by Roquentin's experiences after he has ejected himself from the tram and has found himself in the municipal park. In this well-known passage, Roquentin finds himself face to face with the root of a chestnut tree 'plunged into the ground' just beneath his bench. 'I was sitting, slightly bent, my head bowed, alone in front of that black, knotty mass, which was utterly crude and frightened me'. There follows a 'revelation' on the nature of existence as such. For

existence had suddenly unveiled itself … it was the very stuff of things, that root was steeped in existence. Or rather the root, the park gates, the bench, the sparse grass on the lawn, all that had vanished; the diversity of things, their individuality, was only an appearance, a veneer. This veneer had melted, leaving soft, monstrous masses, in disorder – naked, with a frightening, obscene nakedness.

Roquentin is transfixed by the tree and its root and allowed it to 'press itself against my eyes. Green rust covered it half way up; the bark, black and blistered, looked like boiled leather'. A feeling of the profound superfluousness of all existence, his own included, flows through him. He scrapes the heel of his shoe against the black bark, only to find that inside it was also black. 'That root – there was nothing in relation to which it was not absurd'.[9] Revelatory of being in all its obscenity, Roquentin says of his

experience: 'I *was* the root of the chestnut tree. Or rather I was all consciousness of its existence. Still detached from it – since I was conscious of it – and yet lost in it, nothing but it ... Time had stopped: a small black pool at my feet; it was impossible for anything to come after that particular moment'.[10]

The passage can be taken to embody not only a typically Sartrean revulsion at existence in its raw state, but on a phenomenological level an undifferentiated apprehension of all matter as nameless, obscene, excessive. There is a suggestive historical conjunction in the fact that Morris's own work of 1969 seems to reprise Sartre's basic motif of revulsion at 'closeness to matter', but tries to extract from it a limited form of redemption at the conclusion of the piece. For the work known as *Continuous Project Altered Daily*, spanning 1–22 March 1969 at the Castelli Warehouse on 108th Street – not a mid-town art space but a spacious factory-like location away from the circuits of spectacular display – Morris assembled earth, clay, asbestos, cotton, water, grease, barrels, plastic, felt, thread-waste, muslin, sound-recording equipment and a camera, and with the aid of some wooden platforms and some shovels started moving elements around in an exploratory, non-directed yet structured (what he called a 'motivated') way. He had already prefigured this catalogue of materials in the article published in April, saying that 'certain art is now using as its beginning and as its means, stuff, substances in many states – from chunks, to particles, to slime, to whatever – and pre-thought images are either necessary nor possible'.[11] In the course of writing 'Some Notes on the Phenomenology of Making: The Search for the Motivated' at around the time of *Continuous Project*, he now invoked Ehrenzweig's categorical duality between the focused, object-differentiating perception of consciousness, and the unfocused, dedifferentiated perception of the deeper mind. In *The Hidden Order of Art*, Ehrenzweig imagined the creative process as moving in a 'dual rhythm' between the twin poles of containment and projection – the latter, in this image, corresponding to a sense of 'expulsion, scattering, casting out' that has clear analogies with the sculpture of anti-form. Morris's familiarity with Ehrenzweig would have acquainted him with that other psychoanalytical transition, from the first to the second anal stage, following directly upon the 'oral' stage so thoroughly mined metaphorically by Melanie Klein. In the first, excrements are freely expelled and are considered as valuable gifts; in the second, following the onset of a sense of disgust, the infant learns to retain excrements and debases their value. Yet Morris quite evidently saw how Ehrenzweig modulated the anal duality into a more fundamental Freudian pair, in suggesting that

life (Eros) tends towards ever enriching internal differentiation through eating (internalisation, retention), while death (Thanatos) tends towards entropy, a levelling down of the difference between inside and outside and a diminution of internal tension through externalisation (excreting, expelling).[12]

For it is notable how the creative rhythm between Eros and Thanatos, here ascribed by Ehrenzweig to Freud, was closely followed by Morris both in the format and the procedures of *Continuous Project Altered Daily*. For twenty-one successive days, Morris made a diary of his activities, worked regular hours, recorded the sound of his activity, and took a photographic shot of particular states of the work so as to provide both a record and a starting-point for the next day's activity. An archive manuscript records:

I started with a ton of clay. I had some thread waste from the thread piece. Barrels, I don't remember what was in them. I started putting plastic down. I had 400 lb of cup grease. I started building tables, and I brought felt, the clay got hard. I stretched felt over, making layers or things [sic]. Put lights under the table. Then started clearing things away. At the end of each day I took a photo which was developed that night. Then the next day I'd put it up. So you begin to have a record of the past. The last day I cleared it up and made recordings of the shovelling, all that stuff. So what was left was the recording of clearing up plus the photographs. That's the nature of the piece, always in process.[13]

The photographs seems to confirm that the 'process' of the work moved from liquid disorder to fullness and then back to disorder, from dedifferentiation to pattern and then the reverse, to a final clearing-up operation and photograph which became folded back into the work – a photograph which by definition could not be placed in the space of the work and whose necessary exclusion marked the spatial and temporal boundaries of the piece (Figure 11.4). Morris quotes Ehrenzweig in a Freudian vein directly: 'The act of expulsion (dedifferentiation) in the service of Thanatos is linked with containment (redifferentiation) in the service of Eros'.[14] The part of the diary that has been published reads: 'First Day ... Dumped out 2000 pounds of wet clay ... on to floor. No idea what to be done with it. Began aimlessly – throwing it around ... took set lumps [of clay] and rubbed on square wall about 8 x 8 and with wet broom and hoe smoothed it out, very thin'. He writes of 'bumpy, shitty, compositional decorative elements' that emerge with the pouring of latex over platforms. He writes elsewhere in the journal of 'viscera, muscles, primal energies, afterbirth, faeces ... a work of the bowels', noting with relief when structure emerges, but recording too the inner tension that arises from showing private behaviour to others, like the guilt of masturbation or the nausea felt at the 'fecal quality of the lumps of mud, which perhaps revolts more than I want to admit'.[15] It is as if immersion in the abject and formless constituted a kind of necessary condition for 'good' rhythm and form. Yet Morris was groping for something darker too: what he

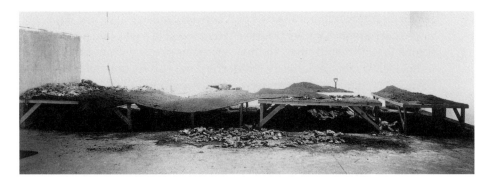

11.4 Robert Morris, *Continuous Project Altered Daily*, 1969

calls 'the motivated' was *paired* (following Saussure) with 'arbitrariness' to reveal a rhythmic alternation akin to a hidden order, the flowing of bodily and psychological energy along bounded paths. Scattering (arbitrariness) and containment (the 'motivated'), like diachronic/synchronic, syntagmatic/associative, were binary terms that structured one another. It is a curious fact that Jacques Lacan had spoken in the Seminar of 29 January 1964 (which Morris cannot have known) of the rhythm between the symbolic and the non-realized or 'limbo', proposing that 'what became apparent at first to Freud, to the discoverers, to those who made the first steps ... is that [the unconscious] is neither being, nor non-being, but the unrealised'.[16] Lacan talks about a rupture in the causal pattern, over which a scar may later appear: 'the Freudian unconscious is situated at that point where, between cause and that which it affects, there is always something wrong'.[17] Art's function, according to Morris at this juncture, is to interrupt instrumental patterning by means of just such an oscillation: 'It is as if the artist wants to do the most discontinuous, irrational things in the most reasonable way ... a kind of regress into a controlled lack of control'.[18] 'Making art', says Morris, 'cannot be equated with craft time ... it is much more about going through with something'.[19]

At least two important qualifications need immediately to be made. The first is to disclaim any intention to reduce even so heterodox and adventurous a work as *Continuous Project Altered Daily* to an exercise in Freudian or Ehrenzweigian theory. For we have Morris's authority for saying that when he is describing his own practice as well as that of others, 'the interest ... is to focus on the nature of art making of a certain kind as it exists within its social and historical framing'.[20] The general principle operative here, asserted over and over again in 'Notes on Sculpture, Part 4', is the necessity to rethink the concept of the 'image' in art and to reassert – or assert

for the first time – the intimate bond between ends and means: 'Ends and means are brought together [in some recent work] in a way that never existed before in art'.[21] And the '"forms" of making' current in an advanced technological urban culture are for Morris progressively those of information processing – he is writing in 1969 – and decreasingly those involving the physical transformation of matter. As he says in one graphic footnote, experience of the means–end connection is to be had in a zone of material production lying beyond the urban core, in the industrial units where metal bearings are packed into wooden crates, where functional buildings are built and repaired with little view to beauty, and where surplus material is discarded or dumped – a conscious antithesis to the sophisticated productive spaces of the mid-town offices and corporate headquarters. This urban nature has important things to teach us about the final form of the city as such:

Centres for production are increasingly located outside the urban environment in what are euphemistically termed 'industrial parks'. In these grim, remote areas the objects of daily use are produced by increasingly obscure processes, and the matter transformed is increasingly synthetic and unidentifiable … Our immediate surroundings tend to be read as 'forms' that have been punched out of unidentifiable, indestructible plastic or unfamiliar metal alloys.

The clear implication is that the avant-garde can do something to enact the reconnection of means to ends, of 'process' to form. 'It is interesting to note', Morris says finally, and apparently in relation to *Dirt*, 'that in an urban environment construction sites become small theatrical arenas, the only places where raw substances and the processes of their transformation are visible, and the only places where random distribution is tolerated'.[22] On this evidence it would seem that Morris's practice was an attempt to see the culture *whole* in 1968 and 1969 – not just its charismatic or alienated parts taken singly.

The second qualification is that in no sense, in the work itself, is the balance between retention and expulsion (the anal metaphor), between Eros and Thanatos, to be read as finally achieved or resolved. As Morris wrote to me in a note long after the event (I had asked to see the entire diary transcript of *Continuous Project*): 'it was all too raw and anxious-making and I don't think I want to think about it … well, maybe it might have some clinical interest as a record of doubt, anxiety, confused ideas, self-disgust, inability to effect closure, etc'.[23] To the contrary, any post-hoc psychoanalytical reading must have uncertainty at its core; and at least one dimension of that uncertainty must be historical.

I mean that disgust, the revulsion that attends certain types or conditions of matter, itself appears to occupy a particular historical interval, and an important one for Morris and for certain other artists of his generation. Aside

from Freud's remarks about the possible confusion of *grauen* (to feel terror) with *grausen* (to feel disgust), the first major intellectual assault on the question was published by the Hungarian phenomenologist Aurel Kolnai in 1929: his important book *Der Ekel* (Disgust) did not appear in a language other than German until its French translation as *Le Dégoût* (1997) and in English as *On Disgust* (2004). Kolnai's achievement in this essay was not only to distinguish convincingly between disgust and other, in some ways comparable, affects such as fear and hate, but to give a characterisation of disgust itself that still looks convincing today. In the case of disgust, Kolnai says, 'from the very beginning there is a shuddering and a turning away from the object, and nausea, either real or intentional', but that disgust is also a sensory reaction to the qualities of an object that is experienced – not the object itself. Two further features in addition to this essentially aesthetic character of the affect are successfully brought out in Kolnai's analysis. The first is that, unlike fear, which is more general in its appearance, disgust is deeply intentional (in phenomenological terms) and 'penetrates the object, probing and analysing it', while in a reverse direction the disgusting object or substance is marked by 'its will to be near ... or, as I would rather put it, its shameless and unrestrained forcing itself upon us'. In a memorable passage he writes of how 'the disgusting object grins and smirks and stinks menacingly at us'. What is even more distinctive about Kolnai's analysis is the paradoxical nature of disgust. Though essentially proximate, the disgusting substance or object not only revolts the subject – not only fascinates it – but is disgusting only on the presupposition that some attraction exists between it and the subject, 'a possible contact with the disgusting object ... which could perhaps be brought about only by myself and not by that object'. Second, the range of objects and substances typically associated with disgust is relatively narrow: it includes rotting food, putrescent human flesh, fluid secretions, mucus, etc. But that is not all. As Kolnai observes, 'much more it is primarily a matter of the general disgustingness of the viscous, semi-fluid, obtrusively clinging. The substances ... carry the motif of an "indecent surplus of life" – an abundance that, true to nature, points once more to death and to putrefaction, towards life which is in decline'.[24]

Kolnai's writing of *Der Ekel* in the late 1920s coincided chronologically with the explorations of melting, viscous forms in Surrealist art and film. Georges Bataille is known to have been familiar with Kolnai's work and to have made notes on the essay.[25] The paintings of Dalí and the films he made with Buñuel are notoriously full of images of putrefaction, obscenity and decay. Disgust as a specifically aesthetic sensation – disgust alongside other varieties of sensational unpleasure such as formal ugliness, distortion, and the complete collapse of matter into the abject and the formless – had by the

early 1930s become indices of a Surrealist interest in alternative realities, to surface again in the writings and teachings of the College of Sociology in the late 1930s. And the particular forms of disgust evoked by the slimy and the viscous were construed as fundamentally ethical metaphors as much by Kolnai himself as by his successor in this respect, Jean-Paul Sartre.

The difficulties involved in translating the sensations of revulsion from philosophy into literature, or from either medium into visual art, should now be clear. The presence of sticky or contaminating matter in the work of sculpture is entirely incompatible with the conventions of a market for art based on ownership, durability and formal pleasure. Morris's concern in 1968–9 with 'closeness to matter' arose at a moment in western art when evading a market for art seemed once again possible, certainly desirable. And yet a fascination with the very mechanisms of disgust is discernible across the entire range of phenomenology, literature and art.

Aside from its ability to function as a political or ethical metaphor across the three media, the psychological mechanisms that are mobilised may bear comparison. Kolnai, as we have seen, though somewhat sceptical about psychoanalysis by the time of his writing *Der Ekel*, nevertheless claimed that 'in psychoanalytical terms ... [disgust] presupposes, as it were by definition, an albeit suppressed desire [*lust*] for the object which provokes it',[26] essentially following Freud's conviction that the emotion of disgust was a reaction-formation that places inhibiting limits on behaviours which seek excessive sensory and especially sexual indulgence (particularly of repressed desire), and hence forms the basis of morality. The question is: which morality? When Sartre carried out his own moral phenomenology in *L'Être et le néant* of 1943 it was an anti-bourgeois morality of revulsion at the insincere, the socially cloying, the inauthentic. Viscosity was precisely the condition of matter that performed that role.

Indeed, Sartre seems to embody the mid-twentieth-century consciousness of one who finds in viscous and organic matter a whole moral and political phenomenology – who is sceptical of a psychoanalytical gaze suggesting that every strong aversion conceals a repressed wish. That is why he is content to approach the morally and politically repugnant through the vicissitudes of matter. 'What we must do', Sartre begins the powerful final section of *L'Être et le néant*, 'is attempt a psychoanalysis of things' – by which he means not things themselves, but the qualities which determine 'the meaning which really belongs to things'.[27] And here we find that, as in Kolnai, *mineral* matter was for Sartre never so distressing as the organic. Simone de Beauvoir tells us that Sartre 'could tolerate a calm sea, the even sand of the desert, or the icy minerals of the Alpine peaks'.[28] Even water elicits a generally positive valuation. In *L'Être et le néant*, water is

a being which is eternity and infinite temporality because it is perpetual change without anything that changes, a being which best symbolises in this synthesis of eternity and temporality, a possible fusion of the for-itself (*pour-soi*) as pure temporality and the in-itself (*en-soi*) as pure eternity.[29]

On the other hand a slimy or viscous (*visqueux*) substance is for Sartre an 'aberrant fluid ... essentially ambiguous because its fluidity exists in slow motion ... it represents a dawning triumph of the solid over the liquid'. Slime, Sartre avers, 'is the agony of water': its snare lies in its being 'a fluidity which holds me and which compromises me ... it is degraded ... slime is like a liquid seen in a nightmare, where all its properties are animated by a sort of life and turn back against me'.[30] Simone de Beauvoir tells us that 'He detested – the word is not too strong – the swarming life of insects and the abundant life of plants ... He liked neither raw vegetables nor untreated milk, nor oysters, only cooked things; he even preferred fruit in jam to the natural product'. Sartre himself described Baudelaire in similar terms: 'For him, *real* water, *real* light, *real* warmth, was that of the city; they were already objects of art'. Nature, 'in its sticky heat, in its abundance, horrified him'.[31]

And yet Sartre's purpose is a moral one too: it can be summarised by saying that the philosophical agenda of *L'Être et le néant* is to construct a lexicon by which human and moral characteristics can be translated by phenomenological association into relations of being. In fact so complete is the metaphor, says Sartre, that the association runs both ways: actions and gestures can be slimy ('a handshake, a smile, a thought' are viscous 'like a liquid seen in a nightmare'[32]), but sliminess also typifies the bourgeois order, the invasion of France by the Nazis, and other socially aroused emotions of contamination:

[It is] as if we come to life in a universe where feelings and acts are all charged with something material, have a substantial stuff, are *really* soft, dull, slimy, low, elevated, etc, and in which material substances have originally a psychic meaning which renders them repugnant, horrifying, alluring, etc.[33]

He then gives an image of slime's duplicitous ambiguity by describing the slowness with which the slimy melts into itself. Honey dropped into a jar presents 'a constant hysteresis in the phenomenon of being transmuted into itself'. The fusion of the drop into the whole is 'a gradual sinking, a collapse which appears at once as a *deflation* (think for example of children's pleasure in playing with a toy which whistles when inflated and groans mournfully when deflating) and as *display* – like the flattening out of the full breasts of a woman who is lying on her back'.[34] The slimy or the viscous, in short, is 'both an objective structure of the world and at the same time an anti-value'.[35] Sartre again: 'If I sink in the slimy, I feel that I am going to be lost in it ... in

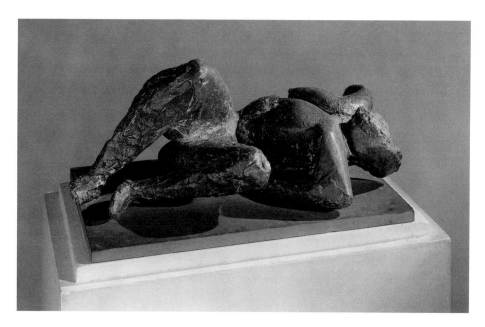

11.5 Anthony Caro, *Woman Waking Up*, bronze, 1955

the very apprehension of the slimy, there is a gluey substance, compromising and without equilibrium, like the haunting memory of a *metamorphosis'*.[36]

The historical moment celebrated in Sartre's writings, then, is one that might be positioned in the rearground of Morris's own: we are uncovering an earlier moment of profound connection between the experience of fascism and war and the occurrence (during the wartime years and just after) of images of putrescence and viscosity in European philosophy, literature and art. The empathy between Sartre's phenomenological reflections on rotting food and the liquid dribblings and scumblings of painters like Wols or Paul Rebeyrolle between 1945 and 1951 have been noted.[37] Wols, after wartime incarceration by both the Nazis and the French, and following a subsequent struggle with alcoholism, was admired by Sartre for having 'constructed palaces [in his paintings] with his own excretions ... the creature dreamed of his own decomposition with his product'.[38] Dalí's excremental phantasies and liquid timepieces, or Man Ray's solarisation inversions where mass becomes empty and space becomes full, these too are examples of how in the late-Surrealist imagination, the body, the plant world and the fluids of nature all horribly and fascinatingly intertwine. In England in the 1950s, Ehrenzweig's creative alternation between conscious object differentiation and unconscious dedifferentiation is once more a fluidity metaphor in as

much as it proceeds in the language of 'surface' and 'depth'. Abstract painting of the time was routinely underwritten in terms of an inevitable 'lowering' of the art-work under pressure from the gravitational forces that propelled dribbled paint downwards towards the floor.[39] At the end of the 1950s, the collapse of form in art was for a while a culturally dominant motif: it is instructive to see how a young sculptor like Anthony Caro, in his *Woman Waking Up* bronze of 1955, seems literally to have incarnated Sartre's description of viscous flesh as a 'gradual sinking … which appears at once as a *deflation*' like the skin and flesh of the woman who is lying on her back (Figure 11.5).[40]

How widely was the phenomenology of disgust manifested in the generation of artists who came to maturity after World War II? There is one case that deserves mention in this context – the installations of the *émigré* Russian artist Ilya Kabakov, for whom 'garbage' has exerted a particular attraction as in several ways symptomatic of the crisis which overtook the domestic and political civilisation of the Soviet Union in the period of its own gathering collapse, the early 1980s. Here we have a 'deferred' collapse – but one that resonates well with the material considered so far. Even before his emigration to the West, Kabakov 'started to make crates and folders; to collect, sew together garbage which surrounded one in the studio, and to write a commentary to go with each object details of where it came from, why, how it wound up here' (Figure 11.6).[41] Elsewhere he wrote:

I gradually began to see in this an image of a unique psychological personage who cherishes each paper, not discarding any paper trash from the past; that's how the hero 'The Garbage Man' came to be. But there was another reason, which expanded the notion of garbage in my consciousness, unbelievably hyperbolising it, making it 'metaphysical'. I'm referring to the special sensation, physical and mental, that everything which surrounded us living in the Soviet Union represented an enormous littered space.[42]

In the *Garbage Man* installation of 1989, among the first Kabakov completed in the West, his country's garbage and that of his own studio became suggestive of a special type of contamination:

The image of a cluttered, dusty, half-abandoned, ownerless existence is firmly connected for me with the feeling of my Homeland and with the hopeless feeling that it is impossible to get rid of the situation, that it is here forever, and that garbage and dirt are the very unique 'genius' of our place.[43]

Far from abating, the intensity of this attitude increased following Kabakov's emigration to the West in the winter of 1987–8. Nugatory experiences of wastage and despair at the Soviet object-world now began to abut directly against a super-idealisation of the West in which there was no effective distinction between the dream and the reality.[44] Self-hatred and cultural

11.6 Ilya Kabakov, *The Rope of Life*, 1995,

loathing had already given rise to other overtly aggressive systems within Kabakov's work. Not only do the fragments of the new installations have verbal tags, but these tags now answer back abusively – 'Take a hike, go fuck yourself!', or 'You cunt, put it down or I'll kill you!' – as if their power to contaminate had turned personal with a vengeance: not only bad objects from a bad culture, but also bad objects projected from the personal to the outer world. 'Anything that I touch suddenly belches out a stream of abuse, insults, curses ... that's how I experience inside me the world that surrounds me', Kabakov explained: 'It reminds me of a crowded Moscow bus on a hot day in July which you can't get off. Suffocating and dripping with sweat, looking around you, trying to find a face which is not distorted with pain and irritation'.[45] An oppressive sense of contamination, not by single objects but by whole continua of things, exudes from virtually each of Kabakov's installations of the period.[46]

Not one artist, then, but two. Following Surrealism and the wartime writings of Sartre, both Morris's efforts to pathologise 'closeness to matter' in

the late 1960s and Kabakov's encounter with 'garbage' following his move to the West some two decades later seem to exemplify formlessness being steered away from psychopathology, narrowly defined, to constitute powerful critiques of cultural forms and processes through metaphors of fluidity and material collapse: in Morris's case the manufacturing culture of the new American metropolis: in Kabakov's, the object-world of the rapidly imploding Soviet state. That there are few instances of formlessness in recent installation or process art having a comparable historical resonance – the majority have been premised on the dry or granular rather than viscous or contaminating matter – seems to underline both the relevance and the limitations of the psychoanalytic deployment of the concept of disgust. Having entered the lexicon in connection with the phenomenon of psychic repression, the sensation of revulsion seems to find its true historical place in an existential phenomenology of material qualities such as the sticky and the slimy that did powerful work as both social and historical critique. To unravel the possibly *redemptive* effects of contamination by the unclean – either in phenomenology, psychoanalysis, or aesthetics – would be to go further still. It would require us to look closely at what it might have signified for Roquentin to speak of the 'atrocious pleasure' he sensed at the sight of the 'small black pool' that lay at his feet in the form of the root of the tree. What did it portend that in the midst of his feelings of revulsion, he said, almost as an aside, 'I felt delighted with my deliverance ... all of a sudden, something started moving before my eyes, slight uncertain movements: the wind was shaking the top of the tree'?[47]

Notes

1. R. Morris, 'Notes on Sculpture, Part 3: Notes and Non-Sequiturs', *Artforum*, June 1967; reprinted in *Continuous Project Altered Daily: The Writings of Robert Morris*, Cambridge, Mass., and London, 1993 (hereafter *Continuous Project*), p. 33.

2. R. Morris, 'Anti Form', *Artforum*, April 1968; *Continuous Project*, p. 43.

3. Morris, 'Anti Form'; *Continuous Project*, pp. 43, 44.

4. J.-P. Sartre, *Nausea*, London (1963) edn, pp. 179, 180, 180–81.

5. Morris, 'Notes on Sculpture, Part 4: Beyond Objects', *Artforum*, April 1969; *Continuous Project*, p. 57.

6. Morris, 'Notes on Sculpture, Part 4'; *Continuous Project*, pp. 57, 61.

7. Morris, 'Notes on Sculpture, Part 4'; *Continuous Project*, p. 60.

8. Morris, 'Notes on Sculpture, Part 4'; *Continuous Project*, p. 61.

9. Sartre, *Nausea*, pp. 183, 185.

10. Ibid., p. 188.

11. Morris, 'Notes on Sculpture, Part 4'; *Continuous Project*, p. 67.

12. A. Ehrenzweig, *The Hidden Order of Art: A Study in the Pathology of Artistic Imagination*, Berkeley and London, 1967, p. 219.

13. Morris, 'Continuous Project Altered Daily', unpublished MS, Guggenheim Museum, New York, No. 69.263.

14. Ehrenzweig, *The Hidden Order of Art*, p. 220; quoted in *Continuous Project*, p. 81.

15. The diary compiled with *Continuous Project Altered Daily* has been partly published. See *Robert Morris*, Pompidou Centre, Paris, 1998, p. 235 and fn 5.

16. J. Lacan, *The Four Fundamental Concepts of Psychoanalysis*, Paris, 1973, ed. Jacques-Alain Miller and trans. Alan Sheridan, London, 1979, pp. 22, 30, 29–30.

17. Lacan, *Four Fundamental Concepts*, p. 54.

18. Morris, 'Some Notes on the Phenomenology of Making: the Search for the Motivated', *Artforum*, April 1970; *Continuous Project*, pp. 81, 87.

19. Morris, 'Some Notes on the Phenomenology of Making'; p. 87.

20. Ibid., p. 73.

21. Morris, 'Notes on Sculpture, Part 4', p. 67.

22. Ibid., p. 73.

23. Correspondence with the author, 2001.

24. A. Kolnai, *On Disgust*, ed. and intr. Barry Smith and Carolyn Korsemeyer, Chicago and La Salle, Illinois, 2004, pp. 39, 41, 43, 54–5 respectively.

25. C. Korsemeyer, and B. Smith, 'Visceral Values: Aurel Kolnai on Disgust', in Kolnai, *On Disgust*, p. 17.

26. Kolnai, *On Disgust*, p. 43.

27. J.-P. Sartre, *L'Être et le néant* (1943); published in English as *Being and Nothingness: an essay in phenomenological ontology*, London, 1972, p. 600.

28. Simone de Beauvoir, cited in Plant, *Sartre and Surrealism*; Sartre disfavours the hard, impermeable world of 'petrified' being, particularly academic sculptures, statues and works of art – only Alexander Calder is prized for objects which move, hesitate, float, reverse themselves, take up a variety of forms.

29. Sartre, *Being and Nothingness*, p. 607. At the same time we find Sartre rejecting the lyrical readings given to water in Gaston Bachelard's *L'Eau et les rêves: essais sur l'imagination de la matière*, of 1942, a work on the metaphorics of water in Poe, Nietzsche, Swinburne, in nature and death, in purification, ritual and even speech.

30. Sartre, *Being and Nothingness*, p. 609.

31. Simone de Beauvoir; see Plant, *Sartre and Surrealism*, p. 49, fn 81 (my translation).

32. Sartre, *Being and Nothingness*, p. 604. Sartre then provides this 'immense and universal symbolism' (p. 605) with a gender: for overlaying a basic ontology of the materially continuous and the discontinuous, quantum and wave – what he calls 'the feminine and masculine poles of the world' – Sartre unhesitatingly describes slime itself as 'a sickly-sweet, *feminine* revenge which will be symbolised on another level by the quality "sugary"'. For a critique, see M. Collins and C. Pierce, 'Holes and Slime: Sexism in Sartre's Psychoanalysis', in C.C. Gould and W. Wartofsky (eds), *Women and Philosophy*, 1976.

33. Sartre, *Being and Nothingness*, p. 605.

34. Ibid., p. 608.

35. Ibid., p. 611.

36. Ibid., p. 610.

37. Notably by Frances Morris, 'Wols', and Sarah Wilson, 'Paris Post-War: In Search of the Absolute',

Paris Post War: Art and Existentialism 1945–55, exh. cat., Tate Gallery, London, 1993, pp. 181–2, 25–52 respectively.

38. Sartre, 'Doigt et Non-Doigts' (Fingers and Non-Fingers), printed in extract in P. Inch (ed.), *Circus Wols: The Life and Work of Wolfgang Schulze*, Todmorden, Lancs, Arc Publications, 1978, n.p.

39. See D. Mellor, 'Existentialism and Post-War British Art', in *Paris Post War*, 1993, pp. 53–62.

40. The sculpture has since been regularly positioned, of course, in terms of Caro's 'progress' in the direction of the pedestal-free abstract metal sculpture for which he was later to become well known.

41. I. Kabakov, *The Boat of My Life*, Salzburg, 1994, p. 93.

42. I. Kabakov, Statement on 'Garbage', in A. Wallach, *Ilya Kabakov: The Man Who Never Threw Anything Away*, New York, 1996, p. 171.

43. I. Kabakov, 'On Emptiness', in D. Ross (ed.), *Between Spring and Summer: Soviet Conceptualism*, Boston, 1989, p. 103.

44. Here is how Kabakov described his earliest experiences in Paradise: 'I am walking along the Champs Elysées. I have been propelled into another world. I see it as paradisaical. But there is some sort of interminable dirt inside me. I am sick, horrible in this alien, wonderful land … I walked up to the fence around Buckingham Palace, there are soldiers inside, it's the changing of the guards – I am walking and looking, but I don't see anything, what's the matter with me?' Kabakov, *The Boat of My Life*, 1993, pp. 98–9.

45. Kabakov, *The Rope of Life and Other Installations*, exh. cat., Museum für Moderne Kunst, Frankfurt, 1995, p. 121.

46. Several subsequent installations took on a profound concern with memory, particularly of the artist's relation to his mother and her life, and the negative experience of the contaminating object-world of Soviet Russia became converted, finally, into a conception of an anal function that has structured more recent projects. For 'Documenta IX' in Kassel in 1992, Kabakov positioned Soviet Russia as the excretory function of the world. Seeing Jonathan Borofsky's diagonal stick reaching into the sky at the front of the 'Documenta' site in Kassel made phallic America seem the adventurous cavalier of the avant-garde: Kabakov wanted a position *against* the avant-garde: in between lay Europe, and a battle for her cultural goods. 'I felt that since I was a representative of the Soviet Motherland, I should take the position which corresponded to its position in the world. Since Documenta is a model of world-wide dimensions, then I should occupy the place of my homeland – and that place, of course was in the rear'. Inside Kabakov's *Toilet* at the back of the site, the visitor could see a more or less convincing *mise-en-scène* in which a Soviet family has set up residence in a toilet, but without first having had the building converted from its former use. One saw a breakfast table and chairs in the space of the lavatories: pictures on the walls, life going on normally – 'a quiet, decent family lives here', says Kabakov, 'it's possible that they just stepped out for a minute to see the neighbours'. Borofsky's 'phallus', Kabakov further explains, 'was triumphantly raised upward, aspiring toward the sky, in comparison to the anal: the battle detachments after horrible attacks and at the moment of exhaustion will certainly want to take a shit'. The *Boat of My Life*, 1993, pp. 98–9.

47. Sartre, *Nausea*, pp. 188, 189.

Index